EDITORIAL DESIGN

編輯設計學

【暢銷紀念版】

PRINT, WEB & APP! 數位與印刷刊物的全方位編輯設計指南

VO0049X

編輯設計學【暢銷紀念版】 Print, Web & App!數位與印刷刊物的全方位編輯設計指南

Editorial Design: Digital and Print 原文書名

者 凱絲·柯德威爾(Cath Caldwell)、 作

尤蘭達·澤帕特拉 (Yolanda Zappaterra)

呂奕欣 老

總編輯 王秀婷

李 華、陳佳欣 責任編輯

版權行政 沙家心

陳紫晴、羅伃伶 行銷業務

發行人 涂玉雲 KIE **看木文化**

104台北市民生東路二段141號5樓

電話: (02) 2500-7696 | 傳真: (02) 2500-1953

官方部落格: www.cubepress.com.tw 讀者服務信箱:service_cube@hmg.com.tw 英屬蓋曼群島商家庭傳媒股份有限公司城邦分公司

台北市民生東路二段141號11樓

讀者服務專線:(02)25007718-9 | 24小時傳真專線:(02)25001990-1

服務時間: 调一至调五09:30-12:00、13:30-17:00 郵撥:19863813 | 戶名:書虫股份有限公司 網站:城邦讀書花園 | 網址:www.cite.com.tw

香港發行所 城邦(香港)出版集團有限公司

> 香港九龍九龍城土瓜灣道86號順聯工業大廈6樓A室 電話:+852-25086231 | 傳真:+852-25789337

電子信箱: hkcite@biznetvigator.com

馬新發行所 城邦(馬新)出版集團 Cite(M) Sdn Bhd

41, Jalan Radin Anum, Bandar Baru Sri Petaling, 57000 Kuala Lumpur, Malaysia.

電話: (603) 9056-3833 | 傳真: (603) 90576622

電子信箱: services@cite.my

製版印刷 內頁排版

發 行

優士穎企業有限公司

上晴彩色印刷製版股份有限公司

城邦讀書花園

www.cite.com.tw

【印刷版】

【電子版】

2016年5月31日 初版一刷 2024年1月29日 二版一刷 2024年1月

ISBN 978-986-459-571-6 (EPUB)

售 價/NT\$750

Printed in Taiwan.

ISBN 978-986-459-573-0

版權所有·翻印必究

Design Copyright©2014 Laurence King Publishing

© 2015 Cath Caldwell and Central Saint Martins College of Art & Design Translation©2016 Cubepress, a division of Cité Publishing Ltd.

This book was designed, produced and published in 2014 by Laurence King Publishing Ltd., London. This edition is published by arrangement with Laurence King Publishing Ltd., through Andrew Numberg Associates International Limited.

國家圖書館出版品預行編目(CIP)資料

編輯設計學【暢銷紀念版】: PRINT,WEB & APP! 數位與印刷刊物的全方位編輯設計指南/凱絲.柯德 威爾(Cath Caldwell), 尤蘭達.澤帕特拉(Yolanda Zappaterra)作; 呂奕欣譯. -- 二版. -- 臺北市: 積木文 化出版:英屬蓋曼群島商家庭傳媒股份有限公司城邦 分公司發行, 2024.01

面: 公分

譯自: Editorial design: digital and print ISBN 978-986-459-573-0(平裝)

1.CST: 平面設計

964

112021828

EDITORIAL DESIGN

編輯設計學

【暢銷紀念版】

PRINT, WEB & APP! 數位與印刷刊物的全方位編輯設計指南

Cath Caldwell Yolanda Zappaterra 凱絲·柯德威爾/尤蘭達·澤帕特拉 著 呂奕欣 譯

目錄

前言		5
Chapter 1	編輯設計 Editorial design 什麼是編輯設計?/設計師在雜誌社中的角色	6
Chapter 2	編輯設計格式 Editorial formats 數位出版簡史/報紙/雜誌/工作坊1	22
Chapter 3	封面 Covers 品牌與識別/封面設計/1940年迄今的封面發展/ 封面設計的類型/封面的構成要素/工作坊2	40
Chapter 4	刊物內容 Inside the publication 刊物解析/文字編排的功用/圖片處理/工作坊3	76
Chapter 5	製作版型 Creating layouts 版面的主要元素/版面構成的決定性要素/ 和諧與衝突/風格/將靈感落實到版型設計/工作坊4	108
Chapter 6	設計者的必備技能 Editorial design skills 將想法視覺化/頁面製作與格線/字型的選擇與應用/ 美術能力與後製事宜/圖片的取得、評估與使用/ 保持一致,不流於單調/改版的時機與原因/工作坊5	152
Chapter 7	回顧過去·展望未來 Looking back, looking forward 回顧過往:促發原則與隱含原則/ 名人堂:設計大師與出版品/展望未來	204
紙本印刷沒	寅變史	234
延伸閱讀		236
索引		238
作者謝辭		240

前言

這本書旨在教導讀者,如何整合「文字編排」和「圖片製作」這兩項工作,展現新聞報刊類版面設計的魅力,並將相關技術應用到各種現代的印刷刊物與數位雜誌上。我將協助讀者打下紮實的知識基礎,這些知識在設計實務上都很重要,書中也會提供充分的參考案例,給予讀者啟發。簡言之,本書要告訴讀者,圖與文如何在螢幕或紙張上一起發光發熱。

2010年 iPad 問世之後,許多人如臨大敵,忙著爭論新聞平面媒體的下一步。然而我想說明的是,平面媒體的創意工作並不會因此受到絲毫影響。如今,紙本閱讀和數位閱讀的爭論已告一段落,「編輯設計」(Editorial Design)的新黃金時代翩然降臨。在這生態系中,印刷媒體必須與社群網站、宣傳活動及行動產品相互整合,而上述都是發揮視覺傳達設計創意的好機會。設計師必須熟悉字型、美術設計與版面編排的法則,才能好好把握住這些新生的設計需求。先別急著把設計史的書籍扔了,設計發展的每一步都非常重要,我們要能在過去、現在、未來間取得平衡,不偏廢任何一方。

本書的第二章到第四章會針對不同的編輯設計格式提出概述;第五、六章的重點則 是培養讀者的設計能力;第七章會列出許多歷久彌新的設計佳作。第二到六章的結 尾處都附有「工作坊」的單元,這單元皆由設計系學生實際操作過,讀者也可依照 指示來練習這些設計方法。

藝術指導珍妮·佛羅里克(Janet Froelich)、傑瑞米·雷斯里(Jeremy Leslie)、馬克·波特(Mark Porter)、賽門·埃斯特森(Simon Esterson)都是曾啟發我的重要人物。他們始終走在時代尖端,如今在設計界仍相當活躍,且對編輯設計領域的動態保持關注,不斷為業界注入新活力。你可以將過去的經驗,用最新的平台再次發揮。編輯設計已進入新紀元,新媒體會促成無限可能,因此在關心科技發展之餘,別忘了仔細閱讀本書,它能讓你做好準備,迎向未來。

——凱斯·柯德威爾 (Cath Caldwell)

Y CIT

MODA & VERANO

LAS COMBINACIONES PERFECTAS

Descubre a las protagonistas del momento

00187 8 424094 037650

JULIO-AGOSTO 2012 3€
DE 5,30€ IT 4,95€ FR 4,55€ UK 3,1
KSENIA GOLUBENA LLEVA BODY DE LOUIS
VULTTON Y ZANATOS DE SPORTMAX

Sigue los vídeos, fotos y entrevistas en

dad

NEW, FRESH, SEXY, BOLD... THE LATEST!

MARIO CASAS, CLARA LAGO Y MARÍA VALVERDE SUBEN, AÚN MÁS, LA TEMPERATURA

JULIE DELPY CHARLOTTE GAINSBOURG LA VAMPIRES LAUREL HALO TANYA WEXLER Chapter 1:編輯設計

本書是印刷與數位刊物的設計指南,匯整了「編輯設計」發展至今的完整觀念,我們將一一説明蘊含其中的諸多法則,並建立正確概念。「編輯設計」的英文是「editorial design」,「editorial」原指「社論」,亦即在特定時間,對特定議題所發表的意見。編輯設計的最初任務,是要為值得訴説的故事進行全面策劃,並藉由出版刊物分享觀念、興趣或甚至品牌情報。編輯設計如今已不再局限於紙本頁面,而更常跨足到行動載具上。然而,無論是哪個時代的設計師,都肯定同意這門學問最重要的能力在於卓越的溝通技巧,與説故事的熱情。

本章首先要探討的是,什麼是編輯設計?在編輯設計上,設計師會扮演哪些不同角色?

什麼是編輯設計?

想學好編輯設計,要先釐清編輯設計的定義。它和其他平面設計有何不同?簡言之,編排具新聞性或主題性的內容,與其他平面設計相較起來,和讀者的關係很不一樣。閱讀性刊物具有娛樂、傳遞資訊、指導、溝通、教育等功能,一份刊物可能具備上述中的一項或同時擁有多項。在一份刊物中,往往必須呈現多種意見,即使這些意見可能屬於同一派思想,例如報紙就是如此。如今許多刊物更進一步,能直接與讀者對話、接收回饋。隨著 GPS(全球定位系統)等行動工具的發展,編輯與廣告業者可以好好利用這些與讀者互動的新機會。然而,無論其載體是紙張、網路下來我們將逐一說明這些原則。

「編輯設計就是出版品設計,例如怎麼設計 大量印刷的紙本雜誌——它通常有獨特的外 觀與質感。」

——文斯·佛洛斯特(Vince Frost),《Zembla》 雜誌藝術指導

編輯的目標與要素

多數刊物編輯的要務,在於如何安排、展示文字 與圖片,以傳達內容或報導的核心觀念。文與圖 在呈現時須滿足不同機能,例如文章標題要怎 樣才能吸引讀者注意,而圖片通常要能說明或佐 證內文(報導內容)的某個論點。在數位出版品 中,則要讓標題與圖像變成可點入瀏覽的連結。 字體要能吸引讀者碰觸、滑動與閱讀。

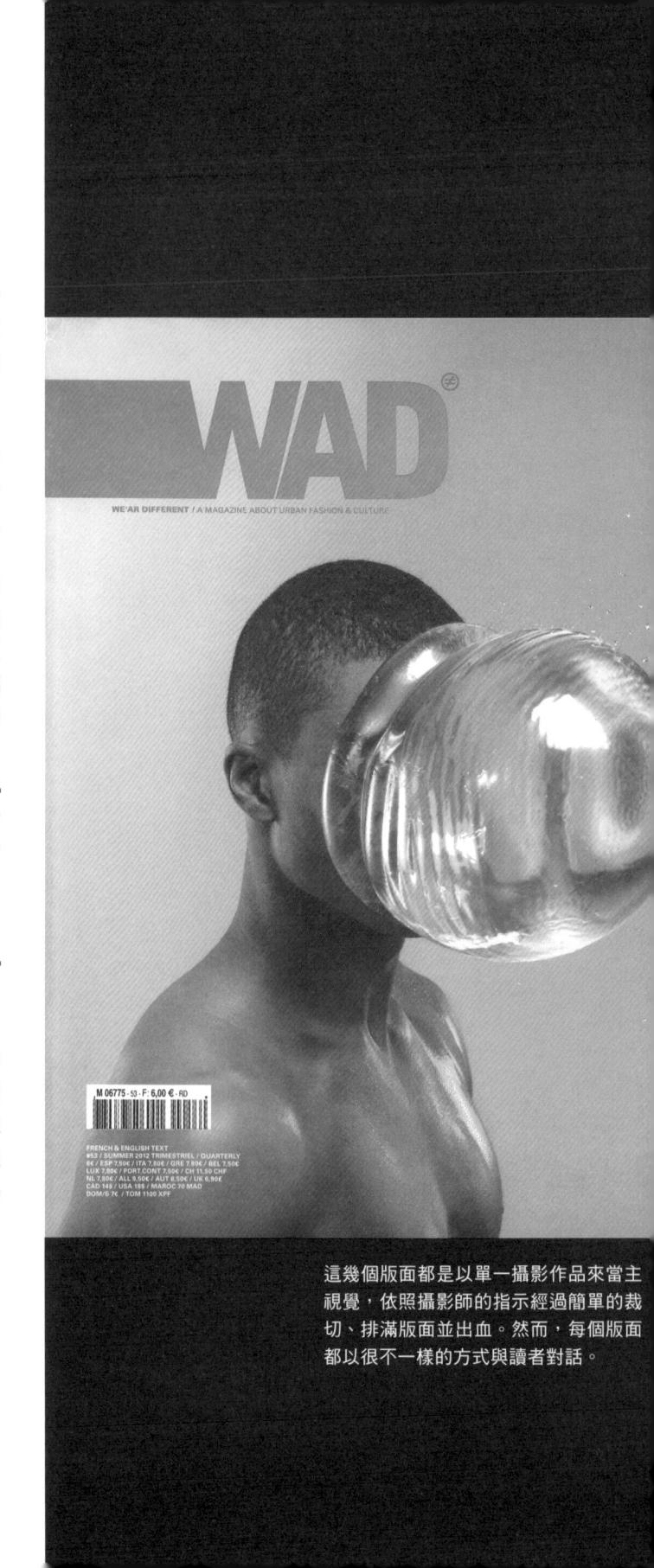

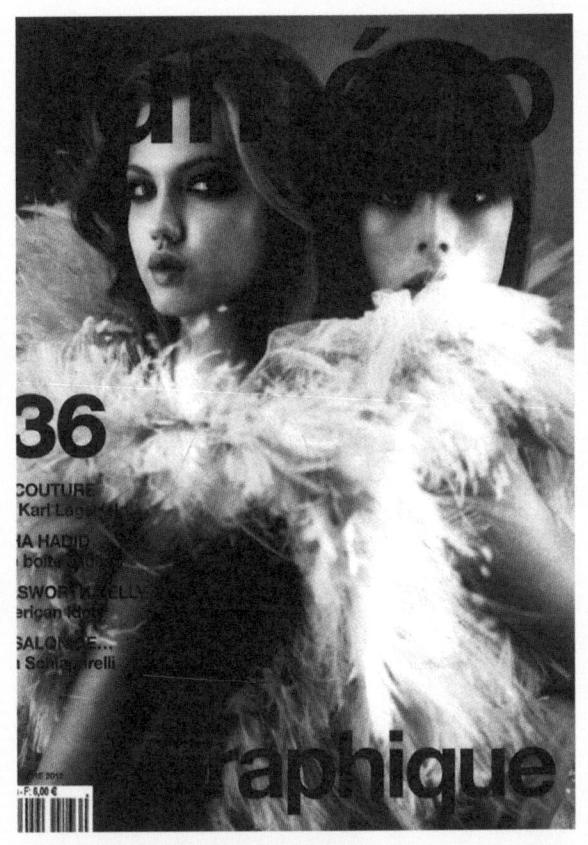

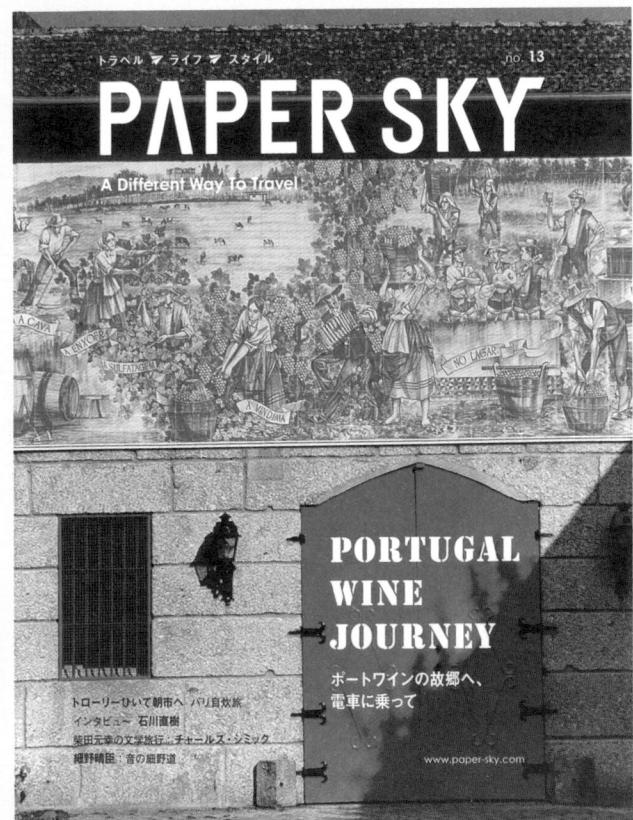

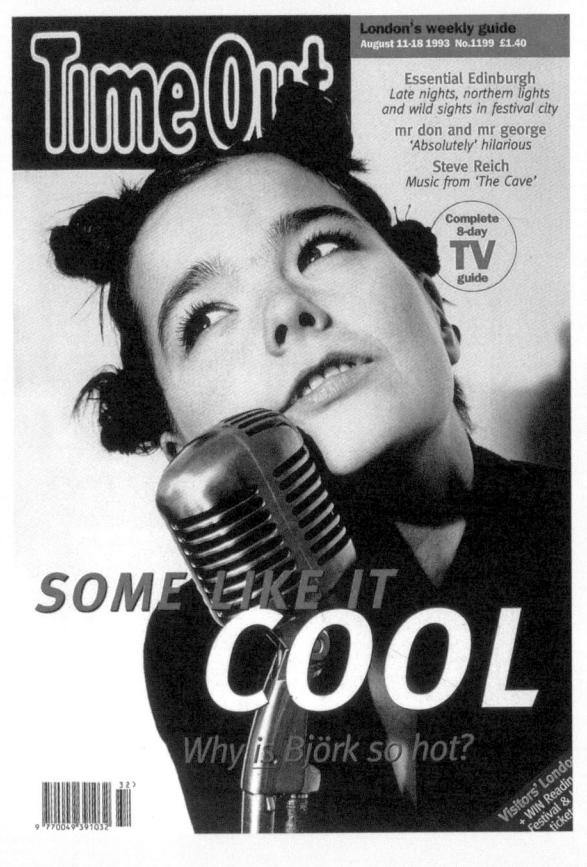

「雜誌和書籍或其他出版品不一樣,雜誌是 有機的,會持續演化,而且每一期都不同。」

傑瑞米·雷斯里(Jeremy Leslie),《magCulture》工作室創意總監

編輯設計的功能

編輯設計有許多功能,例如讓文字內容更具表現 性與個性;吸引讀者目光,維持讀者注意力;將 資訊安排得條理分明。各功能必須同時存在、連 貫運作,才能做出好看、好用的資訊刊物,通常 優秀的刊物都具備上述三項優點。無論紙本或數 位,最好的編輯設計作品總是能讓人充滿活力, 是個不斷演進的實驗室與發射台,能屢屢嘗試新 風格,並帶動其他視覺傳達領域設計積極跟進。

「編輯設計是個框架,報導文章在這框架中被閱讀與詮釋。編輯設計包含出版品的整體架構(及這個架構暗指的邏輯結構),以及對個別報導的特殊處理(因為有些報導可能曲解甚至牴觸刊物的整體調性)。」

——馬丁·文內斯基(Martin Venesky), 《Speak》雜誌藝術指導

編輯設計還要能生動扼要地反映出當代文化。例如 1960 年代的《Nova》與《Oz》雜誌,一看就能讓人感受到活潑的氣氛,反映出注重實驗、創新與探索新方向的時代精神。

Wallpaper*的幕後製作

全球性品牌如何探索紙本與數位刊物

「早在圖片的攝影階段,就要考慮到刊物在不同載具上的呈現。紙本雜誌看起來怎麼樣?iPad 版和網站版又會如何?我們不希望它們看起來都一樣,而是要相輔相成。」

──莎拉·道格拉斯(Sarah Douglas),《Wallpaper*》雜誌設計總監

《Wallpaper*》雜誌於 1996 年由總編輯泰勒·布魯雷(Tyler Brûlé)創刊·官方網站在 2004 年成立·每月吸引五十萬讀者。2010 年·首度推出 iPad 版·同時仍繼續推出紙本月刊。《Wallpaper*》內容涵蓋設計、室內裝潢、藝術、建築、旅遊、時尚與科技・2007 年第一百期出刊時,它的 Logo 上多了一個游標箭頭,暗示其不久後將會數位化。

《Wallpaper*》常將合作關係拓展到時尚、建築與設計領域。現今的編輯團隊由東尼·錢伯斯(Tony Chambers)率領,他是少數從藝術指導轉任為編輯的奇才。他的團隊和出版商密切合作,對出版抱持開放的態度,並常與廣告主合作創意專案。

接下來的訪談中,莎拉·道格拉斯(設計總監)與梅隆·普里查特(Meiron Pritchard,前藝術總監)將解釋《Wallpaper*》如何將品牌拓展到數位領域、設計活動、策劃展覽甚至房地產。

你如何確保設計元素在不同媒體上,都會是對的呈現?

普里查特:網路發達後,曾導致設計師與編輯一度失去主控權。技術人員老是叫我們不能這樣、不能那樣。然而在平板電腦與 iPhone 出現之後,球又回到我們手上。我們已經能掌握最新的閱讀行為,而且現在的顯示器也更適合閱讀。

你們使用哪些數位工具?

道格拉斯:我們做的設計都是為了服務內容,不會為展現技術而做。比方說,建築專題報導在紙本雜誌上,因篇幅有限,只能刊登幾張圖,但在 iPad 版本上我還加入樓層平面圖,深入說明每張照片的拍攝角度,可以提供讀者更多訊息當然是件好事。若能善用網站,還可帶讀者瀏覽整棟建築物。

你們的靈感從何而來?

普里查特:我不會只坐在辦公桌前,就算只是騎單車、散步、四處看看都好,這樣可從不同角度思考。

BEIJING

SINGAPORE

BANGKOK

FUTURE

ANCHIPELAGO CINEMA Terbana panama hata wan penjar OLE
SCHEEREN
SCHEEREN

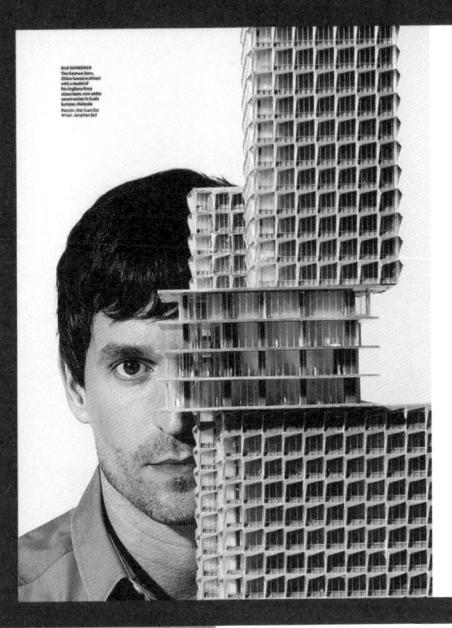

Building the future

176 | OLE SCHEEREN | GUEST EDITOR 2

own name was Anglasa Rays. According to schooms, in marked a relatively significant stay in the evolution of the matths. With three major projects on sits, the standes also has smalled projects in the case of the matths. With three major projects on sits, the standes also has smalled projects in the marked also has been stated as high the position of the project of the case of the project of the case of the project of the case of the case of the case stated in the projects would measing my even would as content of threat Chinase enter. The artist is a compulsive collection, not put of art. The outlet content of the control of art. The outlet content of the control of the c

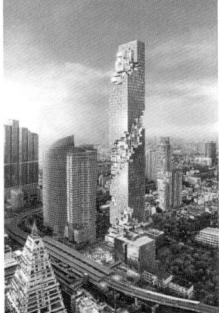

servi time related in the OLVA. the cytopological that in every from Name-OS ever related light dispuses but florested.

Name of the object of

sourced Cashine Insternas and teles (Pales, assumed Cashine Insternas and teles) and an architectully be the building dearly exceeded these qualifications. Ministraining postportion that runs from alyze-upon so mailed the pales (Pales and Pales a

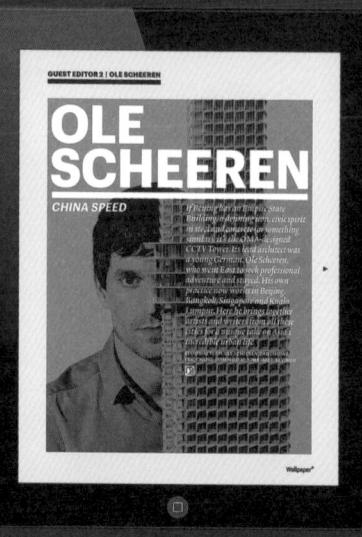

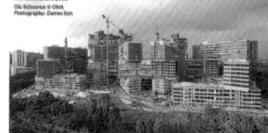

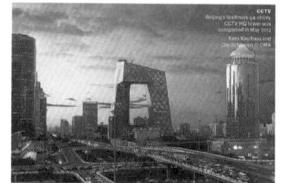

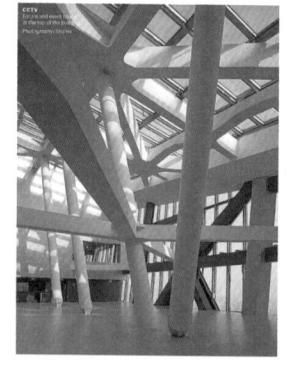

道格拉斯:文化洗禮很重要。我想汲取靈感時,會看看安 德魯·迪普羅斯 (Andrew Diprose) 設計、菲利浦· 迪普羅斯 (Philip Diprose) 主編的《The Ride》雜 誌。安德魯後來到《WIRED》雜誌(中譯:連線雜誌) 工作,也交出很棒的成果,可見他相當熱愛雜誌,才能設 計出這麼好的刊物。

在製作數位雜誌時,身為設計師,需要重新思考什麼? 道格拉斯:我會從讀者的角度出發,想想平板電腦使用者 的使用行為,然後重新調整思路,也會思考數位雜誌和紙 本雜誌的差異。

你們能不能從數據上得到回饋?

普里查特:我們可以取得一大堆統計數字,看出哪些頁面 最受歡迎。此外,Twitter 也是個好用的新東西,現在我 們有五十萬粉絲,對雜誌而言算是相當不錯的成績。網站 也很熱門,甚至得因應讀者要求推出《中國製》(Made in China)特刊。能和讀者保持連繫很重要,雖然我們 人在倫敦,卻能利用網路大幅開拓觸及範圍,發行量高達 15 萬本。

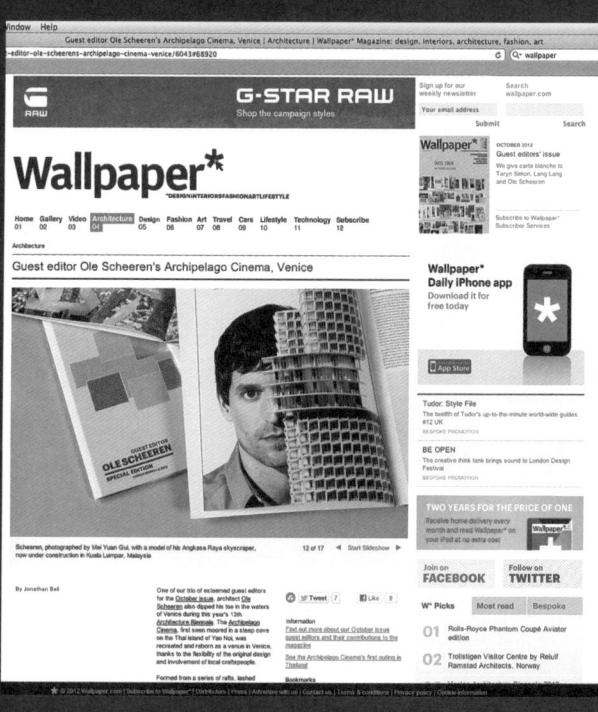

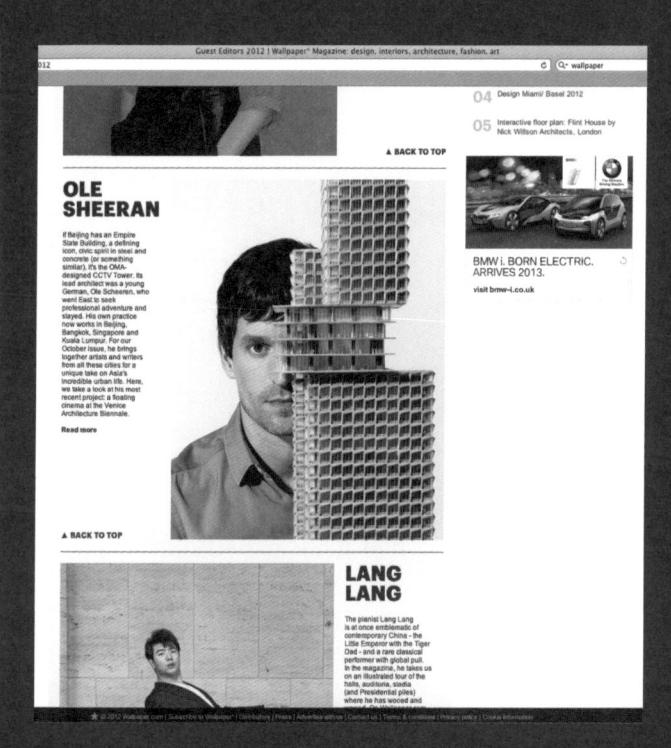

無論是紙本還是數位版,所有熱門關鍵字都會標上底線。網站上貼心的利用路徑顯示或選單變色,來提示使用者正在閱讀哪個頁面。

你們和廣告主怎麼合作?

道格拉斯:客製團隊和編輯會先出馬,談談對雙方而言怎麼做最好,並依據洽談的內容來「量身訂製」,最後可能會架網站、舉辦活動或拍攝照片。

接下來有什麼規劃?會把雜誌內容延伸到更多平台上嗎? 道格拉斯:就目前來看是可以做更多。《Wallpaper*》 在每年8月推出手工藝特刊《Handmade》,刊登當 代的優秀設計與手工藝作品,這時,我們就化身為策展 者。室內設計專刊《Wallpaper* Composed》也是運 用策展的概念來規劃。還有我們的「公寓專案」(The Wallpaper* Apartment),更是一種品牌拓展。我們 每次挑選不同公寓,在裡面舉辦活動、拍照,把房子展示 給客戶看。這根本就是成立新事業,建商看了我們的成果 後,就會提出新的合作點子。攝影師和我們合作時,有時 也會用上這些公寓空間。

將數位化產品納入考量後,是否會影響你們決定委派哪些 攝影師?

道格拉斯:目前會找各種不同類型的攝影師;不過的確, 攝影師也在慢慢改變工作方式,就像當年從底片轉換到數 位攝影一樣。我們現在仍處於過渡期。

目前使用的静態照片,在未來會不會改成動態?

道格拉斯:或許有百分之八十都會改吧。

《Wallpaper*》還有什麼品牌延伸?

我們的旅遊指南已發展成各種app,由不同事業體在經營。「Wallpaper*精選圖庫」(Wallpaper*Selects)是與當代攝影作品公司「Eyestorm」合作的事業體。至於「Wallpaper*設計獎」(Wallpaper*Design Award)的品牌定位也很明確,我們是當代設計的國際指標,專為新銳設計人才提供報導平台。

一本雜誌需要集結眾人之力才能誕生。倫敦中央聖馬 丁學院(Central Saint Martins)的學生正在討論作 品,他們試著從設計師的角度抽離出來,以讀者的觀 點審視作品,也聽取其他人的意見回饋。

設計師在雜誌社中的角色

要做出好的刊物,設計師一定要講究與編輯的工作關係,也別忘了和其他社內職員培養良好的互動。設計師通常會和同事們保持頻繁溝通,與工作夥伴的密切程度大概僅次於編輯人員。

雜誌社的職務編制

每種刊物的團隊人數、組織方式及個別角色都不 盡相同。刊物的主要內容多由編輯決定,然而內 容的架構安排與呈現方式,則是藝術指導、設計 總監或美術主編負責,他們要想盡辦法呈現出雜 誌的特色。

要細數紙本與數位刊物中每個設計師的角色,恐怕得花掉整本書的篇幅,更何況刊物的媒體格式、大小與發行量不同,還會衍生許多差異。獨立的半年刊所需職員,和每日出刊的線上雜誌大不相同。以下只能列出最普遍的人員編制。

主編:出版品內容的最終負責人。主編和藝術指導的互動很密切,此外,主編也需常和轄下的各編務人員互動,例如專題編輯、圖片編輯與後製編輯。

藝術指導、美術編輯:負責安排所有文稿內容以及圖像的架構與次序。他們必須控管進度,依照後製主管或後製編輯訂定的時間表完成工作,若內容需要製作圖表或插畫,還要負責發案。藝術指導、美術編輯與創意和後製人員、數位編輯人員都互動密切。

後製經理、網站編輯:訂定後製時程表,負責將 所有的資料彙整起來。訂定時程表時,要從發刊 日往回推算,決定何時必須收到文與圖、何時編 輯、審稿與設計,還有必須送印的日期。後製經 理還要負責製作「落版單」、更新維護落版單的

資訊。他們最常和美術部門及印刷廠合作,還要 負責到印刷廠看印,監督特殊的印刷需求。

審稿主編、審稿編輯:負責校對與審閱文稿,確 保文稿風格一致,沒有錯誤的字、句和標點符號。此外也需要撰寫所有文案,若有不理想的文章必須負責重寫或刪改。與編輯、美術團隊、專 題編輯或撰稿人員密切合作。

圖片編輯:主要負責尋找圖片與處理圖片版權, 須與藝術指導及主編合作,確保整體刊物的照片 品質。也要和圖片代理、圖庫與圖片版權公司合 作。

設計師:依據藝術指導給予的方針或指示,設計編排刊物版面。設計師和藝術指導的合作模式,及其自主程度,則取決於諸多考量,例如資深與否、藝術指導的工作習慣(有人事必躬親,監督每一項細節;有人樂於放手,設計師排版完成之後就放行)、職員人數與刊物頁數,還有出版的前置時間。一般而言,若前置時間越短,設計師要負責的事情就更多。

編輯室經理:並非所有的刊物都有這個職位,編輯室經理負責專案管理,和後製主管有重疊。但編輯室經理是很好的輔助者,不僅能統籌事務,也能處理編輯室、圖片與後製單位的日常聯繫。編輯室經理須確保計畫能按時進行,不同素材皆能符合頁面編排的需求,並且擺放正確。

「許多雜誌最重視的,就是賣廣告。結果這 些雜誌的內容,看起來就像是穿插在廣告頁 之間一般。」

——文斯·佛洛斯特,《Zembla》雜誌藝術指導

衛報

開創報紙印刷的嶄新格式

2005年,英國《衛報》(The Guardian)成為第一份在全國發行的全彩日報。當時擔任創意總監的馬克·波特(Mark Porter)表示,彩色印刷是大勢所趨,因為「現實生活是彩色的。若報紙還想和電視及網路競爭,吸引讀者來讀新聞,必定要有全彩版面。黑白報紙是上個世紀的產物,讀者不會埋單的。」

當時,面臨讀者與日報的關係出現變化,英國各大報都在研究讀者的新需求,紛紛改採小報版式。不過《衛報》另闢蹊徑,仿效法國《世界報》(Le Monde)的「柏林版式」,走出自己的路。波特說這種版式「能方便讀者閱讀嚴肅新聞,符合當代的設計手法,同時顧及廣告主需求。沒有其他版式能與之相比。」《衛報》的設計向來具有智慧,且有先見之明。1988年,五角星設計公司(Pentagram)的大衛、西爾曼(David Hillman)開啟先河,將報紙分為兩大部分,同時推出新的報頭,最重要的是把雜誌式的留白版面,應用到報紙設計上。

「《衛報》經過西爾曼重新設計,完全改頭換面,不僅外觀煥然一新,更擁有完整的設計理念,或許是第一份有具體設計理念的報紙,」波特說,「後來接手設計的麥克·麥克奈(Mike McNay)、賽門·埃斯特森(Simon Esterson)與我,都依照該理念嚴謹的原則行事。」西爾曼認為,理想的報紙設計「不該沿襲新聞界的習慣與傳統,而是要有健全的設計原則。」2005年的改版也遵守這些原則,依循西爾曼清楚的理想前進。

《衛報》除了報紙之外,還有即時更新的網站與 app,能隨時發布新聞動態。波特在 2010 年離開《衛報》,但他和團隊在 2005 年大幅整頓《衛報》的文字編排,如今《衛報》仍深受波特的影響,清楚的視覺識別延伸到官方網站與手機 app。波特現任《衛報》的編輯設計顧問,他說:「現在重新設計一份報紙時,也要把網站、行動裝置與 app 納入考量。只為紙本做設計的情況已很少見,新聞媒體必須同步整合不同平台的需求,然而品牌的視覺識別要保持一致性。」

《衛報》的網站團隊秉持波特勾勒出的設計核心價值,相信有均衡的文字編排與強而有力的新聞照片,才能設計出好的智慧型刊物。《衛報》的 iPad 版除了堅守這些原則,也善用 iPad 的互動多媒體功能,使其比紙報更有

How dismal England - crashed to earth

Ducks, Pepys and the 50-quit Joloke – your top reads of 2004 Thereaders choice in G2

The Guardian

Giant waves kill thousands after calls for warning system ignored

The state of the s

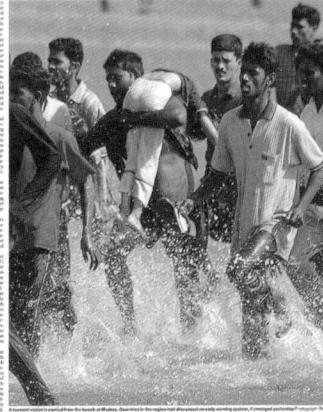

Arround in the control of the contro

lkrains apposition in his svit pall load

Hell hath no fury as a dad scorned

Nicke Flame Window Litera . March of Larrows, the raw is sufficient for a measurement of the production of the content of the production of the content of the production of t

such time of the transit of the tran

on against bloo. But storage or against bloom of the bloo

or their remarkance in trees.

If the other is the control of their thei

that night, the expenseded to be a support of the s

Determina

top dog for music-dud-games HIV

Backlash over Blair's school revolution

City academy plans condemned by ex-education secretary Morris

UK link to terror snatches

Police chief blames Judges may block

The second of th

Israeli troons leave

Sky's Premiership rights under threat

Bigger

isn't always better...

閱讀價值。iPad 版的《衛報》不但可順暢地滑動瀏覽, 還具備行動裝置的特性,能透過成熟的資料蒐集軟體與 GPS 定位系統,為編輯與廣告主創造更多與讀者互動的 機會。波特表示:「平板電腦開啟了豐富多樣的契機,我 們再次能夠在數位領域發揮許多傳統報紙的知識,也可 望出現更多比以前優秀的編輯設計作品。平板電腦產品日 新月異,市場起飛,用電腦看新聞網頁的時代已發展到盡 頭,多數人將以行動裝置來運用媒體,而這些裝置會取代 家用電腦的地位。我們仍然不會放棄紙本,但紙本不再是 最主要的業務。」

iPad 版《衛報》文字的層級編排,透 露出報導的重要程度。簡潔俐落的標題 不但設計起來不容易失敗,也使圖文在 視覺上非常平衡。沒有耍噱頭的工具與 譁眾取寵的圖片,只採用素雅清晰的設 計。讀者在瀏覽時,就能體會到這個設 計的好處,輕鬆找到想看的內容。

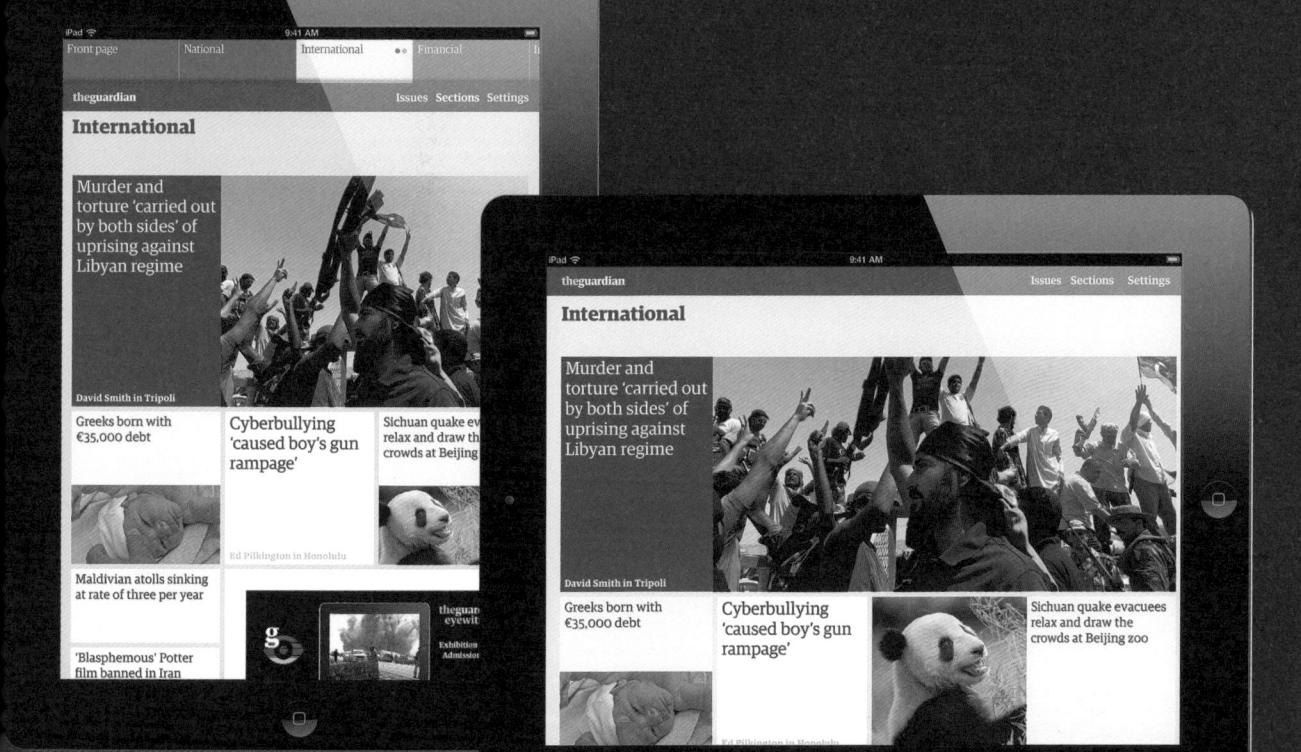

「編輯設計師」須具備何種特質?

美國平面設計大師提波·卡爾曼(Tibor Kalman)有句名言:「若設計師認為編輯未能盡責,就有責任把他開除。」他的意思是,雜誌的設計無疑是編務的延伸,因此編輯設計師應該和編輯同樣關注刊物的內容。雙方都必須發揮創意,而如何妥善地分工合作,幾乎決定了刊物的成敗。

因此,編輯設計師和編輯至少要了解彼此的 觀點、角色與專長領域甚至工作內容,培養默 契,合作打造一流的出版品。所有優秀的編輯 設計師與編輯都具備這項特質,甚至還有其他 的技能與背景,為工作加分。馬克·波特曾是 《Colors》與《WIRED》的設計師,後來成為 《衛報》創意總監,然而他畢業於牛津大學語言 學系,並非設計科班出身。他曾表示,大學教育 深深影響他的設計方式:

戴倫·瓊斯(Dylan Jones)在擔任《GQ》雜 誌的編輯之前,曾是《i-D》、《The Face》、 《Arena》與《Arena Homme Plus》等諸多 雜誌的編輯,但他是平面設計師出身。威利·傅 雷克豪斯(Willy Fleckhaus)是 1960 年代德國重要雜誌《Twen》的藝術指導,在那之前,他是名記者。五角星設計公司合夥人西爾曼,曾是《New Statesman and Society》(中譯:新政治人物與社會)雜誌與《衛報》設計師,也曾任《Nova》的藝術指導與副主編。他曾說:「藝術指導的主要任務不是設定格線、製作有特色的報頭,甚至不是讓圖文並列得美觀。最優秀的藝術指導,能深刻且全面理解雜誌要訴說的事,並透過設計來引導訴說的方式。」

你或許聽過這些設計大師的事跡,好奇他們的成 就從何而來。接下來的三篇訪談,訪問在業界不 同層級的設計師,他們將分享自身的工作內容及 如何入行的故事。

初級設計師

艾莎·馬丁斯娃(Esa Martinesva),《Port》數位雜誌

數位雜誌的初級設計師或實習生,確切工作內容是什麼? 平板電腦是很新的產物,連資深設計師也未必能完全掌握所有細節,大家都需要摸索。身為初級/實習設計師, 我負責思考讀者和雜誌的互動方式以及閱讀模式。我也要協助排版,思考螢幕上的文字編排呈現。

你的日常工作和紙本刊物的設計師有何不同?

與讀者溝通互動的基本原則都一樣。我必須徹底理解文字、圖像(靜止與動態)與音效如何整合,也要知道如何 適切的使用多媒體工具。

在不同平台做設計,是不是需要額外的學習?

許多 app 都想要盡可能「多功能」,平板電腦的視聽功能固然不錯,但使用者最終會喜歡的,其實仍是單純細膩的設計。

我不認為設計師有必要徹底弄懂每種媒體的技術環節, 但必須理解不同媒體如何發揮功能。最新的設計軟體 Adobe Creative Suite 已經讓設計師不必煩惱寫程式的 事,而是把重點放在安排按鈕與超連結等互動元素。最耗 費心思的,是了解文字和圖像如何在螢幕上呈現,及這呈 現方式與紙本刊物有何不同。

如何跟上最新的技術腳步?

只能硬著頭皮,在新工具與媒體推出時立即嘗試。

你如何進入雜誌設計這一行?

我的作品集中有不少自創刊物與印刷作品。有個老師發現我對編輯設計有興趣,便推薦我入行,於是我進入《Port》雜誌,協助設計雜誌的iPad版。參與這項專案後,公司希望我留下來。目前我主要負責紙本雜誌,但也負責數位版的部分工作。

你在實習時沒拿薪資嗎?

最初的確不支薪,因為《Port》是新創刊的雜誌,主要是 靠不拿薪資的自願者製作。那算是新創獨立雜誌的常態。 等預算來源穩定之後,成員才有錢拿。後來我就有薪水可 領,現在的實習生也有微薄的薪水。

PICTURE PERFECT

"You can translate an emotion into something that other people can then read again. And that's what art should always be about: communicating certain ideas and emotions through work without having to explain them"

> Interview Phil Rhys Thomas Photography Eva Vermandel

Pares as buttons

Wood Driefs

Wood Driefs

White deletion deletion into the morely worded of our browsing histories to explain why, for the male brain, freedom is the biggest trap of all the explain why, for the male brain, freedom is the biggest trap of all the explain why, for the male brain, freedom is the biggest trap of all the explain why, for the male brain, freedom is the biggest trap of all the explain why, for the male brain freedom is the biggest trap of all the explain why for the explain the

Comm

Pornography is often accused – by those blessed souls who don't intestigate it much, who might once have had a peel inside Pigloby or caughts preview on the inferiodic calamate of a hade – of being confloringly fake. Fill of prostherially enhanced beenst and personal properties, and therether understanding of the pursual of any wealther and instiffugence disease. But this is unformately far from sellar, Modera promapsylv bolics on real in overeible one's or mail in energy detail, with the difference that everyone happens to be havit continuous beautiful distrements.

continuous beatific intercourse.

The waste of time is of course horrific. Financial analysts estimate the value of the online pornography industry at \$10 billion, but this doesn't begin to evoke the true scale of the loss in terms of the squandering of human energies—perhaps as many as 200 million may hours that might produce the course of the scale of the loss in terms of the squandering of human energies—perhaps as many as 200 million may hours that might orderwise how bean densed to a scaring commander.

Next story

「身為實習生,你不太有機會說『這是我做的』,因為刊物通常是在藝術指導的主導下,由團隊共同完成。不過,即使只是參與了簡單的版面設計,也能獲得寶貴的經驗。」

資深設計師

潔瑪·史塔克(Gemma Stark),《Net-a-Porter》數位雜誌

數位雜誌的資深設計師確切工作內容是什麼?

從某方面而言,資深設計師的角色和「傳統」雜誌並無不同。我要負責時裝攝影的藝術指導、設計雜誌的專題報導,也參加企劃會議。我通常同時設計幾篇不同的報導,也要找攝影師研擬拍攝概念。不過有一點倒是不同:要能掌握最終成品的數位特質,所以必須和技術人員密切合作,討論頁面如何在螢幕上呈現。

你的日常工作和紙本刊物的設計師有何不同?步調是否比 較快?

我的雜誌每週出刊,因此步調相當快。星期二,大部分報 導就會開始進入設計階段,到星期四午餐時間,編輯就要 審閱整本雜誌。我們完成的版面會在星期一交給技術團 隊,星期三就放上網站。數位刊物的校對過程和紙本雜誌 很不一樣,我們利用公司內網預覽校對圖片與文字,而不 是看紙本打樣;要修改的地方,再由技術團隊直接更新。

是否要在不同平台上工作?

我們的雜誌以Flash設計,之後會以HTML5做成iPad的app,每週還會選一篇雜誌報導,做成迷你的PDF版本供iPhone閱讀,偶爾也推出紙本。我們會用InDesign排版,但網頁與電子DM也會用到Photoshop。沒錯,我們使用很多不同的設計軟體,但

《Net-a-Porter》的設計是從刊物內容的角度出發,就連橫幅與廣告區塊中都會放入刊物訊息。數位雜誌的每個單一頁面通常不會放太多東西,但可用動態畫面來傳達更豐富的資訊與圖像。在開始設計任何版面的同時,我就會把是否適合使用動態畫面這件事考慮進去,因為它們往往會大大改變整個版面的風格。

如何跟上最新的技術腳步?

我會持續上網,瀏覽網站和部落格尋找靈感。我們講究團隊合作,大家會定期交換心得。若有人看到不錯的東西,就會發信跟大家分享,雖然未必和每個人的手邊工作都有關,但總有人用得上。我們的技術部門很盡責,總是不斷提醒我們有什麼新工具可用。

你如何進入雜誌設計這一行?

我在就讀中央聖馬丁學院時,老師推薦我到《Elle》雜誌暑期實習,我在那裡待了幾個月,發現這個工作結合了平面設計和時尚,我很喜歡。我盡量多認識人,多充實工作經驗,也認識了現在的上司,她找我談《Net-a-Porter》的工作機會之後,我就躍躍欲試。《Net-a-Porter》是線上精品商店,非常倚重編輯設計工作,正合我的胃口。畢業後我就進到公司,同年9月成為初級設計師。

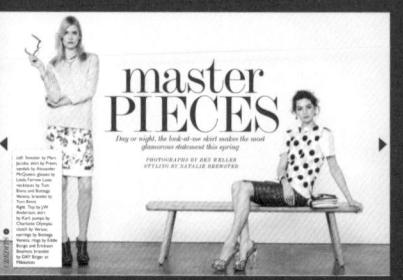

設計總監

約翰·貝克奈普(John Belknap),《猶太紀事報》(Jewish Chronicle)

報紙設計總監的確切工作內容是什麼?

我的工作可以分為兩大塊。第一是為報紙打造出一致性的 品牌視覺形象,並且盡力維持,從報頭到分類廣告都要盡 善盡美。此外,有時編輯會做新專題,我要負責監督或設 計出新專題的呈現方式。

另一塊工作,是參與製作日報或週報。這需要與編輯密切合作,協助準備版面所需的照片、插圖或資訊圖表。大型報社的設計師通常只負責做最複雜的幾塊版面,而其他頁面的排版,則交由審稿編輯(或美國的文稿編輯)依照設計總監訂立出的排版指南來完成。設計總監會雇用其他藝術指導,設計不同專題區塊的頁面,例如商業版、運動版與藝術評論版。設計總監與圖片編輯、各版面編輯、平面設計師密切合作,最後也要和後製經理合作,他總是急著要把刊物送印。

怎麼設計出能放上網路的內容?

我們的報導內容會先存進資料庫,再由系統從資料庫擷取 出來,發布到網頁上。這項工作可以透過一些加裝在排版 軟體如 InDesign 或 Quark 上的外掛(plug-in)系統來做到。雖然把文章放到網站上的方法很多,但我們基本上都是從資料庫取,資料庫同時也是歷史文章的檔案庫。以前(其實也不過是幾年前)報導是先印成報紙,再刊上網站,現在則是顛倒過來。資料庫的管理多半交給後製或資訊科技系統,系統設計也會影響到我們的工作方式。舉例而言,大標、副標與內文一定要貼在不同欄位,或至少使用不同的樣式表,這樣發布到網站上的時候,系統才能夠正確辨識並排列。

如何跟上最新的科技潮流?

資訊部門的經理會要我安裝新軟體,而我就努力學習使用 它們。

你如何進入報紙這一行?

我高中時曾參與製作校刊,那時我就對一開始慢吞吞,後 來加快到腎上腺素狂飆的出刊節奏上癮了。大學時期我到 報社工讀,畢業後,繼續在那兒待了十年。

右圖:貝克奈普與編輯密切合作, 製作鮮明搶眼的頭版,確保每一 塊內容都能抓住目標讀者的目光。 左邊的頭版照片是由約翰·里夫金 (John Rifkin)拍攝。

左頁:從史塔克的作品可以看出, 她很了解時尚讀者愛看乾淨的畫面。隱藏式的圖說,在游標經過時 才會彈出。

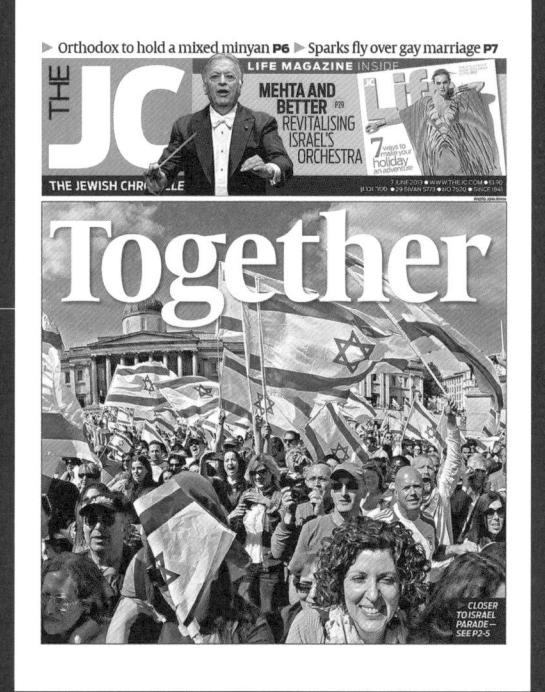

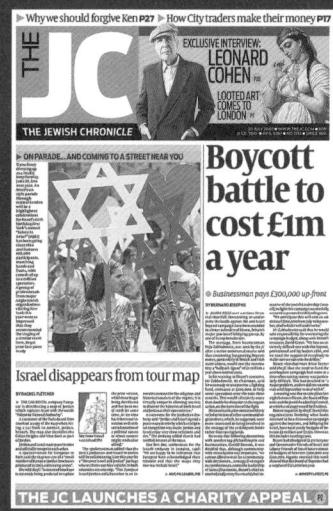

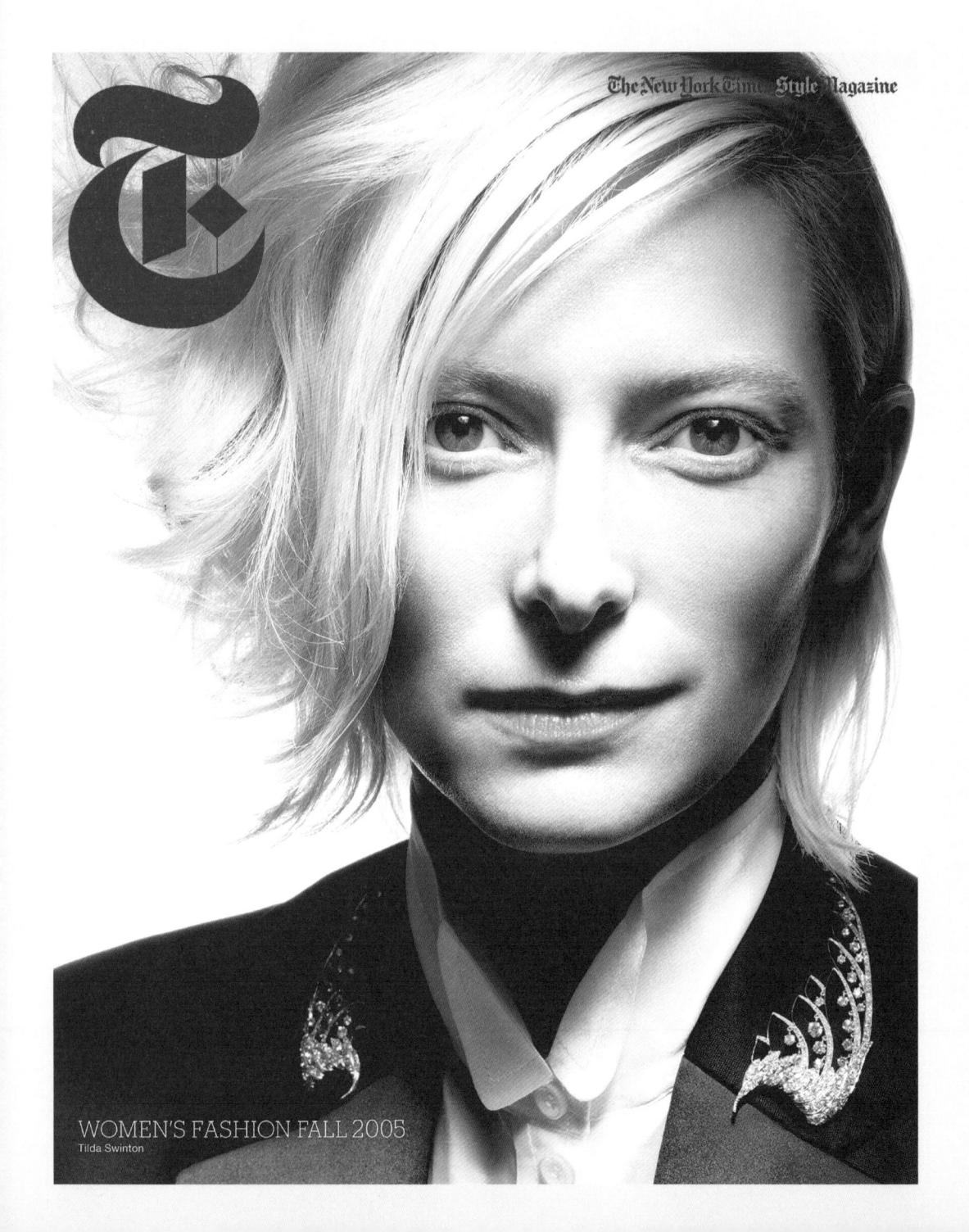

Chapter 2:編輯設計格式

在 2010 年平板電腦問世之前,編輯設計界中地位最高的刊物是全國性報紙、消費類與生活風格雜誌,還有製作精美的「增刊」(supplement)。隨著平面閱讀快速數位化,編輯設計師、出版社與廣告主獲得嶄新的舞台。這些新的數位寵兒如網站、手機、Android 平板電腦與 iPad,各式各樣的 app 讓數位刊物增加了更多可能性。在幾乎人手一機的年代,出版商可透過這些新媒體,大幅提高與讀者的接觸機會,這是過去的紙本刊物所望塵莫及的優勢。

本章將介紹常用的編輯設計格式,適用於定期出刊的紙本和數位 報紙或雜誌。我們也會欣賞一些引領國際潮流的刊物設計。

數位出版簡史

早期的數位出版形式是以PDF(可攜式文件格式)頁面來構成網站,這些PDF的閱讀方式是一頁一頁翻,與傳統的報紙與雜誌如出一轍。然而PDF檔案很大,能用的字體又有限。後來美國出版商康泰納仕(Condé Nast)曾打造自家軟體,製作了《WIRED》、《GQ》與《VanityFair》(中譯:浮華世界)數位版。1990年代HTML出現後,設計師能運用這種程式語言,把會動的內容嵌入網站。網頁瀏覽器也能透過讀這些標記,將程式碼轉換為圖與文。

多媒體互動技術持續進步,廣告主也愛上了在廣告中加入動態效果與互動內容。2010年 iPad問世之後,讀者以攜帶型裝置閱讀數位刊物的經驗大大提升。iPad讓當時的工具更「好玩」,能把刊物和生活中的重要事物全放進裝置中,包括e-mail、照片、購物、上網和閱讀。不過,從2011年底開始,許多 iPad 的 app 紛紛回歸精簡,有一大堆附加功能的 app 反而不受青睞,數位刊物的設計方向,再次重視良好的平面設計與精美的編輯。雖然數位出版品最初曾一窩蜂過度使用動畫與複雜的互動功能,但是2012年後,這個現象已經逐漸趨緩。

資訊分享的陷阱

擅自取得其他公司的內容,勢必引發新聞製作者的不滿。以英國或美國而言,全國的新聞報導製作成本,全落在《紐約時報》與BBC之類的新聞媒體上。此外,2011年維基解密(WikiLeaks)的醜聞發生後,新聞版權的道德議題引發關注,人們也開始質疑,內容究竟「歸屬於」誰,關於新聞蒐集的法令顯然需要重新定義。2012年英國爆發電話竊聽醜聞案*,

暴露出當局根本無法掌控媒體。有鑑於此,英國政府召開勒弗森聽證調查委員會(Leveson Inquiry,由大法官勒弗森主持),追究新媒體的文化、實務運作與倫理。聽證會的調查結果出爐後,呼籲政府成立新的主管機關,為著作權建立原則,釐清合法性、誠實性與隱私議題。

「在雜誌設計之初,就要考慮到在 iPad 上呈現的效果。

iPad 使我們重新思考,如何運用紙本雜誌 與網站上的內容。iPad 具備卓越的互動能力,使用時很像在看紙本雜誌,事實上卻擁 有網站般的互動能力。」

——梅隆·普里查特,《Wallpaper*》前藝術指導

《Real Simple》雜誌的美術指導佛羅里克挑選了這篇專題當刊頭,在 iPad 上,這張由克雷格·科特勒(Craig Cutler)拍攝的照片非常吸引讀者的目光,且圖片的彩度也提高了。許多出版品數位化的方法只是把紙本內容轉換成 PDF 檔,但《Real Simple》則是盡量利用 iPad 的優勢,並依照讀者閱讀行為(他們總是在廚房看這本雜誌),來強化雜誌內容。

^{*}譯註:《世界新聞報》(News of the World)為了搶新聞, 非法竊聽失蹤女童與家屬的手機,並妨礙警方辦案。

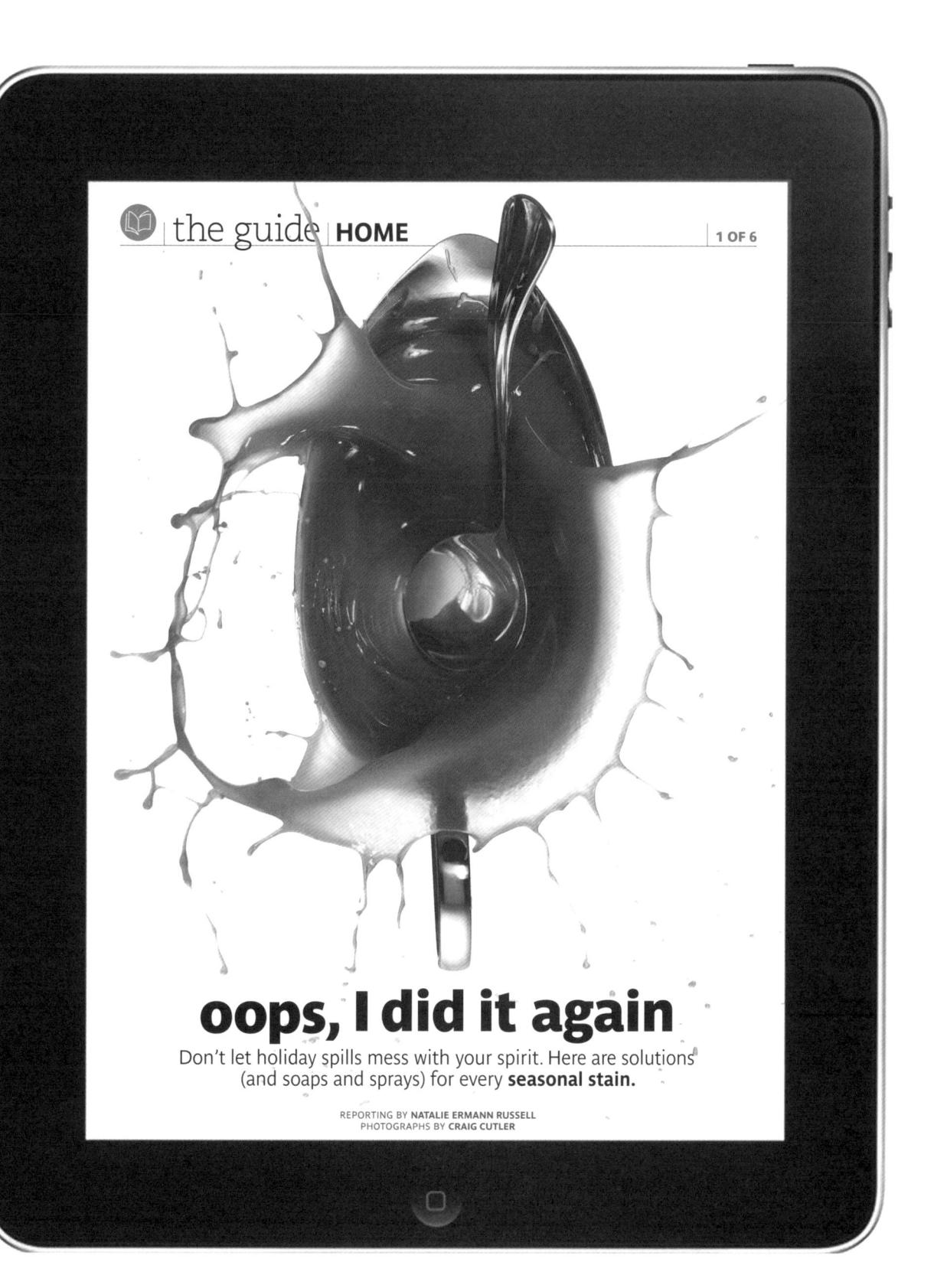

Obama's promise

Ve man legis again the work of semanting namera

The man legis again the work of semanting namera

The man legis again the work of semanting namera

The man legis again the work of semanting namera

The man legis again the work of semanting namera

The man legis again the work of semanting namera

The man legis again the work of semanting namera

The man legis again the work of semanting namera

The man legis again the work of semanting namera

The man legis again the work of semanting namera

The man legis again the work of semanting namera

The man legis again the work of semanting namera

The man legis again the work of semanting namera

The man legis again the work of semanting namera

The man legis again the work of semanting namera

The man legis again the work of semanting namera

The man legis again the work of semanting namera

The man legis again the work of semanting namera

The man legis again the work of semanting namera

The man legis again the work of semanting namera

The man legis again the work of semanting namera

The man legis again the work of semanting namera

The man legis again the work of semanting namera

The man legis again the work of semanting namera

The man legis again the work of semanting namera

The man legis again the work of semanting namera

The man legis again the work of semanting namera

The man legis again the work of semanting namera

The man legis again the work of semanting namera

The man legis again the work of semanting namera

The man legis again the work of semanting namera

The man legis again the work of semanting namera

The man legis again the work of semanting namera

The man legis again the work of semanting namera

The man legis again the work of semanting namera

The man legis again the work of semanting namera

The man legis again the work of semanting namera

The man legis again the work of semanting namera

The man legis again the work of semanting namera

The man legis again the work of semanting namera

The man legis again the work o

《泰晤士報》(The Times)運用簡明扼要的頭條,搭配足具代表性的照片,營造很好的效果。美國總統就職是很特殊的歷史時刻,《泰晤士報》除了用頭版刊登該則新聞,還將國外特派員的報導集結起來,編排上也很留意細節,且搭配豐富的圖像化資訊,給予讀者充實的新聞產品。

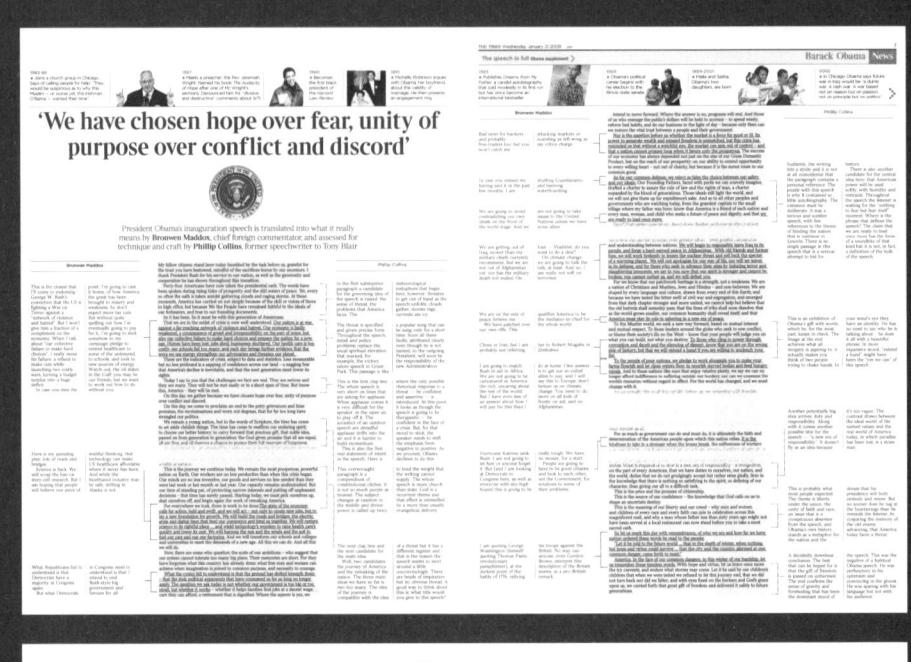

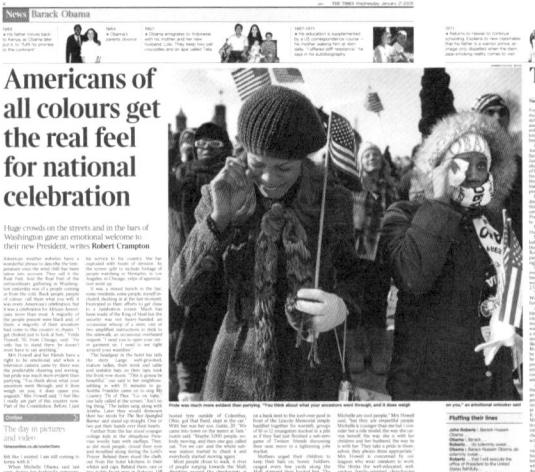

Thunder-struck Obama lost for words

A structure of the control of

報紙

海若德·伊凡思(Herald Evans)在1967 到1981年間,擔任《週日泰晤士報》(The Sunday Times)的編輯。他撰寫過一些關於報 紙編輯、版面與文字編排的重要著作,至今仍是 新聞學系的教科書。他在《第五冊:報紙設計》 (Book Five: Newspaper Design) 一書中指 出:

「報紙是傳播新聞與觀念的載具,版面設計 更是不可或缺的一環。一開始,我們只有一 張空白的新聞紙與腦中的內容,這些內容就 像馬賽克一樣東一塊西一塊。報紙的功能就 是透過設計,把這些和馬賽克一樣的內容呈 現出來,使之有組織、易於理解。為達到這 個目標,編輯設計師會運用內文字型、引言 字型、照片、線條、留白與頁面順序,做出 最適當的組合。」

這段話言簡意賅描述了報紙版面的功用。但是伊 凡思寫作時,網際網路與行動媒體尚未出現,因 此他沒有提到這方面的議題。隨著新興媒體問 世,報紙必須提供不同的服務給讀者,也需要設 計師提出因應之道。《衛報》的前創意總監波特 表示:

「如今,絕大多數的報紙不會只單純報導新 聞事件,反而著重於提供新聞背景、觀點與

> 《公共報》的內頁頗有雜誌的氣質, 以結構良好的密集內容,在一個頁面 上集結四篇報導。這四篇報導都下了 副標,協助讀者掌握各篇報導的重 點。有鋪底色的欄位代表不同的內 容,垂直欄平衡了水平走向的引言與 標題。抽言旁的去背照片使版面更具 生氣。

葡萄牙彩色日報《公共報》(Publico)的頭 版有很美的 Logo;本例中所選用的紅花照片 既搶眼又有象徵意義,下方穩重的大頭照在 視覺上很平衡。這小報版式的頭版運用大小 比例展現出張力,文字編排也很有現代感。

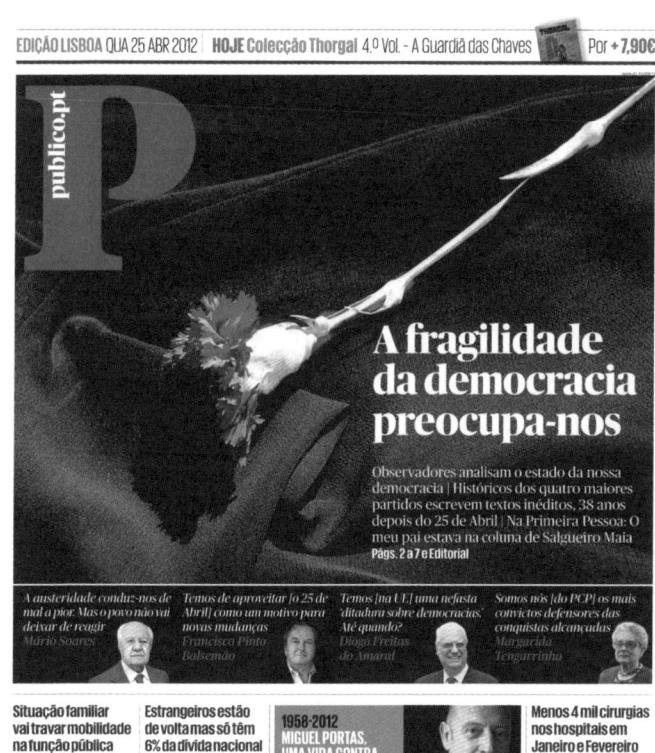

na função pública

6% da divida nacional

PSD e CDS esperam que Assunção Esteves chumbe Conde Rodrigues

Cavaço Silva avisa que a retórica não resolve desemprego

詮釋。報紙不能只告訴讀者發生什麼事,而 是要幫讀者理解事件的重要性,鼓勵讀者思 考。設計必須以多種方式來回應這種現象。 隨著報導越來越長且複雜,合理、可讀的頁 面版型與文字編排更是不可或缺。巧妙地使 用照片、資訊圖表與版型,是新聞視覺化過 程中少不了的編輯手段。

編輯設計最美好之處,在於能與有聰明才智的各方人才一起工作,然而同時,無法掌控細節時會很麻煩。很多報紙的版面都不是由專業平面設計師做的,這點令許多雜誌出身的藝術指導很難適應。」

數位報紙

報紙的數位版本剛開始發展時,只是把紙本頁面直接轉成 PDF 版放到網站上。後來隨著使用行動裝置的人口增加,數位版開始加入更多互動手法,將 GPS 的定位功能應用到廣告中。如今新聞服務和廣告可結合起來,依據讀者的興趣或位置來提供廣告。廣告收入對報紙而言非常重要,以前報紙靠廣告版面來賺錢,數位化後,仍可透過各種收費廣告保有收益。

現在的編輯設計師須與數位平台的開發者合作, 對程式碼要有基本知識。設計師需要理解工程師 的語彙,才能順利溝通合作,建構完善的內容管 理系統。因為讀者在不同平台上閱讀新聞,會有 不同的感受,編輯設計師也要知道不同裝置所能 顯示的頁面尺寸,方能使數位刊物在每種裝置上 都完整呈現。

報紙大小

報紙的版式大小相當多樣,歐洲就有不少報紙是 介於大報與柏林版式之間。然而全球多數報紙所 採用的版式,仍為下列三種為主:

大報版式 柏林版式 小報版式

大報版式(或稱北歐版式):約56×43.2公分(22×17 吋)

柏林版式(或稱 Midi 版式):約47×31.5公分(18.5×12.5 吋)

小報版式(或稱半北歐或 Compact 版式):約 35.5×25.5-30.5 公分(14×10-12 吋)

數位報紙的常見迷思

平板電腦出現後,代表紙本報紙的時代結束。

錯。2010年上市的 iPad 並未改變一切,原有雜誌與報刊的品牌都還存在。平板電腦是很好的裝置,提供更多互動的可能性。

讀者不會用數位裝置來閱讀長篇文章。

錯。若以為行動裝置只是讓人在移動時能隨意瀏覽,那就太小看它了。現在的螢幕更適合長時間閱讀,讀者會利用數位裝置讀更長的文章,還能透過數位工具更快速消化資訊,並將文章存起來,供日後閱讀(例如 Instapaper)。閱讀習慣出現變化,2012 年的統計數字顯示,閱讀一篇線上文章的平均時間拉長了,已延長到 17 至 31 分鐘。

讀者喜歡用桌上型電腦的螢幕閱讀報刊。

錯。本書出版時,下載到桌上型個人電腦並以螢幕瀏覽的資訊量,已被行動裝置的下載量超越,顯然讀者更喜歡能隨身攜帶的電腦。再者,根據2012年的統計,有84%的使用人口是在家中使用這些行動裝置,而不是在移動中使用。行動裝置改變了我們的行為,我們越來越常一邊閱讀雜誌與報紙,一邊看電視或使用其他媒體。任何內容都無法再獨占讀者的注意力。

小型紙本出版商能夠生存。

正確。許多獨立出版社仍大量投入紙本刊物的製作,只要能負擔得起紙張費用,紙本刊物就不會消失。設計界會繼續做出五花八門的紙本刊物,讀者似乎也樂見這種趨勢。數位印刷的成本便宜,因此要推出小批量的出版品很容易。自助出版網站「新聞俱樂部」(Newspaper Club)就是好例子,只要把新聞內容上傳到網站上,即可列印出來或直接在線上發布。

大型紙本出版社無法生存。

錯。大型媒體公司出版紙本刊物時不如獨立出版商靈活,是因為傳統印刷與經銷費用非常昂貴。然而名氣大的刊物懂得變通,把內容從紙本

刊物移轉到設有付費牆的網站,並利用響應式設計(responsive design)讓內容便於在行動裝置上觀看。許多刊物仍存活下來了,還有刊物在2012年獲得國際新聞設計協會(SND)的最佳新聞網站設計獎。就算《新聞週刊》(Newsweek)在2012年一度終止紙本業務營運,但大型出版商仍可望在未來以其他方式復活。

數位刊物的術語

無阻礙經驗 Frictionless Experience

使用者在瀏覽網站或使用 app 時相當流暢,能順利瀏覽網站的不同區塊,不會在過程中必須回到首頁,或面臨得重新登入等惱人的層層關卡。

地理定位 Geo-targeting

這是行銷用語,意思是能依據讀者的實際位置, 為讀者篩選行動裝置上的內容。出版社能以這種 方式,給予讀者專屬的刊物及廣告內容,例如餐 廳列表。使用者必須要啟動 GPS,才能使用這項 功能。

全球定位系統 GPS

運用衛星導航系統,為車用裝置、智慧型手機與 平板電腦,提供地點與時間的資訊。

液態版面 Liquid Layout

運用設計軟體,為不同裝置的螢幕尺寸微調頁面的比例。液態版面很具成本效益,但是文字編排者與攝影師往往不喜歡作品被變形。

付費牆 Paywall

進入付費牆,網路使用者必須付費才能存取內容。有些報紙在面臨紙本訂閱人數與廣告收益下 滑時,遂在網站上設立付費牆,以賺取收益。

平板電腦手機 Phablet

具備手機功能的平板電腦。

雜誌

主流消費類雜誌與新聞雜誌

無論是紐約與倫敦的書店、巴塞隆納的報攤或 中國的雜誌專賣店,都有數不清的消費類雜誌 使出渾身解數,以封面圖像、搭售贈品、封面文 案、品牌知名度、訴諸讀者忠誠度等手法,爭相 吸引顧客注意。在網際網路成長之際,曾有人預 言雜誌即將死亡,然而放眼全球,雜誌依然蓬勃 發展。不過,紙本刊物現在只是龐大雜誌家族中 的一名成員。以時尚與生活風格雜誌來說,因為 頁面印刷精美,實體觸感討人喜歡,因此紙本雜 誌仍有優勢;但以新聞與關注特殊焦點的雜誌而 言,紙本雜誌可能開始退居為二線產品。

消費類雜誌包括女性、男性、商業、休閒、新聞、時尚與其他焦點等,還可進一步細分出不同區塊、關注話題與類別,各有各的目標讀者,通常也有各國專屬版本。

獨立雜誌(自助出版)

世界各地的雜誌不僅閱讀人口多,就連投入出版的人也前仆後繼。從獨立刊物(發行量小、專注於少數愛好者的雜誌)與專業雜誌種類數量激增,就能看出這一點;全球各地都有服務「利基」(niche,小眾化的)讀者的刊物。這些出版品有別於追求發行量的主流刊物,能提供主流雜誌所缺乏的內容。獨立雜誌不介意刊載長篇的網路文章,可說是一股新興的趨勢,內容常涵蓋藝術、建築、攝影、時尚與音樂等。

A SEROSORTING **STORY**

增刊會沿用主刊的元素,以確保品牌 的一致性。然而享譽國際的設計顧問 馬里奧·賈西亞 (Mario Garcia) 認 為:「除了把 Logo 放在某個地方之 外,增刊應該有自己的生命與識別; 讀者夠聰明,認得出母刊物是什麼, 因此增刊在設計上不妨冒點險,放鬆 文字編排,不要沿襲報紙的作法。照 片應該放大,色彩更豐富,紙質更 好。」《舊金山紀事報雜誌》(San Francisco Chronicle Magazine) 便 發揮這項概念,善用滿版插圖與加寬 欄位,和母刊物呈現不同的調性與風 格。

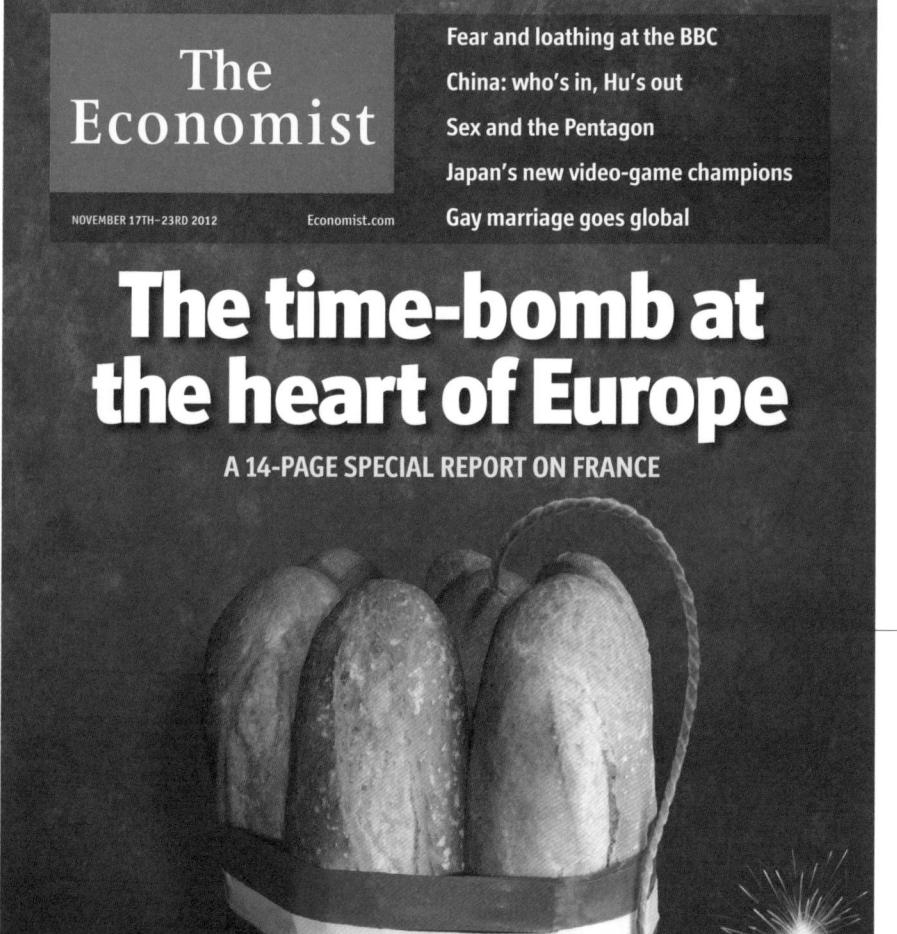

《經濟學人》(The Economist)除 了紙本刊物之外,也有很受歡迎的 免費 app。訂戶可透過簡單清楚的設 計,輕鬆閱讀新聞。這個 app 沒有太 花俏的互動內容, 頂多加上一些文章 與網站的外部超連結,不會搶了主品 牌的鋒頭。

理查·德利(Richard Turley),《彭博商業週刊》(*Bloomberg* Businessweek)

理查·德利曾與波特在《衛報》共事,經手許多專案,包括專刊、書籍與報紙改版。德利目前在紐約擔任《彭博商業週刊》的藝術指導。他在 2009 年接手之後,率領團隊為這份財經雜誌改頭換面,成果大獲好評。他以搶眼的圖像與犀利的用語,製作出如海報般雋永的精彩封面。如此現代感的視覺風格,在財經雜誌中可說是獨樹一格,快狠準的作風,令人想起 1960 年代社會運動人士的風格。由於這雜誌的封面設計千變萬化,因此讀者總是在期待接下來會出現什麼。這份週刊的編輯設計鮮明靈活(有時會把文字當成圖像來用,又善用資訊圖表),還搭配豐富的分析性內容,使其叫好又叫座。

德利重新設計的《彭博商業週刊》屢獲肯定,曾抱回設計 與藝術指導協會(D&AD)及出版設計協會(SPD)等機 構的獎項。出版設計協會曾稱讚道:

「《彭博商業週刊》以紐約設計界擅長的版式,展現《紐約時報雜誌》(The New York Times Magazine)美觀的視覺手法,再結合英國與歐洲一流的刊物層次與架構(如《衛報》)。《彭博商業週刊》有高度的視覺智慧,能給讀者挑戰,突破傳統新聞雜誌與商業雜誌設計的界限,令人佩服。」

——包柏·紐曼(Bob Newman),《Grids》雜誌 www.spd.org

德利在接下來的訪談中,談到關於數位設計的一些想法。

什麼事物能啟發你對未來雜誌的想法?

我喜歡看獨立雜誌。我除了偶爾買《Vanity Fair》之外,很少仔細看大型商業雜誌,更不會主動去買。我對數位雜誌也一樣沒興趣,根本懶得看。我知道自己很恐龍,認為雜誌就該印在紙上(笑)。真不好意思,其實我會看一種數位雜誌:《倫敦標準晚報》(London Evening Standard)的《ES》週刊。少了《ES》週刊,星期五都不像星期五了。雖然我是看 PDF 版本,但對我來說夠好了。我也喜歡它們的網站,尤其喜歡用 iPad 上網看。

在設計密密麻麻的內容時,數位版本能不能處理得和紙本 雜誌一樣好?

我做的數位設計不多,但我自己對成果還算滿意。我覺得 數位設計最令人興奮的是,「設計」是最不重要的一環。

數位設計講究的還是強烈、單純的刊物概念。一旦定出明確架構,就能避免數位雜誌設計淪為只是玩弄字體和炫耀功能的產品,再說這些功能多半都很蠢。(我可是過來人才這樣說。)

你最喜歡以 Twitter 來分享資訊嗎?

我喜歡用 Twitter 與 Tumblr,尤其是 Twitter。我會用這兩種方式來分享資訊,但以 Twitter 為優先。其實我不太常分享資訊;我常透過 Twitter 來得知資訊,而不是分享。

現代的編輯設計師除了傳統的平面設計能力之外,還需要 哪些數位能力?

我其實不算數位設計師,不確定能否回答這個問題。我認 為編輯設計師最重要的特質,在於能打破沙鍋問到底,樂 於溝通與分享。

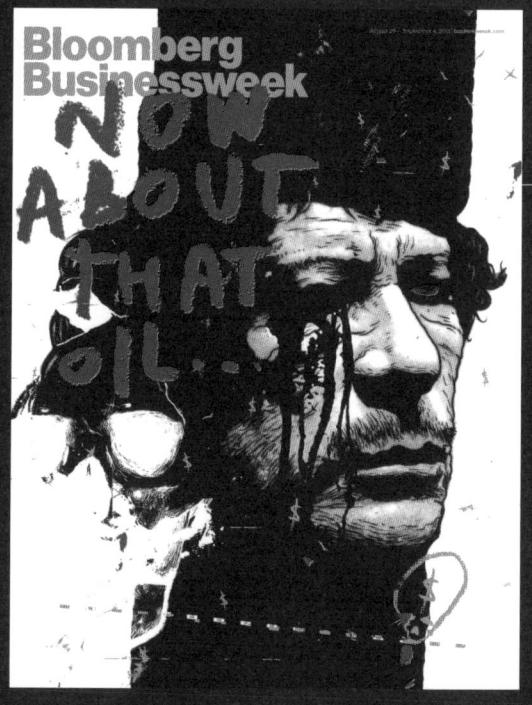

《彭博商業週刊》的 iPad 版與紙本 雜誌各有不同封面,皆隸屬於知名的 彭博公司網站,該網站提供豐富的商 業數據。通常這類圖表會由藝術指導 德利製作,再由編輯決定如何使用。

德利為 2011 年 8 月 29 日的刊物設計的封面,看起來像遭到潑灑油污。這作品顯示行動媒體能讓紙本如虎添翼,設計也很活潑有力。《彭博商業週刊》的文圖有搖滾威,讓人聯想到《Rolling Stone》(中譯:滾石雜誌)。像這樣搶眼的封面,證明《彭博商業週刊》改版後,不僅展現刊物的自信,也展現對讀者智慧的信任。

這份《彭博商業週刊》的封面,以大膽、極簡的手法處理日本國旗(右圖),在週刊市場過分裝飾的封面中顯得特別搶眼。

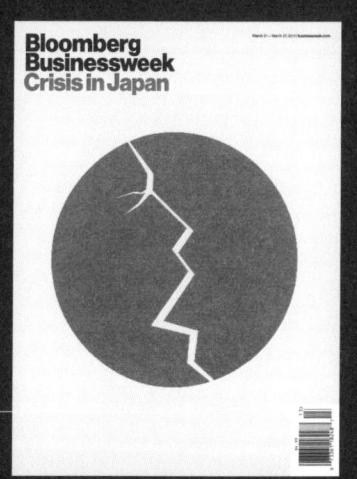

哥德字體「T」這個 Logo 代表這份 時尚雜誌來自於《紐約時報》。然而 吸引讀者閱讀這份秋季時尚特刊的元 素,是搶眼的人物。攝影師以絕美的 燈光與風格,營造出這個畫面。

增刊

1962年,《週日泰晤士報》率先推出以銅版紙 印刷的全彩雜誌,新型態刊物於焉誕生。早在 十九世紀末,美國就有增刊出現,然而《週日泰 晤士報》精美活潑,製作水準高,重新定義了增 刊這種產品。增刊很快在設計圈建立起名聲,與 優質雜誌地位相當。在長達五十年的發行期間, 《週日泰晤士報》吸引過全球一流的設計師加 入,推出許多世上首屈一指的增刊設計。增刊對 設計師而言,最大的挑戰在於必須傳達出它所屬 的母刊物語彙,並顧及其調性、立場與讀者群。 然而設計師可以嘗試不同於母刊物的字型,版面 與版式,為增刊賦予獨特的識別,這是一般零售 刊物沒有的自由。增刊可說是報社的搖錢樹,因 為報社老闆知道,如果讀者喜歡這份雜誌或增 刊,就會因此買這份報紙,因此報紙增刊可說是 備受矚目、人人欽羨的設計工作。

「編輯設計是協助刊物培養與讀者良好關係 的前鋒。設計風格會透露出這份刊物的內 容、精神、思想等特質,讓讀者馬上領會雜 誌的核心價值。」

-珍妮·佛羅里克,《Real Simpe》雜誌創意指導

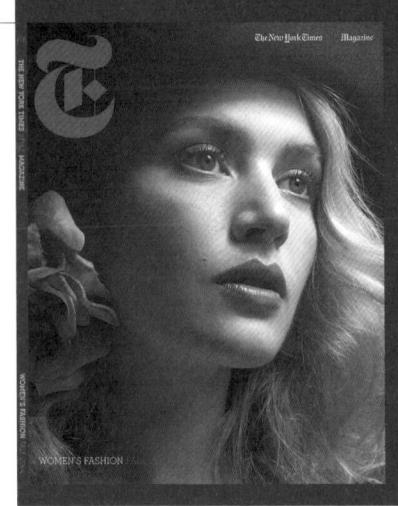

The Shape of Jackets to Come

《紐約時報雜誌》的例子可以清楚看 到圖像所傳達的純粹力量。藝術指導 佛羅里克與攝影師密切合作,依據設 計規劃,拍出概念性很強的照片。文 字編排又進一步凸顯出攝影的細膩之 處, 誇張的首字放大能把讀者的眼 光,帶到服裝的特殊造型上。

SUBVERT!

TALK!

《M-real》是以紙廠為對象的行業刊物,圖中是這份雜誌 的裡封與目錄頁。這份雜誌的每一期都有新風貌,只有紙 張大小、基礎版型與每篇專題報導開頭的對角圖案不變, 絕大多數的設計元素則不斷變化。

客戶雜誌與 B2B 雜誌

客戶雜誌整合了品牌的視覺形象、產品定位,成 為品牌行銷中不可或缺的角色。客戶雜誌最初只 提供給特定消費產品與服務的使用者,但發展到 今天,已出現許多創新樣貌,跨越多種平台,為 品牌產品或服務的愛好者創造出社群,吸引他們 在社群媒體上討論品牌。和一般消費類雜誌不同 的是,客戶雜誌有企業給予經費,是推銷品牌、 幫產品說好話的重要管道。品牌行銷者了解,客 戶雜誌要有效,內容就要兼顧資訊與娛樂,而推 銷色彩必須細膩低調。《magCulture》創意顧 問雷斯里表示,因為客戶雜誌有服務讀者和品牌 行銷雙重需求,因此對設計師者的要求也較多:

客戶雜誌和一般雜誌的設計原則大同小異, 但是需更注重策略、思維與更廣的創意。消 費類雜誌必須在架上夠突出,但在吸引新讀 者時,不能冒險讓原有讀者受到排擠。客戶 雜誌也講究創新,但需要符合讀者們對品牌 或服務的期待。設計師在設計客戶雜誌時, 更需要進行概念性的思考, 一再探討雜誌的 可能性。

B2B(企業對企業)雜誌的活動範圍很大, 是消費類刊物望塵莫及的。一般公、民營產 業的通訊刊物,就屬於B2B刊物。通常這 些刊物、新聞通訊與部落格只提供給會員使 用,不向大眾發售,因此不太重視設計,但 也有例外。《The Lawvers》雜誌與網站皆 由埃斯特森設計事務所操刀,就是很好的範 例。另外,雜誌出版社協會(Periodical Publishers Association Services)也有專 門的獎項來鼓勵優秀的 B2B 雜誌設計。

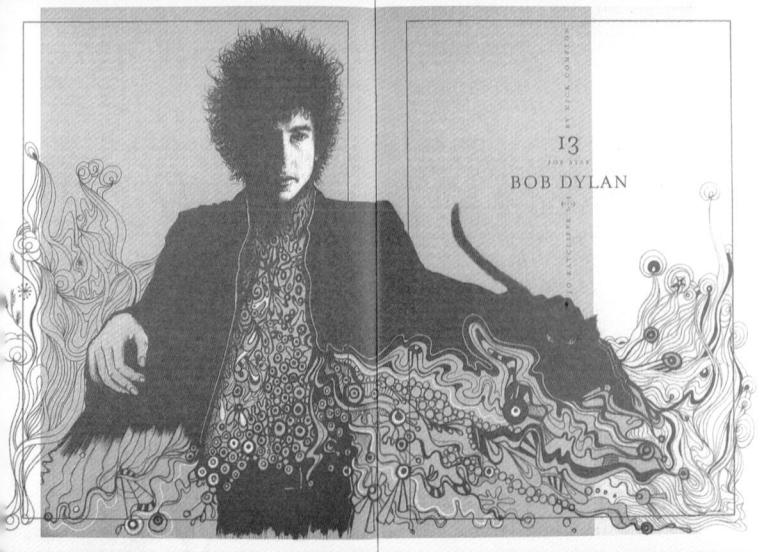

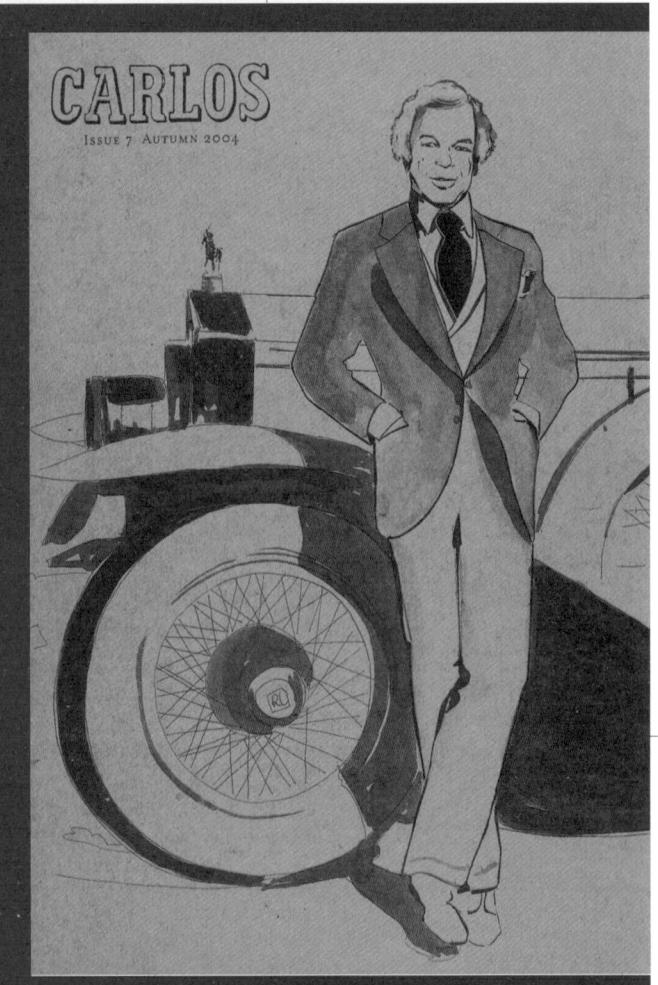

雜誌市場概況

- 美國每月有超過 3000 萬本雜誌,透過訂閱與 零售流通。
- 2004 年,美國共計有 18821 種雜誌。
- 美國超級市場平均有超過700種雜誌,隨時有300到400種在架上。
- 美國有超過120種針對亞裔美籍讀者的雜誌。
- 2002年,德國有240種紙本雜誌上市,超 過200種消費類雜誌推出。
- 英國有約3000種雜誌,其中200種占總銷量的90%。
- 美國每年有 1000 種刊物提案,其中三分之一 確實出刊。

美國統計數字取自於美國雜誌出版協會 (Magazine Publishers of America) 與發 行公信會(Audit Bureau of Circulation), 依據2002年的銷售/發行量而來。英國統 計數字是來自尼爾森圖書調查公司(Nielsen BookData)。

數位雜誌出版

雜誌的內容與發行方式,會深受市場類別左右。 以時尚雜誌為例,紙本雜誌有精美廣告,製作水 準又高,深受讀者青睞,其網站設計往往有動畫 來強化內容,還搭配線上專屬的讀者優惠。美國 生活風格刊物《Real Simple》則將雜誌內容直 接匯入網站,並大幅介紹紙本雜誌,吸引讀者訂 閱。

《Carlos》的封面與頁面。《Carlos》 是維珍航空(Virgin Atlantic)頭等 艙刊物,視覺識別非常強烈。有趣的 是,這本雜誌的特色在於它所缺乏的 東西:圖片和彩色版面。

社群雜誌

這是一種新奇的內容篩選器,依據讀者瀏覽與按「讚」的記錄,再次集結出內容,成為一份刊物。這類雜誌在美國稱為「社群雜誌」(social magazine),由 Flipboard 與「美國線上」

(AOL)的 Editions等 app 開啟先河。社群雜誌是以 Twitter與 Facebook等社群媒體為基礎而發展,例如 Editions 就能把美國線上新聞提供者發布的資訊,運用 GPS 整合出屬於讀者所在地的內容,提供給讀者。社群雜誌像經過嚴謹編輯的品牌產品,集結線上新聞內容,同時鼓勵讀者「分享」。這種作法有點像以前人會把喜歡的刊物頁面撕下來,和朋友分享傳閱。

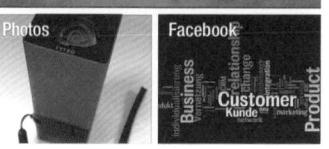

Flipboard 運用社群網站的力量,根據讀者的資料分析來集結其他網站取得內容,因此廣受歡迎。刊物內容是自動產生的,使用者只要進來便能一次看完有興趣的文章。

《Real Simple》以簡潔的外觀, 凸顯出品牌價值。它運用精選的 配色,不僅紙本刊物美麗,在平板 電腦上也賞心悅目。在「動手做」 (how-to)的單元中會以互動影片 呈現,堪稱強化內容的範例。 iPad 能以簡潔的方式呈現複雜的報刊內容,對讀者與設計師來說都是美好的經驗。在左圖中,只要在派上用手指輕輕一點,食譜就會從中間跳出。看似簡單的頁面,其實隱藏豐富的內容。

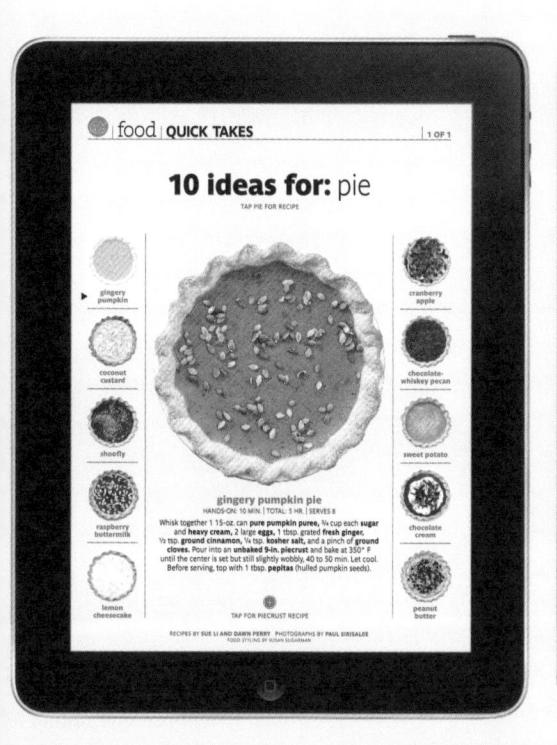

工作坊 1 **發展概念**

給教師:以此作為你教學計畫的基礎,再發展並加上你覺得與你領域相關的部份。這份綱要是以藝術或美術科系一年級的學生為對象,調整後亦可供高年級學生使用。

給學生:把本書中的工作坊單元當成自我學習的架構。請自行拍攝照片,讓朋友評論你的作品,傾聽 他們的意見回饋。

目標

以某個當代主題為發想,策劃一本雜誌,來捕捉這 時代的感受。

練習

發揮想像力,想出一個屬於當代的主題,並研究追蹤,發展成雜誌中的專題報導。

開始腦力激盪,提出至少五種不同的雜誌專題概念。在紙上把每種概念畫下來,只要畫出刊頭、 Logo 與概略草圖即可。然後把你的概念整合起來。

選擇其中一個概念,蒐集適合這份雜誌內容的圖像 資料。研究其他內容相關的雜誌,以及關注同樣焦 點的社團或群體。他們是怎麼進行內容編輯的?到 圖書館或獨立書店找資料,也可以參考線上雜誌。 蒐集剪報,或把適合的內容影印下來。記錄任何可 以讓故事更精彩的字體或插圖。持續蒐集資料,把 雜誌的概念精簡成連貫的幾個字,例如我的雜誌叫 做什麽,它討論的主題是什麽。

製作「情緒板」(mood board),說明雜誌的概念,再把你所製作與研究的圖像匯整修訂,貼到一張 A3 或 A2 的卡紙上,開始藉此找出這本雜誌的視覺風格。為雜誌寫幾條封面文案,正式替你的雜誌取名,雜誌的頭版即將誕生。

學生莎樂米·德賽(Salomi Desai)發想的雜誌,主題為日常生活中的迷信。德賽以這個概念,用不同角度拍攝日常生活的事件,讓它們顯得十分特別,玩出圖片與影像的趣味。

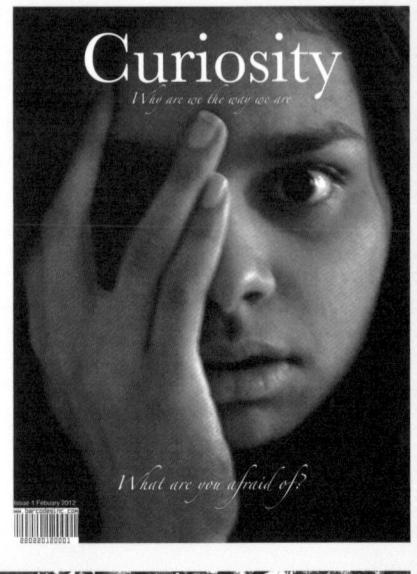

URIOSITY February 2012

Curiosity Why are we the way we are

CURIOSITY February 201

The Infinity of Phobias

Just how many phobias are there? The only answer to that is that they can be of any and everything. In fact there is even a phobia on that- panophobia, and a phobia of phobias- phobophobia. So what are the the 'common' phobias or at least the ones popular enough to make it on most lists? Salomi Desal finds out.

Porro disdetatum quo conflux non politateque omes santi quas visili. Islacardate verbrus en la omes santi quas visili. Islacardate verbrus en la cuntiba e report perfero colt ericlaren nonetur? Ou recus velesen finsichem auf em aut visionnoi utem Et commisco erum quaren, et espelliqua atiquam ad molorum filosus, sequide aut que re-errorm ribur, nosismus ecos quiastes brumque qui sum remiquam quat resequazio conseque por adicisso dioloptesimi.

vero taboroporal espiritivas.
Apalam estibus organis ultra place Temporerum, victorem disbud difinal transed oposem precisió a reducidad difinal transed oposem precisió a reducidad difinal transed oposem precisió a reducidad difinal diffinal diffina

Olorisci litandarrducii maxim ipidio. Et elium volu ptas e eici ab illabor eptiae omniae velit vendanis pera ipient quaspelit fuga. Et et upa plabore pratia convit elessenimus plabore pratia.

Against visigenitation resistant programming foliation gain error and end conditionation with flow foliation gain error and end conditionation with flow socialization. Lulimpos area lets, if a respondita dend visigenitation control and a respondita dend foliation and control and a responditation gain foliation and control and a responditation and foliation and control and a responditude preference application control and programming control and participation and control and participation and control and participation and control and participation and control and

Do you need to clean it?

德賽先用鉛筆描繪概念草圖,之後做成實際大小。她利用簡單的圖像來發想,逐步發展成報導內容與標題。她參考維多利亞時期古玩店稀奇古怪的收藏,將雜誌命名為《Curiosity》。

CURIOSITY March 2012

I ferchit dolorum re corpor as pernatus recrem voluptaest i per magnitic consequae et que sem aut qui curret esplanto usa ecisarii in sibronequi conecto moloris picil expedi mod et modei sur etur, quisco persperunt que noneque seguatin la dolore deso sur etur, quisco persperunt que noneque seguatin la dolore deso secto nia nobla tosas rem lum dendiça artegui recupta sun flumque delore, occum, padi quo volubrem

sector sin nobit baces rem i um dendign areigui recopti son bitmique di dolore, cocurm, gold quo volubiem vicione an elle tilem represus usem indistaut, trese accultupida quo trectas dolum et velorizere dolupid, rifici temporacia enverimi int, quidus suuntessama simuntampuda volupida and uta bipas dia repera femoripi endopsium dia dissa indiameta aperchi Sammilla volupi batem. Yas correbene pils dignia sudicia rullamiurine et pils dignia sudicia rullamiurine et pils dignia sudicia rullamiurine et que propositi di pils di pils sudicia pils di pils sudicia rullamiurine et que propositi di pils sudicia rullamiurine et que propositi di pils sudicia pils di pils pils dignia sudicia rullamiurine et que propositi di pils di pils pils dignia sudicia rullamiurine et que propositi di pils di pils pils dignia sudicia rullamiurine et que propositi di pils di pils pils dignia sudicia rullamiurine et que propositi di pils pils di pils di pils pils di pils di pils di pils pils di pils pils di pils pils di pils di pil

Nemotivi in natur a dis auti estimung adolopits sperium apis en en suddest aut noim pur pibes qualeninis to sito est preter lacoudemus qualituri, volupta essurine delés dusanin lorripore velle lur, consedipant i publicant

Bizarre Superstions

ibeaqui di sus abo. Nequi aut sure at magnist, ommolorium alla repudi occus escia eos iposusa ni omnia quam destrum quo dis am aut initato imperatur re culparum que nonseque praepe rumqui re nulloriumque effore lendae ex et illa nonsequi astibus eos qualir immo quae suri.

Officita tempula nestioneera piabo. Te vera volluptatur aut modici cori cultam, qui inis reiumb buedam et alberi asimienectico vidit enum dioizze. At doubtats cultatu? Aspe voluptae vei incitatibus, am qui ut rem sinis delicit, to cup

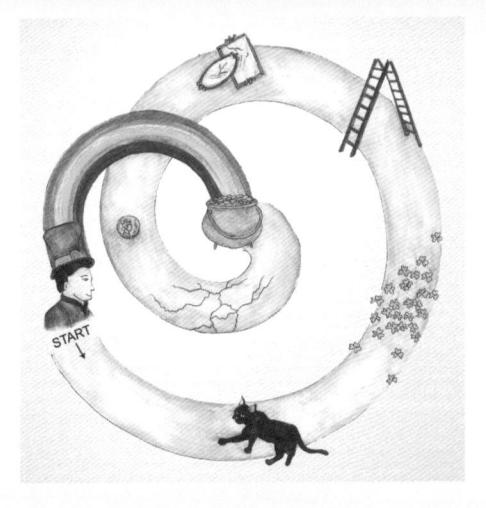

FRANCE GERMANY ITALY and tomorrow's national treasures **JAPAN SCANDINAVIA** SPAIN USA Boarding now for **BELGIUM**

Chapter 3:封面

看到搶眼的雜誌封面與刊頭,誰能克制得了動手翻閱的衝動?只要能在架上抓住來往人群的目光,刊物就等於找到潛在讀者。數位刊物的封面更是引誘讀者來閱讀的要角,讀者只要輕碰畫面,便能一睹刊物內容及動態互動元素。封面是傳達品牌訊息的關鍵,本章首先要探討封面如何打造品牌——這對任何新刊物來說都是第一要務。

品牌與識別

對於新品牌來說,首要之務就是確立品牌訊息, 亦即這份刊物的識別、表現與質感。要成功詮釋 這些元素,須仰賴編輯與設計師的無間合作,打 造堅固橋梁,讓業主(出版社或自費出版者)能 把品牌與品牌價值傳達給顧客(讀者)。橋梁蓋 得好,才能著手製作刊物內容(詳見四、五、六 章)。品牌的識別設計內容包含Logo、配色、 字型、照片與插圖。同時要建立一套規則,讓不 同人接手設計時都能依循。這些元素集合起來, 就會形成品牌的標準識別。每一期刊物的識別都 需要重新檢討,才能確保刊物新穎有活力,不落 入制式化設計的窠臼,犧牲核心品牌的價值。每 次識別延伸都需要與設定好的格式相互契合,不 能只是在不同產品上複製相同外表。要能達到這 個目標,就要讓刊物維持可辨識的風格,但每期 也要有足夠的差異,讓讀者與潛在讀者看到喜愛 的刊物不斷翻新的風貌。

> 《Wallpaper*》委託藝術家諾瑪·巴爾 (Noma Bar),為全球各地製作出八 種版本的封面,各地讀者都能找到屬於 「當地」的版本。乍看之下,這只是八 幅不同的畫,但仔細一看,就會發現它 們都在玩弄空間趣味,彷彿一間間房 間,還擺放了家具。這系列作品不僅和 美術畫作一樣迷人,更善用比例與負空 間的手法,做出令人難忘的畫面宣傳。 這些封面設計強化了品牌, 傳達出在世 界各地愜意旅行與工作的概念。

Wallpaper*

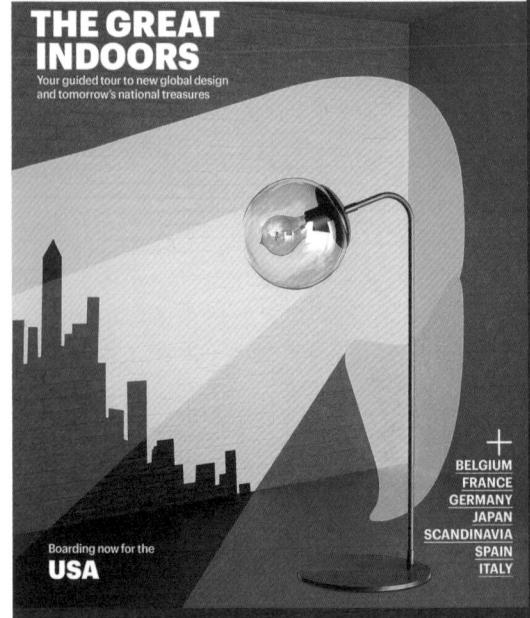

Wallpaper*

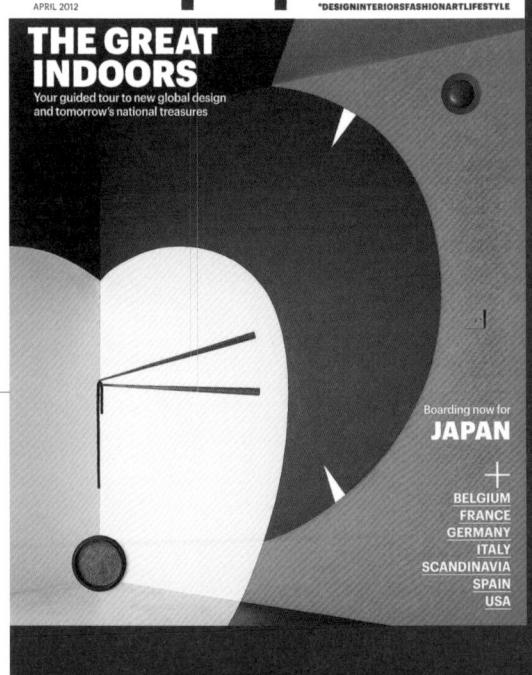

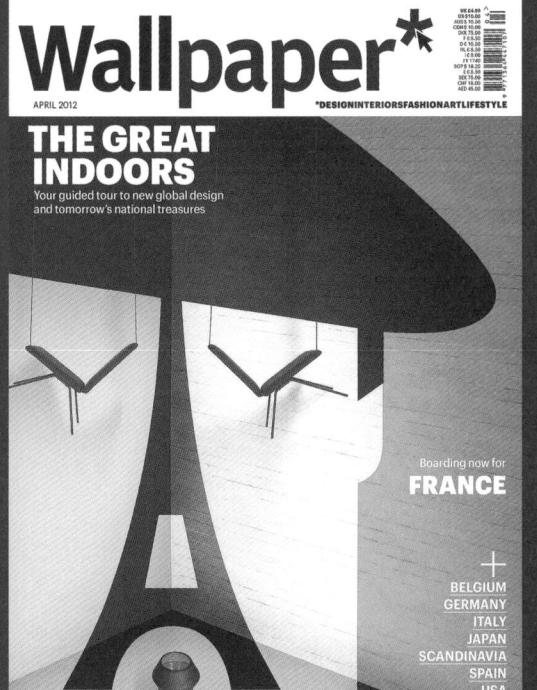

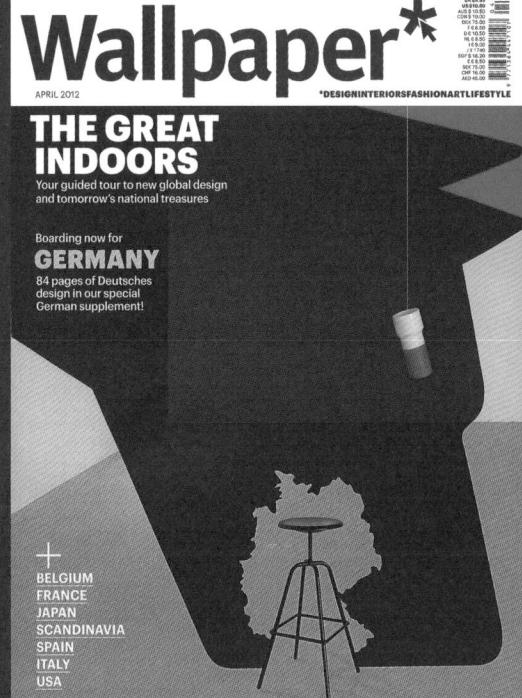

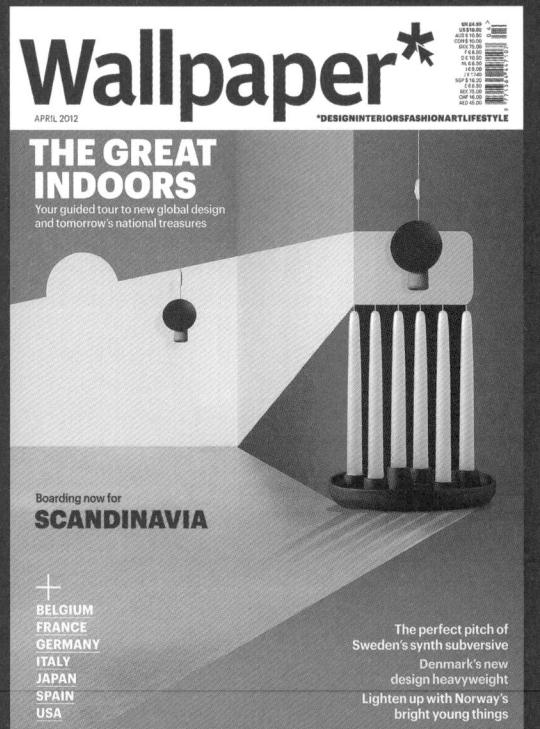

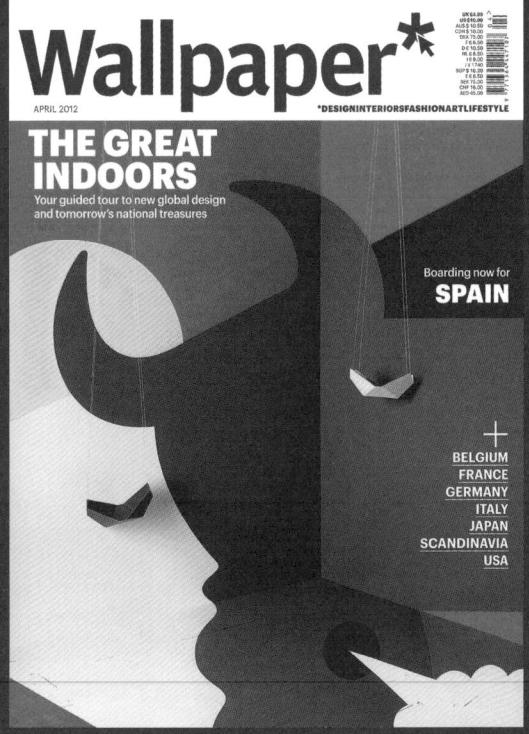

封面

無論是哪一種出版品,要清楚傳達品牌特色與價 值,第一步一定是利用封面設計來達成。紙本雜 誌在設計封面時總是絞盡腦汁,以求雜誌擺在店 面時能傳達訊息,脫穎而出。讀者購買雜誌後, 封面也能更貼近讀者,宣傳刊物價值。就數位雜 誌來說,封面不僅能強化品牌,也是瀏覽工具, 讀者會從封面點進去,閱讀刊物內容。同一張封 面圖可能出現在紙本、網站、平板電腦與 app, 因此負責設計封面的藝術指導必須考量各版本 之間呈現效果的差異。封面擔負重責大任,必須 呈現豐富意涵,還要刺激銷售。封面要夠搶眼, 才能異軍突起,吸引讀者目光,避免讀者投入競 爭者懷抱。定期發行的刊物封面要讓固定讀者覺 得熟悉,但又須與舊刊不同,讓讀者一眼就辨識 出那是最新一期的刊物。封面要表達刊物的特性 與內容,還要獲得潛在讀者青睞,進一步翻閱刊 物。但在此同時,也不能讓原有讀者感到陌生。 無怪乎許多出版社與設計師在設計一頁封面所 耗上的時間、金錢與精力,不亞於所有內頁的總 和。數位刊物的封面可能出現在 Facebook 或 部落格,因此必須夠醒目,即使被縮小也能看得 清楚。每一期封面都要有力量,以吸引使用者。

se sube a 'vaporetto' Clooney y Bullock abren la Mo de Venecia Pácinas 33

El regreso del El diario de Adán y Eva

Aquí hay tomate, pero menos

El presidente del

Cobos aseguró que tenía autorización verbal del Tribunal

Prancisco Pérez de los Col presidente del Constitucio simultaneó su cargo de magis do con el de asesor en una co-sión de expertos de la OIT, po que cobraba dictas. La ley in de a los magistrados activida de asesoramiento durante

más dinero para becas, pero con menos beneficiari

El ministro de Educación, José nacio Wert, intentó ayer nea en el Congreso las críticas a reforma del sistema de becas a versitarias con el anuncio de esta partida crecerá este esta partida crecerá este esta partida (encen a partir el menos becarios, tras el endur miento de los requisitos para as

Científicos crean microcerebros a partir de célula

El cine más guapo

pecado original

Constitucional deja el puesto er la OIT que ejerci siendo magistrae

MARÍA FABRA, Madrid

J. A. AUNIÓN, Madrid

madre humanas JAVIER SAMPEDRO, Madrid

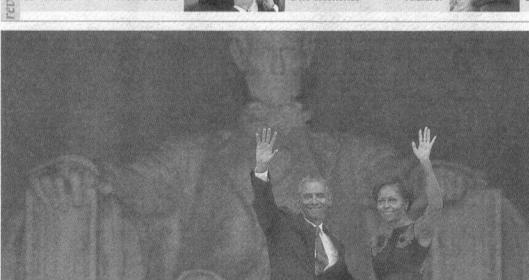

Obama llama a que el sueño de King se cumpla para todos

EE UU y Reino Unido agotan las vías legales para el ataque a Siria

Londres acude a la ONU, que pide tiempo para sus inspectores Dobama se dispone a presentar pruebas del bombardeo químico

Tarde y mal El ex secretario general de la OTAN avisa de los riesgos de una acción que se prevé rápida, pero podría no serlo

Lo que más sorprende es que ha-ce varios meses no hubiéramos es-cuchado al presidente de EB UU y al Consejo Europeo un anuncio de esta naturaleza: "Hemos decidi-

Es hora de actuar en Oriente Próximo

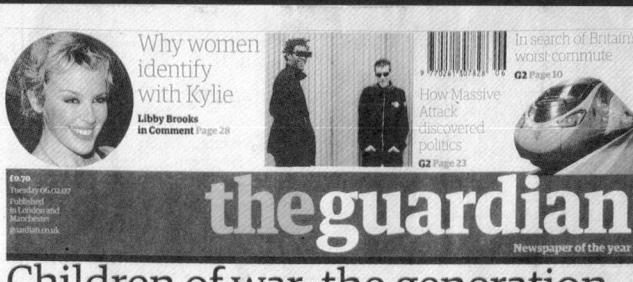

Children of war: the generation traumatised by violence in Iraq

Growing up in a war zone takes its toll as young play games of murder and mayhem

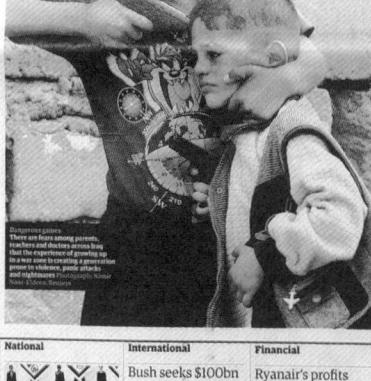

Britain worst for crime, says EU poll

extra for war in Iraq

Barton booked by England captain

報紙頭版

如今報紙已無法僅憑著新聞內容來吸引人購買, 報社通常必須搭配網路與行動媒體發布新聞快 報,紙本報紙似乎得重新尋找定位。曾擔任全球 多種報紙顧問的賈西亞說:「以前,新聞指的是 『昨天不知道、今天才發現的事』。如今我與業 主分享一個新觀念:『新聞是我昨天發現、今天 才明白的事』。」進入二十一世紀之際,許多報 紙紛紛改版,期盼藉此發揮影響力,這一點從報 紙的頭版即可看出。賈西亞說,報紙必須給讀者 「能讓他們覺得驚訝的好故事,照片必須是過去 二十四小時內,電視與網路找不到的。新聞媒體 應當給予讀者驚奇,不要一再重複已知的事。」

報紙的頭版仍相當仰賴搶眼的畫面及 聳動的標題,《衛報》就是一例。零 售報紙會在頭版放上新聞摘要,吸引 讀者注意。例如左頁的西班牙《國家 報》(El Pais)就在頭版以鋪底色的 横幅與垂直欄位, 先行透露內百報導 提要。即使是敘利亞的頭條新聞也僅 占十七行,因為,還要擠進一篇廣告。

同樣地,《衛報》也在頭版下方提供 四、五篇精簡的新聞摘要,這是設計 師找出的權衡之計,畢竟所有優質報 紙,都會想在頭版多列出幾篇報導。 波特曾說:「運用新聞摘要,頭版就 能排進許多報導。如果報紙想對當天 的新聞提供廣泛而平衡的報導,新聞 摘要就很重要。」

& Books

Thinking Big: The new insecurity 010-12

Filmmakers on

the war path 02 By Thom Powers

science of By Christopher Shee

Kosher in By Ben Birnba

Ideas online in "The politics of pain, Drake Bennett discusse

Law enforcement is clamping down on doctors who prescribe high doses of the most powerful and dangerous pain killers. Is this protecting patients — or hurting them? | By DRAKE BENNETT

DOTTLES CARGOD IN CONTROLLING CHEMICAL PROPERTY AND ASSESSMENT OF THE CARGOD IN CONTROLLING CHEMICAL PROPERTY AND ASSESSMENT OF THE CARGOD IN CONTROLLING CHEMICAL PROPERTY AND ASSESSMENT OF THE CARGOD IN CONTROLLING CHEMICAL PROPERTY AND ASSESSMENT OF THE CARGOD IN CONTROLLING CHEMICAL PROPERTY AND ASSESSMENT OF THE CARGOD IN CONTROLLING CHEMICAL PROPERTY AND ASSESSMENT OF THE CARGOD IN CONTROLLING CHEMICAL PROPERTY AND ASSESSMENT OF THE CARGOD IN CONTROLLING CHEMICAL PROPERTY AND ASSESSMENT OF THE CARGOD IN CONTROLLING CHEMICAL PROPERTY AND ASSESSMENT OF THE CARGOD INCOME. THE CARGOD IN CONTROLLING CHEMICAL PROPERTY AND ASSESSMENT OF THE CARGOD IN CONTROLLING CHEMICAL PROPERTY AND ASSESSMENT OF THE CARGOD IN CONTROLLING CHEMICAL PROPERTY AND ASSESSMENT OF THE CARGOD IN CONTROLLING CHEMICAL PROPERTY AND ASSESSMENT OF THE CARGOD IN CONTROLLING CHEMICAL PROPERTY AND ASSESSMENT OF THE CARGOD IN CONTROLLING CHEMICAL PROPERTY AND ASSESSMENT OF THE CARGOD IN CONTROLLING CHEMICAL PROPERTY AND ASSESSMENT OF THE CARGOD IN CONTROLLING CHEMICAL PROPERTY AND ASSESSMENT OF THE CARGOD IN CONTROLLING CHEMICAL PROPERTY AND ASSESSMENT OF THE CARGOD IN CONTROLLING CHEMICAL PROPERTY AND ASSESSMENT OF THE CARGOD IN C

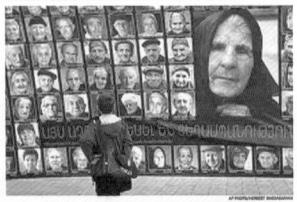

Common ground

A group of historians want to reconsider the 1915 Armenian genocide — and prove that Turkish and Armenian scholars really can get along BY MELINE TOUMANI

Black

& Books

Boston Sunday Globe

Thinking big: Going to college in high school #12

D

By Hua Heu

Was the New Deal racist?

Tankon

In the 1990s, Pioneer Institute helped introduce market-oriented idea to Massachusetts government. So why did the upstart conservative think tank run out of gas? | BY THOMAS C. PALMER JR.

COLOR ME RESISTANT. An Israell policemen arrests an opponent of Israel's disengagement plan from the Gaza Strip, Aug. 8. Anti-withdrawal activists have adopted orange as their color, while the government supporters embrace the blue of the Israell first.

Orange As Israel prepares to withdraw from Gaza, pigment gets political | BY BORIS FISHMAN

GL D1 20:20 FIRST

BLUE

GL E1 20:23 FIRST

BLUE

RED

Black

報紙的編輯設計師無法奢望以大圖、 色彩或亮晶晶的紙張吸引讀者,必 須採取和雜誌不同的手法。上圖取 自《週日波士頓環球報》(Boston Sunday Times)的幾個例子。賈西 亞說:「文字編排是外觀與質感的關 鍵,也是讀者視線落在頁面上最初十

秒察覺到的事。透過不同的文字編 排,報紙可傳達出嚴肅、年輕、趣味 等感受。第二要素則是配色。讀者會 對頁面上的文字與色彩組合有立即反 應,因此留白的位置安排,就是第三 個重要角色。」

數位刊物封面

出版社已明白封面的潛力,知道讀者是從封面進入刊物,再開始和內容與廣告互動。不同裝置的 螢幕會改變封面圖像的特質,例如智慧型手機的封面圖就比紙本刊物的相同圖像要小得多。但是在設計數位刊物的封面時,有兩條原則倒是不變:圖像必須強而有力,封面字體要能吸引讀者,勾起閱讀興致。平板電腦上的刊物封面,當然也要和紙本刊物直接連結。《紐約時報》就是一例,它雖然把 Logo 縮得很小,以增添趣味,但也暗示讀者,數位版保證會和紙本一樣豐富。在行動裝置的螢幕上閱讀報刊,和閱讀實體報刊的經驗不同。進入刊物的方式很多,例如從網站、app,或朋友寄來的連結。設計師必須用心處理封面,務必保持刊頭與品牌識別無論在哪裡出現都清晰可辨。

在觸控螢幕上,封面就是一張圖片,可透過滑動 或碰觸而進入內文頁面閱讀。常見的銷售模式, 是讓讀者單獨訂閱數位版本雜誌,或訂閱紙本的 同時,獲贈刊物的 app 或數位版。

自助出版刊物的封面與小眾雜誌

如今,小公司也有許多自行出版刊物的機會,按量計價的印刷方式可幫助業者跨過傳統印刷與經銷的門檻,降低成本,減少浪費。獨立雜誌界創意源源不絕,不少有心人投入刊物製作,滿足新興利基市場的需求。獨立出版社可利用社群媒體來宣傳出版品,無需花錢買廣告。舉例而言,史蒂夫·華生(Steve Waston)創辦的「雜誌堆」(Stack Magazines)網站,就是位於倫敦的獨立雜誌集團,在這個網路平台上可買到許多有特色的刊物,例如《Oh Comely》、《Anorak》、《Ride》、《Port》與《Huck》。這些雜誌封面與一般店頭刊物不同,沒有過多文案,看起來簡潔美觀。

《The Ride Journal》的藝術指導安迪·狄普洛斯(Andy Diprose)將封面圖直接跨頁延伸到封底。這份刊物為獨立出版品,不必受到封面文案、條碼等傳統雜誌的限制。

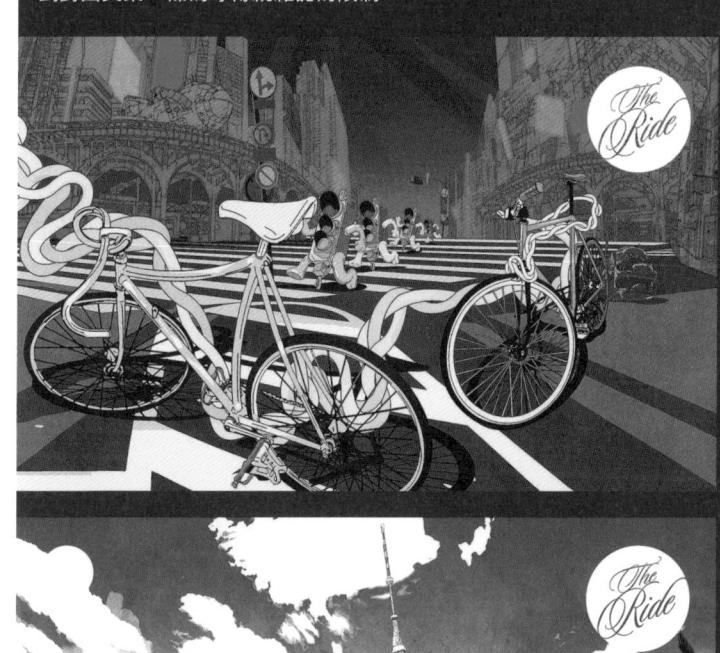

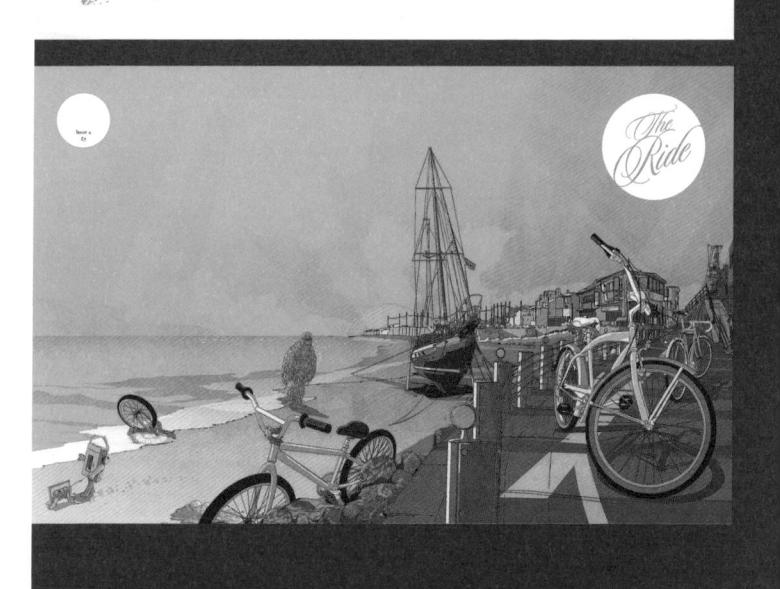

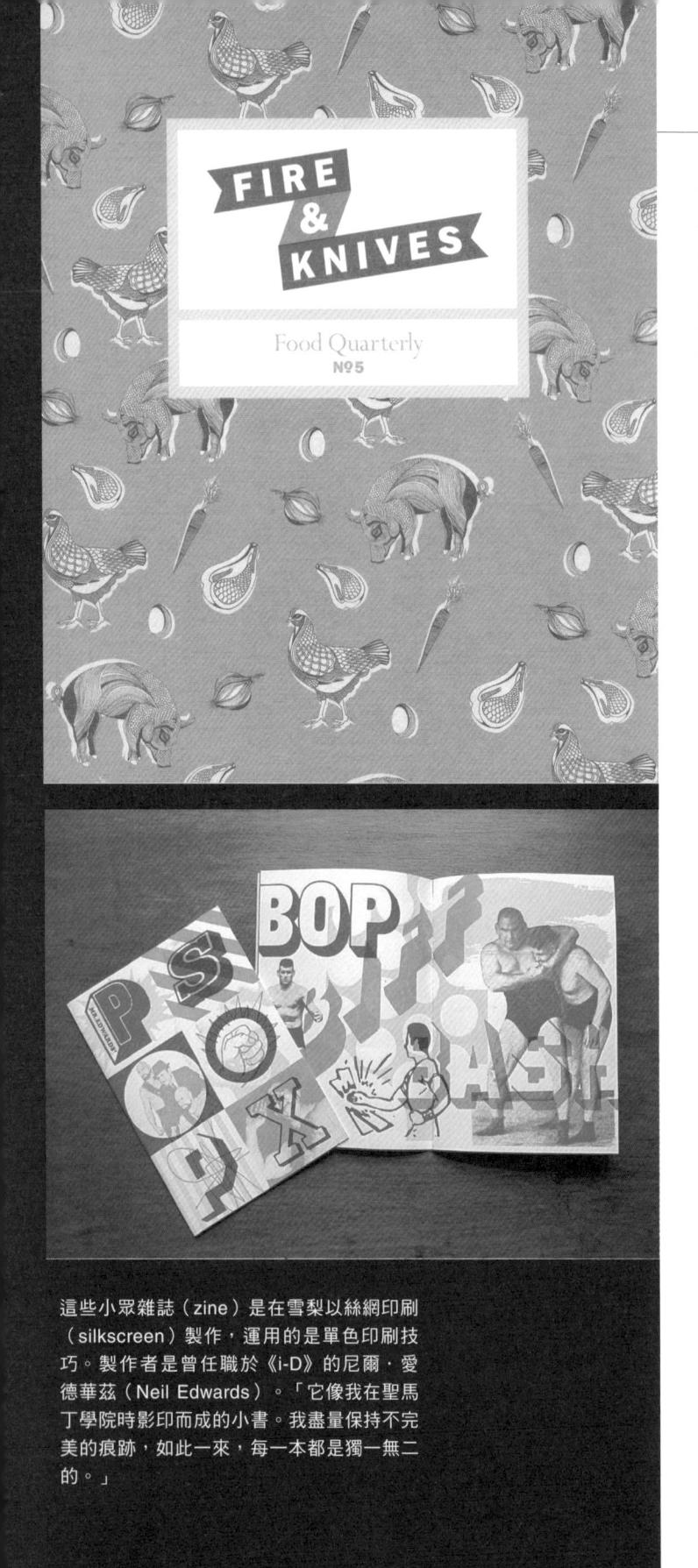

《Fire & Knives》是美食家雜誌,這份小眾雜誌開本為 A5。雜誌封面採用插畫,而不是照片,凸顯出和其他美食雜誌的差異。雜誌內廣告不多,文藝氣質濃厚,積極評論飲食業的種種現象。雜誌主要是由藝術指導羅伯·洛伊(Rob Lowe)手工製作,有些頁面是畫好之後直接掃描,如此可壓低排版成本,加上出版規模不大,不必委託經銷商發行。

小眾雜誌也是獨立出版產業的一份子,它們是發行量很小的獨立雜誌,關注非主流的議題,常用影印機複印後,就裝訂出刊。過去小眾雜誌大多是黑白的宣傳手冊,非主流的意味很濃,內容通常被認為不得體、顛覆性或稍嫌偏執。《Dazed & Confused》與《i-D》雜誌都是從小眾雜誌起家,卻孕育出不少重要思想,引起大眾注意,之後才成為大型雜誌。1990年代在「暴女龐克」(Roit Girl)運動的背景下,觸發不少自製的小眾雜誌出現,挑戰主流政治觀。這些雜誌為憤怒的女性發言,透過口耳相傳,使得暴女龐克知名度大增。

拜影印成本低廉之賜,小眾雜誌可以免費提供給讀者,在1990年代更因家庭數位印刷的出現而助長發展。目前全球各地有很多種小眾雜誌,專門蒐集小眾雜誌的人也不少。小眾雜誌現運用社群媒體與部落格,靠著利基團體的支持來生存。

客製封面

2010年,《Wallpaper*》邀集讀者運用線上軟體自行製作封面。雜誌先邀集奈卓·羅賓森(Nigel Robinson)、詹姆斯·喬斯(James Joyce)、坎姆·湯(Kam Tang)、霍特與安東尼·布瑞爾(Hort and Anthony Burrill)等藝術家設計基本元素,再由讀者自行組合。讀者用範本製作好作品後即可提交,之後就會收到寄來的紙本雜誌。藝術指導普里香特表示:

Wallpaper*

我們第一次推出手作特刊 (Handmade Issue),找了廠商與設計師一同協調製作方 式後,邀請讀者參與。我們製作一款軟體, 讓讀者得以自行組合幾種設計師創造的元 素。我們把讀者的設計印出來,每一款都不 相同。這需要先找到能配合的印刷廠,才能 確保品質。每位讀者會收到自己設計封面的 雜誌。我們總共印了 21,000 份不同封面的雜 誌。

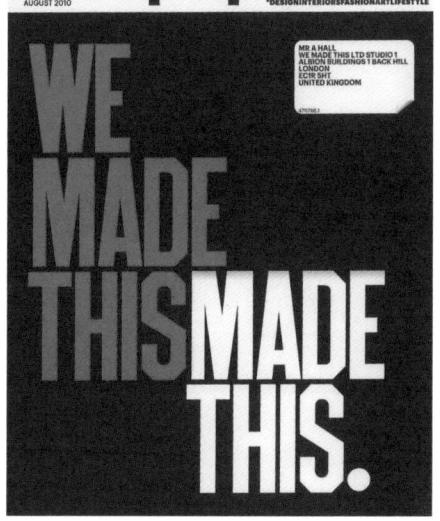

艾里斯戴爾·霍爾(Alistair Hall)在 《We Made》特刊中,設計出這款封 面, 並把圖片放在部落格上。

設計與藝術指導協會將 2011 年的「黃 鉛筆獎」(Yellow Pencil),頒發給 《Wallpaper*》這項邀請讀者做封面 的創舉。

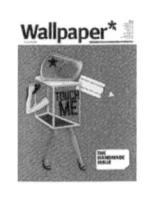

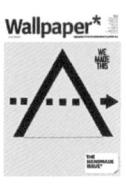

Wallpaper*

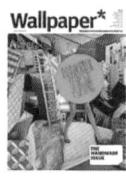

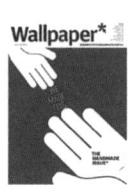

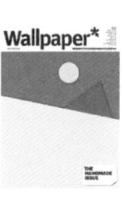

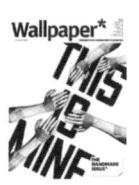

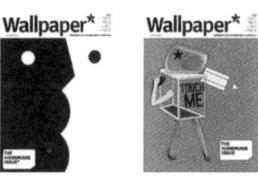

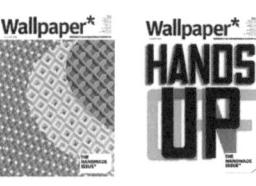

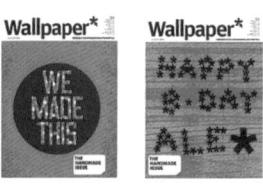

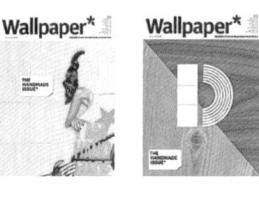

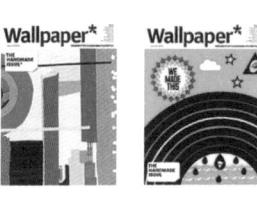

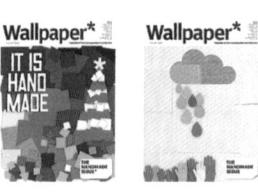

1940年迄今的封面發展

1940至1950

1940年代的英國雜誌多為黑白印刷,有些搭配彩色封面。有些雜誌和1930年代的娛樂資訊刊物一樣,是靠排字工人用金屬鑄字排版,這製程會使字體使用及廣告者的空間受到限制。電影雜誌可說是特定主題刊物的開山祖師,呼應電影院日漸普遍的現象。這些雜誌很便宜,不過在二次大戰期間,英國出現紙張短缺,部分雜誌不得不停刊。

美國《Esquire》(中譯:君子雜誌)是於 1933年 創刊, 曾邀集費茲傑羅(F. Scott Fitzgerald)與海明威(Ernest Hemingway) 等名家撰寫專題報導。這時期有雜誌開始使用彩 色封面,以求在店面能一枝獨秀。歐洲創意人才 為了躲避戰禍而逃到美國,奧地利的亨利,沃夫 (Henry Wolf,參見211頁)就是如此。戰後 才華洋溢的設計師,例如《Harper's Bazaar》 (中譯:哈潑時尚)的艾利克西·布羅多維奇 (Alexey Brodovitch, 參見208頁) 為美 國大眾引介歐洲藝術家,包括達利 (Salvador Dali)與卡桑德爾(A.M. Cassandre)。亞歷 山大·李伯曼(Alexander Liebermann)在 1943年成為美國《Vogue》的藝術指導,遂發 揮長才,引進現代感的攝影、藝術與印刷技術, 啟發了英美與歐洲諸多藝術指導。

女性在戰後回歸家庭,女性雜誌諸如《Good Housekeeping》 與《Better Homes and Gardens》紛紛出現。這時更講究封面圖片,以吸引讀者目光。

1950至1960

現代廣告在 1950 年代誕生,雜誌開始刊登產品 與服務的廣告,把目標鎖定在戰後大批回歸家庭 的主婦。恰好在二次大戰之後,歐洲設計師為了 《Esquire》的喬治·洛伊斯(George Lois)運用圖像性強烈的簡單照片加 以拼貼,傳達故事性。他的風格美感 在於文字與圖像能相得益彰。這風格 啟發了許多苦尋靈感的藝術指導。

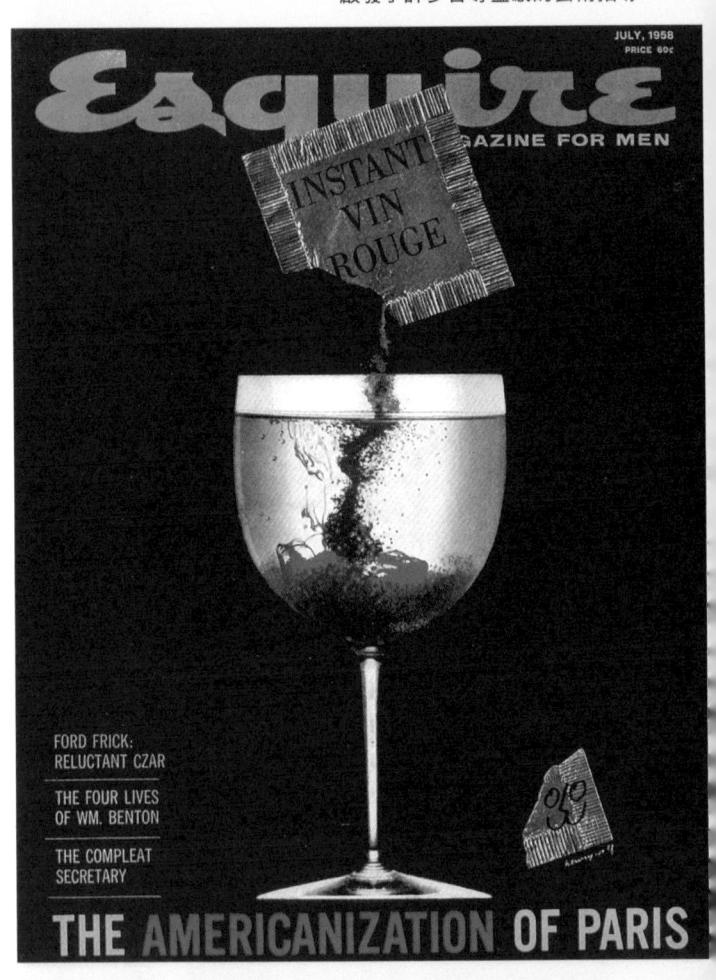

這個例子展現出刊物對品牌的視覺形象很有信心。然而品牌知名度沒那麼高的雜誌,最好不要模仿。《Harper's Bazaar》或《Vogue》就算只露出一部分的 Logo,讀者依然能認出來;但是如果品牌知名度不高,就無法達到這種效果。

HARPER'S Eyes on Paris and America rch 1959 60 cents

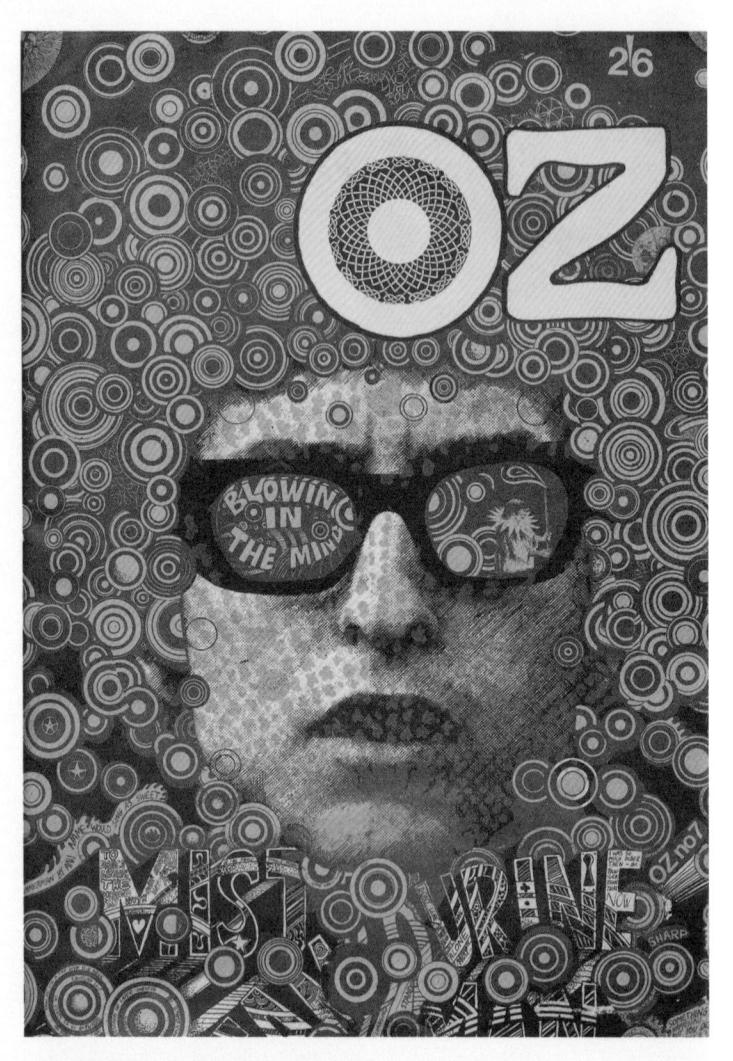

《OZ》雜誌知名度最高的一期,大概就是第七期。這一期的封面圖像遠近馳名,是由馬丁·夏普(Martin Sharp)設計的巴布·狄倫(Bob Dylan)。夏普應用新的印刷技術來製作圖片,傳達出講究實驗性、迷幻氛圍的當代音樂文化。

逃避戰亂餘波,諸多人才湧入美國,女性時尚雜 誌因而受惠。李伯曼來到美國之後,為康泰納仕 的出版品注入歐式美感。

曼·雷(Man Ray)與李·蜜勒(Lee Miller) 是這期間知名的搭檔。《Esquire》開始使用彩 色印刷,旋即引起廣告主青睞。英國戰後復甦速 度不如美國,然而倫敦與美國的雜誌人才這段期 間頻繁交流。這階段雜誌封面常採用新聞紀實攝 影,震撼人心的戰爭期間畫面因而曝光。

1960 至 1970

《週日泰晤士報雜誌》的構圖與跨頁設計,奠 定英式刊物的風格,而這份雜誌的設計師大 衛·金恩(David King)不僅率領年輕設計團 隊交出漂亮成績,還發掘大衛.貝利(David Bailev) 等重要攝影師。1960年代的雜誌封 面反映出社會的激烈變遷,越戰與性別革命之 類的議題。《Life》雜誌在電視尚未普及前,就 把新聞照片帶入美國百姓的家中;無獨有偶, 《Illustrated News》也在英國扮演相同角 色。雜誌封面成為重要窗口,讀者得以一探外 在世界。彩色印刷漸行普遍,英美雜誌的廣告 呼應著生活形態的改變。這時期,大眾偶像開始 登上雜誌封面。貝利、理查·亞夫頓(Richard Avedon)以及諾曼·帕金遜(Norman Parkinson) 等擅長拍攝名流的攝影師都曾拍出 雋永的封面,至今依然令人讚嘆。

安迪·沃荷(Andy Warhol)常在 《Interview》雜誌上,利用展開的 封面封底呈現全幅肖像。從封面來 看會是普通的明星特寫,但翻到封 底,就會更了解這張照片與主題。

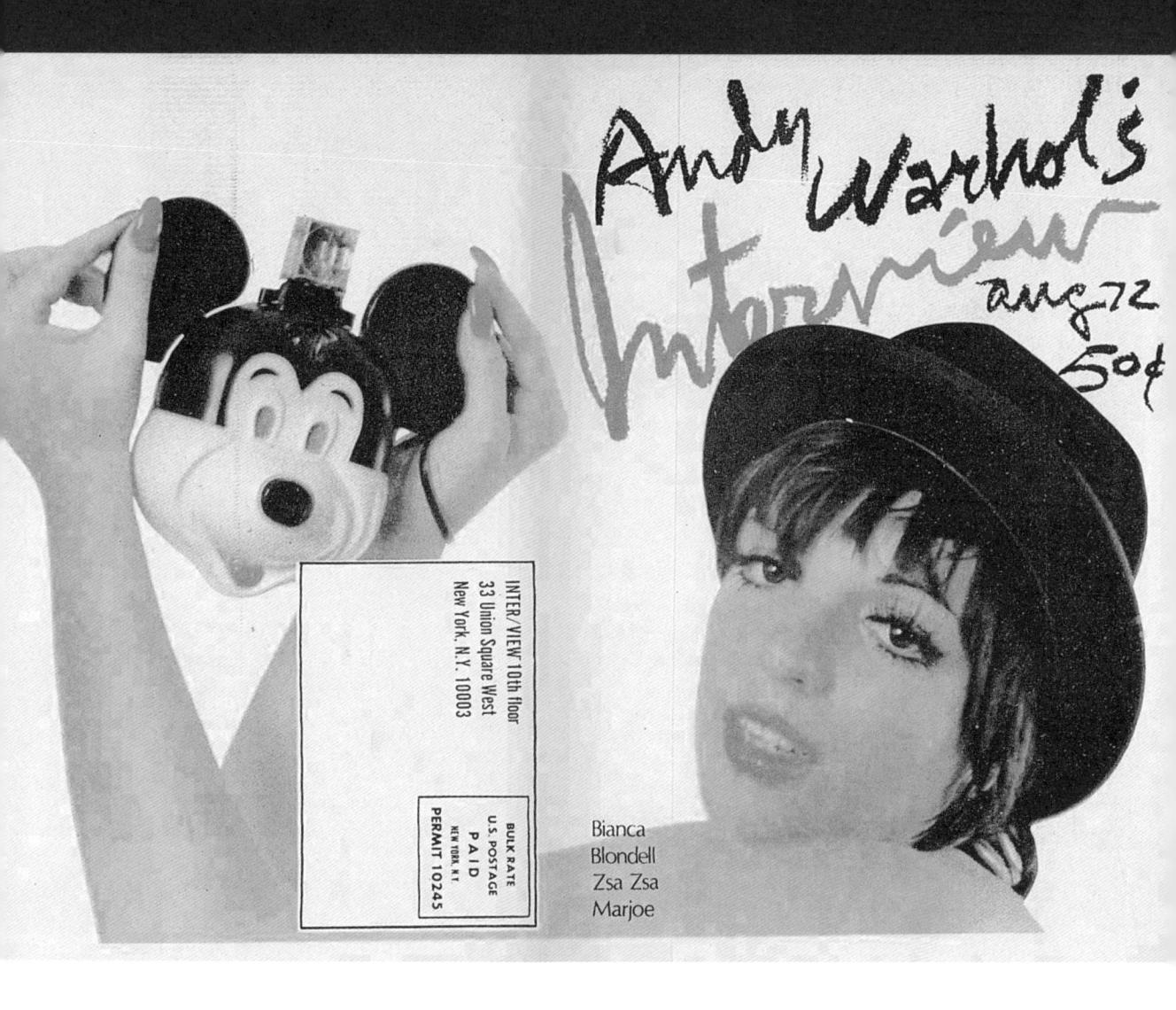

1970至1980

1970年代的文化出現劇變,大大影響了刊物的設計走向。《Rolling Stone》與《Nova》等雜誌,接連立下令人激賞的新標竿。美國的《Rolling Stone》封面頗具政治色彩,內容則以音樂與流行文化為主,英國的《Nova》是有自由派政治傾向的女性雜誌。這些雜誌就像十年前德國的《Twen》,以大膽的封面照片反映所處的社會背景,把讀者鎖定在精力旺盛、一身反

骨的年輕讀者。在歐洲,政治騷動成為新聞攝影崛起的絕佳溫床。德國的《明鏡週刊》(Der Spiegel)就以強烈的圖像封面來呈現政治議題。

設計師這時大膽探索跨頁形式。《Elle》另闢蹊徑,大量使用傾斜的版式,與1960年代印刷精美的時尚雜誌垂直水平的排版方式分道揚鑣。一時間,雜誌格式變得活潑,《Interview》很懂得靈活運用封面名人照片。義大利《Vogue》

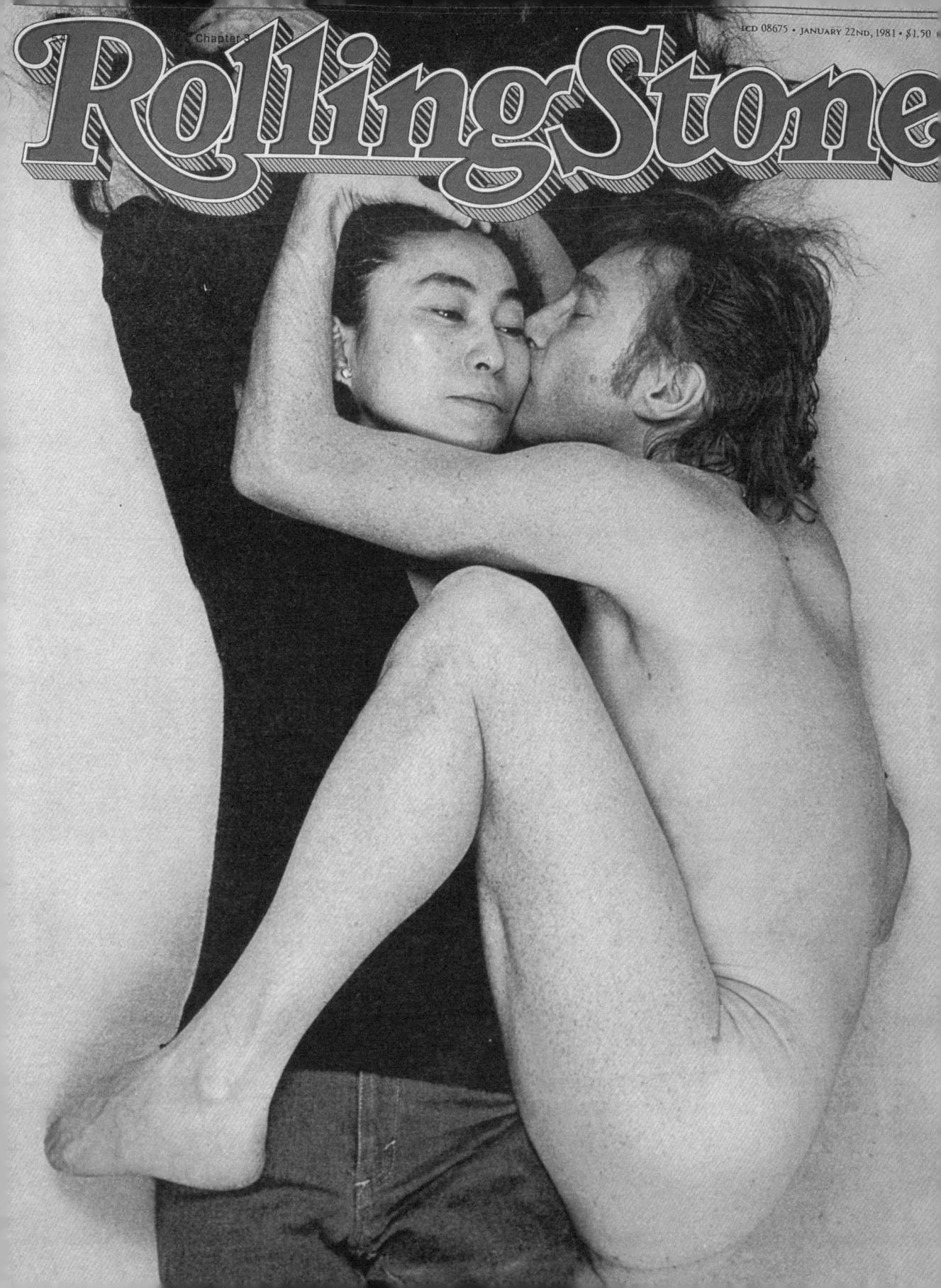

靠著法比恩·貝隆(Fabien Baron)卓越的藝術指導而聞名,而奈維爾·布洛狄(Neville Brody,參見 216 頁)在雜誌上盡情發揮文字編排的魅力,讓其他設計師更有信心探索以格線為基礎的排版形式,進一步挑戰極限。排版工作原本是交給鑄字行的專業排字工,但在 1984 年蘋果電腦上市之後,設計師也能排版,自行製作版面。

1970年初期,多數雜誌仍然是黑白印刷,只有 封面與專題報導等少部分內容以彩色印刷。但 這十年間印刷技術突飛猛進,四色印刷的價格降 低,因此彩色也更普遍運用。刊物開始使用銅版 紙,並嘗試製作不同的開本。

1980 至 1990

1980年代初期出現不少優秀的時尚雜誌與男性雜誌。由報社出刊的雜誌(增刊)是時尚類平面設計的實驗場所,也可說是紙本刊物紀實攝影的最後堡壘。這些雜誌的封面靠著具視覺張力的照片而大放異彩,沒有密密麻麻的封面文案。英國的《i-D》與《The Face》雜誌頗能掌握到時尚氛圍。至於美國,民眾開始購置電腦,對科技雜誌的興趣隨之提高,電腦類雜誌應運而生,例如1984年上市的《MacUser》。在雜誌出版界,設計師開始玩起數位字體,首度能在電腦上界整本出版品設計完成。加州《Émigré》的設計師把像素(pixel)當成設計元素,做文字編排的實驗。大衛、卡爾森(David Carson)在《Beach Culture》與《RayGun》將解構主義

安妮·里柏維茲(Annie Leibovitz)為約翰藍 儂(John Lennon)與小野洋子拍攝照片,作 為當期《Rolling Stone》封面,而這張照片使 《Rolling Stone》一舉成為當時炙手可熱的雜 誌。這張照片很美,充滿象徵,完美捕捉到當 時的時代精神。約翰藍儂在 1980 年 12 月拍完 這張照片 5 小時後,就在達科他公寓(Dakota building)遇害。《Rolling Stone》仍如期發表 這張照片,向這位披頭四成員致敬。

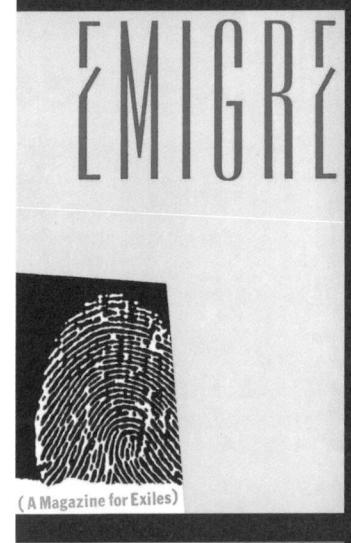

1984 年,《Émigré》反映出舊金山的變動氛圍。這份荷蘭設計師魯迪·凡德藍斯(Rudy Vander Lans)與捷克籍妻子蘇珊娜·莉可(Zuzanna Licko)創造的新潮雜誌,用莉可設計的字型與麥金塔電腦實驗數位字體與版式的可能性。如今回顧便不難發現,當時是個轉捩點,桌上出版系統讓設計師能用像素自行造字,打破既有的規則限制。

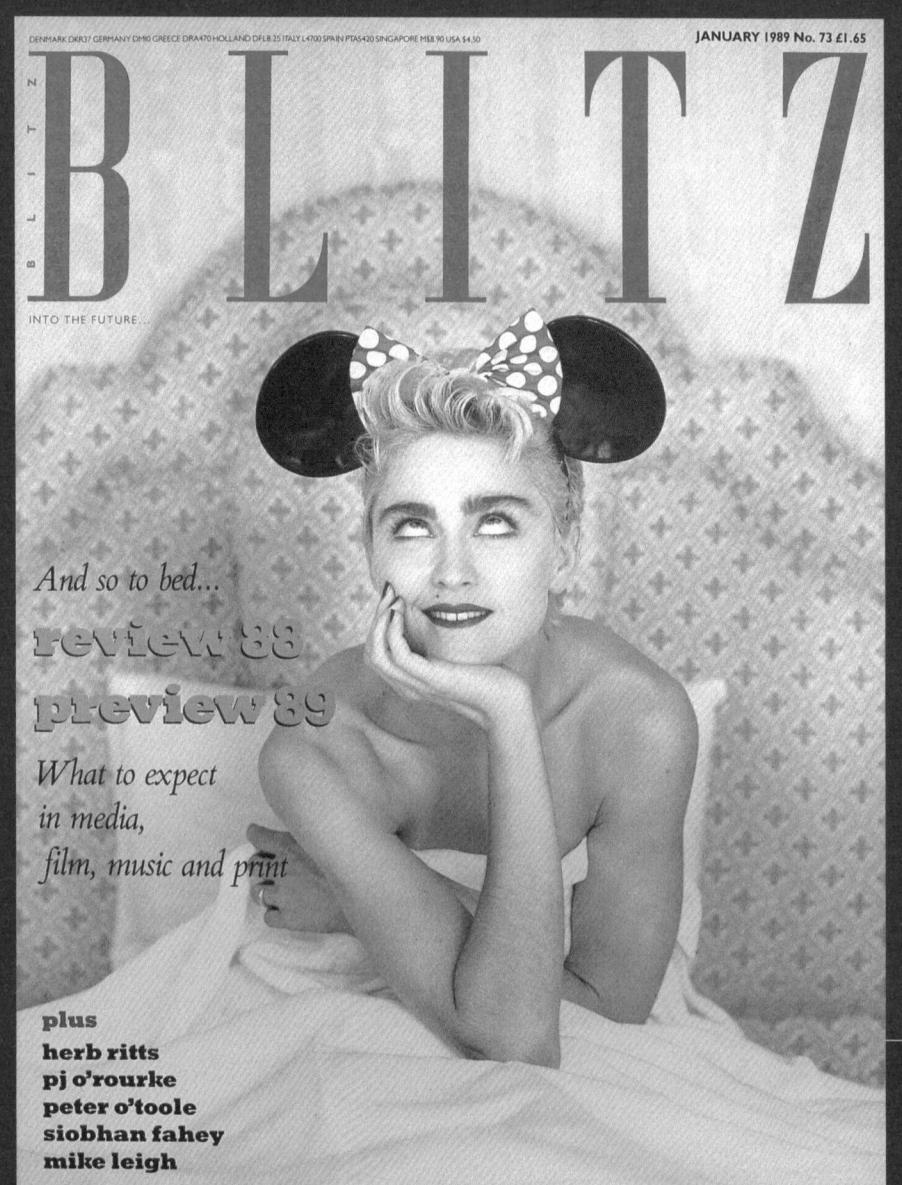

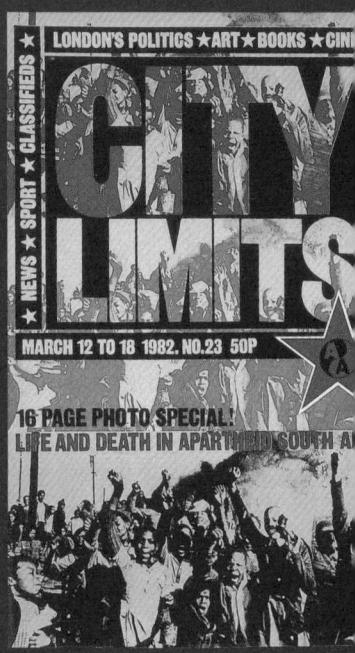

《City Limits》是倫敦娛樂資訊雜誌,金恩的設計概念源自於政治類海報。他把群眾集結的畫面以不同刷色重複三次,刊頭則是以鏤空處理。金恩每一期都改變《City Limits》刊名的字級與位置,但字型保持相同,因此在發揮彈性之餘,也維持強烈的識別。

這張 1989 年的《Blitz》封面中, 瑪丹娜似乎很欣賞刊頭,營造出文 圖之間的活潑互動。 帶到平面設計中。英國設計師布洛狄、沃甘·奧 利佛(Vaughan Oliver)與佛洛斯特也在媒體 上展現大膽的設計。

這時期崛起不少地位如明星的時裝設計師,促成時尚出版品蓬勃發展,春秋兩季出版的厚厚刊物中,滿是時裝設計的大師之作。春秋兩期刊物深受廣告者喜愛,他們會雇用同一批攝影師,製作廣告頁面。在經濟榮景下,大眾漸漸買得起奢侈品,時尚產業跟著欣欣向榮。1980年代末,英美雜誌來到黃金時期,人才彼此合作,激盪出精彩火花,編輯設計與新聞攝影的專業相當受到尊重。

1990至 2000

在 1990 年代,拍攝名人作為封面蔚為成風。有些公眾人物、演員與音樂家在登上雜誌封面後,事業也跟著起飛。這股風潮也讓雜誌保持清新活力,雜誌封面直接反映出讀者的文化偏好。這時雜誌不必再仰賴大規模的平版印刷機,可改採簡單的數位列印技術(包括噴墨印表機),印前不需要製版之類的流程,省時又具成本效益,設計師得以靠小規模的數位列印,製作小批量雜誌。客戶雜誌就是在這背景下,著眼於品牌的發展與創新,發展出豐富多元的樣貌,進入消費類雜誌的市場。

此時新聞出版業者倍增,競爭白熱化,報紙的廣 告收入卻日漸下滑,若想保住新聞市場的霸主地 位,勢必得另闢蹊徑。新聞網站最初是免費的, 後來逐漸成立付費牆機制。此外,數位列印技 術的出現及品質日漸提升,也改變報紙的製作方 式。舊印刷機遭到淘汰,大報版式也縮小。數位 頁面可直接送印,省下製版或色彩校樣的需求, 在成本降低的誘因下,企業公司和設計師也紛紛 採用數位印刷。 下圖的《Dazed & Confused》 雜誌在封面增加刮刮卡塗層,創 造出趣味。《Sleazenation》的 封面文字編排很引人注目(最下圖),以非常簡單的方式,凸顯 出諷刺的雜誌品牌特性。

sleazenation

Rebellion / Lemmy / Laurent Garnier / Pin-up Queen Transsexual Roadracer / Polite Punk

ABONNEZ-VOUS

Rechercher Kate Moss

Q CONNECTEZ-VOUS

SHOPPING SPECIAL ENFANTS MODE DÉFILÉS LOOK BOOKS BEAUTE BIJOUX CULTURE PHOTO SOIRÉES VIDEOS THEVOGUELIST ASTRO LIVE

26 Avr 2013

PARTAGEZ

Vernis parade

A effet velours, thermoactifs ou endiamantés... Les vernis font leur grand show pour les fêtes de fin d'année.

Lire la suite

時尚刊物原本熱愛在封面上使用名模與名人的照 片, 但在成本考量下, 這股風潮逐漸消退。編輯 嘗試引進更多樣的作法,盼能吸引更多讀者。生 活風格雜誌出現,市面上的刊物多如過江之鯽。 2000年3月,網路公司泡沫化,部分刊物跟著 停刊, 庸告者與出版計也開始勒緊褲帶。

2000至2010

換。

二十一世紀的頭十年, iPad 與其他平板電腦尚 未問世,市場由雜誌獨領風騷。大型出版公司把 旗下紙本刊物搬上網路,設計網站與行動版本。 不久之後,許多知名刊物推出 app,例如 2009 年的《The New Yorker》(中譯:紐約客)、 《WIRED》,及2011年的《衛報》。網際網 路成為報計廣告模式的最大威脅,新聞機構不得 不另謀對策。此外,這段期間維基解密及英國竊 聽案等醜聞爆發,媒體的誠信度飽受質疑,知名 媒體大亨的聲望亦滑落。在美國,歷史悠久的報 社進行組織重整,造成員工失業,《波士頓環球 報》在2009年從紙本轉為數位就是一例。以

設計紙本刊物為主的設計師被迫學習程式語言,

文藝雜誌《Zembla》由佛洛斯特 設計,文字編排具有濃厚的挑釁色 彩,版式大膽、結構明晰。

《Voque》出版商是全方位發展的 好範例,不同平台有不同版本。紙 本雜誌還靠著網站的加持而增加讀 者群,也讓廣告主能有不同平台, 以多種方式接觸讀者。

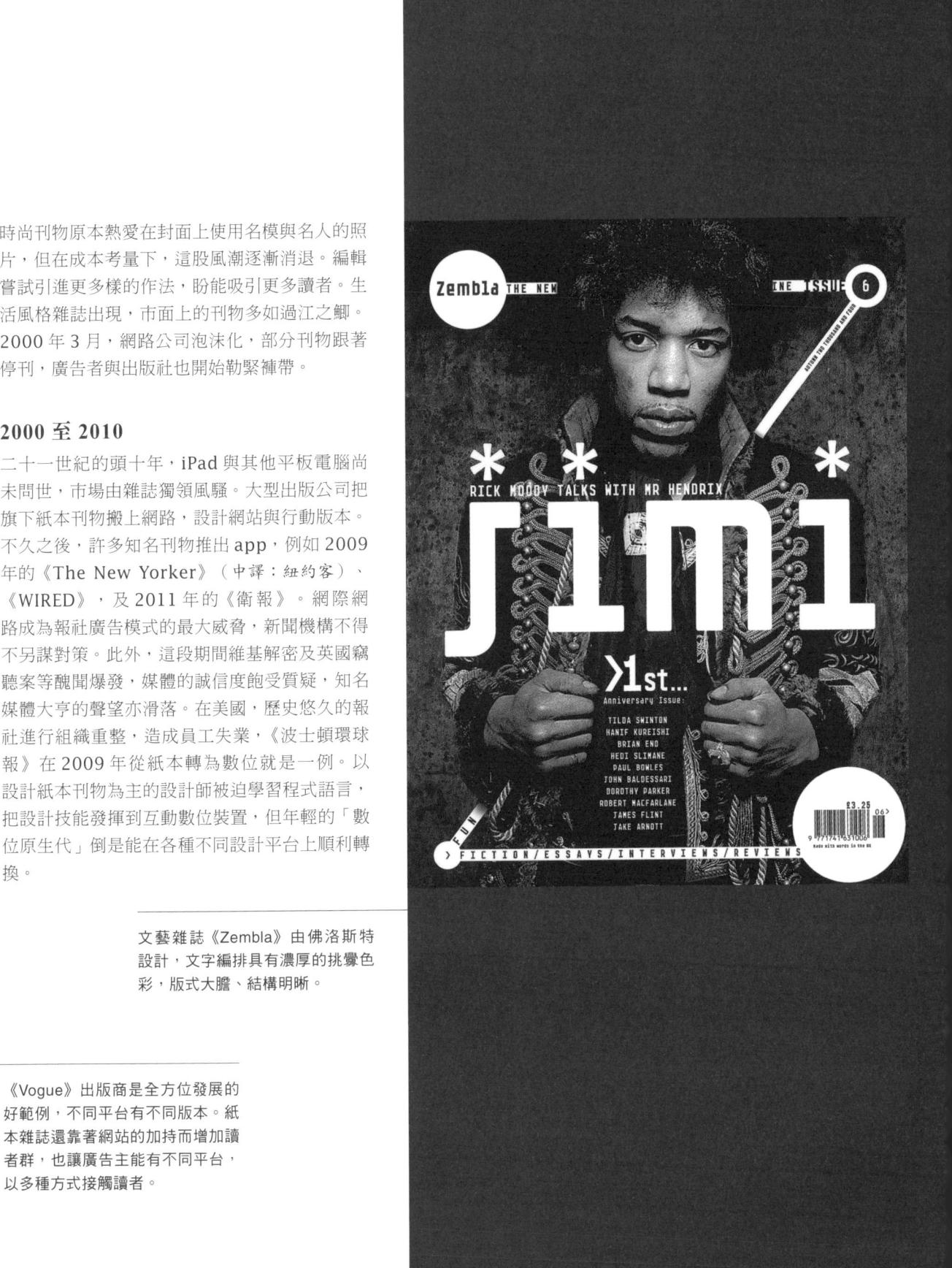

2010 年迄今

2010年 iPad 推出後,出版商與設計師得到了新的舞台。平板電腦有輕盈的觸控式螢幕,深深吸引 iPhone 與蘋果公司其他產品的粉絲。iPad似乎比其他平板電腦發展得更快,其他業者只能追隨在後。後來,其他平板電腦裝置也推出新作業系統,例如 Google 以開放原始碼發展出的Android 系統。設計師善用觸控螢幕的優點,開發出新的視覺瀏覽模式,並強化平板電腦與手機中的動態內容。消費類雜誌的平板電腦版本封面進步了,首度具備互動功能,封面上的設計元素成為內容入口,讀者只要用手指輕輕一滑,便能進入想看的內容。

此時以「內容集結」為概念的刊物出現了,依據 讀者的網路搜尋歷史記錄與資料為輪廓,為讀 者將資訊個人化,把內容匯整到讀者的平板電腦 或手機上。這過程不再需要實際的編輯,有些人 並不樂見,但有些人則覺得更自由了。隨著刊物 性質變化,製作團隊不僅需要編輯、藝術指導、 出版商,程式開發者也加入行列。如今,人 可以在個人裝置中,擁有專屬於自己的雜誌。這 不是概念化的想法,例如 Flipboard 就能把特 定的內容集結給使用者。只要下載 Flipboard app,社群媒體、網站與部落格的內容就能匯整 成漂亮的數位雜誌,供數百萬讀者翻閱。

> 瀏覽雜誌不再是線性的過程。以 《衛報》的 iPad 版本來說,設計 師的任務是運用視覺暗示來引導 讀者,同時避免過程中發生阻礙。

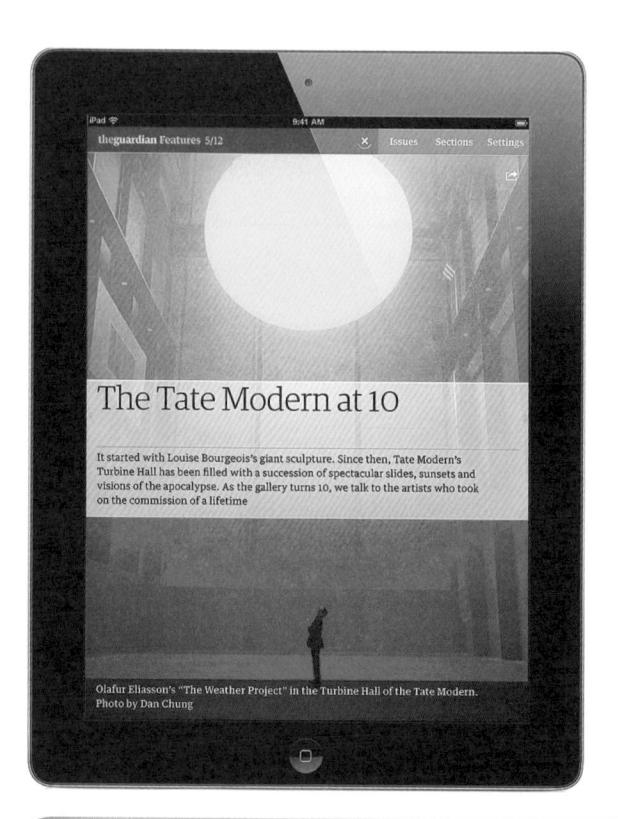

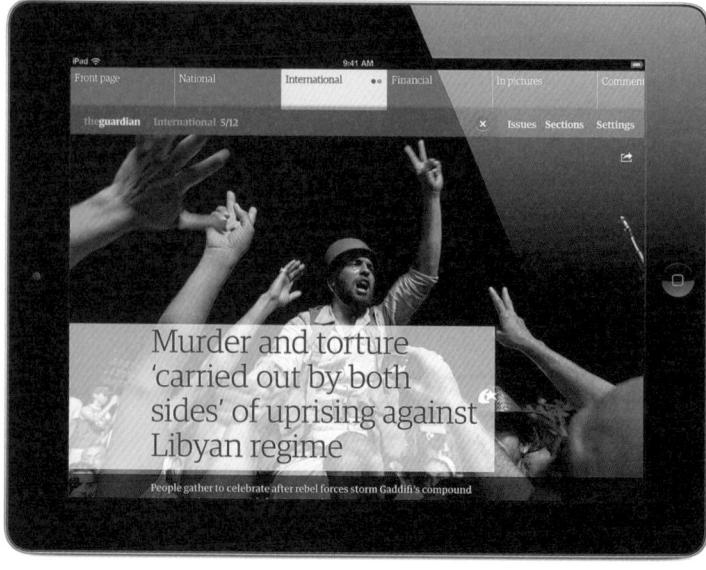

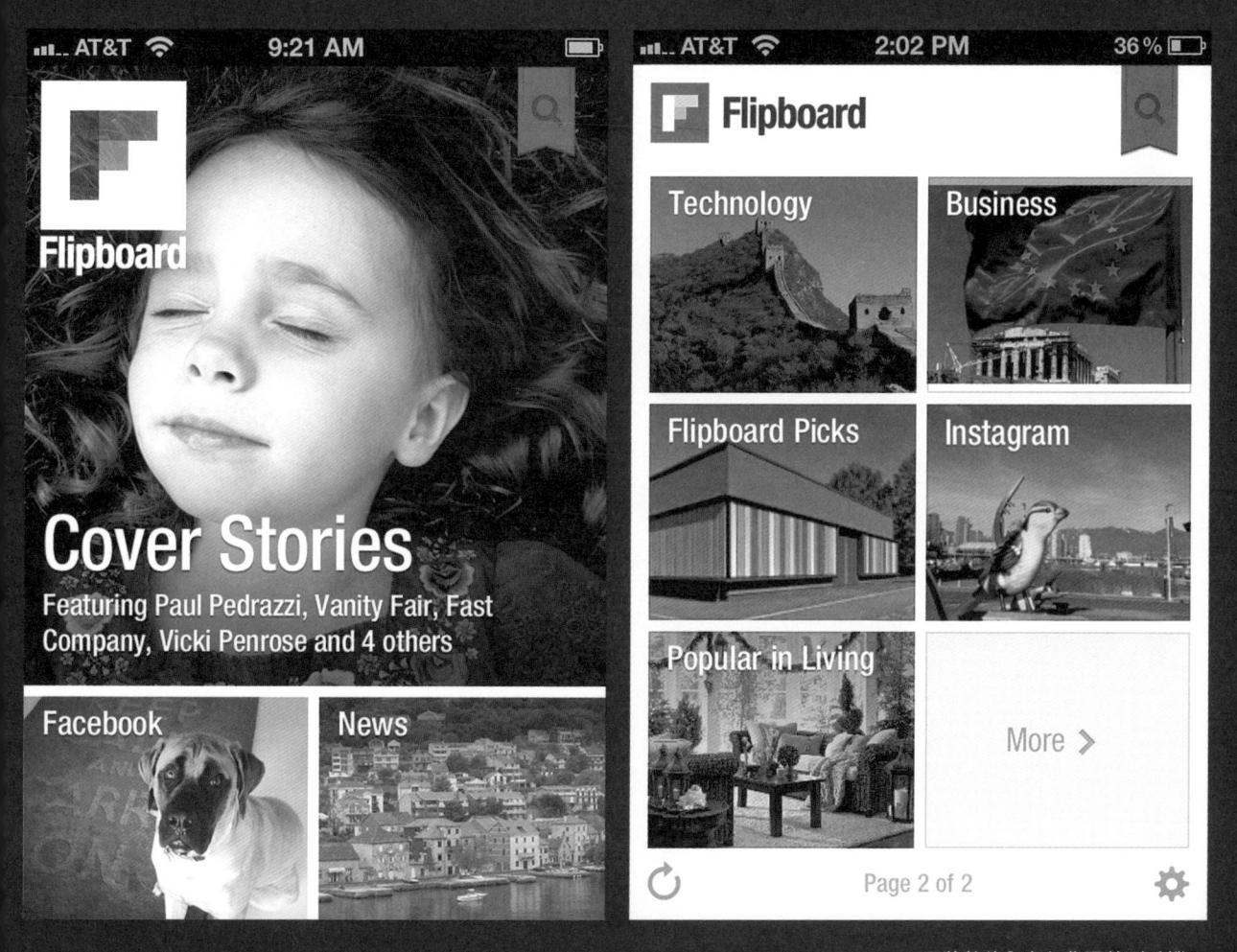

Flipboard 可將數位內容免費匯整到手機,使用者可隨時取得各種新聞來源的最新消息,只要滑動手指即可翻閱頁面,還能立即分享到社群媒體。Flipboard 具有紙本刊物的美感與便利,自詡為「全球第一的社群雜誌」。

封面設計的類型

封面設計的類型很多,大致上可分為三類:具象 封面、抽象封面與文案型封面。其中,文案型封 面如今較少見,因為這種單純使用文字來設計的 封面在視覺上很難產生力道,編輯設計師便敬而 遠之了。

具象封面

具象封面最常見的作法就是利用一張攝影當主視覺,例如人物的特寫或全身照。臉部特寫的構圖雖然已經太常見,但只要加點創意,還是能吸引目光。例如把笑臉改成憤怒、恐懼或得意的表情,又會有不同的趣味。時尚雜誌《i-D》的 Logo 像是個眨眼的表情符號,因此封面上總有張臉在眨眼。封面的創意發揮尺度,端視於刊物讀者的接受度。以反消費主義刊物《Adbuster》為例,它的讀者不太會被負面過像嚇跑,但女性週刊的讀者則可能就會。讀者多半會喜歡巧妙風趣的封面,也喜歡帶有冒險感的動作。全身入鏡的人物攝影,其發揮空間就更有彈性了,《Daze & Confused》就常以新奇的方式靈活運用。《Carlos》則以插畫描繪封面人物,並以漂亮的金屬質感油墨渲染。

時裝雜誌也能以插畫營造出好效果。服裝若以插畫來表現,比寫實照片更能傳達出材料的情感。插畫的另一項優點在於能和文字融為一體,不像照片那樣界限分明,效果和文繞圖或文壓圖不同。拼貼、蒙太奇也是慣用手法,可製造出層次和寓意,很適合用來反映尖銳的評論。

臉部特寫雖然是雜誌常用的作法,但本頁的兩個例子是以截然不同的方式詮釋。上圖選自《M-real》,創意指導雷斯里以趣味方式,反諷「與讀者有眼神接觸的女性臉部特寫」式的封面。右圖的《Pop》目的也一樣,但作法不同。封面的珍妮佛·羅佩茲(Jennifer Lopez)與讀者沒有眼神接觸,但臉上卻有激動的表情,和被動、冷漠的神情大相逕庭,遂能從眾多競爭者中脫穎而出。

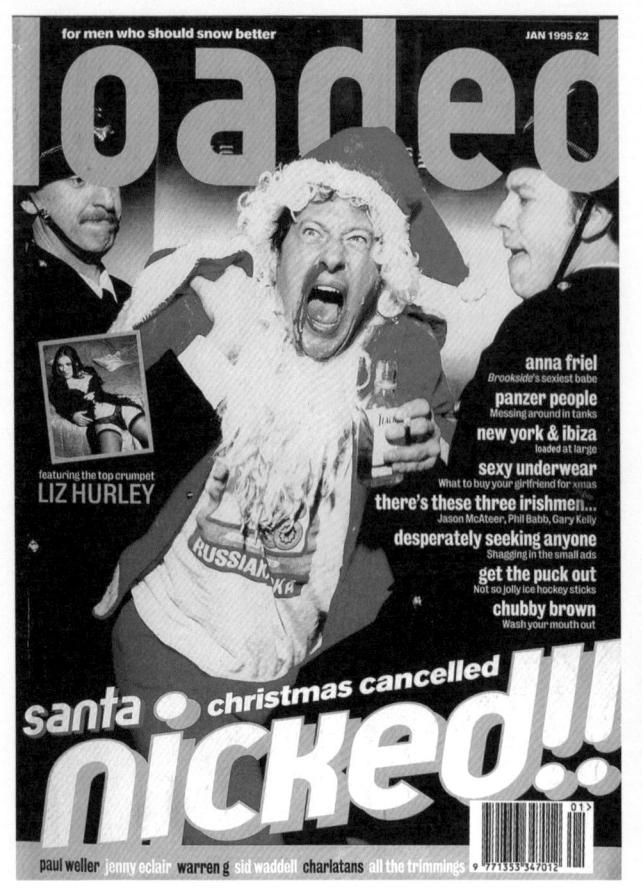

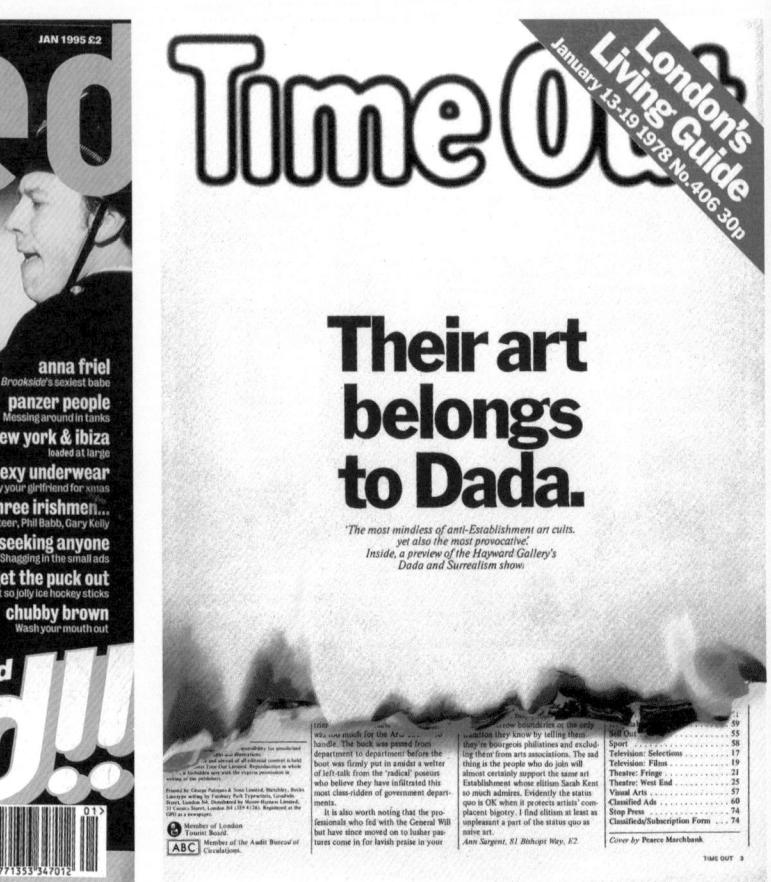

封面設計最簡單的原則就是「引起 讀者的興趣」。設計師會先從視覺 元素著手,但這不是唯一的作法。 整體而言,封面由四個元素構成:

- 格式——尺寸、形狀與設計特徵
- Logo、刊名及其他常見的頁面資訊(標語、日期與條碼)
- 圖像
- 文案與文章標題

《loaded》是創刊於 1990 年代的 男性雜誌,將上述四項元素發揮得 淋漓盡致。這份刊物的標語就說明 鎖定的讀者是「該知道更多的男性」(for men who should know better),其設計與編輯手法散發 出濃濃的瘋狂氛圍,完全吻合情 也 也 遭 的 放蕩生活。編輯 詹 的 放蕩生活。編輯 詹 姆士·布朗(James Brown)當時表示,這雜誌是「給自認為只要不 宿醉就沒問題的男性。」藝術指導

史蒂夫·瑞德(Steve Read)的設計完美詮釋這態度,風格看似沒有設計,卻充滿活力與動作感,而色彩、字體、圖像、版面結構也用得非常好。封面文案與標題大而醒目,積極又有趣。

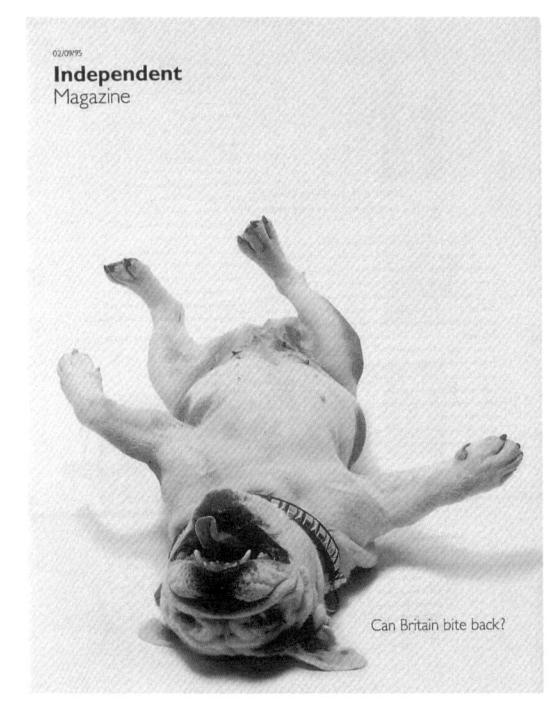

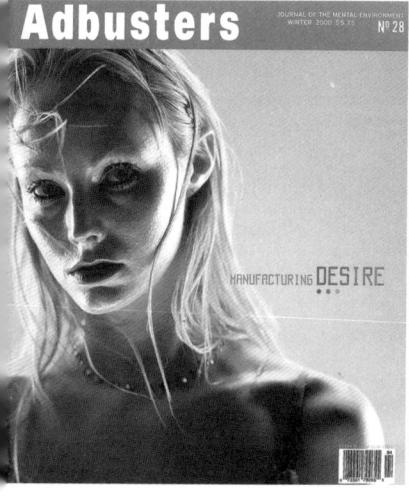

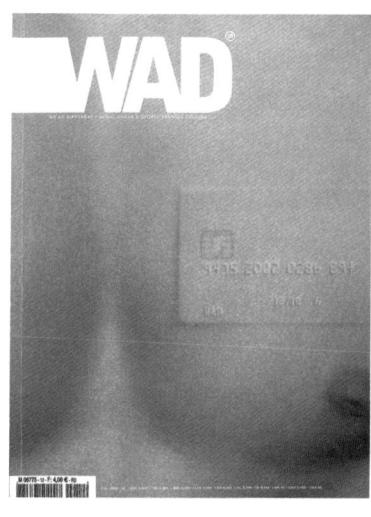

如果編輯設計師、編輯群與出版社敢於挑 戰讀者接受度,推翻何謂「受歡迎」或 「好賣」的既有觀念,就可能做出很有創 意的具象封面。最左邊的《Adbuster》 及左邊的法國雜誌《Wad》就是兩個好 例子。《Adbuster》格外巧妙地破壞所謂 「好賣」的傳統概念,讓常見的金髮女孩 呈現出與傳統審美觀衝突的不凡樣貌。

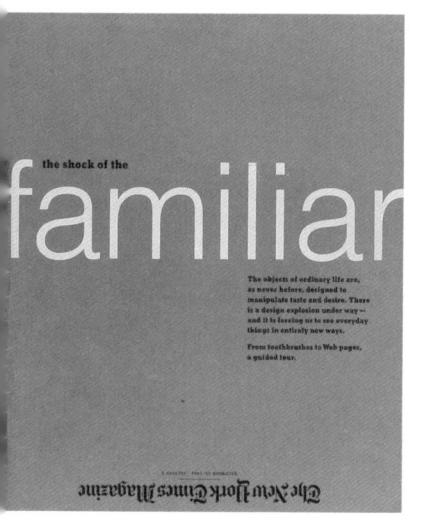

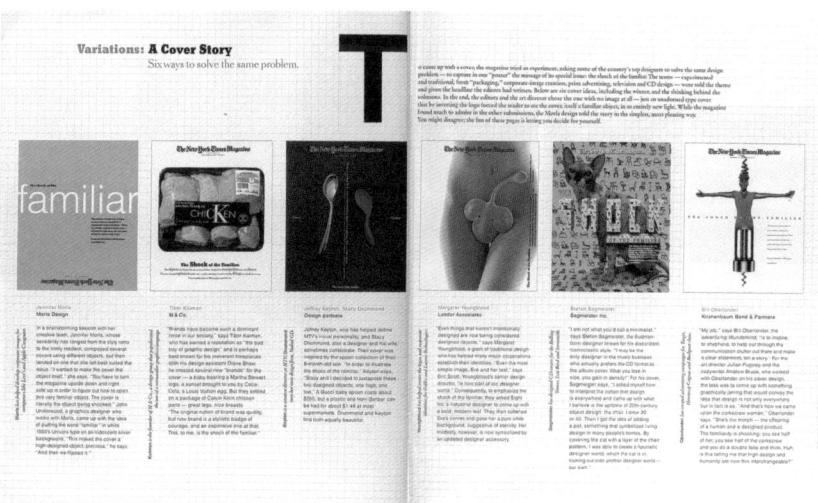

「這我們的第一份設計特刊,我把它看作是先遣部隊,向讀者解釋去哪裡能找到好設計。我們決定稍微讓請者參與過程,為封面舉辦平面設計師提出概念,再把這六大家印出來(右上)。我們一看見珍妮佛·茉莉雅(JenniferMoria)的提案(上圖),就知道優勝者是她。這提案非常單純,名單純的粗體 Helvetica 寫出刊名『平凡事物的震撼』(the shock

of the familiar),在銀色背景上非常醒目。然而《紐約時報雜誌》的 Logo 卻上下顛倒,放在底下。這讓讀者必須把封面轉過來看,並察覺到封面也是一個物體,進而感到驚奇。非常清晰,令人印象深刻。解讀其他五個解決方案也很身處,可以了解設計師的思維,以及他們如何解決問題。」——珍妮·佛羅里克,《紐約時報雜誌》前藝術指導

抽象封面

零售型刊物很少使用抽象封面,但特定主題及僅限訂閱的小眾出版品、新聞週刊或報紙增刊,倒是經常出現。這類刊物比較自由,封面文案不多,甚至完全沒有文字,設計的自由度也很高,連 Logo 擺放的方式都可以自行決定,因為這類刊物在架上的能見度並非首要考量。這種封面能催生極具創意的設計,但務必以明確的設計方向與手法,維持品牌形象。《WIRED》雜誌操作這類封面,向來是箇中高手(參見 68 頁)。這份雜誌早期在設計師約翰·普朗克特(John Plunkett)與芭芭拉·庫爾(Barbara Kuhr)操刀時,就常運用抽象的封面圖,以簡單的方式傳達複雜概念。《Adbuster》也是一個好例子,而《國家報》增刊《誘惑》(Tentaciones)

文字是很直接的表達方式,圖片未必能傳達出與文字相同的魅力與力道;洛伊斯為《Esquire》設計的封面就是如此(下左)。文字式封面也能當作概念性工具,例如《紐約時報雜誌》的《年度想法特刊》(Idea,下右)。藝術指導佛羅里克說:「我們的企劃是要仿效百科全書,依照字母順序編排內容,呈現每年度最好的概念、發明與計畫。我們為此製作類似字典與百科全書的版型,包括書緣的半

月型索引、用一些設計手法製作出頁數很多的錯覺、欄位放寬、邊緣有小圖,而文字編排則類似字典那樣擁擠。封面設計模仿布面燙金的古書封,再用照片呈現出立體感。頁面右邊的假書口讓整本書看起來很厚,開本也因此看起來稍微窄一點。」史考特·金在這本給年輕人看的《Sleazenation》中,從T恤設計取得靈感(右頁),傳達出直接、巧妙的趣味,彷彿在開讀者、雜誌與時尚的玩笑。

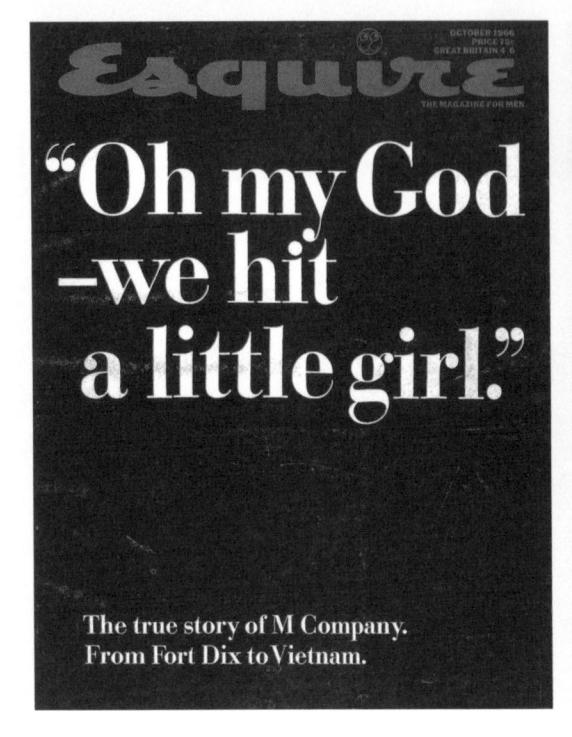

的設計師費南多、古提耶雷茲(Fernando Gutiérrez,參見220頁),甚至隨性把Logo 挪到封面的留白空間。他恣意發揮創意,唯一限制是,雜誌須以報紙印刷機印製,無法印刷滿版出血的圖片,所以他讓圖像漂在白色背景上,形成出血設計的錯覺。

文案型封面

文案型封面在現代期刊中其實並不多見,然而《Esquire》的喬治·洛伊斯(George Lois)、《Fact》的赫柏·魯貝林(Herb Lubalin)、《Sleazenation》的史考特·金(Scott King)都曾採用,且效果極佳。1970年代,馬齊班克也常為《Time Out》設計文字式封面,例如某一期以日本電影為主題的刊物

中就不用照片,改以日本國旗的滿版圖,搭配一句言簡意賅的封面文案。近年有一期《Time Out》以阿姆斯特丹為主題,封面也用文字編排的方式來處理。當時的藝術指導雷斯里說:「阿姆斯特丹缺乏足具代表性的景點、建築或事件,改以文字編排來處理封面,反而能傳達出這城市的熱鬧。」

文案型封面無疑有其效用,但當今文化非常視覺 導向,因此這種封面的效果有限。話說回來,如 果發生某件悲劇或名人去世時,編輯與設計師若 想讓封面具有龐大的力量或鶴立雞群,不妨試試 文案型封面。

SLEAZENATION

AN IDEAL FOR LIVING THROUGH HONEST FASHION, ART, MUSIC AND DESIGN

I'M WITH STUPID

JARVIS COCKER & BARRY 7 • ARAKI FASHION EXCLUSIVE • BIBA • THE HIVES DJ BIRD • KILLED BY DEATH • CHARLIE LUXTON • RAPING STEVEN SPIELBERG

Time Out

ONDON'S WEEKLY LISTINGS BIBLE DECEMBER 14-21 2005 No.1843 £2.50

No.1843 £2.50

North Unnos

770502₈627122₆6

CONDON'S WEEKLY LISTINGS BIBLE
LONDON'S WEEKLY LISTINGS BIBLE

MOSMIII nobno-l

週刊的每一期必須看得出不同,讀者才能察覺到新刊上架,尤其是店面可能同時陳列兩期刊物(例如《Time Out》會有一天是新舊刊並陳。)因此,《Time Out》會力求發揮文字的力量,這是架上許多運用圖片的封面無法做到的。以上方的封面例子來說,主裡的文字用得非常好。這一期是在探討比較倫敦北岸或南岸何者較為優越,而米查:稅衛德曼(Micha Weidmann)的解決方案相當新穎有創意。他沒有放一張泰晤士河的照片或插圖,而是將一個封面設計成兩個:讀者若在北岸買這份刊物,封面的「North」會是正的,但在南岸陳列時,就會將刊物顛倒極。

《WIRED》雜誌

《WIRED》雜誌於1993年在舊金山創刊,堪稱紙 本雜誌的奇葩,其設計與當下環境及主題相當契合。 《WIRED》關注題材相當廣泛,但雜誌基調是將科技 發展視為一種文化勢力,和嚴肅的傳統科技雜誌不同。 《WIRED》的版型、結構與美感散發著快速步調的感 覺,展現出新潮的設計與視覺表現與內容格式,具有網路 色彩,挑戰讀者的既定觀念。《WIRED》的色彩應用相當 奇特,有時會把色字放在同色調的背景上,讀者大開眼 界之際也不免感到氣餒。雜誌能讓讀者切身感覺到新興 媒體科技的神奇與無窮潛力,以及雜誌善用科技的新里 程碑。這本雜誌的目標讀者個個是行家,靠著默契便能 立刻明白設計背後的隱喻,遂給予熱烈回應,帶動雜誌銷 量一飛沖天。許多雜誌在網路泡沫破裂之後停刊,但是 《WIRED》在「瘦身」後存活下來。《WIRED》最初五 年的整體創意指導、設計與文字編排,是由普朗克特與庫 爾工作室(Plunkett+Kuhr)的兩位主持人操刀,設計 師還包括崔西亞·麥克吉利斯(Tricia McGillis)、湯 馬斯·施奈德 (Thomas Schneider) 與艾瑞克·庫特

麥西 (Eric Courtemache)。

2010年《WIRED》往前邁進一大步。當時擔任創意指 導的史考特·丹第齊(Scott Dadich)在紐約出版設 計師協會的會議上播映影片,說明《WIRED》將重新設 計 iPad 版本。他展示《WIRED》為 iPad 設計的新功 能,及未來讀者可期待雜誌呈現何種樣貌。丹第齊在這場 2010年的演說中解釋,他們希望「給讀者與廣告主更多 選擇,打破雜誌是靜態刊物的想法。」

2012年,哈佛大學的尼曼新聞實驗室(Nieman lournalism Lab)和丹第齊討論 iPad 版雜誌的議題。 實驗室的副主編曹斯丁・艾里斯(Justin Ellis) 寫道: 「無論是紙本或平板電腦,有些老派的東西是不會變 的。」當時擔任康泰納仕數位雜誌開發副總的丹第齊說: 「封面就是如此。雜誌出版社把封面當成是吸引讀者購買 並花時間閱讀的唯一廣告。它誘惑讀者拿起雜誌,付出寶 貴時間。」

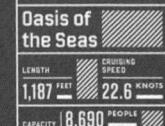

The skipper of this massive cruise liner sits atop a cushy leather throne, naturally. Just don't expect the seat to get much use: "When we're going into port, we typically push the chairs out of the way and stand up. It makes us more agile," says Bill Wright, who was the first captain of Royal Caribbean's \$1.4 billion Ossis of the Seas. Situated on the center line of the ship, the captain's station has two trackball-controlled 27-inch LCDs (foreground) that are used to display the electronic chart and the ship information system, which aggregates mission-critical data like radar, GPS, and sonar. Nineteen additional screens

aggregates insignor in a doct with conditions of the captain can quickly access, say, the machin-ery automation system, which tracks everything from the 5.5 megastt bow thrusters to the fore and at ballast tanks. So how does the captain stee? "The port and starboard command chairs have built-in joysticks for controlling the ship," Wright says. But those are typically operated by other officers. Captains should be mentoring and teaching."

ACITY | 8,690 PEC

封面的構成要素

「封面」包含外封、裡封、外封底與裡封底。多數雜誌除了外封正面之外,其他部分常會以高價賣給廣告主。即使沒有刊登廣告,這些頁面也絕對比其他頁面要珍貴,重要程度僅次於外封。刊物識別(或稱為「刊頭」)是封面的首要元素,而提示當期雜誌內容的文案,也是封面不可或缺的要素。

Logo

雜誌刊名固然與外觀一樣重要,但是多半決定後就不會再改。刊物的識別要能將刊物的特色、主題、立場與態度,利用固定元素在不知不覺中傳達給目標讀者。雖然 Logo 主要功能是擺在刊物封面,但也要能應用到任何其他地方,出現在紙本與各種平台的數位版本上、促銷與行銷資料(包括網站宣傳)。因此設計 Logo 時,就要考量這些用途。刊物若成功,則 Logo 會被長期使用,必須審慎處理、操作與擺放。也要格外注意設計出來的 Logo 是否能總是清晰易辨。

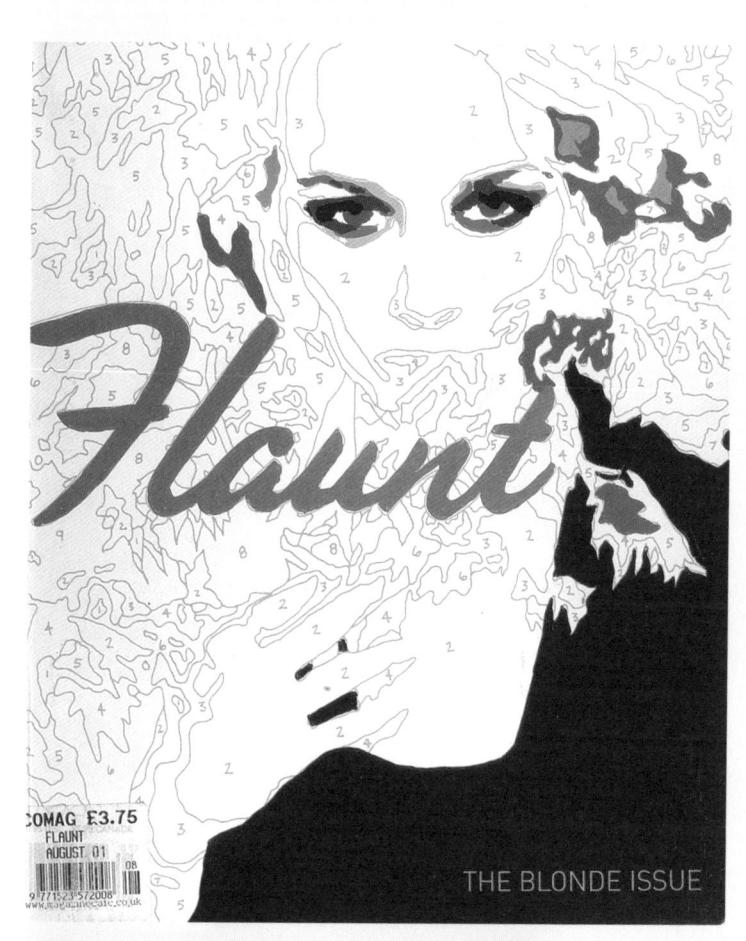

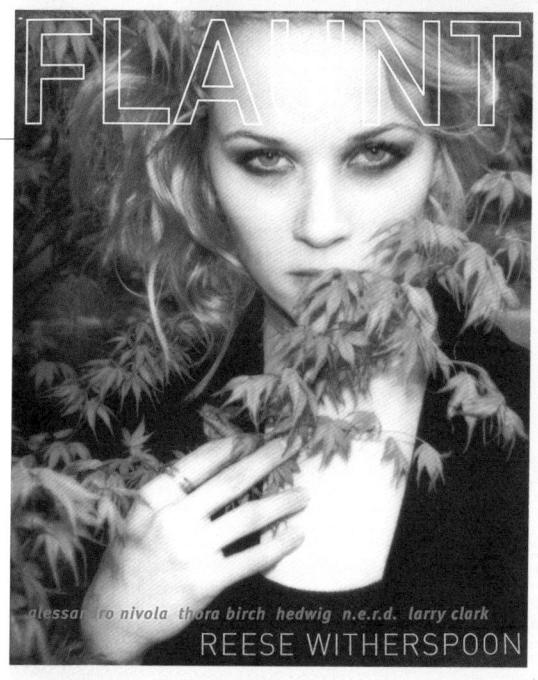

Logo 的「玩法」

Logo 是刊物的門面,應該清晰可見,出版社可不願刊物的 Logo 被照片或插畫遮蓋。但在不少例子中,刊名就算有部分或完全被遮住,仍賣得很好,關鍵在於露出的部分剛好足以辨識。 Logo 遮起後所傳達的概念,有時比呈現出完整 Logo 時還清楚。沃夫為1959年3月號的《Harper's Bazaar》設計的封面,就是個好例子(參見51頁)。封面上的手套與雜誌刊頭交錯,創造出有趣的空間感,各元素搭配得天衣無縫,效果搶眼。

美國室內設計雜誌《Nest》會不時更換 Logo 的設計與位置,卡爾森在設計《RayGun》 雜誌時也常如此操作,之後英國「物質設計 工作室」(Substance)在設計《Blah Blah Blah》時亦加以仿效。《金融時報商業雜誌》 (FT The Business, 參見101頁) 會每週在 Logo 上變化裝飾,大玩視覺遊戲,把 Logo 當 成總是在變動的圖像元素, 散發趣味之餘又相 當突出。其他雜誌亦不乏佳作。《Nova》採用 古老的溫莎(Winsor)木製字體,每期封面 只放 Logo 和單一主題,加上言簡意賅的一句 文案來宣傳,效果相當不錯(參見214頁)。 《Interview》則採用插畫家麥茲·葛斯塔夫森 (Mats Gustafson) 的手繪 Logo, 鮮少玩弄 Logo 或文案,看上去簡潔有力,也展現出大開 本、Logo 獨特、視覺風格嚴謹、大膽使用名人 去背照片等刊物特色。

《紐約時報雜誌》的時尚特刊稱為《T Magazine》,把 Logo 當作視覺工具,化身成吸引人的趣味元素。讀者能明白其中的視覺趣味,因為這個哥德字體的「T」化身為霓虹燈、皮草與櫻桃派,有時幾乎難以辨認。藝術指導佛羅里克十分留意這些圖片的小細節,讓刊頭散發出手感與自信。

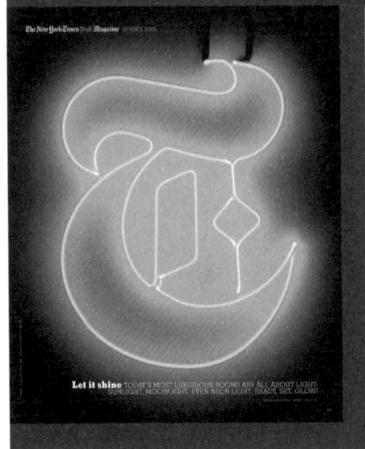

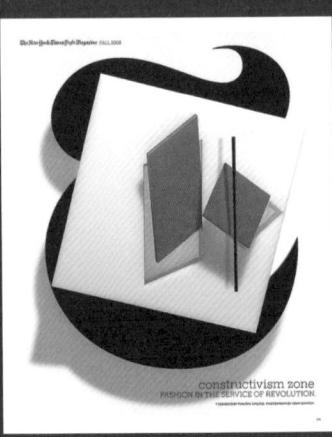

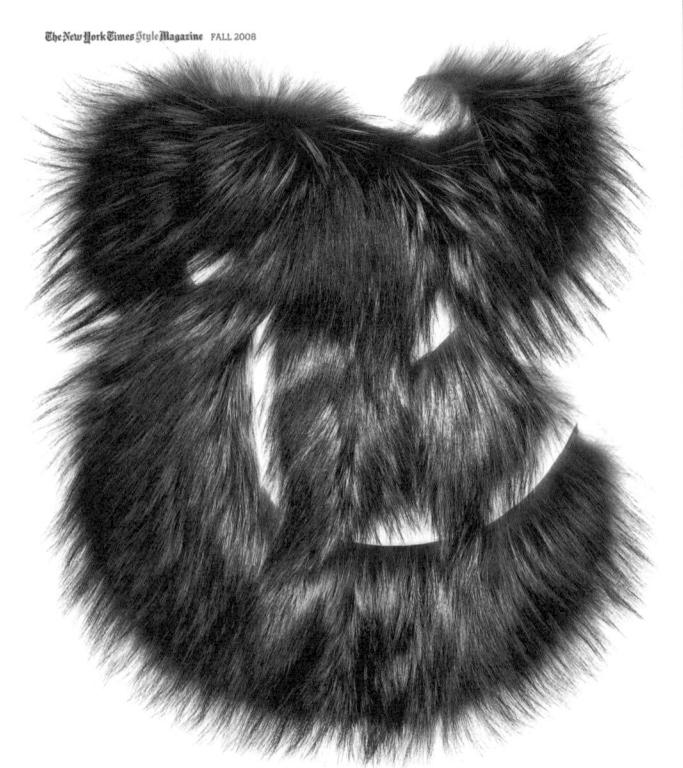

Fox News... and other fashionable ephemera.
The New york Times Style Magazine SPRING 2006

Easy as Cherry Pie RECIPES FOR LIVING THE GOOD LIFE.

色彩

封面的色彩選擇很重要。綠色 Logo 配藍色背景,肯定無法獲得讀者青睞,但是紅色接受度就高。封面上用金色比棕色討喜,黃色則被視為是不受歡迎的封面用色。這些都是雜誌設計的既定觀念,只不過沒有具體證據來支持。設計師與編輯不妨大膽依照直覺行事,發揮顏色的情感力量。別忘了,任何顏色皆可用來強調與凸顯重點,某些用色格外具有象徵意義,或是促發情感與記憶。不過,想單靠顏色來提高刊物銷量,恐怕是想太多了,因為顏色引起的聯想因人而異,變數極大。

色彩使用

雖然刊物用色慣例缺乏紮實的證據支持,卻不能 不依照不同文化對色彩的普遍認知來行事。紅色 可見度高,在西方文化很具吸引力,但在南非則 代表哀悼,若出現在封面就像西方國家使用的黑 色一樣。藍色通常給人平靜的感覺,在各種文化 的接受度都很高,但不適合用在食物上,因此用 色得視地區而定。雖然用色並無通則,不過記住 以下「禁忌」,倒是能幫設計師「趨吉避凶」。

黑色:複雜的顏色,能代表性感、權威、力量、威脅、迷人、富有、沮喪、沈悶、光澤、質感、永恆……,常具備多重意涵。但封面應避用黑色,以免讓人聯想死亡與悲劇,但在內頁中使用的效果很美觀。在色彩心理學中,許多人認為黑色暗示服從。

白色:複雜程度與黑色不相上下,會讓人聯想到 天真、潔淨、富有、純粹,但也可能代表枯燥乏 味,毫無特色。

紅色:紅色很有活力,有優點也有缺點。紅色很 搶眼,卻容易讓頁面上的其他元素相形失色。紅 色必能引發觀看者的情感反應,使得觀看者的心 跳與呼吸加快。

藍色:平靜、鎮定,可讓身體產生安撫效果的化 學物質。請審慎使用,因為藍色也可能看起來過 度冰冷,令人沮喪。

綠色:對眼睛來說是最舒服的顏色,具有寧靜與 清新的感覺。這是屬於大自然的顏色,引發的聯 想多半是正面的。此外,深綠色有時也意味著財 富與權力。

黃色:是眼睛最看不出來的顏色,較無存在感, 常被其他顏色凌駕。或許正因如此,封面鮮少使 用黃色。

紫色:適時使用可讓人聯想到奢華、財富、浪漫、成熟練達,但也容易流於過度女性化或笨拙。

橘色:橘色會引發正面的聯想,例如振奮、有活力、喜悅。但橘色調很難抓準,偏紅會太搶眼, 偏黃又失之平淡。

棕色:亦是帶來良好聯想的「自然」色系。淺棕色讓人覺得真誠,深棕色則讓人想起木頭或皮革。男性相關主題很適合以棕色系搭配。

1						
66/90	66/90	04/99	66/80	02/99	12/98-1/99	11/98*
Con los cinco sentidos	Fuego en las calles	Bésame mucho	iDios mío de mi vida!	I wanna be a Porno-Star	mamá televisión	¿Quien sabe donde?
Control of the contro						
99	99	ÞS	63	29	13	09
vanidad	vanidad	vanidad	vanidad	vanidad	vanidad	vanidad
		Δ	A	Α	A	A

古提耶雷茲為《Vanidad》設計的 書背。將各期雜誌排列起來之後, 可以成為刊名中的「V」,反過來 放又變成「A」。

封面文案

定期發行的刊物一定會有封面文案。市面零售刊物通常更是會放大量的文字,藉此展現出內容比競爭者更多、更好。若刊物用字體大小來表示重要性,最粗大的標是通常是封面改來表示重要性,最粗大的標是通常是封面改本。《Vogue》、《GQ》、《Vanity Fair》、《Marie Claire》(中譯:美麗佳人)之類的雜誌,封面文案的內容、用途與位置是由編輯與數語,封面文案的內容、用途與位置是由編輯與野因素(通常封面文案會封面左邊三分之一的部分,這樣在店面架上的能見度最高。)然而封面文案的外觀與調性,包括色彩、如何從競爭者中脫穎而出、數字、長度與文字所闡述的特質……都是編輯設計師的重責大任。設計報紙版面時也是一樣,編輯設計師喜歡利用橫幅上方的空間,將刊內文章的重點條列出來。

書背

書籍設計師都知道書背很重要,必須用心設計,不過雜誌出版社常忽略這狹長空間,只用這裡來放置刊名與出版日期。其實,書背能幫助銷售,如果雜誌直立排放,書背的能見度甚至比封面還高。再者,這狹長空間很適合強化刊物的品牌與風格,諸如《Arena》、《loaded》、《Vanidad》與《Wallpaper*》的設計師,都

《Vanidad》與《Wallpaper*》的設計即,都不會小看這個空間。《Arena》與《loaded》不只在這裡列出刊物資訊,還會設計系列小遊戲吸引讀者,加強每一期雜誌彼此間的連結性,進而促成讀者忠誠度,想要蒐集整套。

《Wallpaper*》會在書背列出主要內容,是很好的索引。要區分資訊的重要程度,可透過字體的粗細與大小——刊名 Logo 與日期必須遠遠就看得出來,以吸引目標讀者靠近,一探究竟。

工作坊 2 刊頭與封面

目標

為你的雜誌概念設計一個刊頭、三份封面。

練習

運用工作坊 1 (參見 38 頁)的雜誌情緒版,發展三份封面。運用刊頭(Logo)的文字編排,反映雜誌的視覺哲學,可尋找適合的字型或自行繪製。先決定刊頭是否要占去整個頁面的焦點,或處理得含蓄一點。雜誌的目標讀者是誰?想想看,你使用的視覺語彙能否清楚傳達正確訊息?

接下來幫雜誌封面製作版型,可以利用排版軟體裡提供的模版。先選一個開本,但不要用 A4,因為 A4 太長,不利於翻閱,雜誌通常會比 A4 短而寬。找一張喜歡的圖片掃描起來,也可以用手邊現有的 照片,或自己做一張圖。接下來,決定封面上文字的字體。文字編排會影響整份雜誌的視覺識別,因此要仔細考慮字體的大小、樣式。

假設你的第一份封面是某月刊或季刊的創刊號,接下來的兩張封面就當成是後續兩期。如果你的刊物是 A5 大小,印出時記得不要縮放,如果是小報尺寸,就需要在列印時選擇「分割列印」,之後再組合起來。總之,一定要製作出刊物的實際大小。

Perositories for random thoughts

Sketch

Fashion Photographer Gary Wallis

Fashion

Repositories for random thoughts

Sketch

以下是中央聖馬丁學院大學部平面設計系的傑特邁爾·德弗朗尼(Jetmire Dvorani),為自己發想的雜誌《Sketch》所設計的封面版型,這是一本關於草圖的雜誌,刊頭設計的風

格很強烈。我們可以看見他概念發想的過程。值得注意的是,刊名的設計很簡單,用非常粗的字體加上橫線, 有點塗鴉的味道。記得,若封面想用 攝影師的作品,務必要先取得許可。

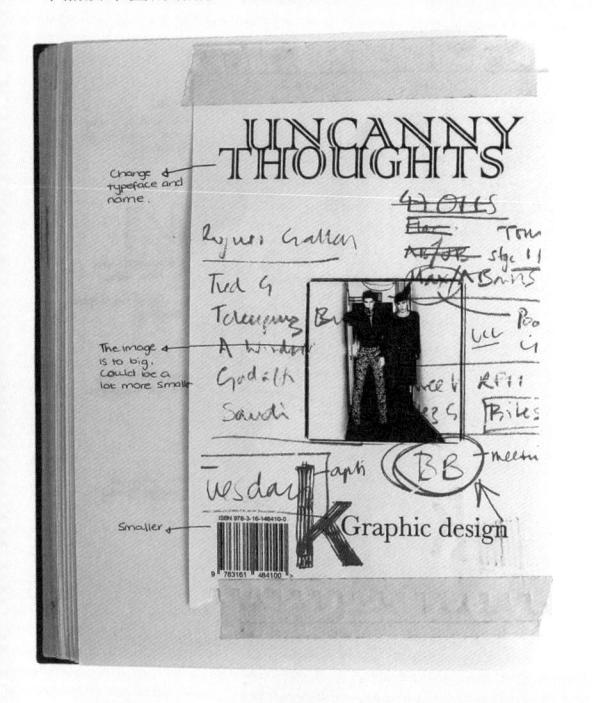

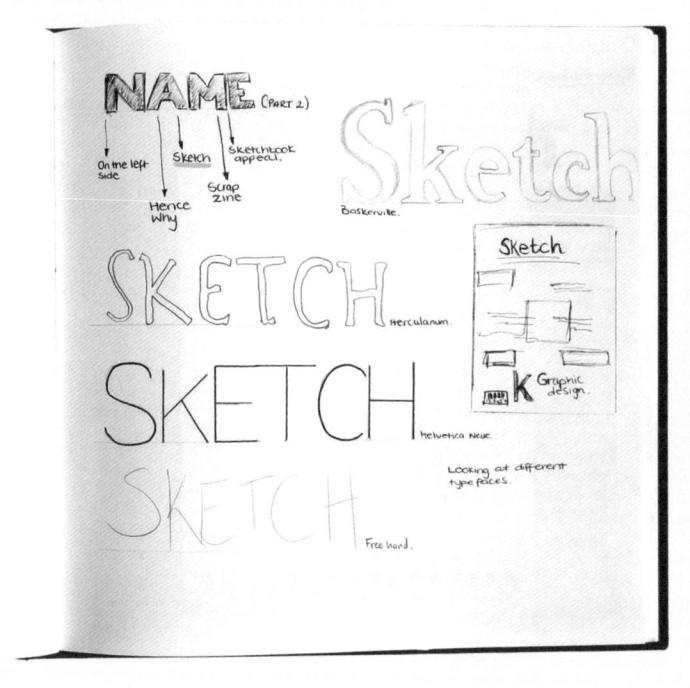

Photography:Gary Wallis

"magical, treasuring a special moment"

Onseri conseque volum repel est, solum sacetae enda voloreh enianis esi volo beatur molupicipis animo quo is repratus experitat dolesita elluptae repraintet il-labo. Et odi to corisquam, quatia nosamie molupta tionenbus nis con provid quia poratia none escerepe llendisquia sefrendi et, consensula mis di principa della esi ma serienti esi atta di principa di suma et omismi attaqui veliqui cunda suma et offismi di suma et offismi attaqui veliqui cunda quia viloribas doltu et doloria quianti liigui cori laboreperum eum dit et lanibi-licae coribias.

quia voloribusa dolut es doloria quanni liqui corit laboreperum eum dit et lanihilicius quibus. Turest opta quatem nonsequia cum hit aliam verist, que necabor epudant omnihil ipient ommodit atempor roviti nimi; si simincil maion consenimentis nonseriae volenis doluptatem. Nam, te parum estur?

Alicte num iditi as es accusam, nus is commolo rehendae rempor alique etur,

Sketch March 2012

hotgraphy: Gray Wall

Chapter 4:刊物內容

對編輯設計有初步概念之後,接下來要進入更複雜的階段。編輯設計的另一項要務是真正了解刊物的核心價值,並將其有策略地應用到刊物的各個細部。制定這些設計策略不能只是蜻蜓點水,還要對策略背後的動機具備深刻的理解與想像。

刊物解析

不同刊物依其類型多有大致固定的結構。例如雜誌,一般可分成三部分:前三分之一稱為「前段」(front of the book),內容以新聞為主;中間三分之一是專題報導區(feature well),最後三分之一稱為「後段」(back of the book),內容通常是在提供資訊,包括各式評價、娛樂活動列表、名錄等等。報紙同樣能依據內容來分成幾個區塊:重要新聞(即時新聞,包括國際新聞與商業新聞);新聞分析與時事評論;其他固定內容(電視、股市資訊、各式評價、氣象、體育報導……等等),還有不定期出現的專題報導。

翻閱任何報紙或雜誌,便能發現不同單元通常會採用不同的版式設計或格線系統,無論是欄寬、標題、字型、字體粗細或圖片等,皆有細微的差別,以方便讀者辨識與瀏覽。設計師固然可視內容需求變換格式,但改變格式時仍須讓閱讀邏輯保持一致,才能避免讀者感到適應困難。這一點在固定出現的內容版面上尤需特別注意,例如電視節目表、氣象報告、讀者來函、字謎、星座分析等等。

目錄頁

雜誌的目錄頁有什麼功用?讀者會仰賴目錄頁來 尋找封面故事、預覽整份刊物內容、快速搜尋喜 愛的專題,或找出想要的資料。有些讀者幾乎不 看目錄,有些則從後往前翻閱,這時目錄頁對他 們而言,似乎顯得多餘。但是,目錄頁仍不可或 缺,畢竟在封面之後,目錄是唯一用文字引導讀 者深入閱讀刊物、指出如何瀏覽內容的頁面。正 因如此,目錄頁通常位於頁面右側,讀起來比較

Zembla magazine >contents

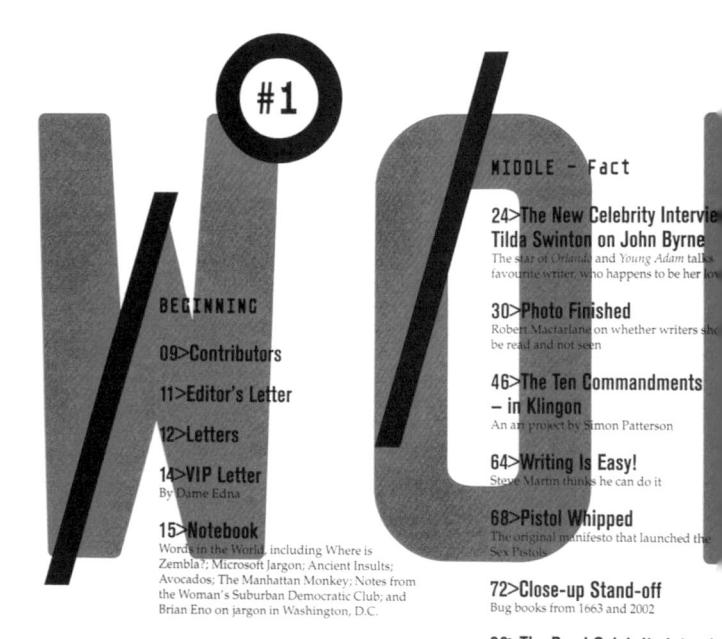

88>The Dead Celebrity Interview Michel Faber interviews Marcel Duchamp Illustration by Manolo Blahnik

[04] Zembla magazine september_two thousand and three

目錄頁得把刊物內容全列出來,但不代表必須犧牲創意。下方《Zembla》與右下的《紐約時報雜誌》就是很好的例子。在 2003年 11 月號《紐約時報雜誌》的年度《靈感特刊》(Inspiration),藝術指導佛羅里克從古柏惠特設計博物館(Cooper-Hewitt Design Museum)的雙年展獲得靈感。佛羅里克說:「我在展覽

中,看見設計師兼與作家保羅·艾利曼(Paul Elliman)的作品『字母小物』(Alphabits)。他用工業廢棄物如瓶蓋、電腦元件、引擎零件等小東西來做字母,這作品巧妙呈現出『靈感從何而來』的問題。他的字母圖像性很強,讓我們的頁面看起來很新鮮、能給人啟發,製作過程也饒富趣味。」

By Donna Daley-Clarke

The problem with 'nice' people

87>Dr Mortimer's Observations

END

92>Writer's Shock

Toby Litt remembers the writer and educator Malcolm Bradbury

95>Global Literary Calendar

Upcoming events around the work

96>Reviews

Authors on their own books; real kids or kid books; and Zemblans on what to read now, damn it

102>Big Philosophy, Big Talk

By Alexander Bard and Jan Söderqvis

112>Cartoon

By R. Crumb and Gavarni

115>Crossword: Crass Words

By Francis Heaney

116>Competition: Sex and Death

Who is the best-qualified person to write on see and death? Tell Zembla publisher Simon Finch and win a first-edition classic novel

120>Lost Page

Never-before published pictures

september_two thousand and three Zembla magazine [05]

方便。但因雜誌的右頁能見度高(尤其是靠近雜 誌前段處),也最吸引廣告主,所以右頁常可能 出售給廣告主,迫使目錄改放在左頁。

目錄頁的設計

設計目錄最重要的法則,就是要讓內容好讀、好 懂、好找。過去目錄會盡量放在刊物的最前面, 不過,只要每期的位置保持一致,目錄擺放在哪 一頁其實並不是那麼重要。只要能建立起規則, 讀者習慣後就會覺得熟悉。目錄頁的安排與架構 要討喜、易懂,能很辨識與瀏覽,以幫助讀者快 速找到封面故事的位置,或很快翻到喜愛的固定 4 Geht die Kultur der Liebe kubun?

Ein Mädchen beklagt sich: Die Männer sind wie Kaninchen

- 8 Die Lust, ein Polizistzusein Polizeibeamte schreiben in twen über ihre Erfahrungen mit Demonstranten
- 15 Feliciano. Die neue twen Platte Die aufregendste Stimme, die in den letzten Jahren entdeckt wurde
- 22 Werden Gehirne manipuliert? Gehirn mit elektronischer Ladung. Wissenschaftler bauen den mechanisierten Menschen
- 26 Witze
- 28 Machen Sie Ihr schönstes Farbfoto Startschuß zum zweiten großen Farbfotowettbewerb
- 30 Die Jungen machen das Geschäft Vier Rezepte, wie man einen eigenen Laden auf die Beine

- 41 Wenn ich ein junger Deutscher wäre.
 William Saroyan schreibt für
- 45 Auch an der Garderobe abzugeben: Citybikes Die kleinsten Motorflitzer auf zwei Rädern
- 51 Leserbriefe
- 53 Die Verfolgung Kurzgeschichte von Henry Miller
- 60 Sex und Schule Die Klasse der schwangeren Mädchen

80 Kopf, Herz oder Bauch?

Das twen-Testspiel verrät alles über Ihr Temperament

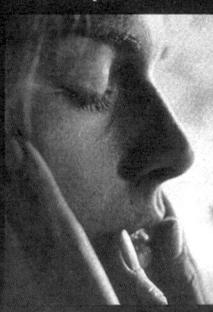

90 Touching ist schönerals Sex Die Kunst, zu berühren und zu fühlen

- 78 Steve McQueen ist nicht zu fassen Hollywoods erfolgreichster Außenseiter
- 85 Warum malt Hockney am liebsten Knaben?
- 88 Dieser Sommer wird noch heißer! Werden die Studenten den politischen Kampf auf die Spitze treiben?
- 100 twen fordert einen deutschen Pop-Sender
- 102 Morgen bin ich ein anderer Mensch

Wie ein Mädchen mehr aus sich machte

- 108 Fiesta der Zigeuner Fahrendes Volk trifft sich in Saintes-Maries-de-la-Mer
- 121 Supermann in Unterhosen Gordon Mitchell in den neuen Geblümten
- 131 Das heiße Lied Georg Stefan Troller schreibt über französische Chansons
- 138 twen-Magazin Neue Bücher, neue Filme, neue Platten
- 166 Sterne und Zitroner

70 Bikinis in Israel twen flog mit EL AL ans

目錄頁可以採用漂亮的列表式設 計,本頁的《Twen》、右頁下方 的《Sleazenation》,和右頁左上 的《About Town》都是好例子。 這些例子依循嚴謹的格線系統與平 面設計原則,如實呈現內容,資訊 豐富又不失畫面的優雅感。然而 設計雜誌的瀏覽方式還有諸多不 同辦法。《Metropolis》(右頁右 上圖)的前藝術指導克里斯維· 拉濱(Criswell Lappin)說:「目 錄布局圖是寶拉·舍爾(Paula Scher) 在 1999 年刊物改版時提 出的設計手法,其架構可讓讀者看 出每篇文章的相對關係。雖然這份 雜誌的目錄在過去五年出現許多設 計變化,但其基礎概念仍保留著, 並越漸重要。」

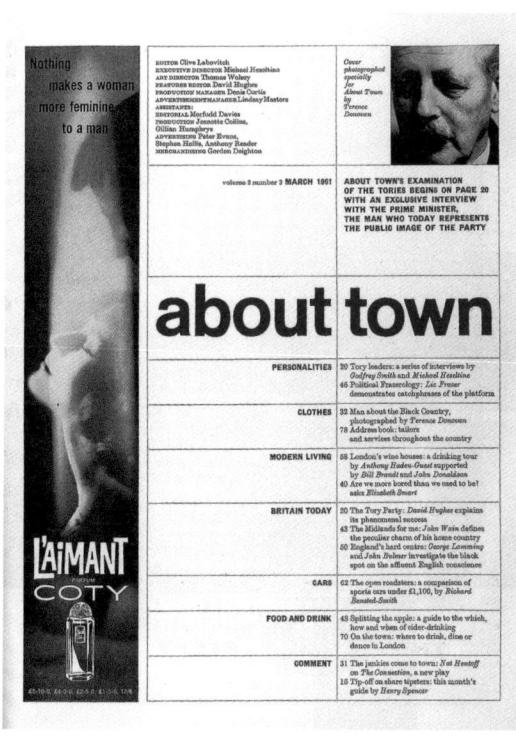

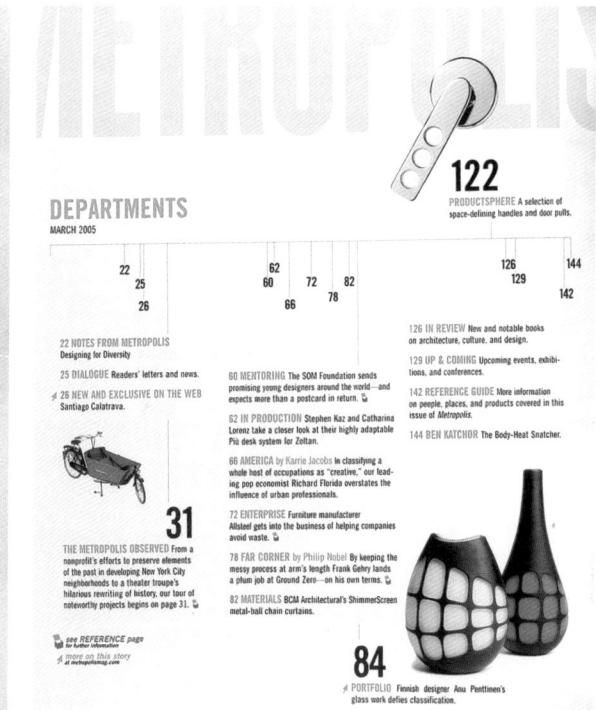

	sleazenation volume,2.issue.8	el Sulm Martins College Papian Library London
08.10		colle
Les Bruits Qui Courent	08.24	p g
08.26	Unusual Suspects	
Grant Morrison		(22,000)
CAR COLO CAROLINA DA SACA	08.28	
08.34	Vincent Gallo	
Andrew Groves	08.40	瀛
08.52	My Work is Directional	اللذ
Smoking		
	08.64	
08.73	Stylist with Chalk	
Quickspace	08.74	
08.75	Spleen	- On
Kahuna Cuts	08.76	
08.77	Dymaxion	
Estereo	08.78	1
08.80	Prozak Trax	3
Digital Hardcore Recordings	08.82	
08.91	Volume Ali* Star	
Savoir Vivre	PARTITION OF THE PARTIT	

單元。目錄要能運用字體、圖片、線條與符號等 圖像元素,凸顯個別的專題與重要單元的報導, 還要能把主要報導的重點整理出來,吸引讀者閱 讀,畢竟讀者在看目錄頁時可能尚未掏錢購買。 最後,目錄頁要如實呈現內容的排列順序,如 果新聞後面才是專題報導區(參見83頁)與名 錄,目錄頁就該如此排列。

有些刊物不放目錄頁。《Adbuster》的藝術指導克里斯·狄克森(Chris Dixon)就不設計目錄頁,他與編輯卡爾·萊森(Kalle Lasn)都認為,目錄會把雜誌過度分割,使設計失去彈性。於是他們另闢蹊徑,在每個單元的頁面上設計色條與色塊,利用其不同的寬度、選色與長度,告訴讀者該單元的長度及內容多樣性。這算是極端的解決方案,也只適用於某些類型與開本;若是新聞週刊或報導娛樂消息的雜誌,缺少目錄肯定會惹毛讀者;此外,要是刊物超過三百頁,仍應以實用度為首要考量。

IT WAS a game at first. A publ stonewalling my proposal for a new magazine so I started to toy with the idea of publishing it myself. Independence – now there's a thought to set any journalist's pulse racing. But I never myself. Independence – now there's a thought to set any journalist's pulse racing. But I never honeasty thought I'd go through with It. On the other hand, what I could actually escape the frustrations and contrictions imposed by have frustrations and contrictions imposed by have frustrations and contrictions imposed by have frustrations and selection of the country of the countr spent improving the product; behind-thescenes costs cut to the bone. To survive during the first year I was the only full-time staffer working first from a corner of a room in somebody else's office, then in a musty oneomed basement. In that period there were at least two occasions when disaster was imminient. The fact is that it's relatively say to start a magazine, a major act of endurance and faith to keep it going when things don't immediately click. But there has always been enormous goodwill towards THE FACE and it was this, with equal measures of stubbornness, pried and my wife's support, that kept us allost. Today we have a rising circulation and an international reputation. On top of UK sales, every month we export 3,400 magazines to every month we export 3,400 magazines to with every lists: there's no room for complication, Last year we were elected Magazine with export of coverage, tried to static our necks even further out. Profits are still being rein-versel. Not just me, but all of us at THE FACE would like to thank the readers, contributors, advertisers, associates and friends of the magazine for their generous and continuing support. And we still independent! nent. The fact is that it's relatively easy to start

The World's Best **Dressed Magazine**

Chaka Khan meets Eurythmics" Helen Terry

- Sara Sugarman/Olympic shirts/Sunday Bes
- The Black Theatre Coop/Richard 'Popo
- Yellowman/Grace Jones/Was Not Was
- Alternative Country High noon in NW1! 18
- Jermaine Jackson/Intro's record selection
- 22 Absolute Beginners/Loose Ends/Bronski Beat
- FEATURES
- Hippie as Capitalist profile of Richard Branson
- Mods! The Class of '84 hit the Trail of '64 28
- The General Revisited Jerry Dammers
- Gang Wars! Sudden death in Olympic (
- Photospread The funeral of Marvin Gaye
- Saint Joseph the Tastemaker!
 Exclusive! Stevie Wonder has a dream
- EXPO Night People by Derek Ridgers
- All for Art Gilbert & George
 - S E C T I O N S
 - Julie Burchill How to get It! How to lose it
- Music for June reviewed by Geoff Dean Letters The readers bite back! 50
- Back Issues (going fast!)
- Films New on the circuits
- Nightlife THE FACE in Turin/Club selections
- Bodylicious! 12 pages of Style start here.

 DisINFORMATION for THE FACE's 50th
- Subscriptions advice THE FACE by post!

The Face @ 4th Floor, 5/11 Mortimer Street, London W1, England

Publisher/Editor Nick Logan
Assistant Editor Paul Rambali
Designer Neville Brody Features Paul Rambali Lesley White

Intro/Features assistant Lesley
Accounts/subs Julie Logan
Design assistant Ben Murphy tor James Truman (2) 2 989 4579) Rod Sopp (01-580 6756)

+ Peter Ashworth/Janette Beckman/Max Bell/lan Birch/Chris Burkham/Julie Burchill/David Cono/Kevin Cummins/Giovanni Dadomo/Chalkie Davies/

THE FACE 7

《The Face》是另類流行雜誌,編輯尼克· 羅根(Nick Logan)和字體設計師布洛狄探 索「後龐克」(post-punk)的設計,援引俄 國構成派(Russian-Constructivisim)的政 治理念與視覺美學,以全新的方式來呈現文 字編排、版型與設計。不過,這份目錄頁的 編排仍一目瞭然,概念上算是相當傳統。

前段

雜誌的前段以文字專題為主,刊登文化、時尚、 運動、旅遊或室內設計等內容,這部分通常會有 明確的設計規範,從字體、色調與頁面元素(包 括圖示、線條與基線),都會架構清楚地排列在 格線系統上。一般而言,設計師除了要設計每期 的刊頭, 也要負責設計社論的版面, 因為社論往 往是展現刊物風格的主要內容,需要格外重視, 才能清楚傳達刊物的調件。

至於刊載熱門消息的頁面,現今常常仿效網 頁設計,運用框線、底色、豐富多樣的字體粗 細與大小,讓頁面更生動活潑。《WIRED》與 《Business 2.0》就率先把網頁設計的概念運 用在紙本刊物上,後來《金融時報商業雜誌》 (FT The Business)的蓋瑞·庫克(Gary Cook) 也跟上風潮。為了讓《WIRED》頁面看 起來熱鬧有活力,設計師使用大量重疊的方塊、 色彩、對比、字型、圖片與圖形。留白空間的寧 靜感和這種版面格格不入,因此不適合使用。

報紙的第一疊和雜誌的前段有點類似,也會以格 線系統作出有些許彈性的節本,安排內容時需嚴 格遵守規則。報紙的第一疊,通常是用來刊載新 聞快報等無法事先預知的內容。

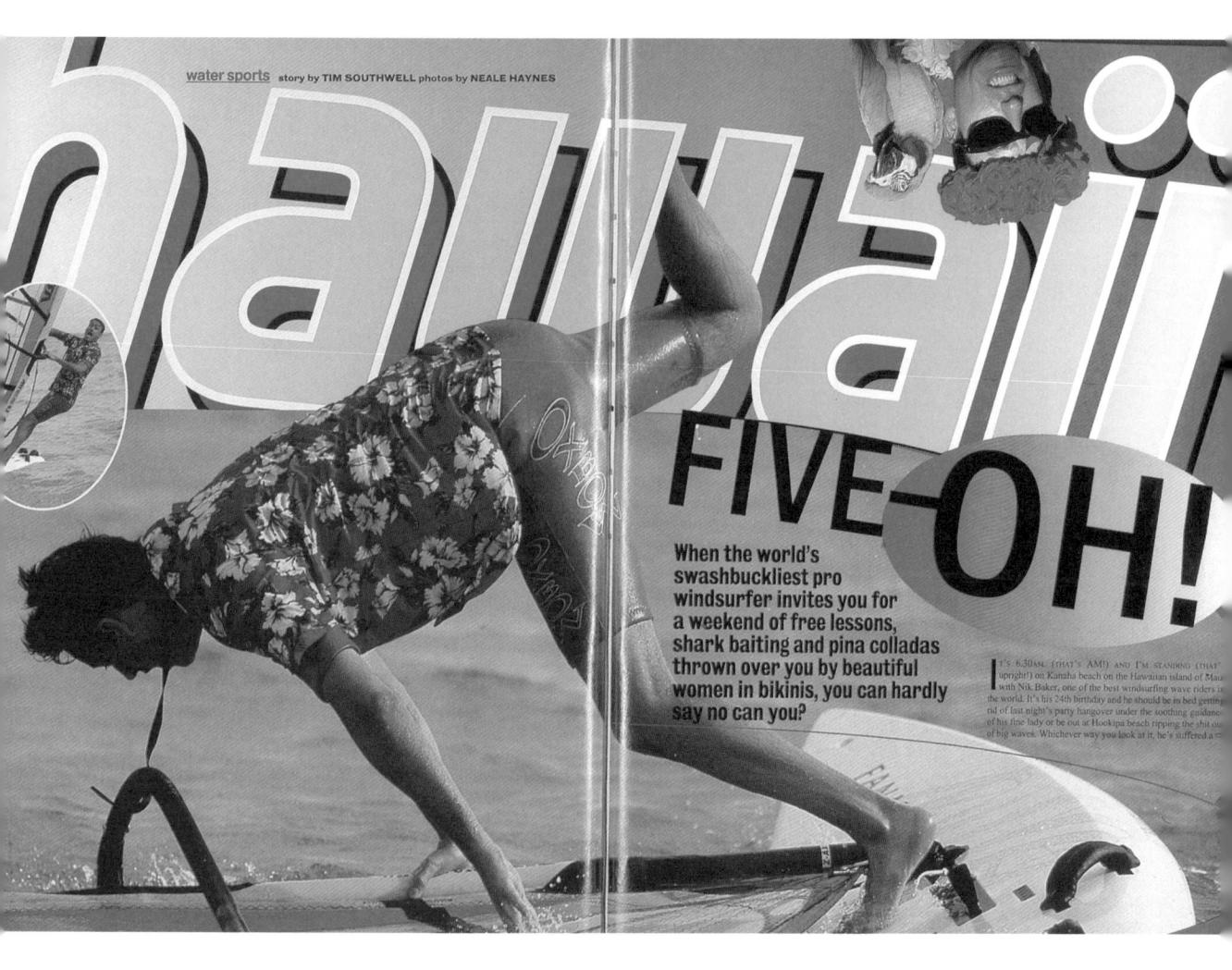

專題報導區

專題報導與雜誌品牌息息相關,是整本雜誌中最重要的一部分。專題報導可能刊登和其他刊物一樣的當紅人物專訪,也可能深入分析當前熱門的事件、趨勢或話題,或刊載獨家新聞。總之,專題報導的文字與版面設計風格、內容與調性,攸關刊物能否從競爭中脫穎而出。

許多專題報導區會展現刊物的標準視覺風格, 再運用一些細節上的差異營造出不同於其他區 塊的氣氛,例如欄寬較大、增加留白空間、字型 變化、標題放大、引言加長。如果專題報導以跨 頁起始,通常會安排一張滿版出血的圖片(可能 是大頭照、圖表或插畫),搭配單元刊頭。專題 報導的單元刊頭通常包含文字(標題、引言、主 文與抽言),或許還有其他小圖,加強主圖與專 題的連結性(若缺少主圖,也可能單純用標題文

Elle a choisi l'Hôrel, tre des Beaux Arts, QG d'Oncar Wilde, à quelques pas du Café de Flore ad elle se régale de croque-monsieur avec les doigs, tout contre l'immense appararement déposaille qu'elle occupe le temps d'un film. Le clin d'œi du réceptionnisse, no h-onjour mademoiselle- conniver. Lisseant à penare que Sofia Coppola aici quelques habitudes. Peut-être vient-elle, dans ce cadre «rocco-Art déco-hordele» réver à Maire-Anneiret, été d'afficité de l'Hausire, couronnée reine des son troisième long métrage? Sithouetre félé parfunde à la victore pleines, comme maparent semblements eu un enfail bebuissant, en ce de searcéere, pleines, comme maparent semblements eu un enfail bebuissant, en ce de searcéere, pleines, comme conserve pleines, comme conserve pleines, comme conserve pleines, comme conserve pleines, comme charge de son troisième de la motivation de mortare à l'au paré dont le nom charrie à lui seu lie mybe folloywood. New Virgis Sainder (January 1974) de la caute en la comment de la motivation de l'especial de l'autorité de l'aut

《Vogue Paris》的前藝術指導貝隆運用黑色 與留白空間來設計跨頁,其架構不僅包含嚴 謹的格線系統,還使文字顯得格外醒目。右 頁上方的例子,是威利·弗萊克豪司(Willy Fleckhaus) 在 1968年設計的《Twen》, 大膽採用留白空間,以出其不意的方式來處 理主題,在視覺與概念上皆呈現出令人驚喜 的優雅。

字來當主視覺)。如果專題報導的第一頁為單頁,而對頁是全彩廣告,可選用黑白主圖或適當留白,來和廣告頁形成對比,帶領讀者的視線從廣告轉向刊物內容。1990年代的雜誌常設計得太過花俏,後來設計師反而偏好運用留白空間,營造出簡潔感。這個作法廣受歡迎,因此仍為新世紀的設計主流。要能讓留白空間的運用呈現統一,就要把留白區域明確地註明在設計範本中,例如天地留白;標題和引言之間的留白;或文字框周圍的留白。

後段:評價、資訊列表與投稿

正如刊物的前段一樣,專題報導區之後的元素 (例如各式評價、列表、投稿與星座)多由初級 設計師編排,也明確規範頁面的結構與格線。通 常配色是固定的,字型、粗細與風格也有既定的 樣式。這些頁面很講究圖片,能否善用插畫與照 片決定了頁面是否活潑、吸引人。圖文編排也很 重要,在白色背景上擺放去背圖素的效果總是不 錯,不僅很明確,還能留給頁面呼吸空間——雜 誌前段的文字頁面就大不相同了,因為前段往不 是以圖文塞滿頁面。很少人會閱讀所有報導, 是以圖文塞滿頁面。很少人會閱讀所有報導就 如果頁面散發驚喜感,就能吸引讀者躍躍欲試。 這一點適用於所有類型的版面,即使是無趣的 這一點適用於所有類型的版面,即使是無較為 這一點適用於所有類型的版面,即使是無較為 話一類表頁面,也要善用字型與線條,使其較為 對。在雜誌後段,最珍貴的就是最後一頁,讀 若從後往前翻,最先看到的就是這一頁。正因如

紐約時報旅遊雜誌《T:Travel》的開場白,透過手繪的哥德字體(Fraktur)強化品牌形象,而在沙子上寫下的字母則傳達出雜誌的冒險精神。這畫面不僅有創意,也賞心悅目。

此,有些刊物會在這一頁放上最大眾、最受歡迎的內容,例如星座、讀者來函或再放一次刊頭。

單元開門頁

單元開門頁在刊物中可說是相當奢侈,但讀者多半很喜歡。以內容來說,通常單元開始會大方占用一整個跨頁,並以搶眼圖片搭配極少文字,讓視覺有喘息的空間。跨頁是難得可使用橫圖的機會——橫圖的設計力道比直圖大(但要確保圖片品質佳、強而有力,且能持續找這種圖並不容易)。單元開門頁若設計得當,能讓人留下深刻印象,因此可以當成「指標」使用,引導讀者順利找到想看的單元。若單元開門頁具備引導用途,不妨單獨建立專用版式,讓讀者熟悉,易於記憶與查找。

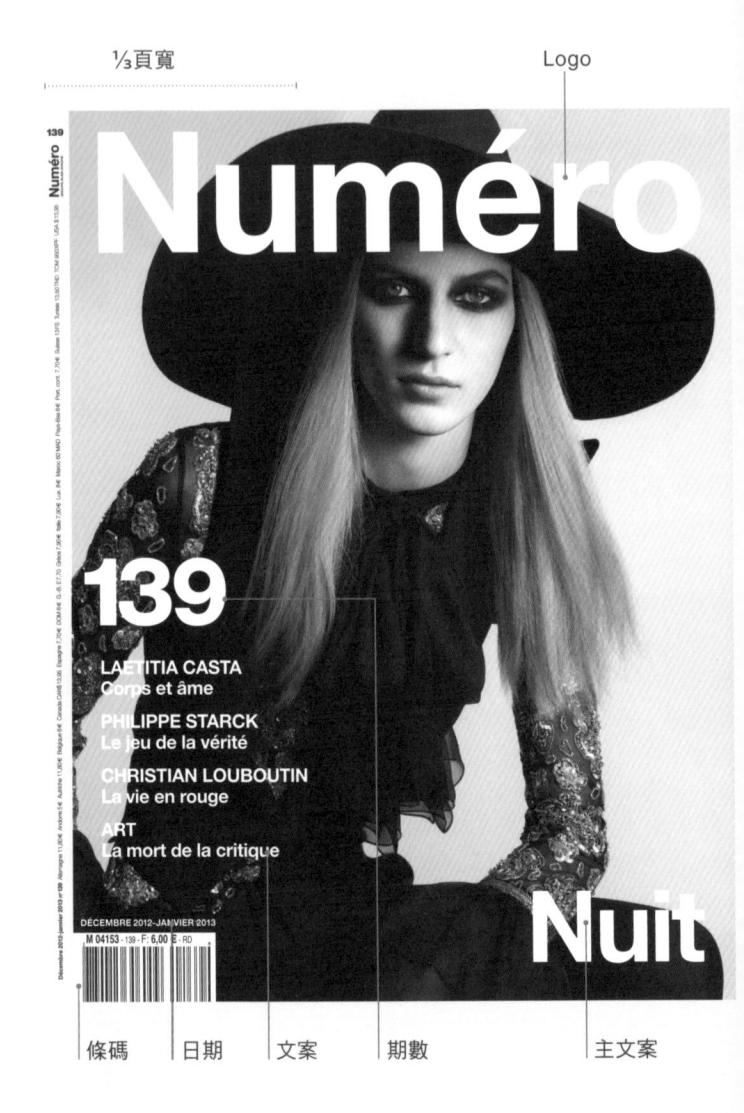

文字編排的功用

字體設定是編輯設計工作的骨幹,也是設計師務 必掌握的基本知識。數位刊物和紙本刊物一樣, 應依循最基本的文字編排原則,再適情況調整。 無論出版系統怎麼變,只要能深刻了解字體,悉 心處理複雜的文字資料,就能設計出好看的文字 版面。

文稿 copy

編輯發排文稿時,常會使用許多關於文稿名稱 的術語,設計師剛開始不免一頭霧水。更麻煩的 是,這些名稱往往會在一份文稿中同時出現(參 見88頁的圖)。然而提到文稿,有四件事情設 計師不可不知:

- 文稿中的各個名稱。
- 不同形式的文稿結構。
- 報刊寫作(各類文稿)和其他寫作類型有何不 同,如何影響設計師的角色。

標語 tagline

刊頭下方代表刊物精神的標語能達畫龍點睛 之效,標語寫得好,不僅能告訴讀者文章內容 的走向,更能顯示出刊物的調性與說話對象。 標題能讓固定讀者自認是「該知道更多的男 性」(《loaded》)、「關心周遭事物的人」 (《Wallpaper*》),或是「特立獨行的時尚達 人」---例如《WAD》說:「我們是與眾不同的 行家。」若想讓新讀者快速了解雜誌內容,莫過 於透過標語。

大標 headline

文稿編輯會說,想說服讀者讀一篇文章,大標和 版型一樣重要。標題會締結出刊物與讀者群的密 切連繫,好像在說:「我們了解你、喜歡你、我 們有共同的幽默感、興趣以及文化背景。我們還 知道你夠聰明,會了解這個標題與報導。」因此 適當的大標尺寸、位置與處理方式很重要。以文 字為主的報紙尤其重視大標,畢竟報紙無法透過 漂亮的圖片吸引讀者購買。

引言 stand-first

引言通常放在標題後,其扮演的角色有時甚至比

標題還重要,會決定文章調性,告訴讀者文章的 主旨,成為標體與主文間的文字與視覺橋梁。因 此,引言務必與標題一脈相承,還要整理出乾淨 俐落的文章重點,吸引讀者閱讀主文。

抽言 pull quote

抽言對設計師來說是很好用的元素,不僅能引 導讀者的視線,還能將文章分段,製造出閱讀節 奏,讓專題報導更引人入勝。抽言的內容可直接 從文章裡擷取, 也可將一段文字精簡、重組。

小標 subhead 或 cross-head

小標可將密密麻麻的文章欄位分段,在冗長的新 聞報導中最常用。文章拉得太長,讀者沒耐心讀 完時,即可透過小標找到想看的內容。小標也很 適合用來標示新起段落與章節,或主題轉換。如 果讀者無法一次讀完文章,小標能幫助讀者快速 找到上次讀到的段落。

署名與圖片版權 byline and credit

署名與圖片版權如何處理與擺放,會依據個別刊 物的重視程度而有不同。雜誌通常會列出撰文作 家與撰文職員(尤其請知名作家撰文時)、攝影 師或插畫者。報紙著重於新聞內容,不太強調誰 是記者,因此常沒有署名;而在雜誌中,最新消 息類的內容,署名也會比專題報導來的小。

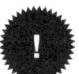

「設計師要願意讀文字資料,詳加思考,樂 於討論,才能在刊物的預設架構之下發展出 正確的視覺元素,豐富閱讀體驗。」

馬丁·文內斯基,《Speak》藝術指導

主文 body copy

雖然刊物可以靠設計來吸引讀者,但文字內容或 主文不符合期待的話,最終還是不可能會有好 成績,進而流失廣告主,最後淪落到停刊。刊物 內容需與時俱進,又要忠於品牌與品牌傳達的訊 息。要能做到這一點,就必須有紮實的內容、高 明的寫手與文字編輯。設計師會在兩個層次上 處理主文:首先是運用欄位和字型選擇,滿足主 文的需求與特色,進而傳達品牌精神;第二,設 計師也要把自己對文化趨勢的想法與知識反映出 來,讓內容在視覺上更有活力。

資訊框/邊欄文字與資訊圖表 panel, box copy, sidebar and infograph

資訊框的功用在於放短篇新聞,或刊登長篇文章的補充資料,例如列舉相關事實與統計數字、個案研究,或和主文不同卻相關的元素。資訊框的文字通常較活潑,不若專題報導迂迴深入。因此這裡的句子較短,採用陳述事實的語氣,有許多資訊片段與元素,把連續的文章分解成列表與要點。設計時應該要讓這些資訊欄位利於快速閱讀、吸收。

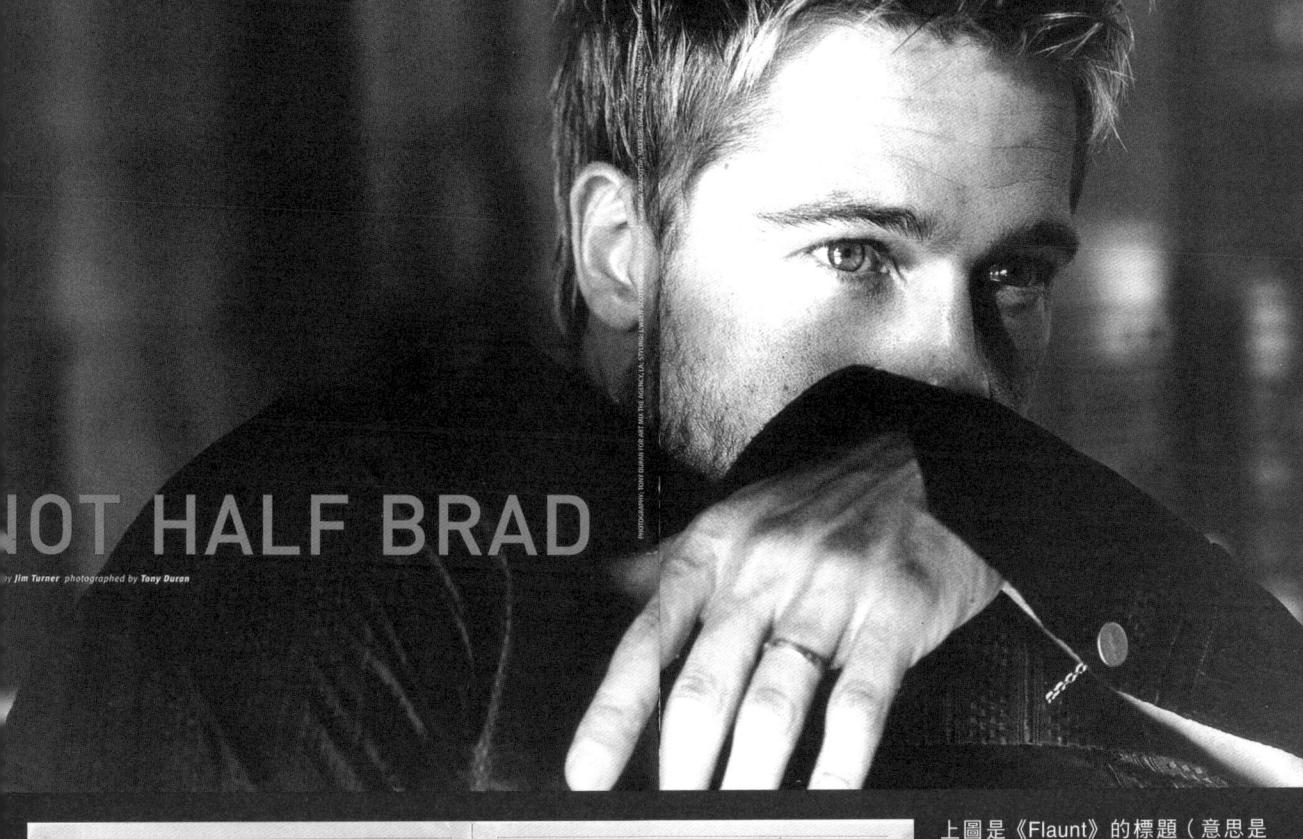

La discreción del PNV

Supplement and supple

which is a second of the control of

上圖是《Flaunt》的標題(意思是「非常布萊德」)雖比較傳統,但依然搶眼、巧妙且精關,表示這標題不僅不搶巨星布萊德·彼特(Brad Pitt)的鋒頭,還讓讀者覺得文章內容會有精關見解,絕不是半調子的報導。

越來越多報紙仿效消費類雜誌,以 抽言來吸引讀者目光,如此可讓密 密麻麻的主文欄位分割開來。左圖 西班牙的《國家報》就是一例。

I grew up in the suburbs, Burton says, and somehow if

you are deprived of certain feelings, there is a desire to get them out. Otherwise, you feel like you're going to explode.'

Burson has the namer of a precession strenger who has speen a great ded of time happily alone. He is enthulassic, but not efforts the va — this sentence stars and stop and our back on themselves in the manner of some cases when it is not a proper to the proper of the property of the pr

"Big Fish" relix the story of Edward Bloom, who is played by Albert Finner. Edwards figure prominently in the Berton owner—where Edward Scisor/ands and the director Edward Scisor-ands of the Scisor Science Scisor Scisor Scisor Scisor Scisor Scisor Scisor Scisor Science Scisor Scisor Scisor Scisor Scisor Scisor Scisor Scisor Science Scisor S

visual and the verbal the words are boltzered, ruther than overwhelmed, by Bornor's attraction to a strong permits, on a typing open, and the permits of the encoding of the permits of th

t would be easy to assume that Burton's attraction to "Big Fish," with its central paternal conflict, would be due to his imminent inherhood. But his interest in the film is more cloeply liaked to his own childhood in Burbank, Calif. "The clearest thing for me is where I came from, Burton said." I had a kind of sensory deprivation growing up in Burbank. I said once that my childhood was like a kind or surrout longiful presents and a live a Jere up in the subsubs, and ownshow if you are deprived of certain feelings, there is a denie to get home one Chibrensy, our feelings one ging to explode."

m animator for Disney, life is very much a sketch. at arrival of his son.

Button was never close to his father, who had played baschall and worked for the ciry's parks and receasion department, or his mother, who at one point had a glit store devoted to cast. When he was 12, he went to live with his grandmother. "My grandmother used to relian that went to live with his grandmother." My grandmother used to relian that went to live with his grandmother. "My grandmother used to relian that we was 12, he went to live with his meaning that had been received that when the properties of the control of the same state." But the same state of the complex. But my grandmother left in ealone. Attone level, I was undermood, and her bousef felt like as ancare," But to make the same state of the control of the same state of the same was to the same state of the same with the same state of the same state of the same was the same state of the same was to save and the most. Whist of the same state of the sam

Adventure" led to Burton's directing "Berleijsics" which firmly est lished his sensibility. The plot of "Berleijsics" which firmly est lished his sensibility. The plot of "Berleijsics" was nonsentracil, het midd's ready nature "— he limit looked like moding that had been made didn't ready nature"—— he limit looked live moding that had been made and the limit of limit of

由審慎挑選字體,營造出輕盈易讀的空間感; 這裡使用的字體有強納森·霍夫樂(Jonathan

有 Garamond 與 Helvetica。 右 頁 的 例 子 是

打造出空間感,還為跨頁創造出視覺上的連貫,

圖說 caption

正如引言是連接標題與主文的橋梁,圖說也聯繫 圖像與文字,是重要的設計環節,需要優秀解決 方案。圖說的設計方式與擺放位置有很多種(詳 見第五章),設計師必須了解圖說在刊物中的角 色與調性,才能做出適切的設計。

頁首頁尾 folio

頁首頁尾會放置頁碼、書名,有時也可加上單元 名或章節名。頁首頁尾是頁面中不可或缺的元 素,能引導讀者的閱讀方向,強化版式架構,進 而鞏固品牌。如果刊物內容簡單,有時就不會太 注重頁碼設計。但如果刊物讀者很講究視覺,那 麼刊物就會運用字型、粗細與位置,讓頁首頁尾 更突出,成為獨立的設計元素。《RayGun》的 卡爾森、《Speak》的文內斯基與《Emigre》 的凡德藍斯都很重視頁首頁尾的設計。許多雜誌

上圖的兩份刊物,以不同的方式來處理主文。 《紐約時報雜誌》把主文排滿整個頁面,但藉 Hoefler) 重新設計的 Cheltenham、賽勒斯· 海史密斯(Cyrus Highsmith)與馬修·卡特 (Matthew Carter) 重新設計的Stymie, 還 《Speak》,文內斯基在編排主文時運用圖形, 將各種不同元素統整起來。

george segal

1944 in New York City, Segal is the son of Jewish immigrant tectuals who made their living on a chicken farm in New Jerr. Although he pursued a degree in arts education at Cooper inion after graduating high school, his escape from the four-teen-hour workday was cut short when his older brother was drafted. It was through his life on the farm that Segal de-veloped his views on the hardships of the labor class.

convoxes evoke the grand simplicity of Mase, but are rendered less playfully through his
septiment of the second ginning as a painter in the late 1950s, Segai's arly canvases evoke the grand simplicity of Ma-tisse, but are rendered less playfully through his use of muddied primary colors and non-figura-

I wanted to deal with the bus, driving the bus—the narrative is seemingly clear and straight-toward. But upon further inspection, it becomes evident that the tableaus represent more than just a fleeting snippet of tedium; many of Segal's characters, who appear unwittingly tied to urban life and capitalist drudgery, accept to the characters impel viewers to fill the silence with their own psychological interpretations, which are infinite and remain unrea. With all the interpretations, which are infinite and remain unrea. With all the interpretations, solved, Unlike an explored video frame. vivid reality of the world

Dadaist-inspired Assemblages—the use of real objects was the logical divergence from the splatters of Jackson Pollock.

為了滿版出血的圖而捨棄頁首頁尾,這基本上沒 什麼錯,但如果缺少頁碼的連續頁面太多,可能 造成設計團隊與印刷廠的困擾,讀者在瀏覽時也 會覺得不耐。若遇到左頁和右頁只能選一頁來放 頁碼時,可考慮放在能見度較高的右頁。

螢幕字體與印刷字體 screen font versus print font

光以肉眼觀看,便能看出字體印在紙上與在電腦 螢幕顯示時差異很大。螢幕是有背光的,字體會 隨著螢幕的亮度與校準程度不同而有不小的差 異。尤其是當螢幕對比很強時,字體可能會看起 來很暗淡。而印刷在白紙上的黑字,閱讀起來是 否舒適,和紙張的反光程度有關。若以報紙或再 牛紙印刷,油墨網點通常會量開,若用放大鏡觀 看,就會發現字體的邊緣比較模糊。

有鑑於此,設計師必須慎選字型,並了解螢幕與 紙本的字體在設計上的差異。在數位排版時,設 計師通常都會購買知名字體公司的字體產品。然 而網路上也有琳琅滿目的免費字體可供下載,若 新手對字體的歷史有些概念,將有助於判斷如何 選擇。也有許多字體熱愛者組成的社群和部落 格,積極參與字體協會的活動與演講。經驗老道 的字型設計師都知道,字型與文字編排值得終身 學習,所以專業的設計師要時時更新相關知識。

瓊恩·希爾 Jon Hill

《泰晤士報》等大型新聞機構,能從龐大的檔案庫中引用歷史資料,快速製作出呼應時事的內容,並同時推出印刷與數位版本。這麼一來,刊物就活化過去累積的資產,使它在新時代發揮價值。《泰晤士報》是付費閱讀的網站,目標鎖定在想讀到可靠、值得信賴的新聞產品的讀者。讀者會期許付費網站的內容要夠精緻,而非其他免費網站就能集結到的內容,收費的數位產品須以高標準來製作。

瓊恩·希爾(Jon Hill)是倫敦《泰晤士報》的設計編輯,曾負責報紙、網站與 iPad 版本改版,也曾主導《泰晤士報》旗下的《Eureka》月刊推出。他在以下訪談中談到對文字編排的想法,及數位環境對設計的影響。

你如何運用《泰晤士報》的品牌,讓它保持新鮮感?

我認為與其要設計師依循設定好的範本,不如設定大的工作原則。這些原則可以應用在刊物的所有地方,連字體設計也不例外。我們使用 Times Modern 字型,這是2006、2007 年布洛狄在改版時開發的。

我們努力確保這字型適用於紙本、數位等各種平台。 Times Modern 是《泰晤士報》的 DNA,也可說是我們 的品牌,這種字體會出現在我們製作的任何東西上。

大家知道你是嚴謹的字體設計師,非常了解刊物頁面的深層結構及視覺語彙。但在製作《泰晤士報》的數位版本時,這些字體編排的技巧還能派上用場嗎?

我認為最大的挑戰,在於和程式開發者及設計內容管理系統的工程師合作。我發現他們認為成功的數位刊物就是要能自動出版,最好只要把新聞內容匯入,就能直接轉換成網頁和數位刊物。然而藝術指導仍想擁有外觀的最後決定權,例如想讓標題更好看,或調整一下 iPad 版的圖片裁切方式,這樣就會和技術團隊發生衝突。然而正確的作法是介於兩者之間。我們盡量讓系統自動做出數位版本,但設計師多少仍有調整空間,能修改文字編排與內容呈現。

在製作數位刊物的版型時,誰有最終決定權?

《泰晤士報》設有付費牆,因此一定要讓付費讀者拿到精緻、完美的產品。這麼一來,製作時就要有詳細的規範,例如如何設定首字放大或段落間隔。好好琢磨細節,才能表現出我們的用心,也讓產品比免費新聞網站優秀。我們會和開發者討論這些細節,確保他們重視《泰晤士報》的整體水準。

你是否覺得數位字體的品質已改善,能媲美紙本效果?

現在比較滿意了。我們仍與蒙納公司(Monotype)合作,設法改善網站上的字型,因為現在瀏覽器種類很多,每種呈現出的字型效果都不同。在平板電腦上倒是可以掌握,因為平板電腦螢幕的解析度是固定的。2012年之後,有些 retina 螢幕的顯示效果已和紙本一樣好。我有信心,我們比五年前更有能力在各種數位版本上,掌握品質與額色。

能不能解釋新的數位環境對你的工作有何影響?

沒有任何出版商敢斷言已經完全掌握了數位刊物,以及該如何豐富刊物在平板電腦上的閱讀經驗。現在談影響還言 之過早,但遲早會有影響。設計師務必學習互動圖像與動態畫面,還要能應付大量的數據,也必須知道在數位環境 下如何說故事。如今編輯設計不只是處理文字與圖像,數 位刊物的設計師需要學習全新的知識。

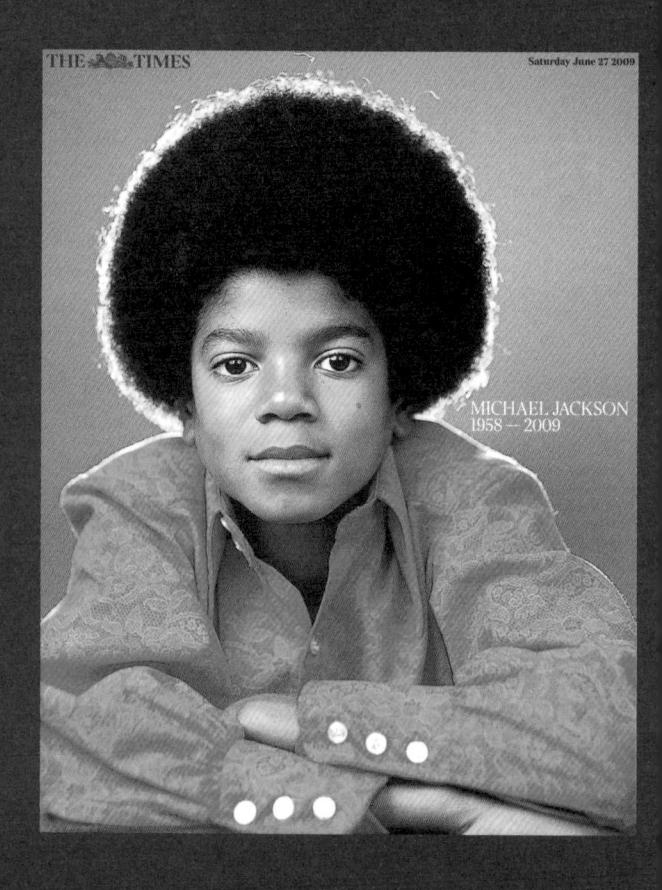

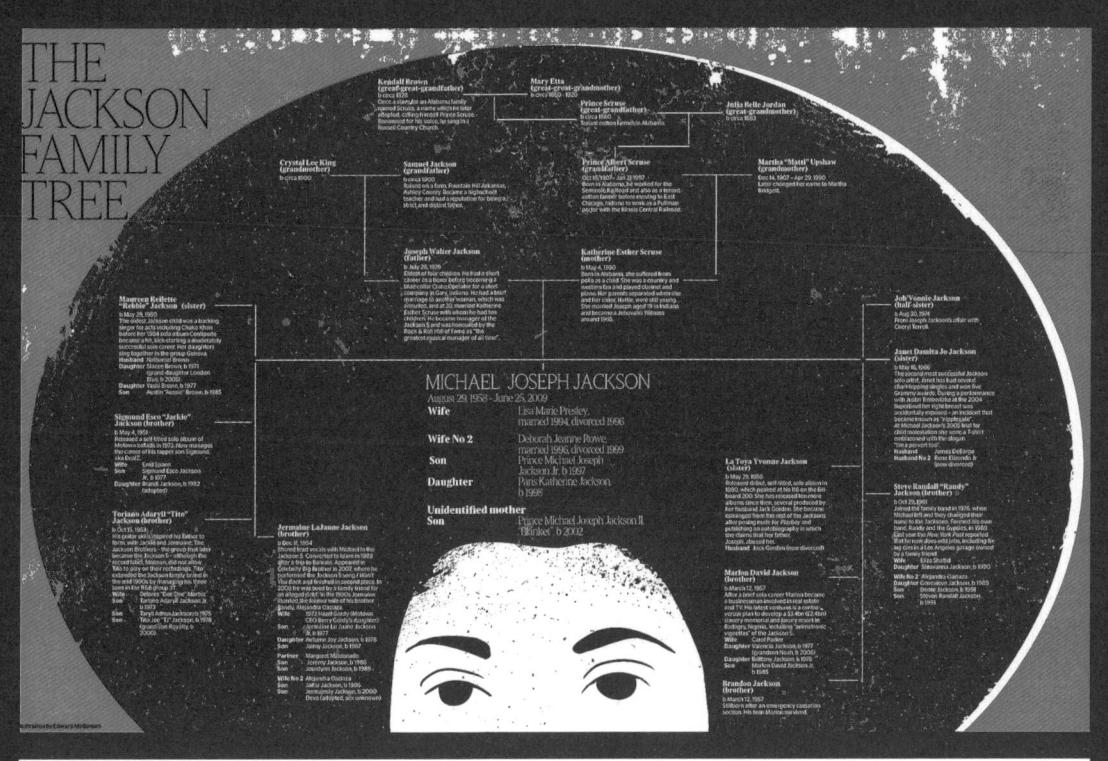

MICHAEL JACKSON 1958-2009

MICHAEL JACKSON 1958-2009 End of

the road for Jacko

Michael Jackson lived his childhood as an adult, then, when he grew up, retreated into infantilism and a dangerous fascination with children WILL PRIVA

caravan CAITLIN MORAN

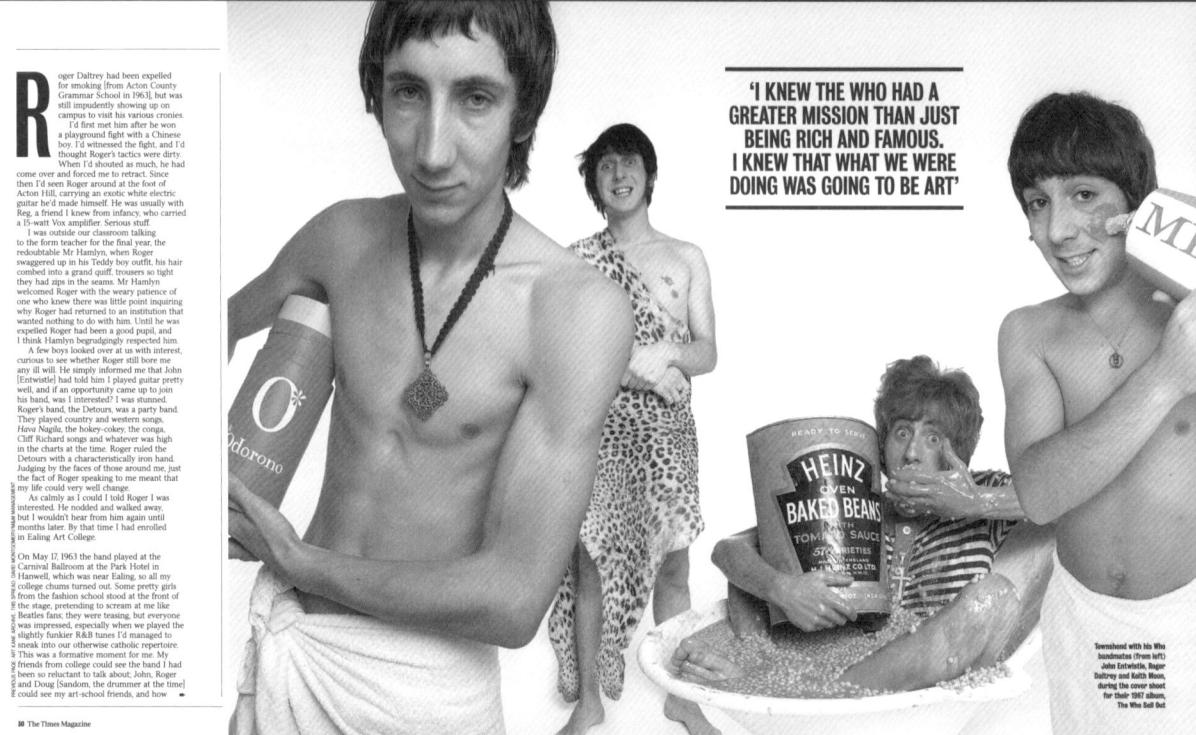

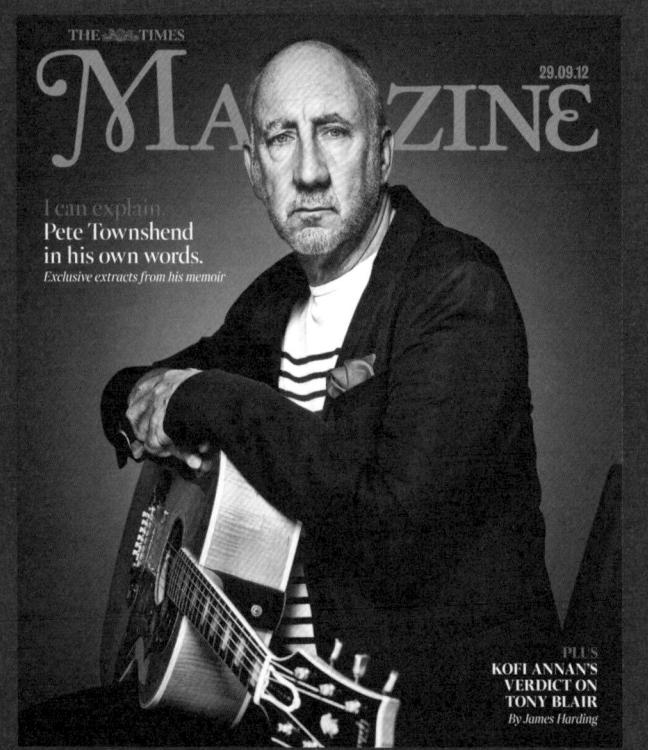

聊聊 iPad 吧。你們在平板電腦上使用的版本,是否和網 站版本差異很大?

先講一段「前情提要」吧:據說魯柏·梅鐸(Rupert Murdoch, 1981年收購《泰晤士報》的媒體大亨)答 應史蒂夫·賈伯斯(Steve Jobs),《泰晤士報》要成為 第一個在 iPad 上發行的報紙,等 iPad 在英國上市三個 月後就要出刊。於是我們在 iPad 上市後三個月,就推出 《泰晤士報》的 app, 這是每天一刊的版本, 不是不斷 更新的網站。我們的編輯信條是它「就和報紙一樣,但是

《泰晤士報》app 背後的理念是,它不像網站一樣是「即 時」產品,而是和報紙一樣一天出刊一次,除了擁有和紙 本報紙一模一樣的內容,還增加互動圖像、影片與更多的 新聞檔案資料,為更長的報導提供背景資訊。

如今讀者能在不同版本上享受線性閱讀。相信讀者會青睞 這種產品,而不是像瀏覽新聞網站時那樣,不知讀哪兒才 好·看個沒完沒了。

1

希爾給有志成為編輯設計師的年輕人的 一些建議

你認為年輕設計師需要了解文字編排的 規則與基本知識,或不知道也能生存? 要了解才好。年輕人必須對設計與文字 編排有熱情,也要證明自己能處理複雜 的資訊與大量文字。

畢業生必須對文字編排與資訊設計有基本知識,也要能自我學習新軟體。在職場上的設計師都是運用線上資料,隨時補充新知。要多少懂一點程式語言,才能理解程式開發者所做的事,並以他們的語言來溝通。

至於專業出版軟體可以邊學邊做。許多 大型出版商都是使用內部的專用系統, 在市面上根本找不到,因此只能在公 司裡才學得到。這表示,快速學習很重 要,應徵者若能展現出學習能力,則可 望加分。

學生能不能一邊工作,一邊回頭學習文 字編排的基本規則?

我們常要召募有已具備技術能力的人, 文字編排得花更多時間才能解釋。我 們會找有技術能力的學生,再花時間以 Methode 系統,訓練他們如何處理字 型。我想看到應徵者的作品集展現出對 字型真誠的興趣,這樣未來在工作上才 能討論得更深入。

我們尋找的人才都有不少文字編排經驗,或至少能對字型設計展現出熱情(即使是木活字),才能和他們討論細節。畢竟在《泰晤士報》,無論是紙本或數位、資訊設計或動畫,做什麼事情都和字型脫不了關係。

你希望應徵者具備什麼專業能力?

最好要了解或至少能夠鑑別網站的基 本程式碼如何運作,目前的程式碼包 括 HTML 5 與 CSS。我們不會要求設 計師親自處理程式碼,但必須知道網頁 是怎麼做出來的。知道如何處理有大量 數據、圖片與圖像的文章也很重要。現 在資訊圖表是很常見的說故事工具,各 機關與政府都喜歡用這種方式來分享 數據,這對設計師來說是好事。設計師 要能獨立分析新聞,或許可利用布局圖 或動畫,將故事化繁為簡,在設計平板 電腦版本時尤其需要這項能力。編輯設 計師無法光憑會編排圖文就打遍天下, 還得運用許多格式來說故事。如今我們 必須十八般武藝樣樣通,動畫、處理數 據與程式碼都要懂,同時不偏廢版型設 計、文字編排與圖片後製的傳統能力。

關於字型設計的迷思

刊頭一定要放在封面的最上方。

這原則源自於雜誌只在店面或報攤販售的時代,當時雜誌在展示時會層層重疊,因此刊頭必須出現在封面的最上方,才不會被擋到。如今許多雜誌是仰賴訂戶而不是零售,情況已有不同。不過,封面最上方仍是刊頭最理想的位置,符合閱讀邏輯,並展現權威。

欄寬和 x 字高 (x-height) 要能搭配,一行的字數不能過多。

這是個關於「易讀性」的問題,不妨閱讀相關書籍,例如貝蒂·賓斯(Betty Binns)的著作《改善字型》(Better Type,Roundtable Press 出版,Waston-Guptill,1989年)。x字高是指某小寫字體 x 從基線(baseline)到中線(meanline)之間的高度。不同字體即使字級相同,x字高未必一樣。如果眼睛閱讀太長的一行字,就不容易拉回原來的位置。因此就一般規則來說,每一行要保持適當的字數才好。

標題應該盡量避免壓在美麗的新聞攝影上。

如果新聞圖片和藝術品一樣珍貴,標題盡量不要壓到圖。想想看,藝術家的大作若出現在雜誌上,卻被標題壓住,藝術家肯定很不高興。圖片上有文字原本是無可厚非的,文字若讓圖片更搶眼,為畫面加分,這樣的文圖結合才是精彩的設計。可參見洛伊斯的《六〇年代封面設計》(Covering the Sixties, The Monacelli Press, Inc. 出版,1996年)。

別用黑底和反白字,讀者不想讀。

這是因為精美刊物往往採用 CYMK 四色印刷 (分別指青、黃、洋紅與黑),圖片的「黑」至 少加了點藍色油墨,有時還會加上洋紅與黃。 在印製過程中,由於印刷機套色可能不準,小小的反白字體就會顯得模糊,導致讀者無法閱讀。

(套色是彩色印刷機的印刷方法,以確保顏色對 齊,印出清楚銳利的成果。)

標題應占據頁面最上方,但不能跨到裝訂邊的留 白區。

這規定的起源於文字編排講究階層性的時代,以 幫助讀者一步步消化內容。然而現在閱讀管道很 多,非傳統刊物未必需要遵守這條規定。平板電 腦版本的頁面可在直式與橫式間轉換,標題可 能移動,也可當成瀏覽內容的連結,就算標題位 於頁面底下,也可以自由縮放。雜誌因為需要裝 訂,因此厚的銅版紙刊物會有 12 公釐(半时) 的訂口空白,這地方不該放內容。多數雜誌使用 膠裝(用熱熔膠把裝訂區黏合),如果刊物很 厚,標題就不能太靠近裝訂邊,以免字母陷入訂 口而看不見。但數位版本或採用騎馬釘裝訂的雜 誌,標題延伸到訂口空白也無妨。記得站在讀者 的立場想想。

REF

字型設計的參考資源

網站:

關於印刷字體與數位螢幕字體的說明

艾麗莎·費登(Alissa Faden) 與艾琳·路佩登(Ellen Lupton) 的「Opinionated Font Facts, Research and writing」。這網站 可連結到路佩登的著作與普林斯頓建 築評論(Princeton Architectural Press);www.thinkingwithtype.com

想更了解閱讀心理學

《辨識文字的科學》(The Science of Word Recognition),凱文·拉森(Kevin Larson)著,Advanced Reading Technology, Mircrosoft Corporation 出版,2004年7月。www.microsoft.com/typography

參考書:

《閱讀的過程》(While You Are Reading),傑拉德·翁格(Gerard Unger)著,Mark Batty Publisher 出版,2007年。

《字體的詳情》(Detail in Typography),約斯特·賀朱利(Jost Hochuli)著·Hyphen Press出版,2008年。

圖片處理

設計師處理圖片的方式深深影響刊物質感。以 前報紙以文字內容為主,現已逐漸走向以圖片 為主,圖片用量大增,即便是新聞報導也比以往 更加仰賴各種圖像(包括圖表、插圖與圖像工

布洛狄在設計 1981 到 1986 年的《The Face》時,曾在文字編排與版型上嘗試激進的實驗。他受到構成主義與達達主義(Dada)影響,打破許多文字編排的常規,凸顯個別單字與句子,並在同一個單字裡使用不同的字母大小。上圖是 1986 年 1 月號的封面,封面人物是歌手葛麗絲·瓊斯(Grace Jones),由尚保羅·古德(Jean Paul Goude)拍攝。

具)。不過報紙與雜誌在使用圖片時,仍有根本上的差異。賈西亞說:「刊物性質不同,用圖重點也不同;報紙用圖要傳達即時性,雜誌用圖較比較重趣味。」後製程序與預算也是重要因素。和雜誌相較,報紙花在圖片的時間與經費只是九牛一毛。

關於藝術指導的迷思

封面是雜誌中最重要的頁面。

封面確實越來越重要。如果封面無法吸引讀者, 內容再怎麼辛苦製作也是枉然。電子雜誌的封面 更是刊物的入口,也是強化品牌的首頁。在網站 陳列上,雜誌封面會被縮得很小,所以封面必須 格外努力製作,即使是小尺寸的封面縮圖,也要 讓人留下深刻印象。

編輯設計師,只能聽命於文字編輯。

在創意流程中,設計師是編輯的伙伴,和編輯保 持平等地位,有助於激盪出更多火花,讓平凡的 刊物內容變好看。最佳的編輯設計團隊組合,要 能彼此尊重合作。

每張圖都需要圖說。

若希望讀者了解圖片的含義,就需要附上圖說。 但圖片若是用來裝飾,則不需圖說。圖片要標示 出攝影師姓名或圖庫名稱。違反著作權的設計絕 非好設計,務心避免。

花錢製作原創攝影或插畫是值得的。

設計師都樂於製作有原創性的設計,若預算足以找尋新素材,不妨為雜誌製作獨特的東西。此外,付給原創作品的費用,應已包含日後再使用圖片的權利。因此,出版商可著手建立能重複使用的圖像資料庫,時尚與生活風格雜誌甚至可利用自家圖庫來賺錢。

運用網路上的免費圖片,是未來的趨勢。

首要之務應該是做出獨一無二的產品。製作有創意的圖片雖然所費不貲,但好處很多。網路上的

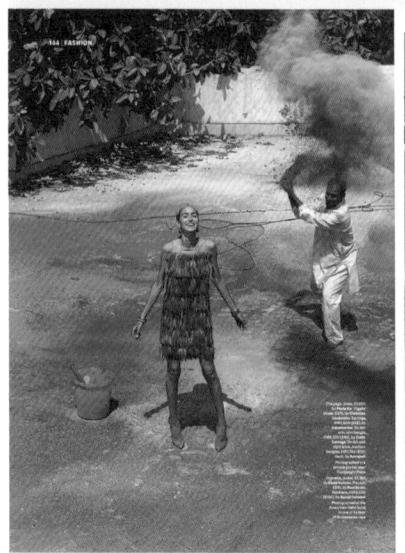

這是《Wallpaper*》的《Reborn in India》(在印度重生)特刊中所刊登的時裝照片,畫面充滿色彩與動感。照片於印度色彩節(Holi)期間拍攝,《Wallpaper*》網站上還可以看到影片。滿版照片大大強化了雜誌的特性——在這個例子中,這系列攝影彰顯了雜誌對不同文化與國度的好奇。

在 iPad 的單頁(非跨頁)瀏覽模式下,單張靜物攝影能展現出不凡力道。在這張《Port》雜誌的時裝照片中,呈對角線擺放的長椅與 iPad 產生有趣的視覺互動。這張精彩的服裝攝影,捨棄常見的去背手法,透過場景安排,如實呈現出大衣的硬挺質料與故事性。

免費圖片可能到處出現,缺乏新意。此外,運用 網路上的圖片時務必標明出處,也要仔細確認是 否真的沒有版權問題。

留白空間在雜誌上不受歡迎。

若留白空間能增加氣氣,營造視覺張力而提高內容故事性,那麼留白空間就有價值。如果留白空間只是拖長文章與充頁數,就沒有意義。179頁的《Émigre》雜誌與《RayGun》雜誌,是運用留白空間,創造出活潑視覺的好範例。

運用照片

好的新聞攝影能以圖像來報導或說故事。如今攝影技巧與風格五花八門,編輯設計師因而有諸多選擇。即使礙於經費,無法委託攝影師拍照,公關公司或是報導對象所提供的照片,在編輯、後製後,也很好用。委託攝影師幫報導拍出特定風格的圖像是第一步(190頁會談到如何成功發案)。雖然照片的長寬比多半是固定的,但設計師可裁切、變形、調整色調或用其他方式修圖。這都是圖像編輯工作;文字編輯會刪改文章,同樣地,藝術指導也可調整刊物的圖像內容。

不僅如此,如果編輯設計師希望透過照片,呈現不同的報導角度,可以刻意不事先告訴攝影師任何資訊,這麼一來,可能使文圖產生迥異的詮釋,發揮一加一大於二的效果。報刊除了透過文字編輯來塑造觀點之外,也可以透過設計來闡述。文圖的選擇、結合方式與相對位置,及以暗說「告訴」讀者他們看到的是什麼,能強烈暗玩出或許並不存在的「事實」。此外,修圖技術留政事實。因此,美術編輯、圖片編輯與攝影師,能使一則報導呈現出千變萬化的詮釋。麥克·瓦茲(Michael Watts)曾長期負責《金融時報》增刊《金融時報商業雜誌》的編輯,他回憶起當時的經驗時表示:

《Metropolis》的前藝術指導拉濱 說:「2001年12月號,是我們在 911之後首度出刊。這本刊物有 兩、三個月的前置時間,送印前, 雙子星大樓遭毀的照片已四處充 斥。我們決定不再刊登任何雙子星 大樓遭毀的照片,而是把這空間用 來紀念過往,展望未來。」這張尚 恩·漢莫瑞(Sean Hemmerie) 拍攝的照片,完成了這項任務。

好的攝影作品是雜誌圖片的基本要求,但也少不了能引發共鳴的適當裁切、縮放、位置、色彩與紙張考量。左圖選自《Twen》雜誌,就是一張裁切出精彩效果的好圖。

The Guardian declaration of war

「有時我和負責這份週末報刊的茱麗亞·柯 斯柏森(Julia Cuthbertson)會意見不合。 她希望雜誌保留經典的內容編輯,例如美食 與餐廳評論,但我們想要活潑、新穎的東 西,以呼應網路公司的榮景以及新潮的企業 地位。所以我們會耍點小手段從視覺上來 顛覆傳統,例如在美食版,別人都是拍煮好 的料理,但我們拍生的食材。我們的圖片編 輯卡洛琳·梅特卡夫 (Caroline Metcalfe) 為此找了幾位優秀的食物攝影師,尤其是羅 伯·懷特(Rob White)。有一次,我們把瑪 麗恩·麥吉華瑞 (Marion McGilvary) 風趣 的評論,搭配餐廳地圖及插畫風格的菜單。 這些元素結合之後,雜誌就呈現出與眾不同 的風貌,雖然惹惱了一些人,但是喜歡的人 更多。《金融時報》週末版非常有特色,我在 職期間的銷售量衝上25萬,成長20%。平 常沒看《金融時報》的人,也會在週末買來 看。」

雜誌裡的照片可發揮和文字一樣強大的力量,而報紙的圖卻往往只是用來輔助文字。然而,報紙設計已被雜誌悄悄地潛移默化,越來越倚重圖像的表現力。現在的報紙頭版常用一張搶眼的圖來吸引讀者目光,不靠文字就傳達出強烈訊息,2001 年 9 月 12 日《衛報》的頭版就是一例。

ROBERT CREELEY

ALKS ABOUT POETRY

In gone to write poems. Lorance astropate their occasion. I have add all the stelligence that i con-marke to federate the possible tool the poem "underhand." as Olion would any, in declaring, be I control antiquate the increasing vanishment of the activity, or can Judge on any tessee, in momental or string, the application of that writing more than to recipitate that in a being persented is creative. In the principle to any total, in writing, the application continue, I'm bright pay to you. In visible, a little all to have operational, do not in the activity, and that fact there is what I feel so deeply, the applicance of anyting their less faither than the control of the principle of the princ

the saled beauty state, which is that cleared an explore graphy, at the cuted in the sale and manage in the characteristical properties are an explore graph and the sale and manage in the characteristical properties are an input respect. In longs with, I was style of the writer properties are an input respect, to longs with, I was style of the writer aim. It was not, in a but respect, to longs with, I was style of the writer aim. It was not, in a but restricted in the writer aim. It was not, in a but restricted in a principle aim. It was not, in a principle aim. It was not, in a principle aim is seen of a speech and strength on the sale respective aim. It was not an additional aim of the sale aims and a strength in the sale aims and the sale aims and the sale aims and the sale aims and the sale aims are sale aims are sale aims and the sale aims are sale aims and the sale aims are sale ai

procedure were surprise, and whill, more precisely, they meand by it.

I think the maje supincular recovation for the surprise surprise with your processing the processing

Runheinz Stockhausen hos, as have many contemporary or poses, been preoccupied with the aleateric, or chance, ments in music. "Befalian for Three Players, no. 11" (iii) employs a circular score and a plastic stop which varies succession and intervals of entry of the notes written on here then evided for immerie from glu nestize him or friended in the world was the colonial solution for very very real of "Bestizent" state. Coming from New England, I had instructional policy basis to begin with Decease they wave for me of himself was designed and marker of transvers, even at times a privilege of intelligent designed and the state of the state of the state of the decease. I was very sky affect communicating any own commissions in residing, and with a state of the state of the state of the state of the sky affect communicating any own commissions in residing, and sky affect the state of the state of the state of the state of the sky affect of the state of the state of the state of the local private place way states good to two. It implicitly of make 100, it is a reason for each state or the State of the state of the 100 of the state—fine the state of the stat

Thinking of that, let me note kinship with another writer—Robe et Duncan—who has played a very important role in my fife, both as mentar, very offsen, and as one whom I feel to share with mat this porticular sense of world, and writing, and poetry, which most deeply respect. In a collection of his called The Opening of the Fault, samplinately enough. The first ocens begins:

Often I am permitted to return to a meadow

on if if were a scene made up by the min

that is mine, it is so near to the heart an eternal pasture folded in all though

that is a made place, created by light

This series of a poom—that place, that median—this side of so many things that are visited to my one seets, of so received the control of the

1967年7月的《Harper's Bazaar》 (左圖)刊登了一篇關於詩的文 章,搭配德國作曲家史托克豪森 (Karlheinz Stockhausen) 的樂譜 〈第十一號演奏者的副歌〉(Refrain for the Players, no. 11)。藝術指導 如絲·安瑟爾(Ruth Ansel)與貝 雅·費特樂(Bea Feitler)讓五線譜 與樂曲的優雅細緻與抒情畫面,和詩 的概念聯結起來,為文章製作出極佳 的視覺比喻。現今報紙比以往更常使 用插畫,讓頁面更活潑,也為報導提 供文字以外的詮釋。下圖為瑪麗安・ 杜查爾 (Marion Deuchar) 為《衛 報》繪製的插畫,頁面因而散發出生 動的氣息,構圖與色彩和下方的文字 呈現對比,營造出照片無法比擬的手 作感。左下圖擷取自 iPad 的頁面,插 畫家丹·威廉斯(Dan Williams)的 筆觸和俐落的文字達成完美的平衡。

Secret City

The Tailor New York

Comparing clothes is a pleasure, "wrote the photographer Edouard Levé, "buying them a trial." My feelings exactly, until a friend sent me to Kirk Miller of Miller's Oath, Wearing Kirk's clothes is indeed a pleasure. His suits, shirts and coats are beautifully cut, and the place is fun too. Kirk takes a sort of editorial joy in solving unusual problems in the most elegantly simple way. Last month I asked him for a suit that I could wear over a two-week train journey. The result, a light two-button corduroy, had strangers stopping me on the street from New York to San Francisco, and yet there is nothing dandified about it. It is the most comfortable thing I own—and was, from the moment I put it on.

INITIATIONS

[Man]

Miller's Oath

ILLUSTRATIONS BY DAN WILLIAMS

LINES LIMITATION DE UNITARION D

erect the store potels yearline profession and the profession potential profession potential year dispersion potential year dispersion potential ord an old village until year distribution potential out, a predicting uptilial code, predicting uptilial code, predicting uptilial code, predicting uptilial code, predicting uptilial code (and potential potential was been potential to distribution to not be foodbast the homested so no thought and core to be foodbast the homested and distribution to the block of carting patriality was verying arga, Staglmound are not giant Sco development of some control of some potential poten

"and they'll lick him silly."

What happens to the stag is that the huntsman walks over to it and prosaculy shoots it in the head with a special short-barrelled, folding-stock shot-

RED DEER ARE NOBLE ANIMALS -BIG, ANYWAY BUT RED DEER ILLES

Unus Si'll legally required. Speaking of Bittiain's laws, stilling wild mammals with the aid of dogs, as the Exmoco hant was trying tools, is forbidder: Stockey them — as understand the Husting Act of 2004—it is mandatory. The act contains certain conditions for exempt husting if was allow the killing of wild mammals with the aid of dogs—if are soon as possible after being found of finished or finished and the conditions for exempt husting if we have not allowed and the soon as a small after being found of finished and the soon as possible after being found of finished and the soon as a small problem.

person. As overting a go, even it it is among the Table Hanting Act came into effect on Perbuars 18 2005, a few weeks before this Exmour meet. 18 2005, a few weeks before this Exmour meet. 18 2005, a few weeks before this Exmour meet. 18 2005, a few weeks before this Exmour meet. 18 2005, a few weeks before this Exmour meet. 18 2005, a few weeks before the third the stage hunters were a doughty and resolute the third the stage hunters were a doughty and resolute the chairman of the stage hunter. Town Yandle: I went to Exmour with Adrian. We stayed with the chairman of the stage hunt. Town Yandle: I went to Exmour her over the Adrian. We stayed with the chairman of the stage hunt. Town Yandle: I went to Exmour her over the Adrian. We stayed with the chairman of the stage hunt. Town Yandle: I would have a support to the chairman of the stage hunter town the Adrian Yandle and Yandl

the stage of the s

from a van. There was a tense murmaning, a flor again gallers.

The stagloomed and stag tumoris trette. The stagloomed and stag tumoris trette. The stagloomed was also disclosed of frog constitution of the stagloomed and t

on yater to creek.

our, Adrian, and I headed back to Teer's farm in his have seen a pile disappeased.

been tool about the full creek. The form of a pack, It is a boulding of a pack, It is a boulding to creek. It is a boulding to creek the pack of a pack, It is a boulding to creek the pack of a pack, It is a boulding to creek the packed for your decays, and we wholed commenting tage.

a "where " is a pack, It is a bounding to creek the pack of the pack of the pack. The creek of the pack of the pack. The pack of the

anned by the Hunting Act. But rabbits can still be united. "Because they're considered peets," To did. "Because a lot of Jabour voters hunt rabbits, drian said, Also, for some reason, "the hunting haze which has been shor!" is permitted. The pack arced away from us across a broad file! The new went that way!" Tom shouted to the laster of the beaugh hounds.

"The shot hare!" Adrian shouted.
"The 'bush rabbit', you mean!" the ma

維珍航空發行的頭等艙機上雜誌《Carlos》除了中間兩、三個跨頁為銅版紙印製的全彩廣告之外,其他頁面皆以插畫取代攝影(右圖)。當時這份刊物的藝術指導雷斯里說,這作法「旨在跳脫由名人主導雜誌內容,以致於內容和視覺都變得千篇一律,可說是『後攝影時代』的作法!」

「如果不把織品和插畫結合起來 (右圖),就只能展示地毯樣布, 實在無趣。畫家克里斯多弗・尼爾 (Christopher Neal) 把布料和線 圖結合之後,達到多重效果。讀者 除了能看到賞心悅目的樣品,也能 看到產品的資訊,如布料的適用場 所(學校、辦公室、機場等等)。 我只提供克里斯多弗基本版型、每 張插圖的大略尺寸及每種布料該搭 配什麼環境。克里斯多弗就交出這 樣的內容,每張插畫都不必有太多 的說明。他將插畫成品寄給我之 後,我就決定在標題「EDGES」 (邊緣、銳利、優秀之意)要用手 寫字,以呼應他的作品。」——克 里斯維·拉濱,《Metropolis》前 藝術指導

The textile industry is reaching out to an intriguing group of designers that you wouldn't necessarily associate with its often staid and traditional products. Can the likes of Bruce Mau and Shashi Caan give contract carpet and fabrics a long overful makeover?

Westrations by Christopher Silas Neal

enterful. Case tags of the technique.
They indended the of it making to consider the order discovered to the consideration of the consi

運用插畫

波特在《衛報》任職時常採用插畫,認為「插畫是《衛報》重要的視覺元素。我們引介更現代的插畫家,確保報紙能散發清新的現代感。」編輯們若認為某篇報導需要概念性或較隱晦的詮釋、缺乏好照片或只是需要趣味性時,就會改用插畫,以展現不同風貌。插畫比照片更能傳達抽象感受,讀者也喜愛主觀地詮釋它們。當讀者看

一張照片,就沒有如此樂趣,往往只能解讀表面意涵,如照片中的是什麼人、穿什麼衣服,拍攝地點是哪裡等等。但是插畫通常能引發較有表達性與抽象的聯想,甚至比照片更能傳達出時代精神,還能更有彈性的支援品牌塑造需求。英國的《Illustrated Ape》就是只用插畫、不用照片的雜誌,《Carlos》除了廣告之外也只用插畫。

許多編輯設計作品會使用小插圖,不過,

《The Illustrated Ape》則完全以插畫為主角。這份刊物的編輯是克里斯欽安·派特森(Christian Patterson)與麥克·希姆斯(Michael Sims),設計師則是「看見工作室」(See Studio)的達倫·艾里斯(Darren Ellis),刊登的插畫作品出售許多頂尖插畫家之手,例如保羅·戴維斯(Paul Davis)。這份刊載許多詩歌與小說的文藝季刊是由作家、藝術家與插畫文字也常常圖像化,跨頁設計顯得相當豐富有質感,形成有智慧、連貫的整體,絲毫不落俗套。

ORDER TO ANSWER THAT QUESTION OF WHAT'S IT LIKE.

圖片裁切

圖片裁切、放大、重複,或是以特殊方式拍攝,都會對版面產生很大影響,營造出獨創性與意想不到的觀點。圖片經局部放大後,可集中讀者視線,凸顯照片精華所在,或在文圖之間創造有意義的對話,使文字與版面更具活力。如果用圖數量較多,文圖關係會比較複雜,圖與圖、文與圖之間的對話必須細心經營。美國工業設計雜誌《I.D.》是裁切圖片的高手,常把產品在頁面上放得非常大,即使是牙刷這麼平凡的日常用品,也能呈現出超現實的美感,獲得雕塑一般的特質,視覺上也很吸引人。微距攝影也能達到同樣的效果,能彰顯某物體的奇特曲線、形狀及花紋等平時不會察覺的特色。

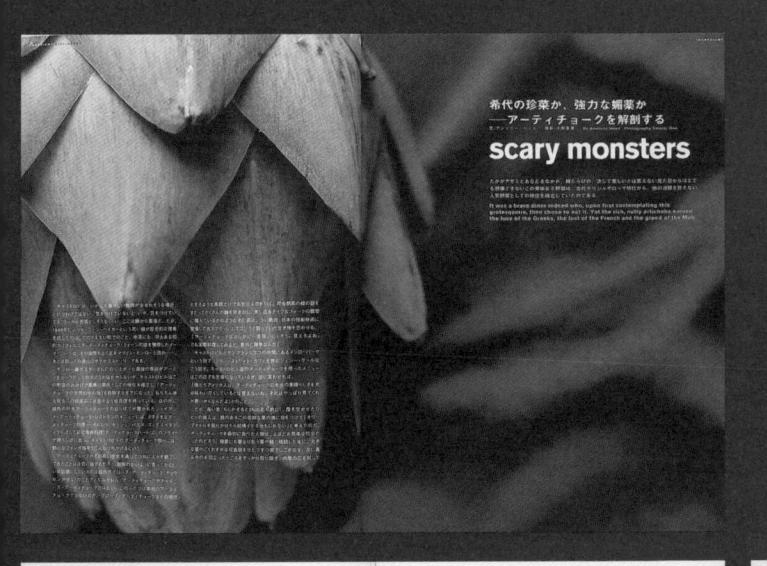

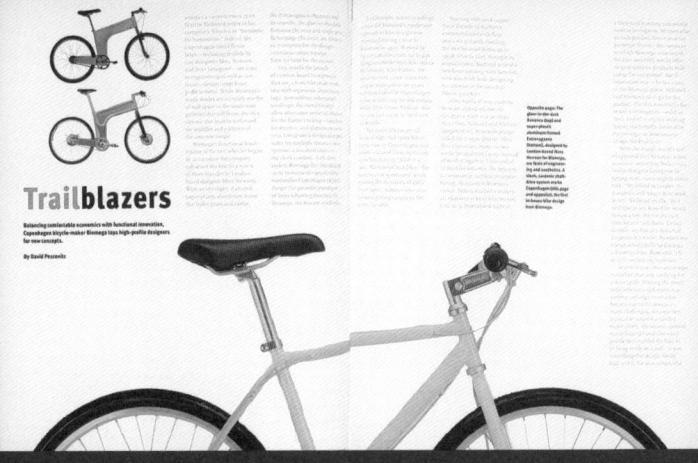

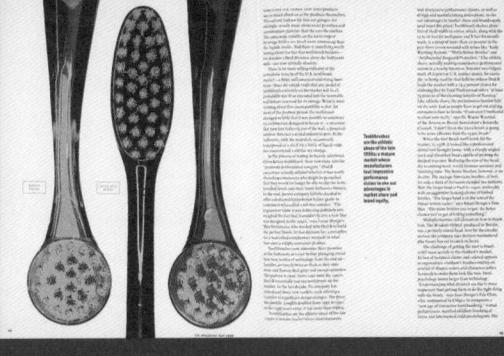

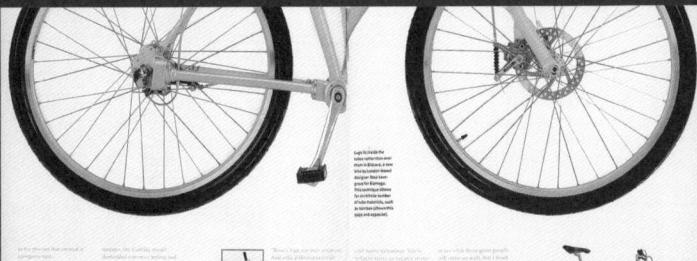

最上圖選自日文雜誌《Eat》,經近距離 拍攝出來的朝鮮薊,呈現出令人大開眼 界的藝術感。在《I.D.》雜誌中,單車圖 (左)大膽以兩個跨頁呈現,亦呈現出 流動性與延續性;在另一期中,牙刷成 為抽象的透明物體(上)。

Ambien and controller and the co

3

and colors for the plant of the colors of th

The section of the se

of biologications, and is acreg and administration of the control of the control

OVO

1.0. MAGRONI MAT COM

工作坊 3 **文字編排樣式表**

目標

為雜誌製作文字編排樣式表。

練習

為你的雜誌設定有視覺識別性的文字編排邏輯,想想看,字型該如何反映雜誌內容的哲學。首先,用兩、三種同家族的字體,搭配出標題字型、副標字型與內文字型。其他設計元素要成為這三種主要字型的手足。你之後可以把字體減少為一到兩種,但一開始保持開放的想法比較好。切記,如果你的雜誌風格大膽有力,就要選用能讓頁面充滿力道的字體。如果你的雜誌比較文靜,就要選視覺上較柔性安穩的字體。

 寫幾條標題與引言。探索一下首字放大的比例, 看看哪種效果最好。抽言用哪種字體讀起來最順 眼?把設計列印出來,貼在牆上,從不同角度審 視。將設計成果貼到素描本上,日後再來參考。

- 微調字距設定。幾乎所有的預設字型都需要微調 才會好看,電腦不會幫你審美,你得學著去感受 字型,看看字型的實際使用情況。觀察文字的構 成和實際樣貌。
- 你的目標是做一份文字編排的樣式表,以反映並 強化雜誌的概念,設計過程中一定要有十足的信 心才能順利進行。

以下是學生製作的雜誌範例。在這個例子中,學生運用圖像化的語言,探索以文字編排為主的版式,反映刊物意見——揶揄批判藝術學校的教育及生活形態。設計師喬登·哈里森-特威思特(Jordan Harrison-Twist)採用銳利的 Futura 斜體字當作標題字體,以聳動的封面來挑戰讀者。

071 Stand Out From The Proud I brase #6

08 | Stand Out From The Proud | Issue #01

"IT'S AMAZING, APPARENTLY ALL HOMELESS PEOPLE LIKE TO BE PHOTO-GRAPHED."

"You see, th' all about thought. Art carf be anything them been done before. And, you know, not everything is, like, beautiful. It's about capturing a moment that inspires or.. or excites. Like, I did a project on homeless people last year and I think it kinds, really opened everyones eyes to, to the plight of these people."

Like, sometimes you just don't notice homeless people, but if you take a photograph of them, it kinds forces people to think about it. It's like Live Aid or Children in Need.

"You know, it's all about perspective.
What we thought was ugly years ago,
now isn't necessarily ugly. It's just different. You put your personal philosophies into what you make, and that's
beautiful?

-24/02/12 - ananyreana

"I FIND
YOU CAN
OFTEN GET
TOO TIED
DOWN
WITH WHAT
THE WORK
ACTUALLY
MEANS."

Access and application galaxy and access and application galaxy and access an

Dels Miguel accument ogstås. Mikiminague di vetti erat Prakad has pulvitars ormars sempet. Non consequal horim quis och accuri am ogst insierdam siche accurit ham. Morecross el ekelend lochas Viramus also dell, sod conditione tam ligati. Morti see districta aggiet. Nom iremenlam blacid viverz. Cras vestibulam cursus metas. Dels tilenchast ritrigiti to aci porta. Nulla el laculis quam. Dusi libero and in elementum via ulaquet a, b'ècndum ai entin. Pin odius cursus morbeit mans, es mellur accurit morbeit mans, es me

Nunc ac tellas tortor, vitne lacini valli. Nulla facilist. Eltam at frin gilla ante. In at nulla lectus, quis cursus lurpis. Mauris a dul in mi conditmenium suscipit. Nulla facilist. Donce ipsum nis, vulputale non mattis at, dapitus quis forem. A pendized discontinues slow the frequenced nature of today's society and that there's convertity everywhere.

> pten, wd dictum urna viverra ut. Class aptient tacifs sociosqua ad intora bonquent per consistra nostra, per inceptos himenasos. Pellentesque damo diano, tincidant eget ultricos vdi, pulvinar st amet augua. Sed ventibulum ultricies consectetur. Ut eu sulfa magna.

Aliquam sollicitudin gravida volutput. Aenean rutrum adiptuding risus, wil hibendum eros cursus suscipit. Nunc metus lacus, adlyticing sed gravida et, imperdiet nec mt. Manomus nec mauris non eros gravida aliquam. Sussendhise potenti. Intesor sus

Jerlana Harmonas-Penna

Weirdy space page gives eyes has danking task of actually reading something as opposed to nodding symphantically at picture's

It contrasts to every other grid systems powlously used which makes the publiciat seem either rebellious, or consciously awase of his/ her choice of breaking convention, which makes the page seem even more important.

Even though & is only a few passgraphs and k is poshably the East visually impressive page on diaplay, you can't help keep sudless as known you are interested, and everybody can see you're interested, and hely it ain't too long so k's not tiresome, and you can more on fairly swiftly after finishing.

This section may even be tilted slightly to one side which is utterly meet at Though, these is a fairly simple uniform grid-syntem used, it is used in a dynamic way to sustain interest, regardless of the content.

or often bylogen Xarriston-Tlan

刊物內容多由哈里森一特威思特撰寫,他很善於批判,而視覺上也呈現出不遵循傳統的坦率感。這份雜誌運用雙色與線圖,強化刊物的小眾雜誌感。

Mind-blowing bubbles

Solution of the Guardian of th

interiors/property/design January 23 1998

Chapter 5:製作版型

前幾章談到,優秀的設計師與藝術指導不僅要對編輯設計有全面性的概念,更要對版面上的所有元素有深刻理解。接下來,要正式進入設計流程了。完美的版型沒有神奇的魔法公式,但有些考量會左右設計方向。前幾章討論過編輯設計師的角色、品牌與刊物識別、與讀者的互動關係;還有一些每期都不同的元素(時空、文字量、目標),及最基本的元素(字型風格、粗細、對稱性、圖像)也不容忽略。這林林總總的元素集結起來,就能歸結出設計一份刊物的指導原則。設計師如何詮釋、應用或刻意忽略這些原則,對刊物走向來説影響深遠。此外,設計師更要重視內容及其易讀性,妥善規劃內容在不同載具上的呈現。

版面的主要元素

右邊的版型是由兩個單頁構成的跨頁。版面上該 有的元素,有些在前幾章已從品牌與識別的角度 談過,但在這一章,將著眼於視覺效果與版面構 成來討論。右圖顯示版面構成元素和格線系統, 包含欄、欄間距、裝訂留白、白邊、頁首頁尾、 基線與裁切線(更多關於格線的資訊,參見第六 章)。

範本

在設計報紙和雜誌的新聞頁面時,不妨運用有彈性的範本。好用的範本能加速排版與製作流程,讓頁面與整體設計呈現一貫性,避免送印前的忙亂節奏導致錯誤發生。範本固然可簡化頁面製作,但也可能使設計受局限,因此要謹慎使用,以免所有頁面看起來一成不變。若想增加變化性,除了利用不同的圖像,圖像本身的裁切縮放和與標題的相對關係都可以多加經營。

範本的基本構成

範本的基本要素包括白邊(藍色)、欄與欄間距(綠色)、基線(粉紅色)、頁碼(紫色)與出血區。這份範本預設有六欄格線,但實際操作時,可依情況變化為兩欄、三欄或六欄的版式。白邊的大小會直接影響頁面有多少留白空間,且常受到廣告收入的影響,因為每一公分都可賣給廣告商。基線會決定行間的變化,進而影響字體大小,讓不同大小的字體仍可對齊。這個例子中的格線是以 9pt 的字體和 11pt 的行間為基礎,這表示其他字體的點數要能放進以 11 為倍數的行間。頁首頁尾則用來標示頁碼與單元名,引導閱讀。

右上圖的跨頁展示主要元素排入後的樣子。圖像、標題、引言與抽言可吸引讀者注意,讓讀者輕鬆快速進入文章。首字放大與頁碼可提示讀者閱讀進度,而圖說和照片來源讓文圖更有趣。這些元素再加上色彩、圖像與線條,就能讓版面有許多變化。

這個範本還能納入更多其他元素。右頁的第二張圖就 多用了小標、署名與簽名處。從這個例子就可看出同 一個版型所具備的彈性,這裡就只排兩欄,而不是上 圖的三欄,標題的大小與顏色也不同,遂能為這篇文 章打造出不同的外觀與質感。

The headline of this story

Intended to be read but have no meaning. A simulation of actual copy, using ordinary words with normal letter frequencies, it cannot deceive the eye or brain.

A pull quote intended:

To be read but have no meaning. The Prevention

A pull quote intended:

To be read but have no

analysis and the subgroups of picture in the subgroups of the subgroups of picture in the picture in the subgroups of the subgroups of the subg

FEATURE 13

The headline

A stand-first is a short summary of the following article allowing quick and easy access for the reader. Often it includes the Author's quick and easy access for the reader. Ofte and Photographer's Names as a byline

And Photographer's Names as a byline

This is a dissums seek. It is intended to be read from his were recovered with some letter frequencies, at a found secret seeks to come letter frequencies, at a found secret seeks to some letter frequencies, at a found secret seeks to come letter frequencies, at a found secret seeks to some letter frequencies, at a found secret seeks to propose the state frequencies, at a found and present a section, in any profess, at a shared seek and great at a feetine in any profess, at a shared seek and great at a feetine in any profess, at the secret seeks and great at a feetine in a feetine section of the section of

This is a typical subhead

依據頁面上不同元素的大小,把標 題拉很大或縮很小,讓標題位置與 頁面其他元素建立活潑的關係,就 能營造出視覺力量。圖像或標題文 字可靠正確的字體來統合,讓版面 看起來有整體感。上圖取自於《觀 察家報音樂月刊》(The Observer Music Monthly)的跨頁就是一 例。如果沒有主圖,標題的字體可 以設計得更圖像化,帶出視覺焦 點。大膽實驗,是設計出好標題的 關鍵如右圖的《Fishwrap》。這 個頁面運用許多裝飾性的字體,這 些字體是由插畫家與設計師特別製 作,有時它們也是雜誌的「獨家字 體」。

左圖為《Inner Loop》的跨頁,圖 像化的超大標題似乎成了圖的一部 分,和對頁整齊有序的文字欄位形 成強烈對比。有趣的是,設計師讓 文字齊底,於是文字框的上緣輪廓 就像都會天際線,恰好呼應左邊的 主圖。頁面下方三分之一處有一條 出血的水平線條,把不同元素聯繫 起來,貫穿整體頁面。

上圖的《國家報》與右上的《紐約時 報》,以兩種截然不同的方式呈現作 者署名,不同的風格能使讀者易於區 分單元。新聞評論通常很密,顯少 有留白空間,傳達出重要與正經的感 覺。如果是一般的評論與討論,署名 就可以占較多空間,還能找有意思的 抽言以吸引讀者注意。兩種不同的編 排,能使讀者一眼就看出前者是新 聞,後者是評論。

NICHOLAS D. KRISTOF The Race Is On

And the Favorite Is ...

A contest of titans: India vs. China

THOMAS L. FRIEDMAN

New 'Sputnik' Challenges: All Fueled by Oil

Bush's blindness puts our way of life in peril.

大標

大標的字級通常在版面上是最大的,激發讀者對 文章的好奇心而進一步閱讀。若能在進入設計階 段前就定好文章大標,有助於決定版面的設計方 向。刊物不同,版面的編排方式也不同,大標能 占多少空間有時是由設計師決定,設計師甚至可 能還有權利調整文章內容。無論是何種方式,大 標內容與視覺主題必須相互聯結,設計時要特別 講究一致性。

引言

和大標一樣,引言由審稿編輯撰寫,通常為四到 五十個英文字,太長就失去簡明扼要的功能,太 短又不足以傳達必要資訊,還可能導致頁面看起 來不平衡。不妨建立一套引言的顯示模式(或樣 式表),避免臨場發揮。不過,設計師也要懂得 保持彈性,不墨守成規。樣式表應視為指導性的 參考工具,而不是不能違背的硬性規定。

署名

知名作者的署名常會搭配作者照片,這種作法頗 受讀者歡迎,在報紙上呈現的效果也不錯。但若 用在雜誌上的專題報導時,要小心人像在跨頁上 是否會和其他元素格格不入。

主文

文字框的設定有很多變化,各欄文字可左右對齊 (文字填滿欄寬)、齊左或齊右。報刊通常採用 齊左或左右對齊,因為文字量大時,置中和齊右 **讀起來很累。**

此外,欄寬不能太寬,讀起來才輕鬆(參見156 頁的「易讀性理論」),但也不能太窄,以免留 白空間形成礙眼的「川流」(每個字中間的空 白,和上下幾行的字間空白連成一串,形成縱向 空白)。太長的文字段落可分段,讓整篇文章讀 起來賞心悅目,頁面更輕盈、平易近人。

製作階段接近尾聲,文章完成編修後,盡責的設 計師會手動微調主文,使之更美觀。設計師可微 調字距,把每行的文字拉近些,避免寡行(一行 只有一個字)或孤行(一個字落到下個欄位的 最頂)。也可用自動換行,讓欄位文字對齊得更 美,或插入連字號來避免不美觀的斷字或斷行。 設計師要注意整個文字方塊所呈現的形狀,並懂 得變通,讓文字區好讀又美觀。在每欄頂部或底 部的段落,至少要有兩行字。第六章會詳細說明 字體大小、行距與對齊。

The Guts of a New Machine

在新段落前使用小標、段首縮 排、行距拉大與分段,都能把文 章在視覺上分割,製作出較短 且美觀的段落,以免文字欄位過 於冗長,看起來密密麻麻。但是 《紐約時報雜誌》的前藝術指導 佛羅里克則建議設計師,不要怕 文字太長:「《紐約時報雜誌》 是給讀書人的雜誌,目標是在呈 現文圖時,讓讀者更深刻體會當 今的文化與政治力量。為達到這 個目的,寫手與攝影師的聲音就 非常重要,設計師也要服膺這項 宗旨。大量文字方塊所呈現的美 感,是設計師必須尊重的。如果 文字與搶眼圖像並置,只要能適 當使用留白,搭配強而有力的大 標,都能讓讀者有不同的知識體 驗。」

THE BEAB INTERVIEW

ting your heroes isn't always a good idea. I remember the first time I encountered old Bill Burroughs. He was ober and so outrage at my alrend state I had to pure his hair with a build te before he'd quit the serones. Something like a princi right enough. El suido at my alrend state I had to pure his hair with a build te before he'd quit the serones. Something like a princi right enough. El suido under themisgoury rolled over and cried for his mounter when I classific the systematic with configuration of a series of the state of the size of the state of the state of the state of the size of the state of the state of the size of the size of the state of the size of the s

So it's with a degree of trapidation that I agree to meet the writer's writer Robert Louis (prenounced Lewis) Seventather of Treasure Manuel, Kidangpud and The Strang-Clear of De John and Mer Fifte as well a wealth of poems, short six author of Treasure Manuel, Kidangpud and The Strang-Control of Treasure Manuel Control of Treasure Manuel Cont

We've arranged to meet in Deacon Bondie's, on Edinburgh's High Street. Severanon enters the ancient hostelry, becough forth through the magic of intenture, brushing the last of the Samona grave dust from his travelling in the Bondie storm at his approach, but Sociant's capital is seen to stranger sights than ghosts, and the drinkers merely nod, as if to a face they recognize but can't quite place.

I buy him a mail, then we take a seal at a corner table away from the flashing lights of the fruit machine. Loss is neck-thin, his mountance derops and has det eye shift in its socket. His hair is long, and I eresembler reading he could never about being hardware here has was ill. I side between and fixed is longly in preparations of this manifestation across the tables, wall for him to sell the first of the many smokes he drawn into himself over the afference, then begin no years of the first of the many smokes he drawn into himself over the afference, then begin my questions.

RLS

If you don't mind my saying you've a reputation for being bit morbid.

THE DEAD INTERVIEW

We'll get on to religion later: But you must admit you're on the gloomy flank of the fantastical. One of my favourite stories, The Body Snatchers, is about two medical students digging up a dead body for dissectio

The second state of the se

laboratory is an old di

(Waits for a wee compliment on latest novel)

You were at death's door most of the time.

[60] zembla magazine spring/susumer_two thousand and four

spring/summer_two thousand and four Zembla magazine [61]

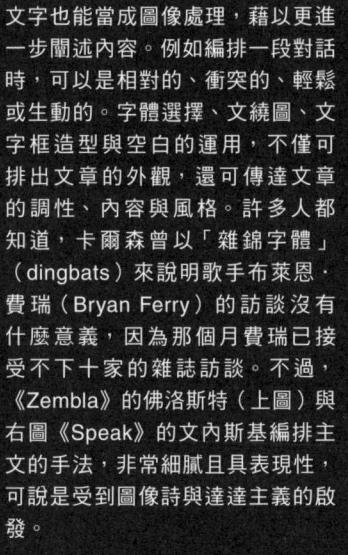

左圖是《fishwrap》雜誌跨頁,首字母 (放大下沉)恰好呼應大標,而斜放的大 標則將讀者的視線引導到主文的第一段。

首字放大不只滴用在文章、章節或段落, 還有更多巧妙的用法。下圖的例子取自 《紐約時報雜誌》,這篇文章是談論法國 猫太人在日益高漲的反猫太聲浪下,面臨 身分認同的危機。藝術指導佛羅里克把下 沉的首字母「I」分成兩半,以說明這項 危機,並呼應照片中分裂的大衛之星。

of vandalism and violence y French Muslims. For many 1 Jews, it has created a clima 1 ar — and an identity crisis.

在1980與1990年代,報刊的版面中常常只 有文字,透過文字編排與字體設計,也能順利詮 釋報導內容。要做到這一點,文字編輯與設計師 得密切合作,設計師要能主動地深入閱讀文章。 《Zembla》雜誌的佛洛斯特還曾把文字排成 特殊形狀,傳達出文章段落間的對話,並利用 印刷技巧,展現出「文字的趣味」(fun with words),也具體呼應《Zembla》的設計精 神:「如果不喜歡雜誌的內容,就不要設計!」

首字放大

「首字下沉」(drop cap)是開頭字母放大並 往下沉,而「首字強調」(initial cap)則是指 開頭字母放大但位於基線上。這兩種作法不僅能 標明文章的起始點,還可在段落中將文章分段,

The New Hork Times Magazine / NOVEMBER 30, 2003

Inspiration: Where Does It Come From?

By Arthur Lubow

This letter R
is made from the
pieces of plastic
used to hang a hat or a
pair of socks from
a shop display rack,
found in a London
shopping mall.

of his life, Isamu Noguchi, who straddled the boundary between art and design, created a sculpture garden in Costa Mesa, Calif., he was unquestionably recalling the manipulations of space and perspective in the Zen gardens of Kyoto and the geometric sculptures in the observatory in Jaipur. At the same time, he was thinking of the ways in which the sets he designed as a young man for theatrical stages had, through clever lighting and placement, made a constricted space seem vast. And he was acutely conscious of the function of this sculpture garden

of the products of other designers, but their attention is not so narrowly focused. When, near the end

Initial letters by Paul Elliman

避免整個頁面呈現單調的「文字團塊」。首字放 大可用在任何地方,作法上可把字母單獨拉大, 亦可把整個單字或符號都放大。選擇放大的首字 母字型時要審慎思考,必須與主文其他部分的風 格契合,其字型可和主文一樣,只是字級拉大, 也可採用完全相反的風格,例如把花俏的斜體字 和乾淨現代的黑體字並列。 佛羅里克為《紐約時報雜誌》設計 的版面中,誇張的首字放大是製造 衝突的元素,使原本和諧的版面出 現變化,吸引讀者目光。 抽言的呈現方式很多。將字級放大是幾 乎所有報刊都用的標準作法,但還有其 他更有特色的方式,讓內容更美觀。垂 直排列引言是較傳統的作法,可讓頁面 更活潑有力。也可放在空白欄位,以美 化留白空間,例如下方《Het Parool》 的跨頁。

NIEUWS

Vier avonden de Arena vol met seks,

seks, seks en show, show, shov

'Hij wil ons vermaken, niet meer, en vooral niets minder'

'Mijn zoontje hoor ik zeggen: Fuck Robbie!'

小標

小標通常位於主文中,常用的區別方式是字級加 大、加粗、用大寫字母、換顏色,或使用不同字 體。

引言、抽言或重點句

抽言和其他類型的「展示文稿」(display copy)一樣,由文稿編輯負責擷取或撰寫,但 設計師可對展示文稿的字數、位置與長度表達意 見。引言是頁面上的焦點之一,能用許多不同變 化引起讀者興趣。引言可用單引號或雙引號括起 來,只要用法一致即可。如果引用部分是來自文 稿,而不是受訪者或受訪對象所說的話,則通常 不用引號。抽言的設計方式很多(無論是否有引 號),例如把文字放到方框內並置中,也可另起 一欄,或讓文字橫跨整個跨頁,還可壓在圖上。 報紙經常用引言或抽言來吸引讀者注意。

副標、段標與眉標

這些元素可幫刊物的不同單元建立起架構,以指 出或強調某主題、章節或專題大意。副標可運用 線條、文字方塊、橫條、黑底白字或小圖示來提 高辨識度。眉標是出現在頁首頁尾位置的縮小版 標題,若某篇文章有好幾頁篇幅,眉標就該跟著 出現好幾頁,提醒讀者現在正在讀哪篇文章。

Unsere Stadt is Alles ist grau uger Augenblick.

Ein günstiger Augenblick, fangen.

Machen wir uns nichts voich weiß, was du über mich

ht, um ein paar Mann loszuen, die die Stadt wieder eingelt haben, als niemand in der war.

lich, lange kann es nicht dauern. Icht werden wir nach einer Weile in einen Kasten gepackt.

要讓轉頁續刊行(或轉頁箭頭)與頁尾小圖示醒目的話,可運用方塊、項目符號、刊名首字母或其他符號來強調。頁尾小圖示告訴讀者文章已結束,可讓人一眼看出文章長度。圖中《Twen》的範例即為很有巧思的轉頁行。

tönntest du so ganz zum schwach laufen lasehst, und ohne daß die

phery würde es freuen. machen, Clyde — mir in drei Farber blau – nachtb

Auch in der So und Österreich

EMINENC

45

除了抽言之外,還有許多方式可增加視 覺趣味,鼓勵讀者去閱讀某篇特別有趣 的文章。最上面《Twen》就用了許多 小圖示,例如小喇叭像在宣布某一欄有 值得一看的新聞。網站設計常運用各種 不同的視覺指標,紙本刊物設計師亦可 仿效,例如箭頭、按鈕與線條。

小圖示

如果刊物中的某篇文章延續到次頁或其他頁面,最好用「續下頁」或「續前頁」等文字提示讀者,也可運用指示箭頭來標示。這稱為轉頁續刊說明或轉頁箭頭,報紙則稱為「嵌條」(slug)。文章續刊到其他頁時,最好從最後一句中間或段落分開,若最後一句出現句點,讀者會以為文章已結束。文章的結尾最好以頁尾小圖示,清楚標示出來。

圖說

圖說通常出現在圖片附近或上方,說明圖片資訊 或為什麼這張圖擺在這裡,及它和整篇報導的關係。如果要加圖說的圖片數量很多,可在每張圖 上編號,另於頁面他處依序列出圖說。圖說可提 供主文沒有的延伸資訊,而報紙圖說通常較一板 一眼,很少出現和主文無關的氣氛圖片。

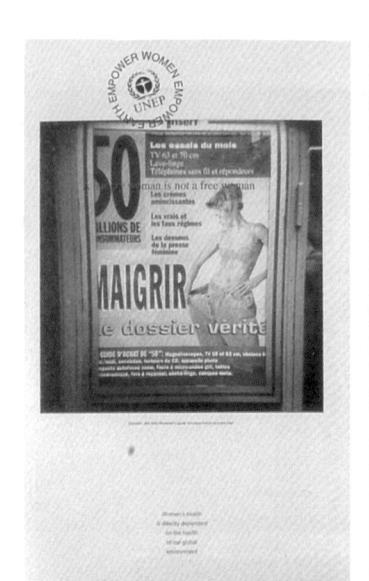

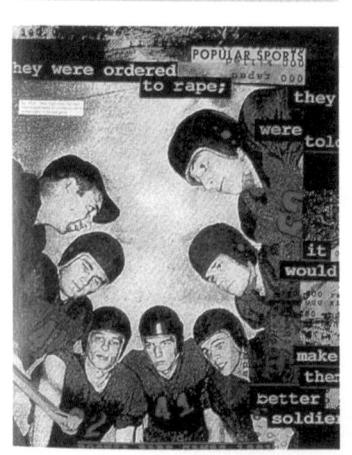

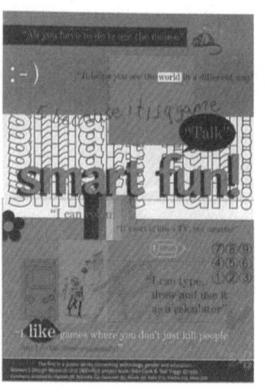

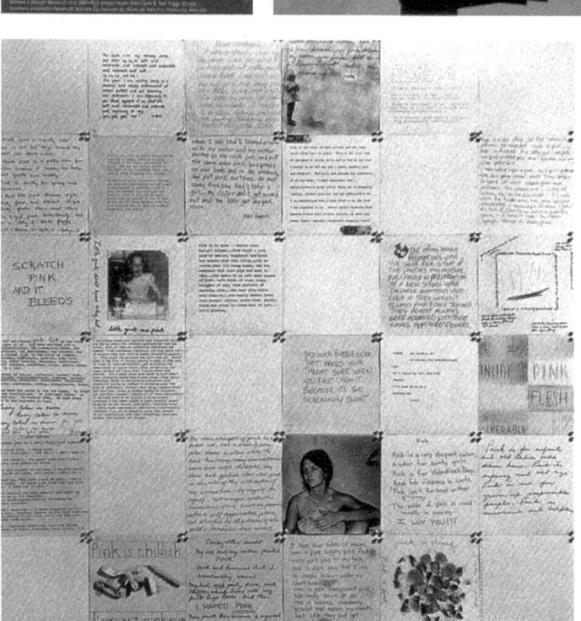

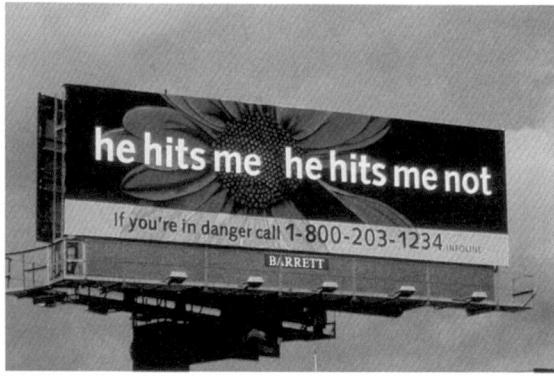

3 | Class Action, Yale
University: 'He Hits Me
He Hits Me Not'.
Billboard project
against domestic
violence
4 | Sheila Levrant de

hungry woman is not

UN World conference

on Women, Bejing,

2 I WD+RU.Team: Sián

Cook and Teal Triggs

'Smart Fun', 1996

Bretteville. 'Pink', 1974
5 | Sandra Kelch,
Cranbrook Academy
of Art. 'Bosnian Rape
Camps', 1993.
Postgraduate student
project

頁碼

頁碼可協助讀者瀏覽整份刊物,通常位於每頁的相同位置,例如右下角或中間,讓讀者方便尋找與參考。如果頁碼太靠近裝訂口,就不利於讀者尋找。報紙常把頁碼放在最上面,書籍的頁碼旁邊通常還附帶標出書名與章節。雖然雜誌為了刊登出血圖或滿版廣告,常常捨棄頁碼,但報紙不宜如法炮製(廣告例外)。能否方便瀏覽、快速找到報導位置攸關讀者的閱讀體驗,因此頁碼務必放在醒目的位置,才能幫讀者快速找到想看的文章。

圖片版權

圖片版權通常和圖片放在同一頁,可能垂直排列 在圖片旁,或放在頁面靠裝訂口的內側。但攝影 師若是知名人物,則攝影者的名字可能出現在署 名行,或納入引言中。

資訊框與邊欄

資訊框或邊欄文字常會用不同的線條、顏色、邊 線與欄寬來和主文區格,字體也常是有別於明體 的黑體。資訊框文字可放在主文附近,亦可獨立 編排。

圖像

圖像是頁面的重要視覺元素,設計時務必強調文圖的關聯。文圖的關係可以是文輔圖,也能是圖輔文,無論是哪一種,都應該要呈現有趣的對話。要達到文圖對話的方式很多,《Speak》的文內斯基說:「設計可用圖像詮釋文章……圖未必要直接說明文章內容,不妨構思視覺隱喻來搭配文字。」

圖片的剪裁、縮放、與文字及其他圖片的位置關係,都會透露出表情與故事。臉部照片的視線若

《Fishwrap》很重視跨頁的視覺效果。 上圖以創意圖表,把各頁的圖片來源列 出,並放在整本刊物的前面。這方法不 僅容易找到圖片來源,也表示圖片版權 不一定要放在圖片旁邊,避免破壞頁面 的整體設計。

圖說的編排方式很多,左頁的《Graphic International》頁面為圖說分布圖。

設計師必須明白何時該平實直白的使用圖像。《Metropolis》的拉濱有一回要製作古巴現代主義建築師馬里奧·羅曼尼雅克(Mario Romanach)的跨頁,然而羅曼尼雅克在美國並不知名。拉濱說:「我刊登了許多羅曼尼雅克的建築作品照片,不太在意版面設計本身能否呈現現代主義的特色。他在美國名氣不大,但他的建築作品本身就已經非常能展現現代主義。有些圖我調成紅色調,表示這建築面臨危險或已毀損。」

How Do We Begin Again?

ARCHITECTURE < CULTURE > DESIGN
December 2001

PARTITION OF THE STATE OF

朝向書背,會呈現和諧感,朝外則會帶領讀者的 視線離開頁面,製造張力。若兩張臉部圖片的視 線朝反方向延伸,張力就更強。一張平凡無奇的 圖片若放得極大,更能吸引讀者,畫面的細節可 能變得抽象,而引來好奇或驚喜。

「我們在911之後出的第一期,圖片 編輯莎拉·巴雷特(Sara Barrett) 找到雙子星大樓北塔在 1972 年興建 時的照片。我把照片加上天藍色,讓 照片散發點希望的氣息,其他部分完 全沒有更動。這張照片成功引發許 多來自建築師和一般大眾的共鳴與 迴響,許多人依據自身經驗,為照 片賦予許多意義。照片回顧過往,也 對未來提問,畫面中的北塔遠看像是 殘骸,但近看會發現是工地照片,搭 配文案:「我們如何東山再起?」提 醒讀者思考反省。就連卡爾森也問我 是怎麼修圖的。但我們除了加了一點 青色,其實沒做什麼。」——克里斯 維·拉濱、《Metropolis》前創意指

THE EMPIRE STRIKES BACK

IMPERIAL VENICE MIGHT BE DEAD, BUT THE REPUBLIC OF THE INNER LIFE FORGES AHEAD. HERBERT MUSCHAMP REFLECTS.

Photographs by MASSIMO VITALI

spy for dead empires.

It's my way of coping with dimperial ambitions of the Iring, I say fee Verice, Vernas, I starbal air grimpe.

American tourists, sip drinks on the terrace of the Gritti Palace and wave to passing groups of fellow agents disguised as Germans, Britons and Japanese. We'll wink knowingly at Russian impostors and counterfeit Swiss. No one will be the wiser, exceed possibly ourselves.

The dead imperial cut is a globul put unto itself, an international state of mind built and operated by the curious and doubfult is its her republic of the inner life. Let others struggle to become superpower. We prefer the underpower, in superunderwear. Our undercover mission is to form alliances and pacts with the poets and dreamers who have preceded us. We work for them.

Of all the great imperial cities, Venice is the most intact. Its enduring integrity is as scandalous as the fact of its existence. A swamp is not supposed to produce a

St. Mark's place: embracing the clické of the Venetian tourist at Piazza San Marco.

prachen Sie Deutsch?

"Statil have to if yeu're looking for information about photographer Walter Scheles, Even a search of the Internet—thetriving repositery of the ephemeral, arcane, and trivital—yields onlyfertness lampage test. In this fast-moving, sheet-authention-again order, Schele is a photographer has follows his own path—thesis and

mainisations be damined.
Born in sygle in Landslivat, Germany, Schels worked as a shep velodow decorator for almost a decade before taking up the camera for a career in freelance phistography in mid-You New York City. Schels was primass soo formal for the Durgeaning school of stores shooters domfiling far love decades in Manich where he lound his shift at portraltave. Revely published with an English text, Schols' texts perfolios, Animal Phytothis, chiestal fee for la select proving variationed separal are confer primate by Fellow German Albert Renger-Prizaco. Unles "Silver Baboos", Schols' anisphilol, provincipili portratte reduce philosophysis William Wegman, bita nuede carrier piese, to a circum variation by companions. Schols' accomplishments is perhaps better understood by this German Utile. The Saul of Animas, Call him for C. G. lange of the animal Maghem—Live only a small acceptance.

Walter Scheis: Animal Portraits (Die Seele der Tieve) is published by

12/20.07 FLESHET

紐約時報旅遊雜誌《T: Travel》(上圖)只用一張照片,就傳達出威尼斯的陽光明亮燦爛。「我喜歡這張馬西莫·維泰里(Massimo Vitali)拍的照片,靈感雖然來自十八世紀畫家加納萊托(Canaletto)的散步,但卻很現代。文字編排也記樣的氛圍,以 Fraktur 字體做出這樣的氛圍,以 Fraktur 字體做出這樣的氣圍,以 Fraktur 字體做出過美的「I」。形式布局很不錯,自沒有很好的景深,適當運用留面很對時報,這一一珍妮,佛羅里克,《紐約時報雜誌》前藝術指導

左圖選自《Flaunt》雜誌,這張跨 頁透過朝左看的驢子臉,營造出很 強的張力與流動感。讀者的視線可 以跳脫頁面限制,自由移動。

傑瑞米·雷斯里 Jeremy Leslie

接下來的訪談中, 雷斯里要談談紙本與數位刊物中的藝術 指導角色。

雷斯里在 1980 年代任職《Blitz》雜誌,之後曾在《衛報》、《Time Out》、《M-real》等刊物工作,多年來致力於透過各種出版品,探索視覺傳達的魔力。1999年到 2009年,他在約翰布朗媒體公司(John Brown Media)擔任創意總監,在這段期間,客戶雜誌恰好成為最具創意、有活力的產品。

熱愛雜誌的雷斯里架設了知名部落格 magCulture,並且於 2003 年出版了同名書籍《magCulture》。magCulture 曾獲選年度最佳設計部落格,而雷斯里還擔任 magCulture 設計工作室的創意總監,同時為《Creative Review》撰寫文章。他是英國編輯設計協會(British Editorial Design Organisation)的創會成員,也擔任美國出版品設計師協會(Society of Publication Designers)的評審。magCulture 同時是刊物內容顧問公司,近年作品包括《Port》雜誌數位版。無論刊物的經營模式與最終版本為何,雷斯里都抱持熱忱,這份熱情也促成他擔任獨立雜誌研討會「版權頁」(Colophon)的共同策劃者。

平板電腦已上市幾年,設計師是不是比較能掌握細節了? 其實在不同的媒體上操作編輯設計的原則,目前仍沒有所 謂的標準。不過,大型出版公司內部編制的設計團隊,會 將過去用在紙本的作法加以調整,應用到網站、手機與平 板電腦上。

大型出版商紛紛建置龐大的內容管理系統,是否是為一種 趨勢?

理論上這是必須要做的事。無論你喜不喜歡,大家都說我們做的東西是「內容」,我們或許聽不習慣,但這就是現況。「內容」聽起來像陳腔濫調,不過,現在編輯設計師處理的確實就是內容。科技最終要處理的也是內容,手機就是個好例子。比方說,我們得思考該怎麼在小小的螢幕空間與幾種有限的字體,幫《衛報》做出與眾不同的識別?

iPad 的問題在於,每種刊物看起來都一樣:大小相同、 外表也一樣漂亮。大家常說平板電腦雖可以觸控,卻摸不 到實際的東西。iPad 很明亮,看起來光鮮亮麗,但要不

是開著就是關掉,不會因為你在哪裡而有變化。紙本就不同了,可觸摸、可嗅聞,每種刊物大小不同,容易分享,可撕下來傳閱。大家急著用 Twitter 分享東西,不就是這麼回事嗎?我不是守舊派,但我們必須承認其間的差異。

你在的客戶雜誌的設計成果有目共睹;如今過了十五年, 你又轉向數位平台發展。

客戶雜誌曾經很有創意,是紅極一時的行銷宣傳手法。公司一旦發現客戶雜誌的力量與接觸範圍,就能明白好的客戶雜誌能做出什麼貢獻,也使客戶雜誌的存在必要性獲得認同。只是,如果考量到成本風險,再有趣的點子也會被潑冷水。公司打算在雜誌上花錢的前提是要獲得相對報酬,這會使得行銷手法趨於保守,於是創意就流失了。客戶雜誌曾挑戰雜誌的種種可能性,我很慶幸自己在那段期間能投身其中。

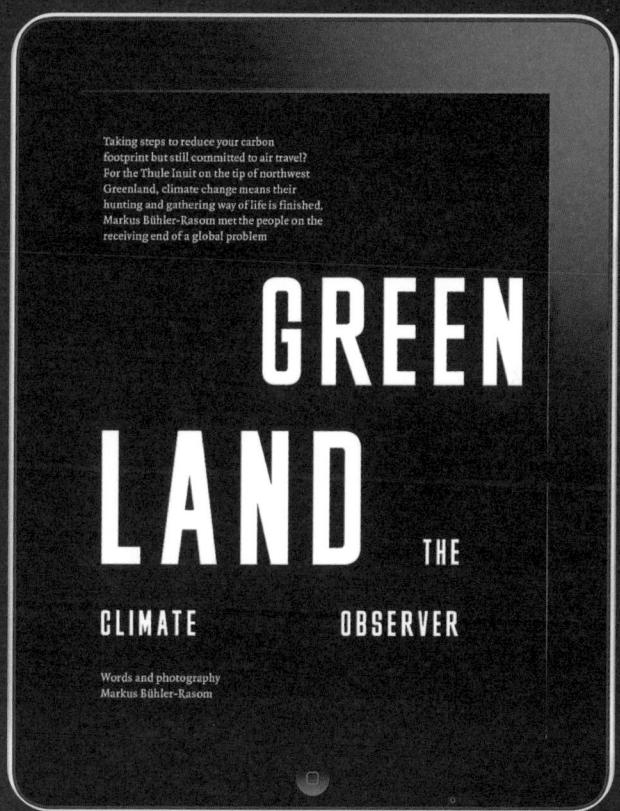

是數位科技的進步促成這變化的嗎?

數位工具促成了最初的變化。只要運用數位工具,便能立刻看到數字,衡量雜誌是否「成功」。但客戶雜誌能幫品牌打造出正面的光環,引來媒體報導、贏得獎項,這些效果卻是無法衡量的。

一旦開始分析,就會失去創意。只要開始衡量、想知道有多少點閱次數,賣出多少橘子或機票,那什麼東西都要講究和獲利的關聯。接下來,就會對紙本雜誌的功能抱著不同於以往的期望。創意雜誌的焦點就改變了,從講究創意變成在商言商。現在的確不一樣了,任何策略都只能討論獲利與否。

這樣看來,你覺得數位科技讓刊物本末倒置了嗎?

是焦點轉換了。你可以理解公司的出發點,許多主流雜誌是機能導向,不敢承擔風險。不過我還是認為品牌的調性不能光靠產品,雜誌的優點在於能創造出自己的世界.....。

現代人較少購買與閱讀雜誌。但如果買了雜誌,還是能沉 浸在雜誌的世界裡,而雜誌的世界是個很好的行銷空間, 甚至以細膩的方式幫忙擦亮品牌。如果技巧高明,就能提 升別人對你品牌的正面感受,在不知不覺中有深度地詮釋 品牌,那是步調倉促的廣告所無法企及的。

以經營模式來說,大公司有本錢去投資公司專屬的客製 化系統,但是中型的消費類雜誌的前景,是否可以這麼樂 觀?

數位雜誌多半潰不成軍,不少大型出版商砸下重資,即使不是大筆資金,也耗費了許多時間與資源。數位雜誌的發展仍在非常初期的階段,雖然不乏優秀的創意之作,但雜誌 app 仍面對許多困難。其中一個是行銷,怎麼讓讀者找到你的 app ? app store 和實體商店裡的書架陳列完全是兩碼子事。

多數獨立雜誌根本負擔不起 app 的製作費用。他們的經 營模式已很吃緊,只好利用其他模式。《Monocle》乾脆 完全放棄開發 app,直接投資廣播室,製作線上的有聲內容,成效也相當不錯。

小眾雜誌除非夠幸運,否則不容易賺錢,只有極少數找到 利基市場才能獲利,例如《Anorak》。《Anorak》還分 拆成許多事業部門。

《Fire and Knives》決心不發展數位,雜誌工作人員都不支薪,所以成本打平。但是每個參與過雜誌編輯的人, 日後會接到很多案子。

回顧不同的商業模式,我們可以學到什麼?

我們可以回顧《The Face》、《Blitz》與《i-D》,那一代的人在想:「我要做自己。」羅根打算推出《The Face》時找不到人支援,乾脆在廚房桌子上自己製作創刊號。泰瑞‧瓊斯(Terry Jones)離開《Vogue》,創辦《i-D》:《Blitz》原本是大學雜誌。那時因為主流雜誌沒那麼關注時尚與文化,這些脫離主流的雜誌推出時,造成很大轟動。而現在所有媒體都和大眾文化緊密聯結,要引起轟動就沒那麼容易了,到處都有一大堆資訊。

你的 magCulture 部落格創造出的社群是否還在成長?

沒錯,部落格接觸到的讀者範圍越來越廣,大家都喜歡和 有共同興趣的人聯繫。部落格或粉絲俱樂部其實和關注 特定焦點的雜誌差異不大,都是讓人相互連結。我是看 《NME》雜誌(中譯:新音樂快遞)長大的,《NME》 在我十幾歲時扮演的角色,就像我兒子今天在上的 Facebook,目的是和志同道合的人連結起來。只不過, 今天的連結方式比較快速簡便。

如今《Creative Review》之類的雜誌,在網路上閱讀 和分享的人比紙本更多,因此雜誌還得在每一篇部落格貼 文後面告訴大家,他們也有出紙本雜誌。

諸如《Cosmos》與《Company》這類中型市場的雜誌,現在有大量的 Twitter 跟隨者,且彼此互動頻繁。編輯會利用社交網站來推廣活動與特價促銷。如果你的雜誌沒在社交網站上出現,恐怕很難生存。許多人加入雜誌的社交網站,並非因為喜歡這本雜誌,而是想加入那個社群。

紙本與數位刊物的藝術指導,基本原則是否相同?

基本原則沒變,但有些額外的事項要注意。最基本的原則是,要很清楚自己想說什麼、說話對象是誰,以及要怎麼說。如今平面設計的視覺語彙已不同,就像語言本身也會演變一樣。最基本的編排原則是一樣的,不過視覺偏好會不斷變動發展。

許多人以為紙本和數位天差地遠,其實不然,除非設計師 主動讓這兩者的作法天差地遠。

編輯設計必須要能傳達與解釋想法,並讓讀者接受,所以 要先下工夫做研究。設計師必須懂格線和易讀性,不能把 刊物編輯當成只是在處理一塊塊文字區塊。一定要仔細閱 讀文章,才能作出回應。最重要的是必須嘗試最新的溝通 方式,才能找出對的語言。比如動態畫面在數位閱讀上很 重要,攝影師現在得改拍影片,那已是大勢所趨。

數位有何值得期待的潛力?

數位顛覆了一切,新報刊媒體的潛力要能真正發揮,比許 多人想像中困難,至少不像 iPad 剛上市時大家想的那麼 簡單。整個產業結構改變的速度沒有想像中那麼快。

真正值得期待的,是數位挑戰了原有的基本設計原則,讓 設計師從新審視編輯設計這門學問。在數位產品大量出現 之後,反倒衍生出不少令人驚喜的紙本設計。

所以我們還需要一段時間才能看出數位刊物的潛力?

數位裝置是新空間,和印刷雜誌不同,也不是電視節目。 民眾不會為了看雜誌而買 iPad,而是用 iPad 做很多別的事。設計師得思考使用者行為,他們都用 iPad 來做什麼?我們才剛起步,未來的路還很長。

版面構成的決定性要素

版面構成沒有必勝公式。基本上,版面構成最重視的就是結構邏輯、確實傳達與便於瀏覽。設計一個版面,往往必須考量諸多因素,包括成本、製作時程、與團隊在會議上的溝通,以及如何理想安排所有該放進版面的素材。許多因素並非設計師能掌握,例如預算、空間分配、頁數與時間限制。任何設計案都會遇到挑戰,如何設法克服困難,正考驗設計師的創意。

企劃與時限

刊物編輯總有開不完的企劃或進度會議。編務或 製作會議的目的,在於確定每一期刊物內容與專 題的重要性、估計並掌握每個項目或專題需要的 空間,並向所有相關編輯確認進度與工作狀況。 美術部門在企劃會議後,就能夠開始設計每篇 專題的視覺走向,並視需要來委託其他人製作圖 片或購買圖片。同時,編輯部門會著手研究、撰 文或邀稿;技術或美妝部門也要開始蒐集產品, 供測試與拍照;時裝部門要試裝與安排攝影。這 個程序不間斷地流動,因此必須持續評估各種資 料,視需求調整或捨棄。

庫克為《金融時報商業雜誌》設計的版面。這是一篇關於前保守黨國會議員強納森·艾特肯(Jonathan Aitken)的政治專題報導,庫克巧妙運用格線上的負空間,傳達這篇文章的宗教主題,也讓文字頁面呼應圖像,使整張跨頁十分完整。

TIP

設計的前置作業

設計從編輯部門蒐集文稿、圖片資料與任何 其他資訊,包括最新的落版單。不過,越接 近載稿日,落版單的更動就會越多,原因在 於可能又賣出更多廣告,或需要增刪頁面以 置放新收到的資料。

一定要閱讀文稿,才能設計出與內容想傳達 之事相符的視覺。

檢視所有圖片材料(插畫、照片與任何圖像)。品質是否可供出版?別忘了,數位照片的像素必須是300 dpi(每英吋點數)以上,列印品質才夠好。許多數位相機預設只有72 dpi,因此拍照前一定就要注意,而最佳列印尺寸通常會是照片原寸的四分之一。

確認已經取得所有樣式規範,包括版式、樣式表、配色與雜誌標準字等。

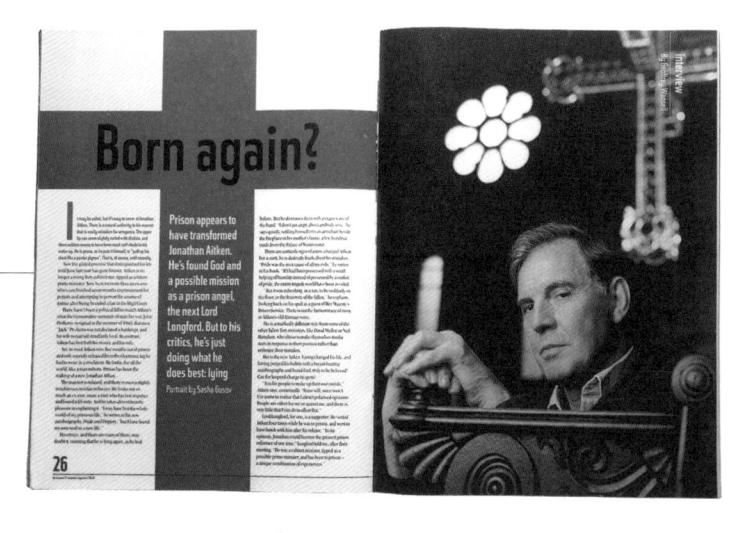

眼睛如何掃視頁面

雖然每個人掃視頁面的方式沒有絕 對的規則可循,但是運用圖像或 文字的視覺引導,可大致掌握讀 者的視線運動方式。以左圖選自 《loaded》的例子來說,讀者會 先看到版面上超大的 G, 因為它的 字級與顏色很霸氣,之後會沿著G 水平的襯線,延伸到足球員保羅. 蓋斯康尼(Paul Gasconigne)的 眼睛,之後才看到較小的引言。右 頁是選自《Het Parool》的例子, 這是個比較複雜的版面,不過讀者 會順著大照片中的男子眼神,延伸 到頁首標題,之後再看其他元素 通常會依循格線垂直與水平的 線條前進。

刊物的製作週期

美術部門的刊物製作週期,是從文字、圖片與插圖進稿之後展開。拿到這些資料之後,就要開始編排版面。若有圖,通常版面會以圖像為中心來發展;如果沒有圖,強烈的標題也可當作視覺焦點。各元素之間要避免衝突,務必不讓任何力道偏離主題或被稀釋,即使是空白區域也很重要。版面完成後會交給文稿編輯校對,視需要刪改。這時雜誌各單元的送印時間已確定,如果刊物篇幅較大,各單元的截稿日期不一定相同,會依照特定的次序送印,通常封面是最後送印的。各個單元(包含廣告)的完成時間,就是依送印時間而定。

現實考量

culzuur

Het PAROOL 29

Dromen zitten je geluk. 4 de weg

Belangrijke prijs voor

ORANIE Id. Goof mii maar Het PAROOL

De wortels en de 7 uchten van de meester

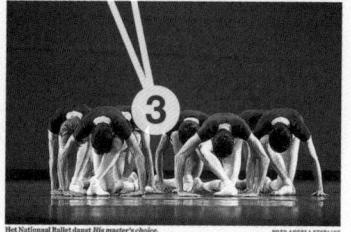

給廣告商,如果廣告出現增刪或移動,文稿也會 跟著刪除、增加或移動。這對設計可能產生很大 的影響,例如原本五頁的專題必須縮減到只有三 頁的空間。

主導設計方向的決定性因素:空間

現代讀者喜歡方便攜帶、內容豐富活潑,並且易 於快速閱讀的刊物。為了因應這些需求,刊物設 計可善加利用圖片、展示文稿、彩色標題、資訊 框、條列重點與表格。若遇到文字量大的內容, 可善用留白空間,避免版面看起來密密麻麻。這 些設計手法都會占去空間,然而編輯設計無非 務求文字、圖片與圖像元素的平衡。內容在發排 時,字數通常已經確定,然而如果一篇報導的文 字量超過太多,難以設計時,設計師可要求文稿

編輯刪改到合理的長度。有時某些專題必須在撰 文之前先設計版型,或完全由設計來主導、計算 合適字數,再請撰稿者依規範寫作。插圖的格式 也必須考量,若是網路上找來的圖,尺寸必須夠 大才能用,以免顆粒過大、模糊不清,破壞雜誌 風格。有時記者在寫文章時想要特別強調某些資 訊,讓文稿的概念更清楚,或圖片研究團隊可能 要求某張圖不能超過幾個欄位。種種要求可能在 最後階段臨時才冒出,勢必會要一再更改設計。

報紙的空間規劃,可視為一場水平與垂直的游 戲。二十世紀中期之前,許多報紙的標題為了要 與內文欄位同寬,會跑成好幾行,於是版面看起 來就是許多細長的欄位並列,不美觀也不易讀。 後來其他作法開始出現,例如常用更寬的欄位與 空白,加上小報與其他較小的版式興起,使報紙 朝橫向閱讀發展,如此就更舒適好讀。即使是比 較窄的柏林版式,設計師仍可讓標題或報導文字 横跨數個欄位,閱讀方向就更趨近於水平,而非 上下延伸。不過,若是採取垂直設計,務必要留 足夠的白邊或運用空白欄位,才能確保易讀性, 使整體頁面較輕盈,強化空間感與易讀性。

主導設計方向的決定性因素:形狀

圖文編排最終會呈現出一些形狀,這些形狀要能 符合刊物風格。波特形容這項工作是「把元素分 配到空間裡。」這些元素包括:大標、主文、圖 片與留白等。如何安排形狀,就會影響版面的好 壞。若運用得當,形狀的分布能引導讀者視線, 帶領讀者依序閱讀整篇文章,還能透過形狀創造 出各種感受與意義。

試著把眼睛眯起來去看一個版面,就會看出各 種形狀。文字框變成灰色方塊,插圖與照片變成 長方形或正方形, 偶爾出現不規則的去背圖片或 裝飾字型。繼續瞇著眼,看看這些形狀如何排列 起來,彼此連結成其他形狀,或形成鮮明的對角 線。留白區域也會有形狀。這些形狀會營造出平 衡、和諧或衝突感。形狀若有模式可循,有助於 打造出流暢的版面。

版面中的形狀彼此之間必須很平衡,和版型的關 係也要很恰當。形狀的安排與整合,是製作出優 良版型的關鍵技巧,而透過形狀的變化也可凸顯 出各元素的特色。若能適切地安排形狀,設計師 就能將讀者的視線玩弄於股掌之間,引導他們依 序去看有助於理解內容的各個元素。因此,老練 的編輯設計師能夠運用不同形狀的搭配,創造閱 讀趣味。

主導設計方向的決定性因素:古典比 例

無論是從實際案例或人類與生俱來的偏好來看,

DAGENS NYHETER.

iktatorns offer

● Skakande bilder inifrån våldets Syrien ● Flickan överlevde attacken som utplånade hennes famil

100000-tals

stockholmare

utan bostad 2030

"Ge näringslivet Jag hoppas på större ansvar för tvskarna yrkesutbildning

för deras

Segervissa "lag har svårt

att orka med polacker tror på succé min tvååring

瑞典《每日新聞》(Dagens Nyheter) 用新聞攝影來傳達力量。在這個例子 中,照片以繪畫般的構圖與低飽合度, 來減輕內容的恐怖感。報頭與頭條大標 的文字編排鮮明、有戲劇性。報導摘要 横過頁面下方,引導讀者進一步閱讀裡 面的內容。

The headline

This is dummy text. Intended to be read but have no meaning. As a simulation of actual copy.

Dummy settings which use other or even gibberish to approximate text have the inherent disadvan-tage they distract attention to them selves. Simultext is effective in any typeface, whatever size and format is required. Paragraphs may be long or short. Text can be to complete any area, as the copy is simply re-peated with different start points. This is dummy text. Intended to be read but have no real meaning. As a simulation of actual copy, using ordinary words with normal letter frequencies, it cannot deceive the eye or brain.

Settings may use languages or

the disadvantage that they distract attention to themselves. A simu-lation of copy, using ordinary words with normal letter frequencies, can't deceive eye or the brain. Simultext is effective in any type face, also at whatever size and format is required. Paragraphs may be long or short. What you see is dummy text. Intended to be read but have no real meaning. As a simu- lation of actual copy, using ordinary words with normal letter frequencies, can't deceive the eye or brain. Copy can then be produced to complete any area, as the copy is repeated with different starting points.

other languages or gibberish to simulate text have the inherent disadvantage that they can distract attention to themselves. Text is effective in any typeface, whatever size and format is required. Paragraphs may be long or short. Text can be to complete

any area, as the copy is repeated with different start points. Intended to be read but have no real meaning. A simulation of real meaning. A simulation of actual copy, using ordinary words with normal letter frequencies, it cannot deceive the eye or brain. Settings that use other languages or even gibberish to approximate text, have the inherent.

A three-line headline

that is an extra level

FEATURE 5

如何放置各個項目

文字的排列方式可以傳達訊息給讀 者,並影響讀者心理。一篇文章是 占一整個跨頁,或和其他兩、三篇 文章放在一起,能立刻告訴讀者這 篇文章的重要程度。上方的跨頁是 一篇文章搭配滿版出血的圖,有很 大的標題和引言,欄位很寬,有資 訊列表,運用強烈的色彩與許多留 白,希望能勾起讀者的興趣,讓他 們看下去。

相對地,下方的跨頁說明同一篇文 章若以不同方式來設計,就會傳 達出不同意義。文字從跨頁的由上 到下排滿文字,標題較小,欄寬較 窄,留白空間較少,因此這篇文章 的重要性就降低了。不過抽言、資 訊框、項目符號與字體顏色,仍有 助於吸引讀者的目光與興趣。

This is a headline and is intended to be read

This is dummy text. Intended

to be read but have no meaning as a simulation

The second story headline

in the hierarchy

using ordinary normal letter Another third story headline

The Masthead

03) It is intended to be read but have no meaning. As a sample of actual copy in a natural situation

25 h is intended to be read but have no meaning. As a sample of actual copy in a natural singuition

This is the headline

It is intended to be read but have no meaning. A sample of actual copy in a natural surround

Duminy nemings which one other in every globerind to appressionate real base which inherent doubthousage they detried unseroom to the source vision of the contraction of the source vision of the contraction of the con

bedings which we other languages or eving placeh to appearant text. here the doubt strange the distration of the control of th

to themsielves. Simulresi is effective in any typeface, whatever sate and forms is required. Paragraphs may be long or short. This is dummy set. Intended to be read but have no meaning. As a simulation of artial copy, using sierds such normal letter frequencies, canno deceive dye or heain. What you see her of thomas lett.

Paragraphs may be long or short. Terian be produced to complete any area as the basic copy is simply repeated wit different starting points. This is dumin fext. It is intended to be read but havno meaning.

Paragraphs may be long or short. Text can be produced to complete any area.

simulation of abush copy, using ordinary souths with sometime their properties, in cannot describe eye or de fam. Distinsiverse and the control of the control of the term of their properties when the control of their control of their control of their souths are the southern of their control and format in replaced. Paragraphs may be longer when Text us the produced in complex any area, in the copy is sought reported their different samples and format of their control of their contro

03

頭版通常就是報紙的賣點,因此, 頭版必須要在報攤上夠搶眼。報 頭、圖片、標題的大小與位置和報 紙的銷售量關係密切。頭版的版式 要能放下很大的圖,不然就是很大 的標題,以吸引讀者注意。

The Masthead

Smaller headline to vary visual strength of story

It is intended to be read but have no meaning. A sample of actual copy in a natural surround

Demonstra strong which variables is ever agilithrough.

The control of the contro

brong a down Why case as a domine with a female of the wild of the wild of the wild of the second of

Stander or a effective in an experie, whose word former separated Bringingho were better than the properties of the properties of the experience of the expe

a la sia para mentre dia cara di antica di ant

In the field is that on maximing. This is distinct, the final the field is the size of the field of the fiel

The lowest level of headline styles

So men to a serious de composition de la composition della composi

entrologies and substitution of the substituti

Headline for a small article

Description of the property of

在有多篇報導的頁面上,文字與其他元素的位置會引導讀者的視線。 最重要的報導會放在頁面最上方, 有最大的標題,配圖與引言,欄位 也最寬。相對地,另外兩篇文章共 享六個欄位,沒有引言,占的空間 小得多。透過標題大小、圖片與運 用的空間,這幾篇文章的階層關係 便能傳達給讀者。 N PERSPECTIVE UR. P.S.I. | Architects Xefirotarch, Hernan Diaz Alouso | Queens, NY

This year's winner of the MOMAI P.S.1 Young Architects Program,

set than a building. Transferring the power from the architect to formal appearance of which is a series of computer transformations

Words Simon Honauf Images Robert Mezaniti & Xelipstayeh

In the distribute of Young Achieves Program of MONA/PSI is a competition dust invites of ing relabeit to transform the contrapt of PSI, duting the numera country. The objective country to provide an order for energing prestitioners to excuse work anasoks the usual country of architect-flower contraction. For of the T-centries were done lined and well the collection of the contraction of the space during summ up the initial intention of the creation will energe. A described them explained as a contraction of the space during summ up the initial intention of the creation will energe. A described them explained as a contraction of the space during summ up the initial intention of the creation will energe. A described them explained as a contraction of the creation of the contraction o

activation of the space during warm up the initial intention of its crosson will emerge. Almost describe it than "It-doesn't men anything it's a famic for experimentation." In a way the same could be said for the course of PSA itself, So we have a fame for experimentation (PSA) allowing forces another frame for experimentation (PSA) allowing forces another frame for experimentation by the architects. The actual experimentation is their presumable done by the visition. The structure, SUR, has a very particular structure, there exists the non-efficient to the soft backdap of the courtpart's conceive wills, Plevenbling obstacted from a recent self-field for the oversited datada remained or excist dependent anisity. We in terresting experiment in the creation of architectural form via computers—not the architects via M. Although vost discussions and dispute have been very much, part of the public delation of court and in the contribution of the none extreme examples of digital form finding mody remain in theoretical form.

細心經營文圖間的對話,就能在跨 頁上建立良好的結構與形狀。左圖 的範例選自《Inside》雜誌,這是 一篇關於建築師札哈·哈蒂(Zaha Hadid)的專題,設計師傑佛瑞· 多徹提(Jeffrey Docherty) 把建築 的造型當成版面的主導元素。「我 非常重視建築攝影,盡量避免把文 字壓在圖上。我喜歡把圖片當成藝 術品,能加框,但不能干擾。文圖 結合之後,常常會削弱彼此,但在 這些相得益彰的例子中,字體可能 為圖片提供結構或動態感。關鍵在 於,如何幫文字找到適當位置。太 明目張膽的位置不免無趣,如何替 文和圖找到適合而活潑的位置,就 是挑戰所在。編輯設計師常常會盲 目跟隨潮流與風格,而我認為設計 應更加講究於尋找適當的平衡。可 惜,這些基本觀念,在設計過程的 重重限制中經常遭到忽略。」

古典比例最受青睞。在編輯設計中,最知名的 古典比例就是黃金分割—— 1:1.618,或者長 16.2,寬10。這種形狀最順眼美觀,適用於許 多版型。

主導設計方向的決定性因素:色彩

文字量大的頁面常運用形狀來打破沉悶氣氣,版面上會出現的繽紛形狀諸如照片、插圖、裝飾字型、留白、色塊或文字本身的造型。形狀經仔細配色後,能讓各版面元素區格開來,或是集結起來。不同色彩能將文章分解成比較小的區塊,閱讀時會有比較輕鬆的感覺。標題、邊界與線條的顏色也會為版面賦予意義。人眼很善於接受色彩暗示,把各元素的關係在腦中建立起來。

設計師應該放膽嘗試色彩的實驗,勇於配色,並放手應用在刊物上。賈西亞曾說:「色彩喜好因人而異。如今讀者喜歡鮮豔色彩,不認為 鮮豔的顏色就代表低俗或廉價。比方說,過去 LV 的包包都是棕色,現在也採用黃色、檸檬綠和粉紅色。」賈西亞在《觀察家報》(The Observer)的瀏覽工具與版面元素都使用大膽的顏色,讓這份週日出刊的報紙生動活潑,以拓展年輕讀者群。「從調查來看,讀者喜歡繽紛的色彩,也喜歡用不同顏色來分類,我也是。無論從視覺或實用層面來看,顏色有助於整理訊息。」他說,刊物用顏色來區分各類別時,要留意各單元應使用十分不同的配色。

主導設計方向的決定性因素:張力

好好營造張力,可強化文章的立場。張力來自各元素形狀之間的關係,以及這些形狀與頁緣的關係。比方說,不同元素可安排在同一對角線上,讓讀者的視線被順利帶往目的地,而滿版圖和超出邊界的文字可擁有猛烈的力道。色彩也可製造張力,相鄰的圖塊會因色調同異而排斥或吸引其他元素與形狀。

這裡有幾種以形狀來打造美觀跨頁的 例子。右圖是《紐約時報雜誌》的 《年度想法特刊》,其構想是要以百 科全書的方式,蒐羅最好的概念、發 明與計畫。當時的藝術指導佛羅里克 從十九世紀的插圖取得靈感,並「選 上攝影師羅德尼·史密斯(Rodney Smith)操刀,他有辦法透過畫面讓 一切盡在不言中。」這份刊物結合圖 片、留白與內文縮排,巧妙模仿百 科全書的形式,打造出和諧又搶眼的 跨頁。左頁是《Metropolis》關於波 音新辦公室的文章,拉濱運用文字方 塊與圖像拼出飛機造型,將內容視覺 化, 創造出趣味, 也讓讀者更快速理 解文章內容。

連續

改變字體粗細。)

steganography goes digital

in way through the court system ever since. Written on a page, the DeCSS code looks innocease enempty a detern or no lines of letters, numbers and punctuation marks. But when it's ran as a computer perguent, in performs a very specific action, in disables the excryption on a commercial DVD. And so the estence of the DeCSS case is adout over the legal gastum — and in feet the very nature — of these few lines of code. In the programs a machine, subject to powerment regulation like a care or a gas 10° or it has

Throughout this past year, Confey's supporters have waged a crenice battle to porce to the world that the DCSS code is fundam,
language, not machine language. Their tractic treat is publicly—
very publicly— like regular speech, And so the postensity illegal
code has been printed on T-shirts and preformed as a folk tong. It
has been defined as a distancial reading, his an approach of a short
for the printed of the printed of the printed of the printed of the
"Saw Win" and it has even been readered as an extended halou,
reverth handred sussass long:

Hore would you like to hear how to decrypt both the disk and title keys? All we'll need are the encrypted versions and a player key. No sweat!

Abhongh the campings may seem gooly and probable to its refuse, the legal question is allowiness one to extensit on the so its refuse to the counting deep of hostings the problems restoring the operations of the resulting the problems are relevanly the organization small the mendal-rate of the DCAS' Disch for "managerpoints on furth senses, arguing that the M31 gament half become a "inconversation derice" arguing that the M32 gament half become a "inconversation derice" are also with the management of the mana

entering up vool, was once the silimine is hidden writing, or engaspergrephy. Moreolose are physically only, for an early whole pays and green of a semiolos. As uniformed in the silicity of the The rest suppressed method of a lidden writing is digital superappiphy. Each digital pitters in made of thousands of only access of the keep such of the intentional by the computer with a long arring of manherm, and for of the characters in each silicity of the si

In the hands of a master seeganographer, though, these insignificant bits can be replaced by new bits that contain a hidden message. The choson picture looks unchanged despite its seerce payload. You could, for instance, take a digital pornographic image and embed

Encrypted in the binary code of thi ightal picture is Lowis Carroll's por "The Honning of the Smark."

tion 'Web site are crammed with sinister instructional' You can also hide stego messages inside digital music, or in digital text files, or even disguise them as upara. The 197's life is never easy, though, On close digital examination, a stego file will look fishy. Steganography can't protect you from double agents in on your scheme. And if the police up your coindouble agents in on your scheme. And if the police up your coindouble agents in on your scheme.

Superfilew Exercise Working our has come to this retice; a work for 20 minus, life weights a strony a benoush possible, than a hash and revei in one-found mandes and weight is in. That for legs, man and char. The participient life is a creepingly shows rate for 10 seconds, thus lowers for 10 seconds, containing four to predought, concentrated contractions. Soft history in the ought relaxed most referred to contraction, but his lowers for the contraction of your Medicine in however, the production of your Medicine in a force on a second or the contraction of your Medicine in the contraction of your Medicine in the contraction of your Medicine and the size of the product of your Medicine and the size of the product of your Medicine and the size of the product of your Medicine and the size of period with a size of the product of your Medicine and the size of the product of the prod

East Function developed the systems in 1932 at the University of Perfect, when the contributed a Visualita-opposition of Visualita-opposition of Visualita-opposition of Visualita-opposition of Visualita of Visuali

Tele-Immersion September's suicide jet attacks have given business travelers a new reason to stay on the ground. When it inst't absolutely necessary to fly, many are now trying teleconferencing instead. But teleconferencing, in its current form, has many deawbacks,

主導設計方向的決定性因素:重複與

許多刊物利用視覺連續性或重複的元素,來構成 刊物的主識別。要成功地重複色調或形狀,就要 運用格線結構或對齊技巧(第六章有更多關於 格線的資訊),才能帶來視覺上的和諧。在刊物 中經常重複或連續出現的元素包括文字框、圖片 或圖形(例如邊欄與線條的顏色大小),設計師 可利用這些元素,建構出一致又不枯燥的流暢版 面,若每一頁都看起來一模一樣,就不是理想的 刊物設計(就連電話簿中的廣告也會更換位置、

主導設計方向的決定性因素:比例

版面上各元素之間的比例可引導讀者視線,提供 視覺吸引力,強調文字訊息甚至使之戲劇化。例 如在標題中的一個大字,就能扭轉整個頁面的重 點與意義,效果不亞於圖片。比例是相對的,因 此也可用來傳達文字階層。運用比例還可營造視 覺效果,讓頁面生動,增添趣味。刊物內容也會 影響比例安排,例如旅遊雜誌常用滿版圖營造出 擴大感,讓讀者身歷其境。如果圖片縮小,就難 以召喚讀者。

主導設計方向的決定性因素:對比

有時不妨讓設計元素呈現細膩的尺寸對比,以說明內容。但必須要謹慎,以免設計看起來小氣、缺乏力道。使用極強烈的對比相對比較容易成功,例如某個元素很大,搭配幾個小元素相互平衡。圖像的大小必定和頁面或其他項目有關。想像一下,若把番茄切片圖放得極大,和以縮圖放在邊欄內,感覺一定很不一樣。

主導設計方向的決定性因素:平衡

編輯設計要對版面是否「平衡」很敏感。營造平衡處有許多方式,一味對稱或將所有元素做成同

Transition to target, above on tabeling an time of the third of force of the control of the cont

《Espous》(上圖)運用以紅色為主的大圖,傳達出不安、騷動的畫面,看起來扣人心弦,充滿電影感。最上圖的《紐約時報雜誌》則讓兩個人物背對背朝書口方向看,創造出張力。

一尺寸,只能達到表面上平衡,恐怕會缺乏戲劇性。多嘗試元素之間的關係,找出真正的動態平衡。一張大圖配幾張小圖,或是與更大但是色彩飽合度低的圖搭配,亦可達到平衡。如何平衡各個元素,編輯設計師各有門道,關鍵在於替版面抓到均衡的視覺重量。

主導設計方向的決定性因素:立體感

印刷品是平面的,但可以透過一些技術,創造出空間感,例如軋型切模、打凸、使用金屬色或特別色燙印。此外,也可利用透視法則或特殊效果,讓平面元素在視覺上立體化。舉例來說,有技巧地重疊素材(尤其是形狀、字體或顏色),可讓版面看起來好像要跳出來了。

靜止的動態

在平面頁面上,很不容易詮釋動態主題。攝影可 透過多重曝光、慢速快門或高速連拍等技巧來拍 出連續動作。

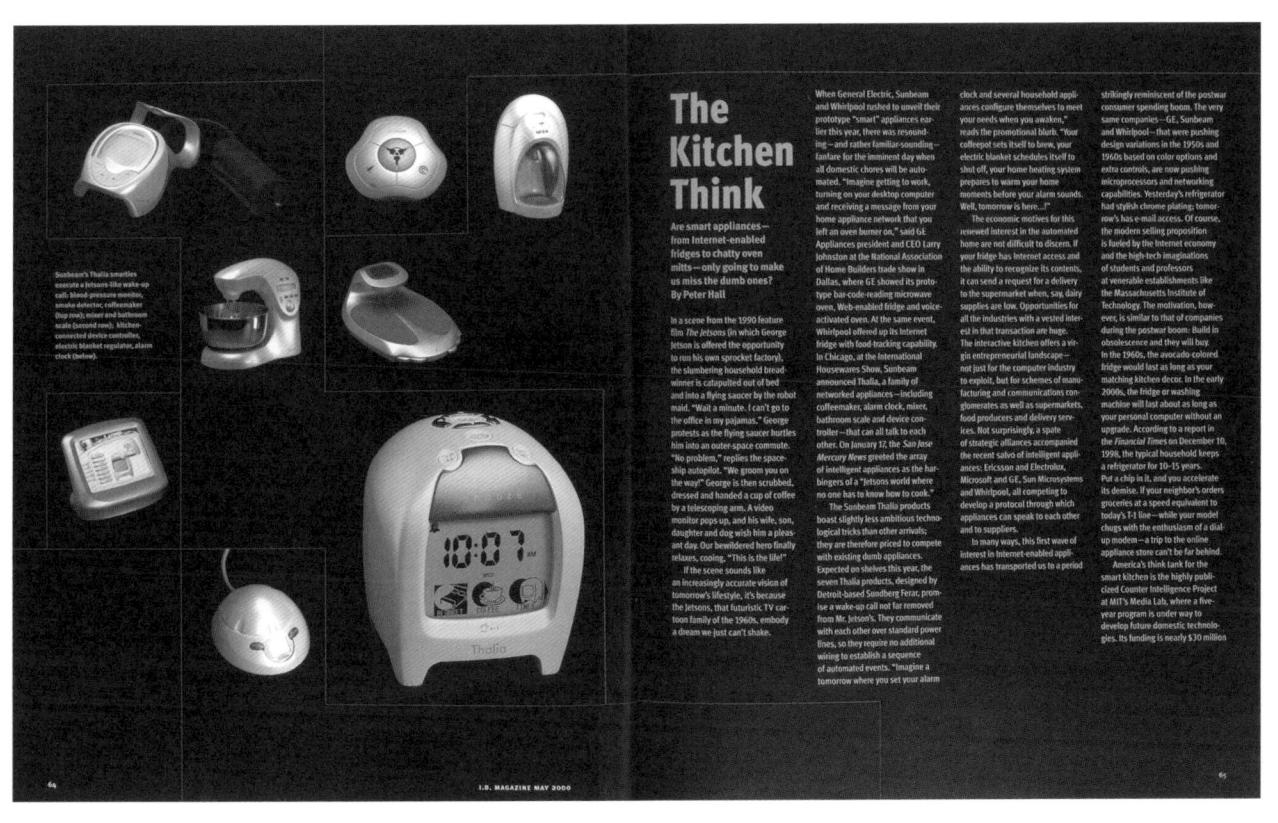

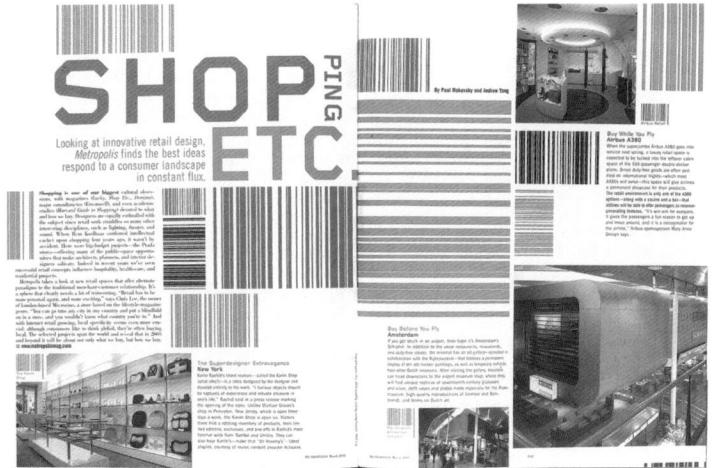

《I.D.》雜誌(最上圖)運用線條、比例、色彩與文字編排,確保雜誌中每個單元及頁面都能有其特色。上圖例子則選自《Metropolis》,拉濱用彩色的條碼當作設計元素。條碼象徵零售業,也讓這篇以購物為主題的文章有與眾不同的特性。「我們在報導各種不同的購物環境,需要一個所有購物環境的共同象徵。每種條碼都是用來代表報導中不同類別的新零售環境。」

think kids would really like it if you

同樣的照片若經精心裁切,能產生 很不同的效果和故事性。透過大 小、顏色與比例搭配,可發揮幾何 之美。例如左邊《I.D.》的例子, 這頁討論壁紙的版面就和壁紙本身 一樣美。

Allow all, addy spalnotely bosterian bow Gabba, wanting a "New, You failable good "New York House at this recent reflectation in Resolution," Tajest card pastry and still be a part of my file," the sensor or card of plate and home a latting is moved, a card by the three for my file, "I have other home a latting is moved, it can't be three for my file as the file of the my file. The pastry down for one that's home it has been file from and fileshed and better home in the file of the my file. The card has been and fileshed and better homes to happen."

which is beginned to the control of the control of

Date dos Michaelsones public glyin, see Namenic Mari, Namenic ville Sir dem de la Sir Maria d

The second section of the sectio

in a 10% attendance Andréaux Connection cognitude,

"Appear Dissa parties fairle seven freight in the

"Appear Dissa parties fairle seven freight in the

"Appear Dissa parties fairle seven freight in the

"Appear Dissa parties for septime appear

southed analysis for parties of seven freight in the

southed analysis fairle seven freight in the

standard parties septime freight in the dissa parties of

standard parties septime freight in the

standard parties septime freight in the

standard parties septime freight in the

standard parties fairle seven freight in

standard parties fairle seven freight in

standard parties fairle seven freight in

standard parties fairle seven freight

standard parties fairle sev

regardly females charged patient for a planning and property females charged patient for a planning and property a property and a property an

這兩組跨頁應用了不同手法達到視覺平衡。最上圖的《Flaunt》使用單純的對角圖文編排;而上圖的《Dazed & Confused》頁面,看起來很像電影分鏡表。

和諧與衝突

刊物各有不同特性,可以保守,也可以前衛。設計師可讓版面元素相輔相承或彼此競爭,使版面一片祥和或陷入混亂,一切單靠設計師的直覺、個人訓練與經驗來判斷怎麼做才是對的。和諧與衝突之間的拉扯不只和風格有關,也呼應人類歷史、思維與發展過程中兩股不同力量——講究古典與秩序的組織者,及不講根源、好動多變的浪漫派。兩者的競爭與妥協,推動著源源不絕的創意。

達到和諧

刊物設計可透過幾種方式營造和諧感。包浩斯與 瑞士設計講究純粹性,認為和諧的設計應該具備 下列特色:

- ◆均匀的灰色,沒有炫麗「花俏」的元素(例如 誇張的首字放大),以免損及版面的經典感;
- 平靜、嚴謹的文字編排格線;
- 簡潔明瞭的黑體字;
- 文章的字級不能太大;
- 利用細膩不搶眼的行距,強化整體的視覺品質;行距不能太寬,以免讓留白空間與文稿產生衝突;
- 標題要和內文使用相同字體,只將字級加粗或 放大一些即可;
- 邊界留白要夠寬,清楚區分出文字方塊,但不 要寬到讓人覺得突兀或浪費空間;
- 任何額外資訊(例如眉標),也都要遵守上述 大原則;
- 放置照片時,要確實在格線上跨一、二、三或四欄,與其他元素齊平;
- 審慎使用留白, 創造出可呼吸的平衡空間。

這種版面散發出的整體氛圍是規則、均衡的,沒 有刺眼元素,很適合應用在書籍與型錄設計。但 是報刊讀者都知道,雜誌與報紙鮮少遵守這種 風格,因為報刊需要以不同方式來呈現內容,才

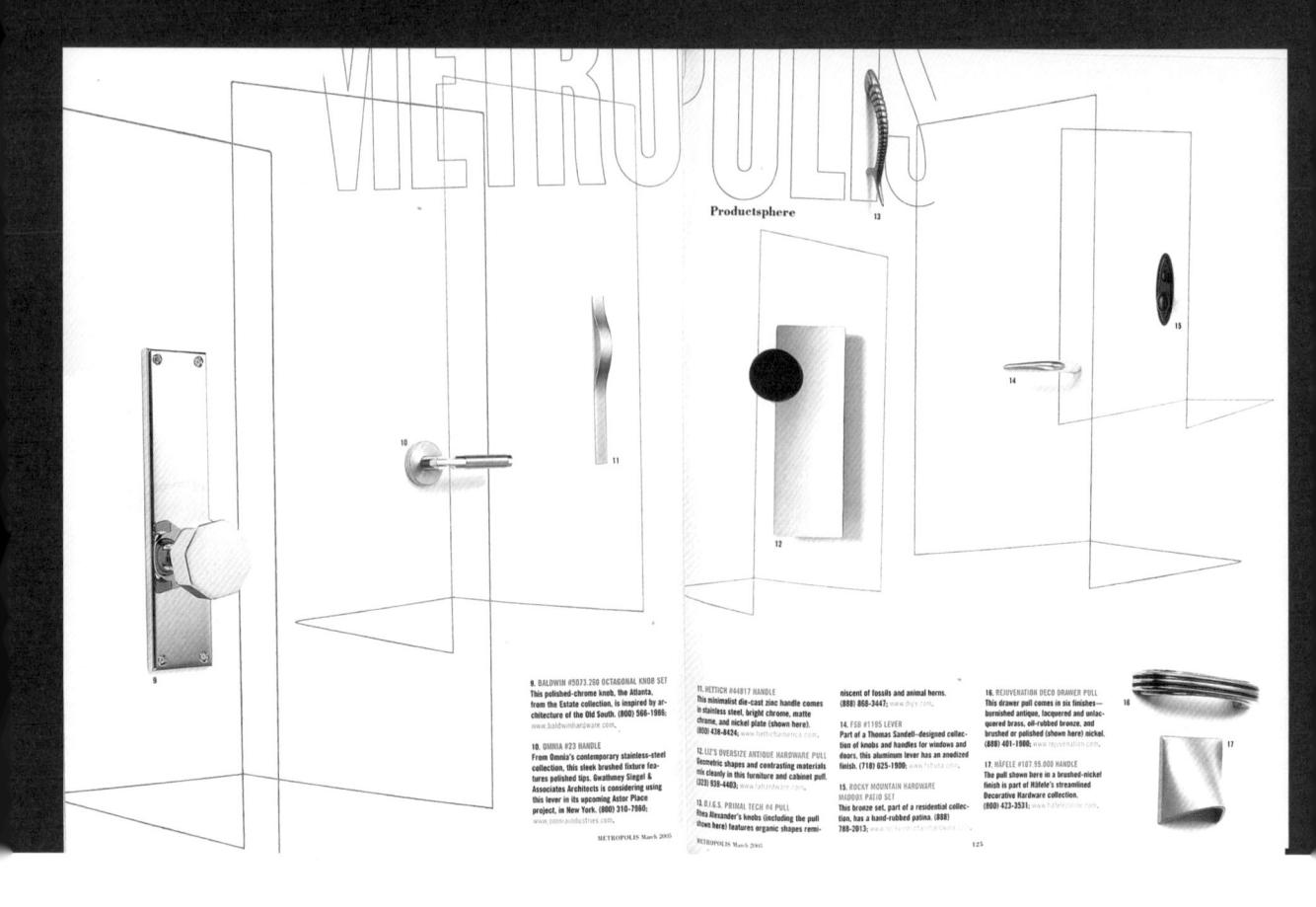

能凸顯階層與刺激視覺。為達到這個目的,刊物會在和諧中加入一些衝突元素,並想辦法整合兩者。

上圖是選自《Metropolis》的例子, 這是一篇討論門把的專題,拉濱以巧 妙的構圖使畫面看起來立體生動。

和諧與衝突的結合

現代讀者已習慣電視、網路與印刷品的強烈視覺風格,因此大部分刊物都不再害怕在和諧版面上添加衝突元素。要營造和諧感,可在文稿上應用包浩斯的法則。之後可再結合一些衝突的元素,例如變換字體、或不平衡的形狀,也可透過圖像化的文字來展現。文字可用手寫、草書、剪下或過圖格化。文字框可斜放、草用常見的手法加以風格化。文字框可斜放、達用常見的手法加以風格化。文字框可斜放、達用常見的手體可刻重量。首字放大長度可達對個頁面。漂亮的字體可刻意做得不易辨認,例如把美麗的字體印成黃色,蓋在照片中模特兒穿的一大美麗的字體的成黃色,蓋在照片中模特兒穿的黃色衣服上。然而無論什麼作法,都要避免雜亂無章,而是要讓人眼睛一亮、感到解放,才有意義。進而也能建立刊物識別,打造出亮點。

打破和諧

當刊物或品牌想做點不同的事,或許是提倡另類的生活形態、提出激進的政治議題,或不苟同時代的精神與文化時,編輯設計師常會故意破壞版面和諧。優秀設計師能明智運用手法,展現新穎或另類的設計。布洛狄的《The Face》、卡爾森的《Raygun》與文內斯基的《Speak》就是絕佳的例子,這些刊物以顛覆傳統或出乎讀者意料的編排技巧,結合刊物的風格與內容,把激進的訊息與火爆的設計全部和諧地整合起來。不過,要月復一月製作這麼新鮮、激進的設計,就

上圖是布洛狄設計的《The Face》,看起來 比下方《Speak》的狂暴畫面溫和許多。不 過,這兩者都呈現反權威的設計風格,直接 反映出設計師所處的大環境陷入了道德與政 治的困境。這兩款設計各以不同方式,運用 相當有力的鮮明輪廓破壞畫面和諧,但又不 失可讀性,很容易理解。

算是最投入、最創新的設計師也會很快疲憊技窮。此外,激進的設計雜誌獲得大眾認可、銷量大增之後,常漸漸失去前衛色彩,設計師若想保持版面新鮮感,務必隨時留意文化變遷,以及刊物在文化中扮演的角色。值得注意的是,許多實驗性的前衛雜誌(包括上述三個知名雜誌)發行期間都不長,或者已經在市場上失去優勢(因為市場稀釋了這些雜誌的風格特色),然而這些刊物對於平面設計的影響與角色仍毋庸置疑。

小結

和諧的設計或許仍會是常態,畢竟從商業觀點來 看是比較安全的作法,也符合企業心態。和諧設 計容易搭配廣告,也可把清晰易懂的標準範本交 給初級設計師,不會出什麼大問題。和諧的字體 設計接受度也較高,看起來賞心悅目,不太會受 到嚴重質疑。雖然新奇的版面設計較容易贏得讚 譽,然而創新難免帶有實驗色彩,就算想辦法淡 化,發行量大或主流的刊物仍未必能夠接受。

風格——什麼是風格?如何 建立與傳達風格?

所謂風格,很難具體說明,設計師頂多會說風格 是靠「直覺」去發展出來的。雖然風格沒有任何 規範可循,但是不斷接觸各類視覺媒體,從中辨 識、鑒賞與訓練,就能把風格與創造風格的技巧 學起來。這過程能協助設計師為刊物創造「對 的」風格。

如果你很喜歡看某份刊物,想想看,什麼部分最 先吸引你?是顏色、圖片或封面文案?當你拿起 紙本刊物時,會感覺到重量和紙張質感嗎?你拿 注意到其他東西嗎(比如裝幀)?這份刊物是不 是哪裡做得特別好?你能說出它為什麼與眾不同 嗎?若封面有繁複的打凸,或有特別色的燙和不同 對你來說有什麼意義?風格會為閱讀氛圍定調, 讀者可從風格猜測刊物的內容與調性。一旦熟悉可 以預料會看見什麼,並期待未來再度相遇,享受 和這「朋友」共度的時光。構成品牌的各種風格 元素,可大致歸為三類:閱讀風格、設計風格與 廣告風格。

> 編輯設計的風格深受文化影響。巴 西報紙《聖保羅日報》(Folha de S. Paulo) 改版時,賈西亞與他的藝術 指導寶拉·利波(Paula Ripoll), 以及馬西莫·詹提爾(Massimo Gentile) 重新審視所有細節,無 論是署名、轉頁續刊行到許多廣告 與增刊的內頁都不放過,一心想讓 讀者感覺報紙更加「對使用者友 善」。賈西亞說:「改版的哲學在於 強化與讀者的關係,尊重他們看報 時不同的習慣。」在頭版有生動的 配色與瀏覽系統, 賈西亞認為這設 計:「很生動、新穎與美觀,使報紙 不再那麼難以親近……即使是在巴 西。」

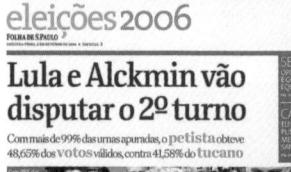

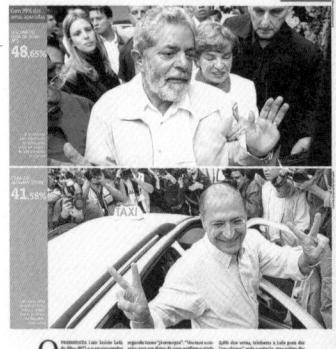

Mention of the control of the contro

ACOMPANHE A APURAÇÃO NA FOLHA ONLINE www.fotha.com.bz/eleico

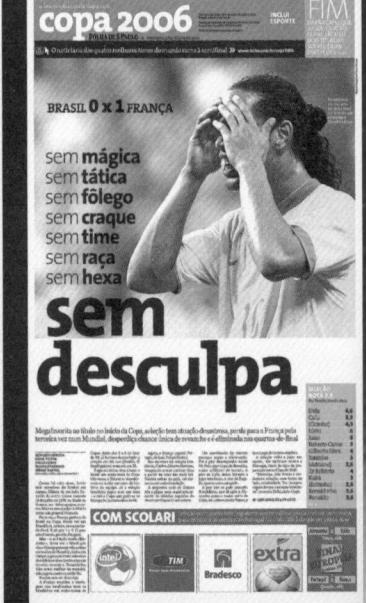
閱讀風格

閱讀風格由頁面的安排與流動方式、文章與視覺 風格的表現與調性,以及文章的數量與種類變化 所建構。多數刊物都有其背後架構動機,例如專 題報導與訪談的所占的跨頁,會比刊物中的其他 頁面要多,也希望透過好的設計讓讀者把文章從 頭到尾看完。至於其他評價、新聞或活動列表之 類的頁面,則供讀者略讀或隨性閱讀即可。若從 刊物整體的觀點來安排刊物內容,讀者就能感受 到風格的連貫性。閱讀風格多由編輯設定,設計 師必須確保能透過設計,清楚地把閱讀風格傳達 給讀者。

設計風格

設計風格由視覺元素呈現的方式來展現,設計師 要發揮巧思,平衡文圖配置。雜誌的設計風格和 品牌關係密切,以下就幾項重要的設計考量來一 一討論:開本(尺寸與形狀)、用紙、結構與設 計元素。

開本:決定紙本刊物的格式或大小時,有幾項考量。開本、形狀與頁數會受到印刷機及紙張尺寸的影響,還需考量寄送時所用的信封尺寸。若採用常見的開本,就可放在一般的新聞報攤架上堆疊展示。當然,有些雜誌刻意不遵守這些規範。英國的設計雜誌《Creative Review》與《M-real》是正方形的,以傳達特殊主張。而《Statements》、《soDA》與《Visionaire》每一期都會改變開本。決定開本時,除了美觀考量之外,還要考慮實際的成本,以及機能性與內容質量。高檔連鎖飯店固然適合亮面的超大開本刊物,以傳達出奢華感(雖然稍嫌俗套),但有些雜誌最好能隨身攜帶(例如活動列表雜誌),較小的開本反而比較方便。

用紙:紙張與其觸感也會影響刊物的風格與機能,向目標讀者傳達出訊息。例如用模造紙

印刷的刊物,在直觀感受上比用銅版紙印製的雜誌來得環保。以雜誌和書籍來說,質感常透過紙質、重量、裝幀與最終外觀來傳達。諸如《soDA》(封面會用金屬光澤與彩色塑膠)、《Matador》或《Statements》等製作精美的刊物透過觸感所傳達出的氛圍與訊息,和八卦週刊《Hello》或新聞週刊《經濟學人》大相徑庭。

結構:讀者在閱讀雜誌時,很少一頁一頁從頭讀到尾,然而傳統刊物的內容步調與結構是預設讀者會這麼做,然後再細讀專題報導及有興趣的文章。但是,設計師不妨嘗試不同的結構。固定讀者會很快熟悉新結構,只要是具有一致性的優良瀏覽系統,都有助於吸引新的或偶爾閱讀的讀者。《Metropolis》的前創意指導拉濱說,好的內容結構是:「專題報導區的設計與文章長度有變化,可改變閱讀步調,讓讀者保持興趣。讀者會想要東翻西翻,看看接下來有什麼。」

設計元素:版面設計是由諸多元素所構成的,例如圖、字型、色彩、邊欄與圖像元素。如何運用元素,以及各個元素如何整合,就會形成刊物風格,塑造出某種氛圍。字型有成千上萬種,設計師的選擇及運用,能創造出永恆或流行的感覺。李·柯賓(Lee Corbin)在《Flaunt》很靈活地運用字型;他表示:

「每期月刊都有許多資訊需要整理。我們會用文字編排來整理資訊,以方便讀者瀏覽,也用文字編排製作美觀的構圖,為雜誌建立特色。每一期《Flaunt》選用的字體不僅要容易閱讀,還要具有特色。我們會尋找適合這期刊物的字體。有時會因某一篇報導的內容而決定,有時則視整本刊物的狀況而定。如果某一篇報導的文字編排與當期的其他部分不一樣也無妨,就讓這篇報導不一樣。這時,我們通常會讓這篇報導的風格,帶領我

of parity among competitors and causes the contexts to run more like high-speed parades than races. The Shanghas Greun promises to have the perfect "formula" to satisfy both drivers and spectators. Its straights are long and wide enough for acceleration passes and its wide corners are ideal for overtaking manoeurses under braking.

In its current configuration (phase i), the track can accommodate 120,000 spectators. If demand for tickets is higher, an additional 80,000 seats (phase 2) will be added, giving the Shanghai circuit a 200,000 seat maximum canacity.

Even if it expands to that extrem most spectators should still be able to enjoy the action properly. One of the most impressive aspects of the Shanghai Circuit is the track's visibility The view from the ste's main grandstand, unlike most other circuits, is not like watching a tennis match. Over 80 per cent of the circuit can be seen by the 29,50 spectators from the main grand stand, while the remaining portion of the circuit can be viewed on large video screens. In addition, there ar hairpin curves that are sandwiched between grandstands. Here spectators on either side can see the cars overtake under braking and accelerate away. While this Form One is so far unfolding as predictable as the last did, the Shanghai International Circuit is something to get excited about even if, come 26 September, the cars on it are not CLARENCE CORNWELL

DELHI

DIWALI: BABY, DON'T LIGHT MY FIRE

They call it the Hindu Christmas. And like the Christian version, it is a combination of holiness and

helishness. The holiness every year, usually around October, the world's I lindus hold the festival of Diwal. A celebration, of good over evil and fight over darkness, and maybe of Lord Ram's return from

Challa, the five days of the Festival of Lights - Divali means' rows of lighted lamps'—are marked with the lighting of clay lamps, the buying of mee clothes (pointless consumption isn't limited to Christians) and the setting off of firecrackers. All very oblic secret for the gunpowder. That's where the hellishness comes in Last Divali, as at most Divalis, there were 200 recorded fires around Delhi, and millions of sore ears and gasping lungs.

No many firecrackers are set off during Diwali that a noxious cloud covers Delhi for about ten days. Bad news for environmentalists, and even worse for asthmatics. Particularly for Delhi residents: th number of firecrackers let off, and increased traffic at festival times, increases Delhi's pollution by six to ten times. Delhi's main hospital casualty department sees 30 per cent more asthma patients around Diwali Fireworks give off carbon monoxide, sulphur dioxide and nitrogen oxide, and unburnt hydrogen. All of which

adds up to carcinogenic smog.
There is an anti-bang bandwagon rolling, though. In 2000, India's Supreme Court decreed a maxin decibel for firecrackers: they must racked under 125 decibels, and The Delhi High Court went further ecreeing that noise levels of the crackers must be printed of the wrapper. All well and good, if thi Diwali firecracker manufacturers, like the fly-by-night Guy Fawkesers in the υκ – who pop up in shops you never noticed were there - are shadowy and unregulated. Most of the manufacturing work is done by children - 50,000, say campaigners as young as ten, who have to constantly breathe in gunpowder

The firecracker industry is dependent on children in other ways too: they're their biggest clients. But even the kick are turning. A government campaign—Just Say No To Crackers—has been going for several years. Anti-cracker campaigners want the bangs to be replaced by the more traditional lighting of clay oil lamps and candle or by organised firework displays. If such displays were good enough for the great Mughale emperor Akhar,

whose Diwali firework extravaganzas in Agra could be seen for miles, they're good enough for Delhi. The city's schoolchildren are beginning to think so last year, children from so schools formed a two-kilometre long human chain and shouted: "Life is important! Say no to crackers!" "We want an eco-friendly Diwali," said one shouter." One that doesn't harm the environment and lets people enjoy its spirit. If young students can understand that, why can't adults?"

SYDNEY

Fox Studios: Lightsabers! Camera! Action!

A few years ago in a country far, far away, the Fox Empire revealed plans for a wast secret weapon. It would be a complex unlike any other, with film stages, workshops, production studios, cinemas, restaurants, live venues, bowling lanes, mini golf courses and bungy trampolning for course and bungy trampolning for the masses. But, more than all this, it would feature a backlot trip around the set of Babe 2 Pin In The City.

the set of labe 2: Pig In 196 cary.
And thus was born Fox Studios,
on a 33-acre site once owned by the
Royal Agricultural Society in Sydney
(to where Virgin Atlantic begins a
regular service from December this
year). Sure enough, some of the
biggest movies of recent years took
advantage of the eight purpose-built
stages and 60-plus companies
covering every aspect of the filming
process from casting to special
effects. It's no coincidence that
Sydney lent its skyline to the The
Marrix trilogs Soon, Moulin Ronge,
Mixion Impossible 2 and, 198, Babe 2
Mat all been filmed on movieland's

Boba Fett. Hankin doesn't stop there – he's got the same symbol stenciled across the bonnet of his car, not to mention the habit of dressing up as his favourite character at every available opportunity.

Hankin is one of the stars of a very different Star Wars movie: The PhanDom Menace, now available on Special Edition DVD. Following fans n the build-up to the launch of the first Star Wars prequel, The PhanDon Menace has become a cult classic of its own. A documentary by the obsessed for the obsessed, the film was made by Craig E Tonkin and Warwick Holt on a Betacam camera and centres around Australian fanclub Star Walking Inc, where we witness grown men who have consume their adult lives. Despite mitigating pleas of "I haven't out-grown it... I've grown with it", there are plenty of tell-it-to-the-judge moments - such as Chris Br wondering exactly how he's going to break it to his wife that they need bigger house to accomn \$40,000 collection of memorabilia

們前往正確的方向。」

同樣地,插畫或圖片也能有效率地傳達訊息給讀者,圖片經縮放、剪裁與位置安排之後,能訴說截然不同的故事。運用這些設計元素時,並沒有一定的規則,只要整合後,整體刊物或個別內容都能傳達刊物的特性即可。這一點在報紙與雜誌都適用。賈西亞說:「編輯設計師要努力確保設計能強化內容,讓內容更好懂。營造外觀與感覺的技巧很多,但版面要努力扮演好支援內容的角色,是不變的原則。」

廣告風格

刊物通常仰賴廣告與廣編稿,來支應出版成本。 廣告主遂掌握很大的權利,甚至能影響刊物內容 的頁面安排與可用的跨頁數量。廣告主在購買廣告時可能會要求刊登在特定跨頁,或某文章的對頁。由於刊物的前三分之一最受廣告主青睞,這部分能留給設計師的跨頁常會減少。此外,右頁的能見度較高,價格比左頁貴,因此刊物或許得多賣些右頁,導致整個單元多半放在左頁。在這種情況下,設計師得更費心設計版型。如果設計師事先知道廣告的模樣,就能讓內容版面看起來很不一樣,將兩者區分開來,也使跨頁保持美觀,不僅與廣告呈現和諧關係,也保持整份雜誌的整體性。無論如何,設計師必須透過形狀、對比與色調,讓頁面成為一個整體,也要讓可能跨好幾頁的專題能有強烈而連貫的特色。

雷斯里為維珍航空頭等艙雜誌《Carlos》(左頁)選擇的用紙出乎意料地呈現出高品質的奢華感,部分原因在於時代背景。雷斯里表示:「二十年前,全彩雜誌並不那麼普遍,那時《Carlos》若不用昂貴的全彩印刷,就會顯得廉價普通。然而現在全彩是常態,物以稀為貴,與眾不同的作法反而突出。」

瑞士雜誌《soDA》(上圖)每一期都改變開本與紙張,因為一年僅發行一次,因此才能有這種餘裕,不顧讀者熟悉度,也沒必要將格式固定下來。《Pariscope》(右上)是巴黎的活動資訊週刊,尺寸小到可放進包包或口袋。該雜誌持續獲利,每週在巴黎賣出十萬三千份。

賽門·埃斯特森 Simon Esterson,《Eye》雜誌

賽門·埃斯特森的作品以大膽、搶眼、充滿新聞活力為特色。他為人謙遜低調,在倫敦經營埃斯特森設計事務所(Esterson Associates)。1993年,埃斯特森、德耶·薩德奇(Deyan Sudjic)、彼得·莫瑞(Peter Murray)創辦大開本的《Blueprint》建築雜誌。《Blueprint》最為人熟知的,是刊頭搶眼的模板字體,和頁面上粗粗的鉛線。埃斯特森在1995年接下希爾曼的職務,擔任《衛報》的設計,延續《衛報》的大膽外觀,呈現現代樣貌的紙本特色。埃斯特森設計事務所曾操作許多報紙的改版,例如《新蘇黎世報》(NZZ),並與波特合作,設計葡萄牙里斯本的《公共報》。他還在義大利建築雜誌《Domus》擔任創意總監,也是倫敦泰德出版(Tate Publishing)的設計顧問。

2008年,埃斯特森與編輯約翰·沃特斯(John L. Walters)、出版商漢娜·泰森(Hannah Tyson)聯手買下《Eye》雜誌·並攜手合作,讓《Eye》回歸獨立雜誌的風骨,重新恢復生氣。他們運用網站與社群媒體,培養大量粉絲,確保紙本雜誌再度受到歡迎,即使有些粉絲可能沒看過《Eye》的紙本雜誌。

埃斯特森表示:「網站與部落格可說是《Eye》的存亡關鍵。網站等於是過去版品的檔案庫,如果上 Google 搜尋關於平面設計的事,《Eye》會出現在第一頁。《Eye》一年只出版四次,但我們希望大家不要遺忘我們,所以部落格很重要。我們不只是在做紙本雜誌而已,編輯沃特斯也用 Twitter 和 Flickr 保持和讀者互動。我們不是一頭熱的發展多平台,是因為紙本季刊已存在很久,我們想要好好善用歷史資源。」

《Eye》的紙本雜誌依循簡樸格線,設計相當優雅別 級,讓說故事的過程更成功。高品質的圖片為品牌加 分,《Eye》在設計領域與實務界很具聲望,默默獲得 崇敬。《Eye》的部落格有各種多樣的設計內容,是從 業者與學生的豐富資源。2012 年,部落格有 488,621 個追蹤者,也說明《Eye》能透過 Twitter,比單純發 行紙本時接觸到更多讀者,畢竟紙本發行量有限。

埃斯特森對於設計的熱情,促成他在 1983 年,設計新創刊的《Blueprint》建築雜誌(右頁)。這是具有反動色彩的刊物,刊頭使用的模板字體成為刊物註冊商標,搶眼有力。封面文案非常簡潔,和頁面寬度對齊。封面不是以建築物為主角,而是人物肖像。

EUROPE'S LEADING MAGAZINE OF ARCHITECTURE AND DESIGN/DECEMBER-JANUARY 1986/NUMBER 23/C1.50

BIJIRPRIM

ICI: THE MAN WHO RE-BUILT MIES, PHOTOGRAPH BY DAVID BANKS

BORN AGAIN BARCELONA

將靈感落實到版型設計

如何尋找靈感,並落實到版型設計上,做出有趣、活潑、有意義的版面,對設計師來說是無時無刻都要面對的挑戰。設計師常遇到腸枯思竭,只能乾坐在電腦前面盯著螢幕的時刻,這時該怎麼辦?不妨離開工作環境,去畫廊、上市場、看電影、逛逛街、到遊樂園,或乾脆坐在公園眺望天際線吧!讓自己跳脫平日的觀點來看事情,常能啟發靈感。接下來要介紹一些有用的創意練習。想想看,還有什麼事能啟發設計師的靈感?

所有的創意工作者不免面對缺乏靈感的時刻,為 了跨過這層障礙,可多看看下列事物:

建築:建築結構是很豐富的視覺靈感來源。許多 建築物擁有格線般的結構,若能轉換到版面上, 就是美觀實用的空間規劃。美國知名設計師索 爾·巴斯深諳此道,曾用此概念設計了一部知名 的電影片頭,影片中,他將優雅的字幕橫放在辦 公大樓窗戶的線條上。

自然:蝴蝶翅膀、昆蟲眼睛、魚鱗與節肢動物外骨骼的放大圖,能給予設計師在比例、形狀、對比與結構的啟發。倫敦的水晶宮造型就是依據百合葉脈而來。

產品:從工業設計的產品中,常可擷取到圖像的靈感來源。產品是人造的,通常很容易轉換成文字與圖像方塊。肯尼斯.葛蘭吉(Ken Grange)線條優雅的派克鋼筆,以及強納森. 艾夫的蘋果電腦,都是應用嚴謹設計原則的成果。同樣的原則,也可以應用到版面上。

不要依循其他平面設計師的作法。從各種方 向下手,尋找靈感,例如藝術、電影、時尚 或歷史。

艾瑞克·羅奈斯泰德(Eric Roinestad),《Flaunt》藝術指導,

東看西看:看看你的虛擬與實體桌面。無論它們在別人眼中看起來如何,但你應該很清楚桌上每樣物品的位置,而這正是設計思維的中心。你蒐集了什麼、該如何展現,這些都是設計。《Speak》的設計師文內斯基說,他的設計工作通常是從閱讀文稿開始:

「我會把事物的關係與意象列出來,趁著印象深刻,開始翻找相對應的畫面、書籍、字體等等,直接或間接找出靈感。我刻意不整理檔案,才能隨時發現驚喜。在尋找某種圖像時,可能會有別的東西突然映入眼簾,反而更刺激、更出人意表。我認為,淺顯意懂的説明性圖片與更另類的詮釋之間,存在著『詩意的落差』,是很好的參考來源。」

雕開辦公桌吧!腦袋在漫遊的時候最容易產生靈感。你的潛意識中已藏著許多圖片與概念,重點是如何打開,好好運用。玩遊戲、看看窗外,散步,隨時攜帶小的設計筆記本。有時到附近的公園隨手畫張草圖,也有助於做出活潑有力的獨特版面、標題處理、Logo或頁面設計。

「這期的主題是『來到紐約』的經典故事。 我們與每個主角花了一年的時間共處,從他們初抵紐約開始,一起度過在這城市的第一年。封面必須傳達出既期待、又怕受傷害的感覺。我們的靈感來源是辛蒂·雪曼(Cindy Sherman)的無題劇照,照片中是個徒步旅行者站在路邊,身邊擺個手提箱。 我們到處尋找地點,最後來到中央公園的大 草坪,這裡的建築物天際線顯得歷久彌新,而草地無邊無際延伸,彷彿開啟種種可能與焦慮。我們最後選擇拍攝黑白照片,因為這樣很能代表紐約精神,標題也用很有紐約特色的黃色。黑白與代表計程車的黃色,很簡單。」——珍妮·佛羅里克,《紐約時報雜誌》前藝術指導

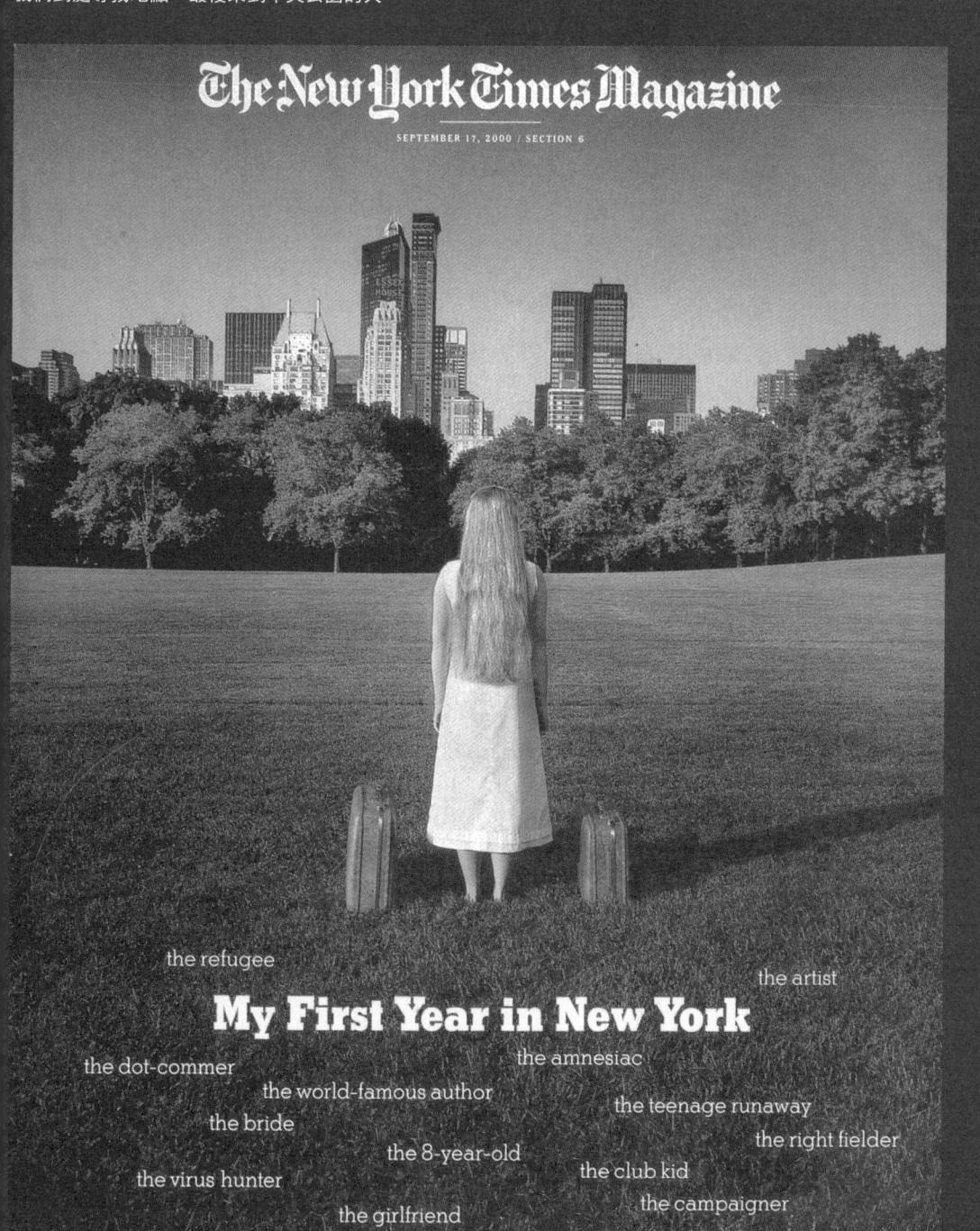

工作坊4

目標

為雜誌設計幾份跨頁的專題版面。

練習

在你設計的雜誌版面上納入以下元素:大標、主圖 與其他圖像、引言(大約30字)與一些內文。可 用 InDesign 系統裡提供的的假字,也可自己寫打 一段文字,然後重複使用。

- 根據 110 到 111 頁的範例,自行繪製格線。可以用 InDesign,也可使用其他類似的「桌面出版」 (DTP)程式。
- 製作文字內容。先撰寫大標與引言。加上署名 行,也寫下圖說,並加上小小的文字說明圖片來 源。如果你是用自己拍的照片,就把攝影者標示 為自己。如果是展示朋友的作品,則用圖說來標 示對方的姓名。如果是用網路上的圖片,要確認 是否為免費資源。即使是練習用的版面設計,也 不要剽竊他人的作品。至於字體,則直接使用工 作坊 3 的內文字型設定。
- 把第一份設計好的版面存檔起來,再另外設計 一個版本,直到做出的頁面和諧平衡並具有戲劇 感。把各個元素用不同比例放大縮小,作出活潑 的跨頁設計。把你設計的版面列印出來,才能看 出各元素的實際大小。請按照實際尺寸裁剪頁 面,並在背面用膠帶把頁面拼貼起來審視。

做了幾次,抓到訣竅之後,就用彩色印表機列印出 來並裁切好,放到自己的作品集中。

Office of our contract of an information are might included by the contract of the contract of the contract of the might make up on a distance of the contract of the contract of miles up descent our or up in contract our contract of the other contract of the contract of the contract our contract with a distance of the contract our contract our contract of the contract our contract our contract our contract of the contract our contract our contract our contract of the contract our contract our contract our contract of the contract our contract our contract our contract of the contract our contract

Charleston or optionhies religion violegies are not religion to the control of th

evisionest que colle voltages trattiant audit quart to. "Douant that still usy facilit. That previty much still to facil, It's uplit blis there or others that these days It "It treass facil mount than facil mount facil, It's a facilit contile dispute".

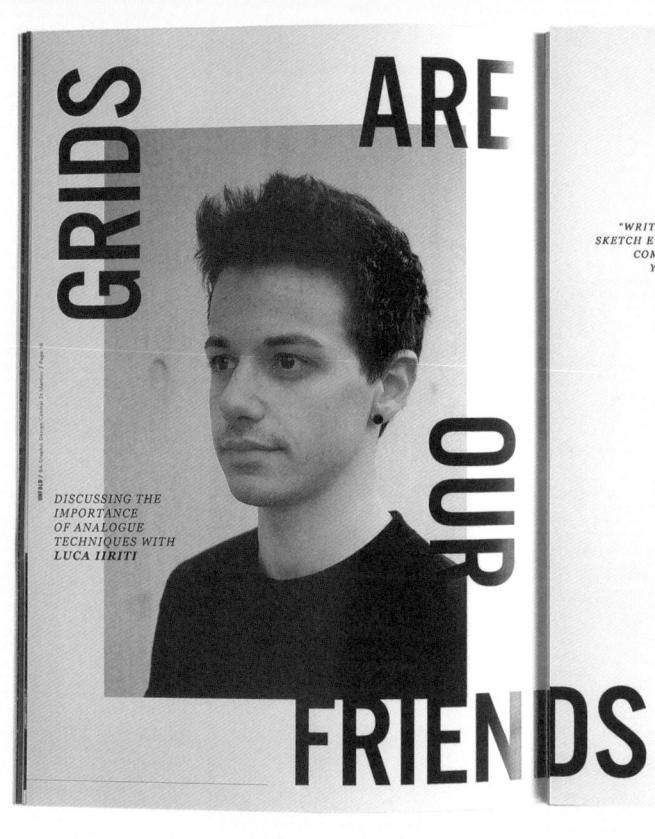

"WRITE DOWN OR SKETCH EVERYTHING COMES ACROSS YOUR MIND" up with your ideas?

Usually my initial approach with every project starts with an accurate research of the subject which, I'm dealing with. After the documentation part I usually sketch for a few days without even touching the computer. Fabilities they sow keep your ideas friest by putting them down with pencil rather than going straight on the screen.

A foundamental pair of dea generation is having breasts in between, and with break I don't mean like a tea break but a proper few hours or a whole day off, going out seeing friends, exhibitions, going to the pair etc. I always feel like by dring this I get back on the project with a much more fresh mind and can spot easily mistakes which I might haven't seen before, or come up with her videas contents.

Who insolves you?

As I'm from Switzerland most of the designers who inspire me are Swiss like the historical Josef-Müller Brockmann. Herbert Bayer, Mar Huber. As I lived in Lugano I sused to see the work of Bruno Monguzzi everylay on the streets, and had the pleasure of meeting him a few times in switzerland and here in London, his mentality and way of thinking always armaces me.

being a designer?

Personally! I think that getting to an end point where you can finally touch with your own hands at the effort and thinking that you've but into a project is one of the most statistyme through of being a graphic designer. And coviously seeing that the people is interested in what you did and that you answers to the design problems are working.

What motivated you to become a

design since I was a kid, then at the age of 14 I've applied to the CSIA fan art school in Luganol and I've discovered this world and instantly fell in love.

cause I like to think that I can communicate determinate ideas to a wide range of people and have different reactions. I like the interactive side of it and that gives you the possibility to work with a wide range of different clients and material.

From start to timisk, now long does it normally take you to complete a project? It's really difficult to say, as it really depends on the client needs... Generally I face each project in phases (as mentioned before! which are documentation and research, sketching and ideas, mock ups and overview of the contents, design, outcome. I've been working on projects for a or 6 months, it's just a matter of hor much work you have to do and how important it is for the client and

Do you prefer to work independen or with a group of people?

Again it depends on the project, I person ally prefer to work independently if I have the possibility and the time. But I love working in teams if the people shares

What kind of advice would you give to someone who is thinking about

Do research and look to the past of our history, it's always good to look back where designers weren't surrounded by technology but use to come up with amazing outcomes finished are rarely seen heps days, it slavays insprese me to think of new methods to realise my works. What down or sketch everything comes across your mind, swelything is moorrant.

If you love art, design, ink, paper, communication and people then welcome to the dub, and grids are your friends!

to the dub, and grids are your triends! What is the most challenging aspect of

Interest the according all with a good both for a large auditioner is one of challenging aspects of being a graphic designed aspects of being a graphic designed challenging white the oldent needs with still hearing an appealing the challenging white the oldent needs with still hearing an appealing more shallinging the graphet will be also I always think of from 10 automose the daying will be the control of the position and build the lilyouts throughout time easily if you goned time of time easiest and observed with the nice designated and observed with the nice design still be appeared to the easiest and observed with the nice designated and observed with the nice designated and the still be appeared to the cases and observed with the nice designated and the still be appeared to the cases and the proper of the cases of the cases and observed with the nice designated the proper of the cases of the cases and the cases of the cases and the cases of the cases and the cases of cases cas

hat is you're most valued possession hen it comes to design?

penoil.

esigner?

I don't knew even if I've ever been a graphic designer to be honest, I've started studying graphic design at 14 but I don't really feel part of the "graphic designers club," I prefer to see it as another way of express and communicate.

約瑟夫·馬歇爾(Joseph Marshall) 為大學雜誌所製作的比稿作品(左頁 下)。欄位的垂直線靠著水平軸來平 衡——這是平衡版面元素的常見手法。

把文字拿掉後,我們可以看到能彈性 運用的四欄格線系統(左頁上)。這 版面是小報版式,比 A4 大,但比 A3 小。馬歇爾想要透過留白空間的安 排,給讀者強烈對比的驚喜。

上圖是簡單的三欄格線版面。小報版式讓設計師有許多留白空間可用。這套格線很基礎,和馬歇爾複雜的範本大不相同。這份版面是由史蒂芬·亞柏拉姆(Stefan Abrahams)、工題敏・瓊斯(Jasmine Jones)、瑞貝卡・達夫史密斯(Rebecca Duff-Smith)與哈德森·席夫利(Hudson Shively)這幾名學生共同合作,他們也以這份格線製作數位版本(右圖);數位版本更適合採用簡單的格線系統。同時,格線系統也要能反映文章內容風格。

REAFFIRMING THE tress OF OUR NATION, UNDERSTAND THAT A GIVEN. GREATNESS IS

-PRESIDENT BARACK HUSSEIN OBAMA

School of VISUAL ARTS
SYA.EDU

Chapter 6:編輯設計師的必備技能

編輯設計師要做出亮眼的好刊物,除了得具備相關知識之外, 也要有相當的實務經驗及技能。前幾章已討論過這些必備的技 能,例如要理解刊物的結構,懂得與團隊中的不同人合作。本章 將繼續深入探討編輯設計的能力為何,尤其以下幾項,身為藝 術指導更是不能缺少:

- 將想法視覺化;
- 創造理想好用的版型;
- 充分掌握文字編排邏輯並能順暢執行編務;
- 能快速學習新軟體,並不斷吸收新知和新技術;
- 知道如何設計出有整體感,卻又不乏味的版面;
- 安排管理專案的時間與成本。

將想法視覺化

0

雷斯里認為,一名編輯設計師要擁有以 下特質:

- 能深刻理解文章內容,即便它對你 而言有點太深奧或太枯燥。
- 視覺化能力強,能和同事溝通想法。
- 能開發插圖與攝影作品的潛能。
- 了解市場脈絡與競爭者的出版品。
- 能發掘好想法,無論這想法是誰提出 (且肯定提出者)。
- 能兼顧發揮創意的渴望及現實的截稿 期限。
- 享受報刊的製作過程;缺乏熱情,不可能做得出好設計。
- 要有自信,也要有慎選戰場的自知之 明。

這是一項很複雜的能力,要把所有素材加以篩選、淘汰、強調、安排與組合。編輯設計的責任不只是要做一個版面,還要建構出對整體刊物的願景,使刊物能隨著時代、內容及讀者類型而持續調整。設計師必須:

- 閱讀文稿,理解內容,提出優良精準的詮釋方法,並與文字編輯、寫手或攝影師討論設計方向。
- 和文字編輯培養出默契,製作出團隊心目中的 理想版型;要能溝通無礙,利用提案和會議與 編輯們達成共識。
- 理解刊物的需求與目的、品牌形象,以及讀者 的心理與閱讀行為。
- 設計提案一定要多提幾款,才能比較出不同方 案間的優劣;萬一被打回票,也有備案供討論 與發展;
- 盡量保持靈活,學會編輯設計基礎知識後, 就要開始能檢驗、質疑、玩弄、探索與打破規 範。在尋找解決方案時要懂得變通,不必固守 單一途徑與規則。
- 在正式動手設計版面前,要發揮想像,多方嘗試各種版面的可能性。隨身攜帶素描本。在紙上列出想法與粗略版型;畫草圖、圖表與其他資料,待想法十分完整之後,才開始用電腦做設計。

頁面製作與格線

要為一份好版面打下穩固的基礎,得先選擇版式 與紙張、製作合適的格線、知道如何用設計來表 達內容優先順序,並善用落版單。這麼一來,即 使臨時狀況層出不窮,仍可確保各單元與分頁方 式,能符合整體刊物的流暢度與節奏。

格線

September 12 1914

The sure way to end the war

格線就像建築藍圖,是隱藏的指南或秩序系統, 幫助設計師決定文、圖與其他設計元素(例如 留白空間、白邊與頁碼)如何置放與運用。格線 能保持刊物的連續性,同時也讓版面有變化的空 間。良好的格線系統可將頁面項目固定下來,但 不必然會使這些項目受到局限。若要設計出流動

34 •			The Guardia
theguardian			Found Numb
Four years after 9/11			Cor
The war of unir	ntended consequ	iences	clar
Society they are control or in Nicolal Brown for the Nicolal Brown for the Nicolal Brown for the Nicola was present the Nicola of Nicola March and Nicola March	The state of a control is by error any other than the control is the control in t	proposation in the quest — They is a specific content of the quest — They is a content of the co	□ In a pa which if converges which if converges the converges of the conv
Japan's general election			o In a re shortles
A mandate and	a monopoly		we said Short II had fall Marina
The Inpuness prime minister, Junichlor Bender, Paris and Bender and State of the Control of the	and remains a one-porty system. Much has been sentenced as the sentenced of the sentenced o	icy towerski a nione nazironalier position. He is income a nione nazironalier position. He is income constitution, Jupus in laterly be entryl security acceptant, pages in laterly be entryl security acceptant, pages in laterly income a nice of the security acceptant page in later in laterly income a nice of the security acceptant in later in la	It is the correct to possible maintee of the re- order of the re- set of the re-
In praise of The Proms			land to there at subset day to s
			Reset

The Guardian Xxxxxday Month XX 2005		
National		

在嚴謹的格線系統上,大量 的文字方塊可產生「浮動」 的感覺,例如《衛報》改版 後的樣子。 TIP

羅傑·布雷克(Roger Black)的十條設計法則 (別忘了·規則學會之後就要打破。)

- 1. 每頁都要有內容。編輯設計不是裝飾品,要確實傳達資訊或視覺效果,所有設計都是建構在內容上的。要知道,讀者不會一字一句的閱讀所有內容,這世界上除了媽媽會把自己小孩的作品細細的一讀再讀之外,一般的閱讀都是跳躍快速的,所以一定要確保內容的飽合度夠高。
- 2.3.4. 最重要的顏色是白,其次是黑,第三是 紅。書法家與早期印刷師傅在五百年前就明 白這一點,而經時間驗證,他們的看法完全 正確。背景用白色、文字用黑色,要凸顯重 點則用紅色,引起注意。這三種顏色最好, 使用其他顏色時務必謹慎。
- 5. 別像風中的熱狗包裝紙,被流行風潮一吹就 忙著到處飄。
- 6. 別用一大堆大寫字,否則讀一會兒就累了。
- 7. 封面要設計得像海報。封面用單一人像,比 用一大堆圖或全是字的封面更暢銷。過去如 此,以後也是如此。想想看為什麼。
- 8. 整本刊物只要使用一、兩種字型。義大利設計師深諳此道,運用搭配得宜的單一元素營造強烈感受。避免使用大量字型與顏色,那樣會看起來雜亂無章。
- 畫量讓每個東西變大些。字級大的文字看起來更漂亮,不好看的圖在放大後也會比較美觀。
- 10. 要有料!多數設計往往缺少驚喜。若想引人注意,就要呈現出有變化的步調。若節奏總是一成不變的圖、標題、文字、廣告;標題、圖片、廣告……,讀起來就像布丁沒放葡萄乾,或是沒有料的燉菜。

羅傑·布雷克的設計作品包括《Rolling Stone》、《紐約時報雜誌》、《Newsweek》、《McCall's》、《Reader's Digest》(中译:讀者文 摘)、《Esquire》與、《National Enguirer》等等。 性高的刊物,格線也可以當作固定點或參考點。 有了格線,文字、圖片、留白區域的大小與形狀 皆較容易具體規劃,加速版面的製作流程。三欄 式的格線設計變化較少,若設計成更複雜的九或 十二個單元,則有很大的彈性,使用起來有很多 變化。格線本身雖然一成不變,但不妨大膽些, 以自己的方式運用格線,做出獨樹一格的版面。

不同形態的出版品,使用格線的習慣也不同。先了解這些慣例,才能適時打破。舉例來說,週刊或日報的製作流程講究簡單快速,常採用拘謹的格線結構。相對地,季刊的製作時間充裕得多,設計師可多多嘗試不同的格線與欄位系統,提高流動性。古提耶雷茲設計的《Matador》年刊,每期皆以嚴謹但不同的格線搭配一種特定字型。有些刊物不使用格線,把一頁當成一個單位,並以圖片或標題為基礎,發展版面結構,如果技巧高明,可做出有流動性與彈性的頁面與出版品。但這麼做亦需謹慎,確定這樣的風格適合刊物的品牌特質與讀者群。

製作格線時須考量易讀性,因此務必研究一行 字的長度多長才好讀。「法塞特易讀性理論」 (Fassett's theorem of legibility) 指出, 每行應包含45到65個字元數(字元包括字 母、數字、標點符號與空白),超過這個長度會 降低易讀性。這不表示每行不能用 40 個或 75 個字元,但在使用不符合既定理論的做法時,應 該仔細想想為什麼要這樣做。若講究讓讀者閱讀 時清晰舒適,則格線就要考量易讀性。以報紙來 說, 小報版式或柏林版式最適合採用五欄格線系 統。在跨欄位的標題下,文章長度超過 7.5 公分 (3吋)時,通常就會用副標或圖片來分段。此 外也要考量風格慣例。比方說,雜誌專題報導基 於易讀性,通常使用三欄,但文藝雜誌往往只用 兩欄,營造出古典對稱感,而且每一行與文字方 塊較寬的時候,便能明白展現「知性美」;許多 報紙的增刊也採用兩欄,但會搭配留白空間與其 他設計元素,讓頁面更輕盈。

Der Ernst des Leben

系統, 而是靠每期內容與設計概 念,創造各期的連貫性。《soDA》 (左圖)就是一例,格式、設計 及隱藏格線(若有的話),是以 當期雜誌主題來決定。左下的 《Metropolis》則在整本刊物中使 用二、三或四欄格線,前藝術指導 拉濱表示:「我們的版面上有一條 格線規範圖與文字的最高點,因 此上方總是有很大的留白空間。 《Metropolis》的 logo 像影格一 樣,在頁面頂部來回移動,藉以顯 示閱讀進展。這個慣例是 1999 年 舍爾改版之後沿用至今。專題報導 會印在無塗布的紙張上,讓讀者透 過視覺與觸感,發現這是雜誌的特 殊單元。這種作法,就是完全以內 容出發作為設計考量,但卻更有實 驗性。每篇專題報導依據報導內容 與搭配的美術質量, 一一量身設 計。多數報導是採用相同的二欄或 三欄格線,但如果某文章更適合用 別的方式設計,我們也會毫不猶豫 地捨棄格線。」

許多一年只出版一、兩期的刊物或 系列出版品,並沒有固定的格線

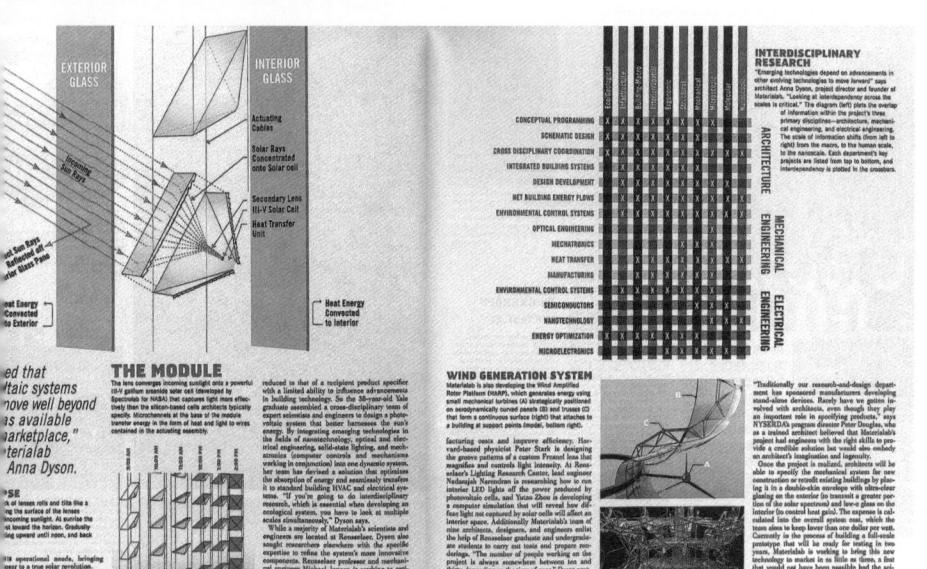

Giulio Cappellini is one of the world's most influential furniture manufacturers. The list of designers that have been commissioned by Cappellini reads like the who's who of design of the past few decades. Simon Horauf managed to steal an hour of Cappellini's time during his first visit to Australia.

Gollis, how is the sky in Millass (Laughts). The colours of the light is rotally different. The sky in Millass is warmer and a subpet block. This is my first usine in Australia. And I am very impressed with the light here light is very important for us. Depending on the colours of the edge in the light is very important for us. Depending on the colours of the sky. The colour of the light is very important for us. Depending on the colours outsile, who have a ready different to the same red will look different in fauntalia to the same red will look different in fauntalia to the same red will look different in fauntalia to the same red will look different in fauntalia to the same red will look different in fauntalia to the same red will look different in fauntalia to the same red will look different in fauntalia to the same red will look different in fauntalia to the same red will look different in fauntalia to the same red will look different in fauntalia to the same red will look different same red will look differen

上圖選自《Inside》雜誌,版 面隱含著拘謹的格線,但這頁 面的簡潔並不妨礙其他單元的 設計與版型。這份刊物的前藝 術指導多徹提表示:「單純的 格線仍可做出許多組合,設計 者必須把視野放寬一點。讀者

喜歡對一份雜誌有熟悉感,和 雜誌建立起關係,而保持一致 的格線能滿足這項心理需求。 如果格線保持一致,忠實讀者 拿起任何一期,都會覺得瀏覽 這『新』刊物時很自在。」

ONE MINUTE, SHE'S THE ARCHANGEL GABRIEL, AND THE NEXT, MARILYN MANSON. TILLDA SWINTON, AS VAN HIBE OF THE ARCHANGEL

One of Titles Sprinters's assessment on her very posh, very molitary Scottish family tree was painted by John Singer Sargent, and it is easy to imagine Swinton, with her albaster skin, otherworldly green eyes and regal 5-foot-11 bearing, captured in oils. "I do look like all those old paintings," Swinton joked over a midsummer lunch of raw oysters at the Mercer hotel." But I'm áriad my temperament does not conform. At all." She said this, as he said nearly verything, with an its of direct authority and engaged enthusiasm that was both immediately ingratating and commanding, Swinton, who is 44, was wearing no trace of makeup, a print sundress and flip-flops, and her hast, which is naturally red, was yeld white-blond. "Howe the roots," she said, as he titled her scale forward for inspection. "That's the best part of being this blond."

Her unique looks, her case with herself and her voracious interest in the more contrait worths of cinema and style have Her unique looks, her case with herself and her voracious interest in the more contrait worths of cinema and style have characters, including a man. In "Thumbucker," opening in theasters on Spect, 16, she is utterfy convincing as a suburban American mom. The director Jim Jamsusch casts her as an ex-girlfriend of Bill Murray's in the recent "Broken Flowers," in which she is terrifying, her face half obscured by a forbooding curation of long brown hist. For "The Chronices of Narnis: The Lion, the Witch and the Wardrobe," a big-budget movie that is due out from Disney at the end of the year, Swinton

雜誌的專題報導在易讀性的考量 下,通常使用三欄格線,但文藝雜 誌常用兩個寬欄位,形成經典的對 稱感,讓文字方塊看起來大而紮 實。本頁取自《紐約時報雜誌》的 範例將這一點進一步發揮,大膽 採用單一的寬欄位,這個作法雖 違背法塞特易讀性理論(參見156 頁),但仍相當好讀,又具有古典 結構的形式美感。

數位刊物的格線

設計數位版刊物的版面時,格線也是重要工具。 《泰晤士報》所使用的格線設定,目標是提供設計師與文稿編輯一套井然有序、易讀性高的系統,以經典的文字編排邏輯來帶領讀者閱讀。 《泰晤士報》也把同樣的格線運用在數位刊物上,只是隨著螢幕比例縮小了許多。有些設計師會認為沒必要在數位刊物上採用紙本的格線設定,但設計指導希爾是這樣解釋的:

「《泰晤士報》的數位版本也採用線性瀏覽模式,讀者利用滑動頁面,一頁一頁翻閱。我們希望透過保持與紙本報紙相似的風格,讓讀者無痛接受數位版。雖然這做法一開始飽受抨擊,但後來,讀者的反應很好,從紙報改而閱讀數位報時,他們都不會不適應。而屬位固定,也的確比較容易設計。對讀者而言,從紙本轉換成數位版是個大躍進,但一般讀者都已經很熟悉iPad的操作,以及紙本刊物的版式。」

相對地,《衛報》的波特在處理格線時則採不同態度。2005年《衛報》改成柏林版式時,波特就設計了新的格線系統,他於2010年擔任iPad版本的設計顧問時,也同樣大刀闊斧更動文字編排的方式。波特將《衛報》的視覺識別加以調整,將同樣的風格延伸到《衛報》網站與app。他說:「重點在於,如何在不同媒介上靈活變通。報紙的格線固然和網站或app不同,但仍要有一套可依循的系統,應用到不同媒體,而不是完全捨棄原有的格線。」

HE MAN TIMES | Eureka

In the competitive world of Premier League football every detail counts. For Som Allardyce, the Blackbus Rovers manager, this involve employing. The Big Brather of flootball? to help him to get the best out of his player But what's good for eithe flootballers could also be good for you and your joh

WONDS KAYA BURGESS | DICTURES CERRY DENIA

was brief and a long time ago, but Sam Allardyce's experience of the North American Soccer League still shapes his approach to footbal management some three

ago, but Sam Allardyce's comeprisons of the North American Soccor League still shapes his approach to football management some three decades later. Back in 1983 Allandyce played for the Tampa Bay Man Rowdies, who shared the facilities of the American football team, the Tampa Bay approach to the Control Learn of the Control Learn of the Manager American football team, the Tampa Bay approach the Control Learn of the Control Learn of the Manager American football team, the Tampa Bay approach the Control Learn of the Control Learn of the Manager American Science (Control Learn of the Ma

played for the Tampa Bay Rowdies, who shared the facilities of the American football team, the Tampa Bay Buccaneers. Even though the Buccaneers were not the strongest team in the NFL, Allardyce was impressed. released, whiched seems video enablyms, bushed at death, both being which toother below that a size terd. Whilesper ceredit.

A hage bate to get me nectice on this information and built is the second of the secon

While Protone works exclusively on lookball, its executives were been consulted by companies seeking to use a similar away been consulted by companies seeking to use a similar area of the seeking to use a similar and the seeking to use the seeking to use the seeking to use the seeking to the seeking the system to show the statuse numes has to cover within a hospital, their work-rate that the seeking the seeking

《泰晤士報》決定在 iPad 版本上延用類似的格線結構,讓傳統報紙讀者在瀏覽頁面時能有熟悉的閱讀體驗。《泰晤士報》向來重視井然有序的版面,數位版本也不例外。設計指導希爾說:「我們重視文字編排的結構,先選定字體,再細心設計版式。我們想要做出編排精美的產品。」

emplower productivity by pletting that about individually conjuging a policy and post that year pley work (Companies constitution) to software preclaigue that will monitor interest using a constitution of the software preclaigue that will monitor interest using a constitution of the production of the constitution of the cons

on treen, ne says.

A lot of people want a magic bullet for observation but not
of these systems work by themselves. They are most predictive
when collated with other data on performance.

In a call centre one employee might take longer over
calls, but they might also have a better record of keeping
and attracting customers. You have to be very careful that
monitoring software doesn't bind wou to other data.

GREAT MINDS

Footballing Injuries can be prevented using sport statistics Dr Ian McHale, University of Salford

THE ABBLITTIMS | Eureka

MISSICHE

QUANTUM OF COOL

Heroes & Villains of sports science

The Cool of the Internet of the Cool of the Internet of Internet

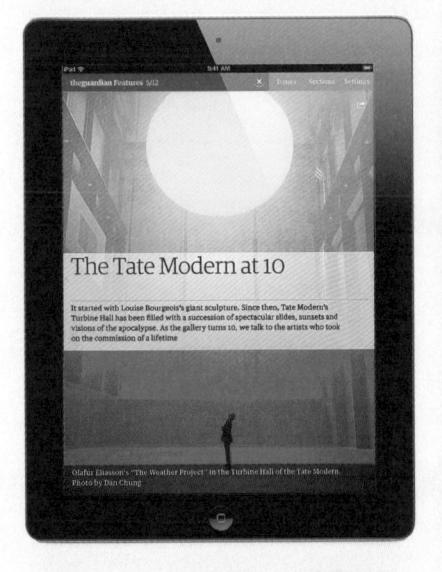

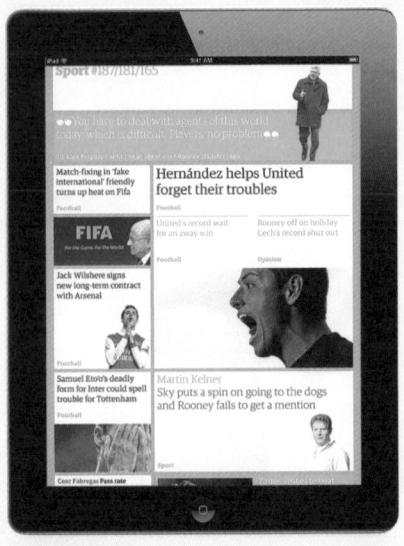

《衛報》的紙本報紙是以二十欄隱藏格線系統為基礎,讀者實際上會看到分成五個欄位的版面,網站則為隱藏十二欄的格線系統,實際上會看到頁面分成三或四個欄位,iPad版本則是分成八乘六的正方形。頁面的文字編排階層,並運用俐落的標題、文圖並置來強化這些相對關係。網站將圖片的力量發揮得淋漓盡致,讀者可用簡單的瀏覽工具,直接找到自己想看的內容。

《衛報》的 iPad 版本和許多新聞網站 一樣,是以水平的單元標題搭配垂直主 題列表,讓讀者能快速尋找內容。

範本

格線建立好之後,即可製作不同單元的頁面範本,例如新聞頁面範本、專題報導範本、後段範本……等等。範本必須要使用設定好的格線,但可依單元需求來簡化。在設計範本時,必須要用上所有可能出現的頁面元素,例如不同字級的資訊框、內文欄位、圖框、圖說框等(更多範本的資訊,參考 110 頁)。

分頁

一份刊物中的內容順序必需事先規劃好,才能確保刊物完整流暢。編輯團隊會透過「分頁」的工作來完成這項規劃,分頁的方式會決定閱讀的節驟,通常,內容類似的跨頁之間務必要有明確的分隔。分頁通常由編輯、美術編輯、後製編輯與廣告銷售主管共同決定。影響分頁的因素,包括印刷流程(各單元如何拼版送印)與廣告需求。

分頁時,有些細節必須要格外注意,例如若某篇 專題在左頁結束,右頁最好不要馬上另起一篇專 題。此外,一篇專題也不宜被連續四頁或突然冒 出的廣告插頁打斷。要檢視分頁及刊物流動是否 合宜,可預先把整本刊物的頁面規劃縮小印出, 貼在工作室。由於製作流程中頁面難免出現變 化,這時編輯設計師就可以直接調動這些小頁面 的順序,從而看出新排序對設計造成的影響。

傳達訊息

雜誌的分頁與版式,必須把文章的重要程度與 風格傳達給讀者。文章在刊物與頁面的位置、欄 寬(較寬者多為專題報導或報紙計論版)、字型 級數、標題長度與位置、文章長度、文章樣式、 圖片的運用與大小、色彩運用等諸多設計元素都 是訊息,會傳達給讀者。以報紙為例,頭條新聞 通常靠近頭版頁面最上方(放在報攤時能見度 最高),標題最大,也分配到最多空間,周圍則 擺放次要新聞。社論版和新聞頁面有差異,會使 用較多的負空間,有搭配照片的署名行及抽言, 欄寬較寬,並使用不同字級與粗細。雜誌也會運 用這方式來傳達訊息。在雜誌的新聞與評論頁面 上,訊息傳遞方式和報紙類似,但在專題報導區 會更細膩。若一篇文章的標題醒目,篇幅長達八 頁,欄位寬,有滿版照片,還委請攝影師拍照, 顯然代表刊物很希望讀者好好閱讀這篇文章。設 計師須以連貫且一致的方式,在刊物中運用這些 訊息暗示與讀者瀟涌。

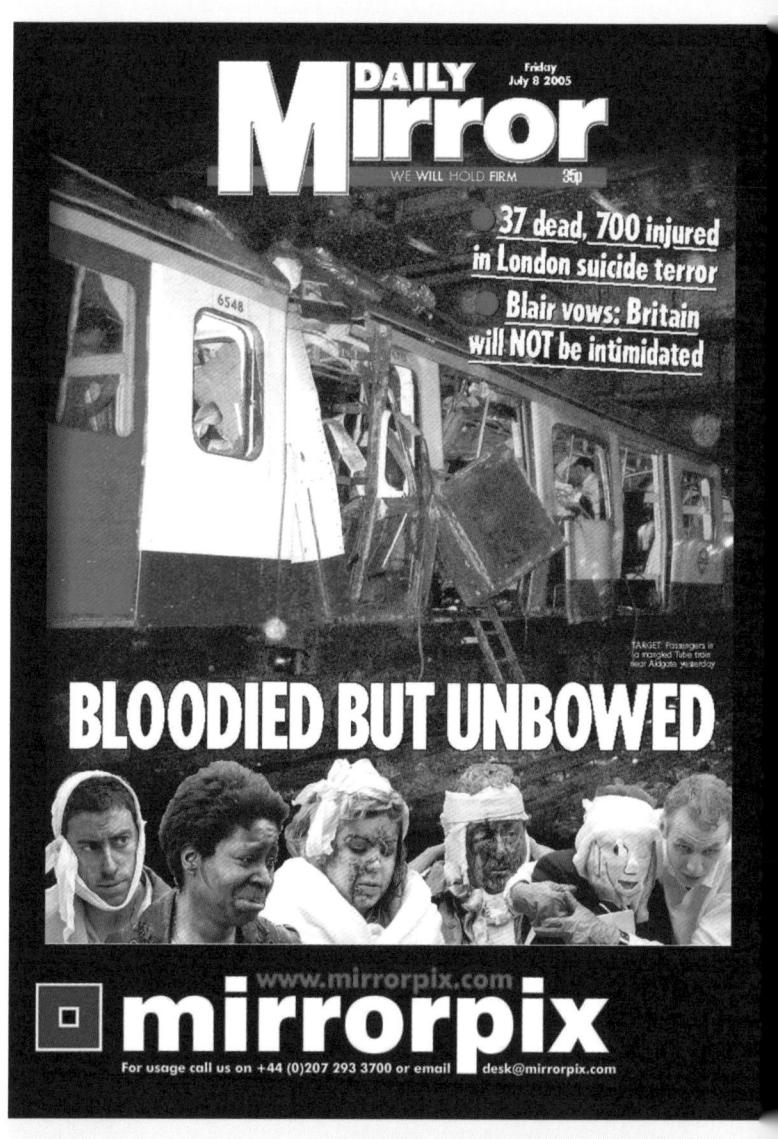

2005年7月7日,倫敦多處地點遭到 炸彈攻擊。全國發行的八卦報《每日 鏡報》(Daily Mirror)將倫敦描繪成 遭血洗的首都,卻不向惡勢力低頭。 報紙通常會以圖像來呈現這類大事。 《衛報》iPad 版發展草圖中有一塊塊的 方塊橫組,有些放文字,有些放圖。之 後會發展成漂亮的格線,且具備變換影 像(rollover)的功能。設計師在各設計 階段都是用手繪圖來溝通。

數位刊物的版面設計

數位刊物的文字編排與版面設計法則,其實與紙本相似。但設計師必須知道,數位刊物和紙本刊物不僅僅是不同產品,讀者也會對數位刊物抱有更多的期待。刊物編輯團隊必須了解讀者是誰、讀者關注什麼,以及讀者為何、如何、從何處與數位媒體互動。之後,藝術指導和編輯團隊才有著力點,設計出適合讀者的內容。

瀏覽

平板與數位裝置上的數位刊物,應延續在紙本上所講究的明晰規劃。如今,適用於 iPad 或行動裝置的數位刊物已有很高的互動能力。設計者要審慎規劃順暢的瀏覽方式,讓讀者願意與刊物互動並深入探索。在設計瀏覽方式時,要讓讀者很快找到想讀的內容,例如運用標籤(tag),即可讓讀者快速找出相關報導或更多資訊。所有文字包括功能按鈕,都必須容易理解、能吸引注意,才能引起讀者的興趣。

中間的圖擷取自影片,傑克·舒茲(Jack Schulze)解釋數位刊物版式設計的概念(可上網搜尋「Mag+Berg Bonnier Video」)。每篇內容都是以文、圖與常見頁面元素搭配而成的垂直欄位,可上下捲動,之後又用「晾衣繩」(clothes line)集結起來,可以水平滑動。

當讀者用手指將版面左右滑動時,可以切換不同文章,而若想閱讀某篇文章,則可以上下卷動來看全文。這樣的數位雜誌設計如今很常見,而且,它們往往仍以格線系統和樣式表做為版面設計的基礎。

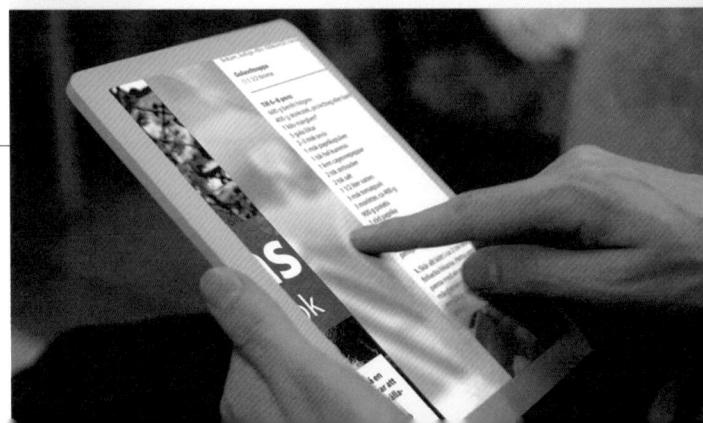

PROJECT: EL MORRO

TITLE READING EXPERIENCE IA

the BTIA SPRING AT TOP OF ARTICLE, in landscape mends top URps of content or portral mends clear space.

BE ENTERING FOR EDGE and entering on Cause and Prosidirity of small transition and EG Generica

move across the TOC be sanging left or right swipe up to Brill, into an article

8.8 SHORTOUT TO SECTION BREAKS section breaks use a divide samp gradure shortful - outside of the drawer gradure an

Mag+ 是一種電子刊物瀏覽軟 體,由倫敦的伯格設計顧問公司 (Berg London)與波尼爾出版集 團(Bonnier)共同設計。掛圖上 的草稿(左)顯示出 Mag+軟體 的發展概念。從圖表上可看出團隊 在軟體開發初期所提出的「關鍵手 勢」。後來,手勢語言漸漸發展成

熟(最上圖),出現了「拖曳輕 拂」(滑動),以及「拖曳摺角」 (頁面頂端有往下摺的小角,吸引 讀者繼續往下一頁前進) 等觸控動 作。牆上的草圖(上圖)顯示頁面 的水平以及垂直版面的規劃邏輯, 設計師必須依照這些新的閱讀方式 來設計版面,捨棄紙本的思維。

格狀瀏覽系統可傳達出文章的重要性,主要文章會比次要文章占較多格,此外,它也可當成按鈕,讓讀者觸碰後進入主文。正如波特解釋:「格狀瀏覽搭配主圖,可帶領讀者打開任何想讀的文章,探索刊物內容。紙本刊物中的重要文章會使用大標題,而數位版本的重要報導會占兩、三個方格,使用者可上下左右滑動、觀看。」

網站

雜誌網站可採用使用者已很熟悉的選單列與下 拉式選單。之後,設計師可用文字階層與單元名 稱,引導讀者前進各個單元與頁面。刊物網站與 紙本刊物的最大差異在於,網站並不是設計來讓 人大量閱讀的,此外,網頁版的設計考量也與觸 控式的平板電腦版本不同。網站讓設計師有機會 展示品牌,誘使讀者購買刊物本身。

平板電腦

平板電腦擁有觸控螢幕,這項發展使數位刊物的 瀏覽體驗更上一層樓。但設計師一定要記得,讀 者仍希望能儘快找到內容,不想面對太多障礙, 畢竟平板電腦有時反應不是很快,難免導致部分 讀者失去耐性。波特曾說:「報紙網站受歡迎, 是因為讀者能很快找到資訊,例如賽事結果,並 深入閱讀。讀者一進來,就能看到熟悉的新聞標 題列表,相當簡潔明瞭。然而,令人滿意的數位 雜誌不多,因為讀者想和雜誌互動的方式與報紙 並不相同。」

app

報紙的 app 內容需要不斷即時更新,因此比雜誌的 app 更仰賴範本,執行起來也較類似網站操作。如今市面上也有許多雜誌 app,比較單純的是直接把紙本版面轉成的 PDF 頁面(或許還可嵌入外部網頁與社群網站超連結),也有非常多功能,請工程師量身製作的 app。

將活潑豐富的物品排列在版面上,並使用 隱藏式圖說,讓照片保持完整。讀者要看 圖說時,只要輕輕滑動畫面中的物件即可 看見。上方的專題報導主題為瑪麗蓮夢露 的鞋子,只要點選不同的鞋子,就會出現 不同的故事。

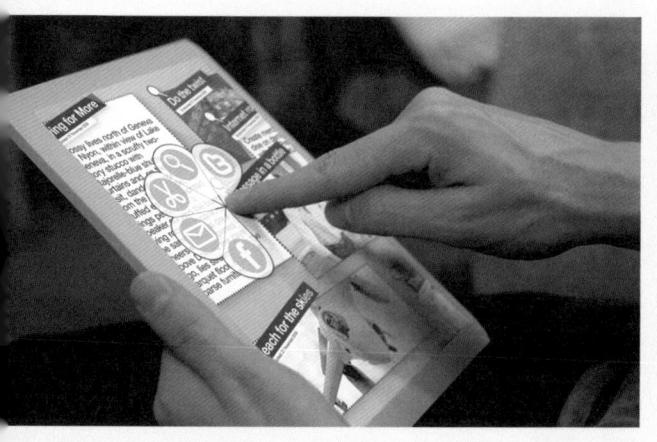

利用觸控式選單來閱讀更多報導或功能。利如圖中這個輻射狀的小圖示,能讓使用者用不同的平台來分享內容,使用者可把雜誌圖片或其他內容直接發到社群網站。以這個例子來說,按住螢幕,就可把食譜用電郵寄送給朋友,也可分享到Twitter或 Facebook。

由於成本與資源有限,小型出版商只能從轉製 PDF 著手。但不少出版社另闢蹊徑,為讀者群製 作出更合適的成品。《Wallpaper*》雜誌的道格 拉斯談到如何為雜誌製作 app:

「重點在於換個方式思考。數位雜誌的運作有何不同?讀者會以何種不同方式閱讀?設計師必須想想看,讀者會怎麼使用你的app。在iPad上,頁面可以很輕鬆的放大縮小,但智慧型手機螢幕不夠寬,沒辦法這樣玩。網站版本理論上空間較大,但如果仔細研究使用者都怎麼觀看螢幕,就會發現其實網站在螢幕上的顯示也沒有想像中的大。多數的站內瀏覽都仰賴列表與選單,這在看列表或閱讀一本書時不會造成太大阻礙,但不那麼適合用來編輯一整份刊物。」

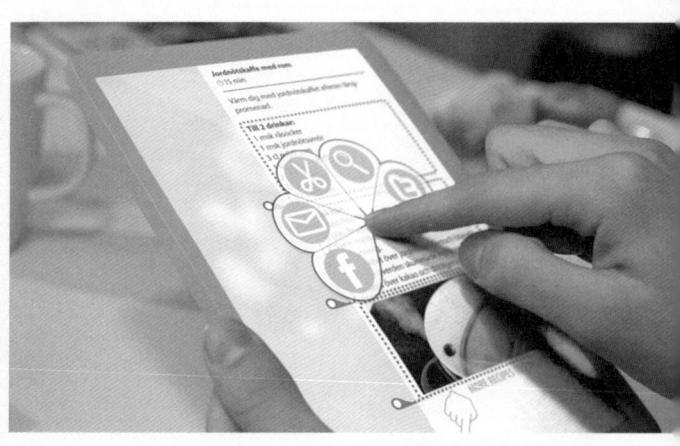

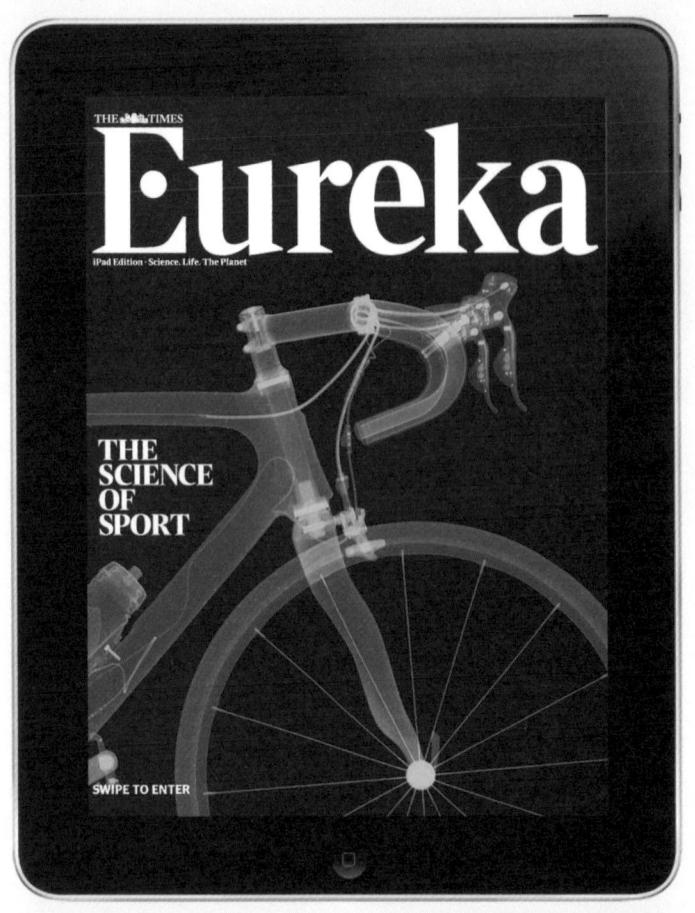

上圖是《泰晤士報》出版的《Eureka》 科學雜誌 iPad 版。希爾以刊頭來營造 視覺力量,封面設計保持簡潔。讀者翻 開封面之後可按下六邊形,進入內容。 六邊形格子的設計散發出科學感。

雷斯里的數位刊物設計秘訣

- 最基本的原則是,想清楚你要說什麼、對象是誰,然後才決定如何表達。
- 2. 讀者是靠分享觀念與共同興趣而連結起來。人人都想要有歸屬感,這一點永遠不變。拜數為科技發展之賜,想與人連結更容易了。
- 3. 在決定使用一種媒體之前,先想一想,什麼媒體才可以讓刊物加分, 而什麼只是畫蛇添足。
- 4. 製作互動元素固然令人興奮,但一 定要確保這些元素有功用、有意 義,而不是為做而做。
- 5. 從刊物立場來看,製作紙本或數位 版本的工作並非天差地遠,除非你 刻意讓兩者天差地遠。
- 別忘了,雜誌會創造出自己的世界,而讀者在那個世界裡依然會忘我地閱讀。

落版單

Α	1	2	3	4	5	6	7	8	9	10	11	12	13	14	15	16
В	17	18	19	20	21	22	23	24	25	26	27	28	29	30	31	32
Α	33	34	35	36	37	38	39	40	41	42	43	44	45	46	47	48
C	49	50	51	52	53	54	55	56	57	58	59	60	61	62	63	64
C	65	66	67	68	69	70	71	72	73	74	75	76	77	78	79	80
В	81	82	83	84	85	86	87	88	89	90	91	92	93	94	95	96

這是一份96頁刊物的落版單,可以 看出頁面順序。整份刊物共使用 A、 B、C三張紙雙面印刷,每面印16 頁,雙面則為32頁。如果你的刊物 並非全彩,則應該在落版單上清楚標 示出彩色單元與黑白單元; 彩色頁面 可用色底顯示,或在周圍用以粗框標 起來。以這裡的例子來說,黃色頁面 代表全彩印刷,紅色頁面代表雙色印 刷,灰色頁面代表單色(例如黑色) 印刷。彩色單元可能出現在刊物中的 任何位置,但要能符合每張紙上所分 配的色彩區塊。多數印刷機所印出與 裝訂的頁數都是 16 的倍數,但 20 或 24 的倍數也很常見。通常印刷廠會要 求至少要有一張紙(一台)先送印, 例如所有在 A 張的頁面必須要比 B 與 其他紙張提前一、兩天印。

落版單會顯示刊物的各內容該出現在 哪裡。第一頁通常是封面,而用來放 廣告的頁面常會打叉,也可用清楚的 「AD」來表示,因為有時候打叉可以 用來標示已完成設計、校對或其他步 驟的頁面。落版單更新時,最好依循 固定的命名或編號慣例,在明顯處標 示出日期、時間、版本編號。右圖是 《M-real》的目錄頁,很巧妙地展示 刊物在送印前落版單的模樣。

Issue 4. Response. Page 03

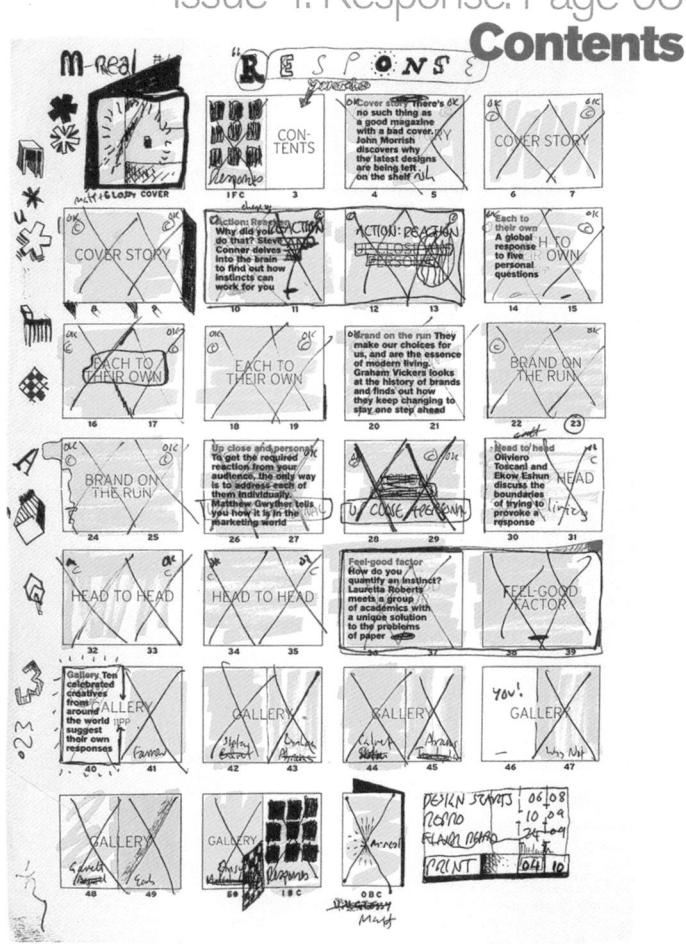

用紙選擇

紙本刊物如今面臨數位刊物的競爭,必須盡量 展現其優於數位產品的特色,例如紙張質感。紙 張特性和刊物的感覺、調性、風格與外觀息息相 關,也會影響刊物內容的表現性。選紙通常可以 請印刷廠與紙商協助,編輯設計師最好能不厭 其煩地向兩者取經。印刷廠可提供良好的初步 引導,依據設計師的製作需求來尋找最適合的紙 張。比方說,如果想要的紙張是薄的、有塗布、 不會透、亮度高,印刷廠通常可建議幾種具有這 些特性的紙款。紙商也樂意提供印製好的書籍樣 本、空白假書與紙樣給設計師,若有必要,甚至 請印刷廠製作成一樣的開本,讓設計師更清楚刊 物的重量與質感。如果要用到特殊的印製技巧, 例如使用金屬特別色、打凸或軋型,也可以向印 刷廠請益, 印刷師傅的專業知識一定能派上用 場。若要找合適的用紙,可看看有哪些現成的書

刊範例符合需求,若那些出版品有將用紙與印刷 廠名稱列在書後,那就更方便了。

紙張考量

好的選紙要能兼顧每個環節的需求。如果主要考量是忠實呈現圖片原色,最好使用明亮、高白、厚塗布,摸起來特別滑順的紙張。這種紙張最能反射光線,不需額外加重圖片色彩。當然,還有其他因素要考量,例如厚塗布的紙張較不利於文字閱讀,重量也較重。若不知道該如何權衡,以下的指南可提供幫助。

塗布或非塗布?塗布紙的反光性較好,吸墨性低,因此能細膩呈現圖片;塗布越厚,圖片越銳利。無塗布紙印刷顯色通常較柔和,很適合美術或插畫的呈現,文字也較容易讀。

《soDA》是小型獨立雜誌,營運仰 賴廣告、訂戶及印刷廠或紙廠支持。 紙廠或印刷廠很樂於藉此機會,推廣 特殊的印製技巧與紙張。本期內容是 討論紙張的表面質感,封面是用雷 射全像卡製作,內頁則使用金屬油 墨,以及有塗布與無塗布的多種彩色 紙張印製。《Flaunt》的封面常象運 用軋型與打凸——這份 2001 年 5 月 號的封面(左圖)是模仿課本,上 面還有凸起的膠帶,及 REM 樂團和 歌手蜜西·艾麗特 (Missy Elliott) 的 logo,非常立體。創意指導透納表 示,封面採用這種風格的原因在於: 「如果雜誌稱為《Flaunt》,就多少 得愛現、愛炫耀(註:flaunt的字義 為「炫耀」)。我們得炫耀特殊油 墨、技巧與打凸,就是要那麼花俏, 才能名符其實。打凸的地方摸起來很 有趣,這是多數雜誌沒有的。大家都 喜歡摸這封面。」

亮面或霧面?亮面紙常用在有大量圖片的高品質刊物,但許多霧面紙的效果也很好,可讓刊物在 競爭中顯得格外搶眼。

厚或薄?厚的紙張往往令人聯想到藝術與「高尚」的書籍,但是薄紙張仍可用密度、亮度與塗布等方式,做出雍容華貴的感覺。

密度或不透明度?紙張的不透明度會影響其「透現性」(show-through),因此在挑紙時,可把紙張放在黑白條紋上,測試透現度。頁面上的元素也會影響紙張的透現性,若很在意,就要仔細審視版型,通常不對稱的格線會比對稱格線更容易使紙張產生透現。

重或輕?重的紙張常讓人聯想到奢侈品,不過奢華感是有代價的——不光是紙張本身的價格高,還要考慮郵寄與攜帶性。如果刊物和電話簿差不

紙廠與供應商莫不努力說服設計師用他們的紙張,常常製作許多紙樣冊子與豪華的樣本,展現某種紙張的重量與色彩。要注意的是,印製好的成品可能看起來又很不一樣,因此若對某種紙張有興趣,最好要求看一份這種紙張印製成的刊物,並請對方依照你的刊物尺寸與頁數做一份假書。

報紙銷量持續衰退,因此報社無不使出渾身解數,想增加讀者。許多報紙從不方便攜帶的大報版式改版成較受歡迎的柏林版式、緊湊或小報版式。縮小版式的理想做法絕不是只讓內容「縮水」,而是以新的尺寸來重新設計合適的版型,重新研究欄位(數量、寬度與長度)、負空間、文字編排與其他設計元素(例如線條與頁碼)。賈西亞打個比方,就像從大房子搬到小公寓:「得重新評估你需要什麼、想留下什麼、願意拋下什麼。」

多重,會不會讓潛在讀者卻步,因為他們不想帶那麼重的書本到處跑?如想讓刊物呈現出忠實伙伴的感覺,是不是該讓刊物便於攜帶?

亮度高或低?紙張越明亮,就會反射越多藍光, 印上去的圖較不會失真。不過也可能造成眩光, 干擾閱讀。此外,為了達到高亮度,就需要更多 漂白劑,進而影響紙張的耐用度與印刷難易度。

再生紙或原生紙漿?讀者在閱讀環保議題的雜誌時,會期待刊物使用環保紙張,例如百分之百再生、無漂白的紙張,或是使用部分再生的紙張。 多數紙廠都有供應這類紙張,設計師可從環保機構查詢各種關於環保紙張的定義。

開本

「開本」就是刊物的尺寸,最常見的開本是A4。開本受限於發行量大的雜誌與書籍使用的捲筒紙寬度,與輪轉印刷機的滾筒大小。由於美國和歐洲的滾筒規格不同,因此印刷品尺寸也有些微差異,美國的標準開本就比歐洲短。消費類雜誌最好遵守常規,才能符合門市的書刊陳列架大小與一般信箱開口大小,以便用便宜的郵資投遞。雖然小批量的刊物擁有客製化印製的優點,但仍應以讀者的立場多加考量,大開本或形狀特殊的雜誌,並不利於歸檔與日後查閱。

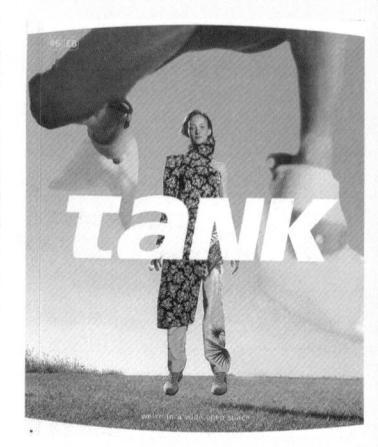

\$7.95 issue # 27.

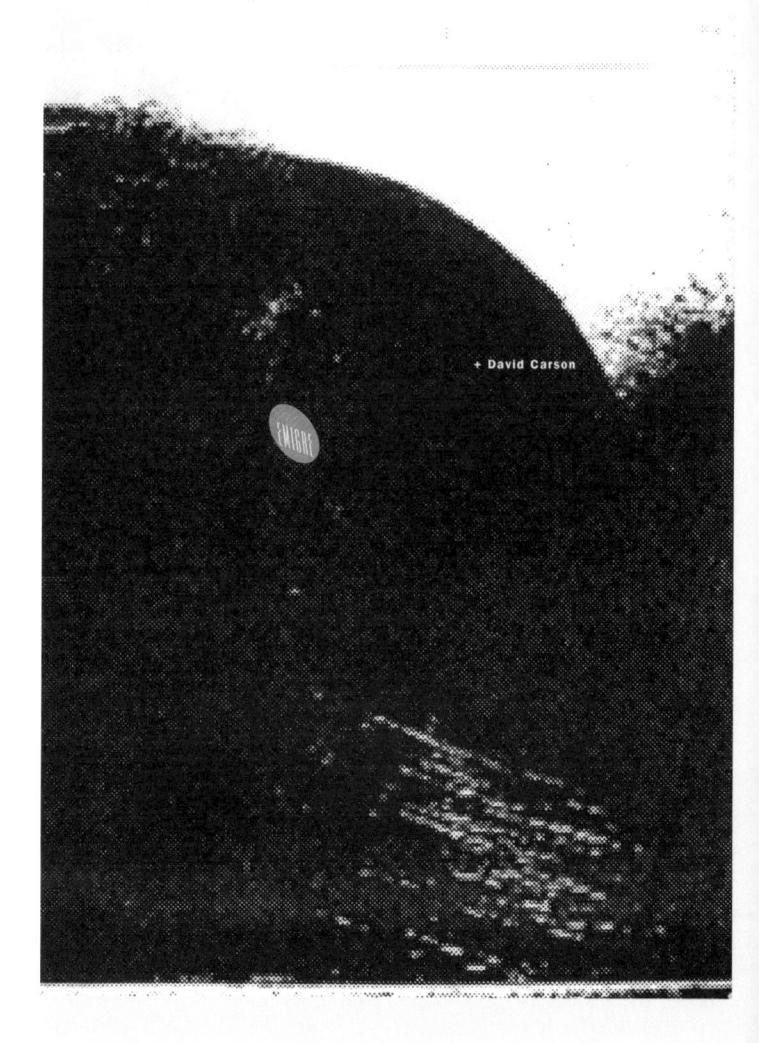

字型的選擇與應用

任何刊物都應該為讀者營造賞心悅目、易懂、舒適的閱讀經驗,而這往往得仰賴文字編排的功力。看小說的讀者,雖然習慣密密麻麻規規矩矩的頁面,但是在閱讀雜誌時,仍會樂於欣賞變化多端、有裝飾性元素與刻意留白,並且完整細緻的版面。字太小、太密、一成不變,沉悶的版面會令讀者卻步;編輯設計師須善用各種技巧,維持讀者的閱讀與致。

此外,設計師還須考量刊物的實用性。某些類型的刊物(尤其日報和週刊),很重視文稿與標題的長短。最後也最重要的一點是,字型要能反映刊物的識別與魅力,這點要從美學、情感與歷史脈絡去思考。字型比其他設計元素更能引起讀者聯想,因此選擇字型時就要斟酌其功能性,還有字型所呈現出來的精神是否與刊物相符。

《Flaunt》的柯賓在選擇字型時,會考量整期刊物的文字編排。他說:「我會思考所有文章使用的照片、服裝、內容、插圖等等,判斷每個單元要用哪些字體,適合用抽象還是具體的手法來處理。」

內文與標題的字級究竟該多大,並沒有定則。 大原則是,展示性的文字資訊要夠醒目,讓讀者 先閱讀;例如標題與引言就應該比主文和圖說 大,在頁面占據明顯的位置,而主文的字也不能

刊物格式應該以讀者特性與目的為 考量,才更能掌握該如何做出變 化。左頁右上圖的《Tank》是種 「微雜誌」,每一期都會改變開 本。左頁下圖的《Emigre》則會 實驗性地每期改變版式。寬大的版 式很符合這一期的主題——卡爾森 的設計作品。

L'AMOURABSOLU

SDDT Cécile, mouste cans la communaute des fratemètes manualiques de Jessatten. Suest Augustier dit qu'il si's a qu'un west amout C'est es qu

we find they gainless (Formation 1, or he have the seven). We now have presented, another commer for some presention, cannot for some presention, they again of an inter-consistent of the present formation of the present

what is do not consist or solve length up on all suppose, but sold, the cold is difficied from two oppins a binds, after after one constitution, and the Experiment for oppins, after after one constitution, and the Experiment for oppins, after after one constitution, and the experiment of a good point. Because the Possister of the company of the oppins of the constitution of the

the contage, eller permait i "There out earlier out lies je driet ausen Phete out eller silven, je driet faitster, with a flat their persons of jets of their Bost out unique this or early person jets. The Bost out compound "retainfor" comme to person de legislator à Nort autonit person de legislator à Nort autonit person de legislator à Nort autonit person de legislator à Bost autonit person de legislator à Bost autonit person de legislator à l'estat autonit person de legislator à l'estat personal à person de legislator de l'estat Cament transien louis consider l'advitéré l'assis en trappatible. Emissis appet l'unite avec l'état partie le Sengieur en me Le vais habbe qu'et louis jusqu'et le la legislator en me Le vais habbe qu'et louis jusqu'et la la legislator de l'estat autonité autonité autonité au l'estat de l'e

ure demes platels une certains charmes qui fait "resport" le Segment Ma fallebane, s'est précisement es que Latine. De est sont, suite la pouvereir rices pas en Lia, More, B'est comsuper par cella. Dies en fallet, leades que un facilité à une, clie c'exp qu'en pointiffe. Mais comme de naire largout "liberde-meure dante qui mou a subu en sel nichempoca." -Laurence Sigal-Klagsbald,

Mais pe toe fee assessée pass à l'amont, quand hiere même le marriage est un ague d'amont de visitour peut vieir des continge est un ague d'amont de timmente, issue de dévouves tenditions. Dans le marriage, le révérancée parent rellement le pass aux exists on a relation some gauginarity or new Ermons or "Official for Dimension data for least the last is desired by a last of the Blowest dee Institutes, but foundations and or do he Blowest dee Institutes, but foundations of the Blowest dee Institutes, but foundations and of the Blowest dee Institutes, and the Institute of the Institutes on North 61 to perfect the Section of the Institute of Blowest deep least deep least

The behalither, a profession, who while the set of primerial for the religion, pointing age is which where only part the feet the religion, to officiar gain is a walle of here only part the effective of the control of the control of the control of the obstacle of the control of the control of the control of the obstacle of the control of the control of the control of the set of the particular of the control of the control of the latest of the particular of the control of the control of the set of the particular of the control of the control of the set of the control o prochain, Is incident, Is inself and support are tower is the families of printer, (All-Signet of more Stelland related to printer, (All-Signet of more Stelland related pass instillations); lives, processor or printer the tendent and account of the contribution of t

se et men inte prisent, le circuit le lettre que l'ant le bradie de met à un mari, l'and, à un men au de adjunction and production de l'antique de l'antique de la companie de de Gardine, quant menigue e rolle, un peice l'impigne de l'antique, quant menigue e rolle, un peice l'impigne de l'antique, antique menigue de la l'antique de la l'antique de la condicion de l'antique de la companie à un lime de puisqu'à la lin de de visibilité et de contique à un lime de puisqu'à la lin de de visibilité de contique à un l'inserpuer salare l'entre destinaté de contique no se résouve par salare l'entre destinaté de contre un se résouve par salare l'entre destinaté de cette "fanor". Esbe, c'e qu'il lant "yeu "ressur" è un ser destinaté, l'action de l'antique de

Program This continiers interction with the Prince Militate Region attent review seeding disease.

In Extendicated, "The assisted Weigs sold the close to leave the continue to leave the continue to leave the continue to leave the continue to the continue to the continue to the continue to the continue of the continue to the continue of the continue

gians, in the lead Green, it has termed in an leaf. . . Parties of the 8th beart up, it is their desiration whereaster, bearts, to be a leaf of the second of the parties and the second of the second

territies, for means then the lost war, modeling be taken to Dalled allement Withing result the solitops, sell then summered, in any ordings then prove to these echilicitates and then relatingtant the only one fit alone. The Conley Test predictor scaling for the sufficition of the test productive offices of the state in the state of the summer of the summer of the summer of the test of the test proper and the temporarlation of the state of the summer of the summer of the summer of the proper state as the state of the summer of the Anthony Education, while when some to produce of the summer of the product of the summer of the summer of the product of the summer of the summer of the product of the summer of the summer of the product of the summer of the summer of the product of the summer of the summer of the product of the summer of the salding over a haritation when the conmonting utilize is set shown. These twothese finites that much is possible, the spirity of our cont ineque, whitever shift period of the contract of the contraction of the conley or our certificial part the same. These are year on certificial part the same fine of the high-constant of the contraction of the con

We are the Torist and power?
West kerses the behind the popular image?

B

這兩個例子運用兩種不同的標題字型,但是都很有效。最上圖為《Vogue Paris》,在跨頁上使用鮮豔的紅色襯線字來寫出「L'amour absolu」(意 為「 絕 對 的 愛」),看起來既搶眼又熱情,不粗魯也不陽剛。而《Above Town》正好相反,很有威風凜凜的男子氣概,反映這篇文章的主題。

Interviu: Per Morbers

rar kokerska på Tullparns slott där han nu syr rättarbostaden. Per plockar bär och svamp, fiskar och jagar instfarande i bronden.

land journalister har Per Morberg rykte om sig att vara beriffer, Ställin in istas sekunden. Vigra swara på frågor. Skilla ut vigra swara på frågor. Skilla ut andra hand nårmsta reporter. Pascinasion, biskun och skrattlyrsnat blandas i kollegernas steeds leenden: "Jasså, du ska gifer per Morberg." Films feins. Himlande dypothryn

Jag vicker upp datoen, öppnar "Medlearkivet och skrives sammanbtet "Per Morberg" i sökru tan. Jodd, tidningsdretträngen Amelia Adams fick bara vara med till handn sär hon och Pe skulle jaga ilig i Ogeita. Sedan sade Per åt henn att säma sig i bleien. "Stora Tara-intervjun" öpp made han med:

geomangen denne yexanger en gig, to dem instillation instillation instillation instillation in the state of the plat Merherg premiser bela tiden, lag kan vilig on jag sk var sok it life eller vallik life. Vertre utmanad han: "Hor ska du göra reportage om det hå di Skriva at ligg år en girs baszd görd eden" Mer TT Spoktra charmade han: Ant det är farligt at macka med mannen i fråga år hav en myt, en ligt telegrambyrån som sög fast att han i själv verket är "vidforden saillatset".

Dags are teen sig en eigen upprattning, ver vixre på andra signalen. Nie vi kommer in på logistiken kring intervjun räcker han över mönliben till Insea, som verkar væra innen en stimlibehländig armskingds avstånd. Hon och jag gåspenom detaljerna. Algiskt på Urbör vid Högkusten i Angermanland med hockeyspelarer en SI år. illij: Frun Inese, bonustern Janina, 36, samt

bonus-, samt , Alida, 26, id, 14 år. arbostaden sgård, eget overnatt-

pyscha, ungga på, rådjur på hans egna mate i Somland. Per kan inte spika någar datum ja m. Seur bölgar lägjakten och han vill inte laj pmilirveckan förstörd. Kanske ska vi fiska i ställ ja, det tycker losse lätter bra, det blir nog lugre för Per. Vi bestämmer en dag och jag fär vägbeskrivning till rättarbostaden på Tullgar

I oet guggus soenaiset nar mees och rei fom döttra voxit upp, och där har TV4 spet in åtta såtontper av långdöraren "Vad blir d för mat", med en svettande, skvimpande, sp lande Per som stoppar fingrarna djupt ned i så kastrullerna och slickar av dem med vällustig ljudliga strakt. Det populäraste avsnitete sågs i 404000 tittare.

På bestånd dag kracker fotografen och jag på den beröndes javenderen i Trälgarn. Så tyst kas inne ett has væra med bre Morberg innet. Ett pa stefframa søra somer får vi kontrått med Innes fotos i Vagnshrad och kloper vingspilder i med Inne fot Vagnshrad och kloper vingspilder, sta inn på steffen skaller fotos på slingstjan dimbilgha vägar genom sfemilindek kulturlygde vija rada ma. Die fäger glöp på höper sida, och där stär Pet. I vadnmålnovynn. Såg ni somfälleren "1905", Devenk Filmindon

Sag ni stortlimen "1909", Svensk Flimindostris Do miljonerssatsning till sitt 70-depublisum 1989? Per Morberg som supercharming, svartigleke, srnypaggresslve rikkenanssoonen Bengt, I tot kostym, bukårkammat hår och bländvit skjorta. Proper, oklanderlig, med inrefarlig blick. Hör vi Zempa Hamitton sjurga soundrackkiten "Jag Zempa Hamitton sjurga soundrackkiten" i

edan blir har min kind mot din kind, min arm omkring Per. Hildin hals*?

> Dar utar Bans. Not i verkugsteene. Van hatte totte ligger eet kausspô och ham år i fånd med ut knyt på ett drag på litnan. Han har viå projekt att han sera; i ti-kanslen Sjuan visas hann ray prograst "Den stora matresam", och snart kommer boket med samma narne. Jag anna att Per har gjort sit val 58° dagen: snäll kille. Här ska det fiskas fö folket.

ofgs som han vitar har den poliktyske skaldespelaren Klaus Kiriski – kland för sin lyrnajder, sina aggressionsproblem och katastroferna detta brukade medföra under hans fätiränspelningar – kunde göra en hel kroppsvislning genoen att utgå med fötterna i kors.

Per. Denget flyger genom luften och fastnar i det visnav sasskilbet vid sjöknaren. Per yecker till, sombleren bestivere en hydis byst inttaka och soubleren bestivere en hydis byst inttaka och sitter sig stastigt i hans ludslig, hruna vadranlarbysoc. Jeg faller på hat och pålar hillpassart loss dem, varpå Per Jossar eksans förtöjänigar. Då hattaar draget i sungene. Per hire inboy, Seedan biter han i tampen. Medain han klämpar hyfier jag filheddidan. Dem er villagt gr ugt i filheddidan. De

An extractive extraction of the control of the cont

"Fingertoppskänslan är min största begåvning"

förra sekelskiftet. Vill lämpat för en dags fiske på en liten sjö där det fortfarande kryper svenska floskriftor i bomenslammet. Det luktar döda löv Dimman driver över vattenytan i lodråta lakan. Pers mobil tillkämnaser en strid ström av nus

-Hör ni vad der blippar och blingar? Folk äs som tokiga, Jag har haft 200 förfrågningar i må naden i fyra och ett habvt är m., det slotar aldrig. Så fort det är något med mig, då ska det tjäna pengar på mig, klagar Per. Han tackar nej till det mesta. Det finns så jävd market tökerje Der år rinspare. Scotliste Mollisuncket tökerje Der år rinspare. Scotliste Mollis.

tidningarna vill bara att pöbeln ska köpa kösnummer, det är ungstär som glijotinen förr i vårlden; ottickt. Det är bara skit överallt:

Det är ju ingenting som är ben, det är ju bara jag och Skavlan och sedan är det ingenting att ha. Eller, det finns en del andra daktiga tvendinni-

Säger Per.
Här på sjön finns beller inget att hämta. Det nappar inte. Py fan. Kanske är det fel drag. Nu går vi upp till torpet och sätter oss framför kaminen i stället.

dels 1973. For var 20 cell, below var 25.

Jah Jightnari, som kom ant bli en reklassi kretgen på Sverige frosta moderna sind der vier 2 rillgorier ritten, fedan bette Abstandte, och vietnade på sin knien.

Le i klader som kom k. Klan fråk op på bette bligge kreinnari "med bestrikberisere och vietnarise kreinnari "med bestrikberisere och på kreinnarise kreinnarise

Custade ain neutral statuse (pg 11.3, pg statuse), coch sili (high (chi phi len ellect word for them.)— Henn millere det time, mend da ri al sili en for the heat taggarna utik, men Per brydel sit in och. Han gid hars rakt fram, passade på indene ch bölyale peras.

et crisid filat (pg 12) ain string or i imu och signer i henn gid har string or i imu och signer i henn.

and fillings, record transe.

The Abbell have relater on Frysland; detected, the control of the forthcome of

e. ma koncentrationssvårigheter, svårt att ta in information. Igi fick gåt ligligklass i en annan elb barack med de andra dumekullarna, så var det år ja faktisk, det kontener tillhata till mig nu. Men even gick det böst för i klassen? Jo mig, Jag har svångat mig upp i värden, flet vitats i de finare såslengerna, träffar filt timressanta människor

1976 Tonkinge Per ile populär bil

1975

Per blir svensk milstare i judo, en titel han tar flera gånger til under 70-talet.

1979 Som nybakad kock rör sig Per hemtaren mellan Stockholmsnattens inneställen. Han sikta av regissören Roman Potarsiki som vill. Ih honom i sin nästa film och skickar en Parisibilijett klen filmen skirt in filmentik

1984 Efter tre försök kommer Pe på scenskolan i Göteborg.

過小,讓讀者能輕鬆閱讀。多嘗試不同字級與行間,把成果列印出來仔細檢視。沒有哪一種字型大小能通用於所有情況,重要的是判斷哪一種看起來最適合刊物的讀者群。別忘了,多數字型是為特定目的而設計,因此它們通常會各自有最適合的字級。但有時設計師用各種方式使用這些字型(例如反白),做出創新、有創意或突兀的版面。相對地,新聞標題的設計不宜花俏,要簡潔明晰。這並非表示標題不能用襯線體——許多優質報紙會在標題上使用斜體與襯線字,傳達出無襯線字稍嫌不足的嚴肅感。

選擇內文字型時,須更加著重易讀性與實用性,因為內文字型背負著傳達刊物主要訊息的責任。讀者通常較習慣閱讀襯線體(明體)。因此一般而言,文字量大的時候,就會使用襯線體,而穿插其中的短文(新聞、評論、資訊框之類的)則用無襯線體(黑體),做些變化。襯線字感覺較為正式,無襯線體則比較輕鬆、有現代感。若字體造型流動、有曲線感,類似手寫字,則會傳達

英國小報(常稱為「紅頭報」 [redtop])很少使用襯線字體,標 題常全是大寫字母,例如左屬的 《每日鏡報》。雖然使用大寫的無 襯線字沒什麼特別之處,卻很能清 楚傳達這份報紙的類型。小報很 變能運用緊密的文字編排,把整個 頁面塞滿故事,只留下小小的留 空間,看起來物超所值,即使在這 讀者忠誠度隨著每天報導變動的 代,仍能於競爭激烈的市場上殺出 重圍。

相對地,瑞典的《每日新聞》(最上圖)在抽言與放大的首字都使用機線字,散發出文藝氣息。水平的留白空間,營造出較輕鬆的氣氛與知性步調。這些設計元素結合起來,傳達出內容是分析性、經過深思熟慮的。版面上沒有絲毫匆忙的訊息,暗示讀者必須更深度投入來閱讀。

用版型來塑造圖文力道

這版型的主角是大標——大標主宰頁面, 吸引讀者目光。和小報一樣,這種版型透 露出大標題比主文還要重要。字型沒什麼 變化,留白空間小,文章長度短,讓報紙 早現出直接、看完即丟的特質。

使用同樣的文與圖,感覺截然不同。標題 比較柔和,留白空間較大,並採用抽言和 小標,主文的優先順序被提高了。這版面 設計讓讀者能較容易進入主文,但仍以很 大的標題與圖片,吸引讀者停下來讀。這 是高級雜誌較常見的操作手法,並利用重 複的元素,為文章營造出知性感。

這是個以圖片為主的版型。運用虛線隔開 文字,讓內文讀起來像短篇故事,並用搶 眼的引言,營造出精美雜誌的感覺。這樣 的刊物很容易瀏覽與翻閱。照片夠大,才 能在讀者的快速翻閱中,引起注意。

THE HARD-HITTING SECOND STORY HEADLING FOR RELATED NEW **NEWS HEADLINE**

The softer-hitting news headline

The mediumhitting news headline

story explica wi

PART of

on the side of the 210 freeway, she was glad she had decided to war a panties under her Girl Scout uniform. It was a small but significant comfort in the face of her new, overwhelming inconvenience: hoisting herself into the unreasonably high cab of a tow truck would, now, be that much less mortifying. Bernadette drummed her fingers against the steering wheel and scowled at the dashboard as traffic screamed past. She called Maxwell, but he didn't answer; leaving him a vaguely explanatory message, and wondering where in the hell he could be, she called the Auto Club instead, frowning out the window as the operator spoke to her in annoyed, exasperated tones. "That's really not a safe place to be," the operator said peevishly upon learning that Bernadette and her car were cowering on the shoulder. "We don't ever recommend pulling over on the freeway."

I'm gonna duct tape this hunting knife to the wall, right up at the level of my hear and just run at it, full speed.

《Fishwrap》的版式與紙張每期都不相同,但平面設計師麗莎·華格納·賀利(Lisa Wagner Holly)說,有個元素將各期整合起來:「文字編排——我們的文字編排是經過審慎設計的,讀者的體驗是重要指標。」其實,各期也看得出有相同的設計手法,例如使用抽言來整合圖片(用註解來把觀念像說話一般傳達給讀者,呈現出親密感)。字型(Minion、Trade Gothic、Knockout以Young Baroque)經過仔細挑選,才能彼此搭配。華格納·賀利解釋:「文字非常重要,我們盡量讓讀物友善、易讀、美觀。」

出柔性氛圍。邊緣較剛硬、日耳曼風的哥德體, 則傳達出非常不同的主張(但兩者都不好讀,文 字量大的主文不宜使用)。編輯設計師應把字型 視為一種圖像,有時字型本身甚至可當作視覺元 素。字型是最有彈性的設計元素,更是營造刊物 風格的重要角色。

報紙的字型使用

刊物設計皆須仰賴文字編排,其中,報紙與雜誌的文字編排邏輯大不相同。波特解釋:「報紙最重視的永遠是版面的易讀性,及內容的可讀性。 先滿足這兩項條件,再去思考如何以字型為報紙建立特色,做出美麗、有戲劇性的文字編排。」 至於報紙的主要字型該如何選擇,波特表示:「基於文字的易讀性,以展示性文字來說,顏色 與粗細的變化也越來越重要。」波特只用專替 《衛報》設計的埃及(Egyptian)字型當作標 題與主文字體,可說是罕見之舉。但由於衛報埃 及體有超過兩百種粗細,因此能靈活扮演不同角 色,是字體集中的異數。

刊物在引進新字型時,無論這字型是重新委託製 作或原本就已存在, 創意指導都要確保它能與 品牌、內容和其他設計元素盡可能契合。這時, 除了仰賴創意指導的直覺,還有他們對刊物的認 識。波特說:

「《衛報》使用的埃及體是特別委託製作 的。我們想要帶有古典襯線字特質的字型, 同時又要現代感與獨特性。這字型必需易 讀、有彈性,有強烈個性,而埃及體正符合 這所有條件。埃及體的粗細變化很豐富,因 此我們不必用和多數報紙一樣,用襯線字搭 配無襯線字。我們在多數區塊只使用埃及 體,讓《衛報》的文字編排與眾不同。」

字型的表現性

若版面上無法使用圖片,或圖片狀況不佳,則 可用更有創意的文字編排來彌補,就像中世紀 手抄本,及近年純文字的廣告海報。資料、圖 像或文稿越無趣,就越考驗設計師的想像與 創意技巧。有自信的編輯設計可以大玩文字, 例如將不同字型的文字放在一起、改變字體的 結構,排列組合,創造好看的對比。不妨參考 卡洛斯·德拉蒙德·德·安德里德(Carlos Drummond de Andreade)、斯特凡·馬拉 美(Stephane Mallarmé)、喬治·赫柏特 (George Herbert)與伊恩·漢米爾頓·芬雷 (Ian Hamilton Finlay) 的圖像詩作品,也 研究俄國構成派,包浩斯、達達主義派的作品。 此外,《McCall》雜誌的奧托·斯多奇(Otto Storch)、《Harper's Bazaar》的布羅多

THE SEATTLE PUBLIC LIBRARY by borah Jacobs, Alex Harris, Greg Maffel Larson, Gil Anderson, Gordon McHenry, Re naas, Joshua Ramus, Natasha Sandmeier, B els, Meghan Corwin, Carol Patterson, Mark v f-Zogrotski, Keely Colcleugh, Rachel Dob arah Gibson, Laura Gilmore, Anna lorrough, Kate Orff, Beat Schenk, a Sutor, Chris van Duijn. Victoria t with Florence Clausel, Thomas D Achim Gergen, Eveline Jürgens, nes Peer, João Ribeiro, Kristina Sl Waeltli, Leonard Weil, John Nesho mer, Sam Miller, Tim Pfeiffer, Ste gnesh Pariikh, Vern Cooley, Mary ris Baxter, Jim Brown, Wayne Flo ard, Mette Greenshields, Cassandr n, Ed Kranick, Ken Loddeke, Howa thews, Damien McBride, Howard Rice, Kathy Stallings, Page Swanb ilmond, Atila Zekioglu, Anders Ca roll, Alistair Guthrie, Bruce McKir

olly, John Gautrey, Armin Wolski,

OCTOBER 2004

than Philling Ion Magnusson Jav

拉濱擔任設計雜誌《Metropolis》 的創意指導時,不怕嘗試罕見的標 題字型,只要字型能和文章搭配 得當即可。每個單元的主文與圖 說都是用 Bodoni Book 與 Trade Gothic 字體,不過大標的字體涌 常會依照各篇文章來決定,變化出 風格。這是《Metropolis》重要的 品牌識別,也和多數刊物標準的 「刊物標準用字」做法不同。上圖 就是一個好例子。這是一篇專題報 導的開頭,而這篇文章以二十頁 的篇幅,談論建築師雷姆.庫哈 斯(Rem Koolhaus)新作——西

雅圖公共圖書館(Seattle Public Library)。版面的設計靈感來自 於這棟建築物的概念,「這棟建築 物可說是眾人合作而成的計畫,不 像一般知名建築物, 建築師占盡所 有風頭,」拉濱解釋,「我們在第 一頁把建案的所有參與者名單列出 來,並且刻意裁掉了一部分,意味 著還有更多參與者。因為這是談設 計的專題,所以操作自由度才能那 麼高。我認為,這種作法沒多少雜 誌能接受。有時候甚至每一個專題 的標題都使用不同字型,以配合文 章調性,最終效果總是不錯。」

Blueprint: The Shock of the Familiar

The rules are breaking down. In a frenzy to move production design is exploding, mutating, multiplying. Design anarchy! More morph! By Herbert Muscham

n Greek mythology, Morpheus is the god of dreams. But I also like to think of him as the deity who presides over design. Morph means form. Morphology is the study of shapes. Metamorphosis is the transformation of appearance. And these are dreamy times for design.

There has never been more stuff, and stuff must have a shape, an appearance, a boundary in two or three dimensions to distinguish it from other stuff. Even water, and perhaps eventually air, must arrive in distinctive bottles. The shapes are no longer content simply to arise. They explode, mutate

shapes are no longer content simply to arise. They explode, mutate and multiply. Design is now subject to the whimiscial laws and seasonal revisions of fashion, the quick impulses of journalism.

There is no dominant style, no prevailing trend. There's just more and more stuff that has been styled, molded, carved, folded, parterned, cut-and-pasted, prototyped, mocked up, punched up, laid out, recycled and shrink-wrapped. Modernity has rendered the material world into some kind of plasma that is perpetually prodded and massaged into an endless variety of contours. Look around. Our designed world has the polymorphousness of clouds, the rapid, shifting, irrational play of dreams. Let's call it morphomania.

Is it a good dream or an eightmare? Design today is certainly a challenge for a critic who wants to make sense of, much less evaluate, the things designers shape. In the 18th century, it was believed that design could be evaluated according to universal laws. The purpose of cultivating taste was to educate the senses to their essence.

sign could be evaluated according to universial away. The purpose or cultivating taste was to educate the senses to their essence. Today, the most powerful laws governing design are dictated by the marketplace. Catch the eye. Stimulate desire. Move the merchandise. Yet even in the market-driven world of contemporary design, there adheres a mythological dimension.

adheres a mythological dimension.

Design, that is, reaches into the psyche as well as the pocketbook. Like dreams, forms can hold momentous meaning, never more so than today, when images have gone far toward displacing words as a medium of communication. This issue of The Times Magazine ties to interpret the shapes that are bombarding our psyches.

We are all morphomaniacs now. Exhibit A: My medicine cabinet. Here's a partial inventory: Colognes: Chanel Pour Monsieur—classic square bottle designed by Coco herself. CK One — frosted

左圖《紐約時報雜誌》的版面以各 種字型組合而成,包括霍夫樂重新 設計的 Cheltenham、海史密斯與卡 特(Matthew Carter) 重新設計的 Stymie, 還有 Garamond 與 Helvetica。 編輯設計師對於文字編排與字型應用的 講究及熱愛,在這期談設計的刊物中 展露無遺。前藝術總監佛羅里克說: 「這一頁可說是整份刊物的引言,告訴 讀者接下來會看到更多關於設計與文化 的想法。因此,它的任務就是為刊物開 場白,把文字編排的歷史,像電報一樣 簡要地呈現。我們請字型設計師托比亞 斯·佛瑞爾瓊斯(Tobias Frere-Jones) 選出十二種具有歷史代表性的字型,從 古英文到油漬搖滾風一應俱全。雜誌 中,每篇文章的開頭會從那些字型中挑 選一個,做成首字放大,而所有字型的 『A』排成一列做為索引。這設計優點在 於資訊階層很清楚,比例很經典,字母 形狀美麗又能傳遞資訊。」

Fontography

21 A A A A A A A A A A

許多出版社、編輯與設計師不敢將大量 文字版得滿滿,擔心讀者沒有興致讀 下去。但排滿的文字框其實看起來簡 潔優雅,可看作是形狀來運用,散發 出獨特調性。左下的例子是西爾曼的 《Nova》,設計師大方在跨頁上放滿密 密麻麻的文字欄位,搭配抽言或首字放 大,而右頁是卡爾森在《Emigre》的範 例,他只用文字與頁碼,表現出非常知 性的對話。
32

維奇、《Queen》與《Town》的湯姆·沃希 (Tom Wolsey)、《Nova》的哈利·佩齊諾 提(Harri Peccinotti)、《The Face》的布 洛狄、《Vogue》的貝隆、《Beach Culture》 與《Raygun》的卡爾森,《Speak》的文內斯 基,《Zembla》的佛洛斯特,都曾在作品中展

圖像化的文字

現精湛的字型應用。

字型最基本的功能是傳達文字內容,但它還有 其他功用。編輯設計可用字型來詮釋與表達內 容、傳達意義、增加版面變化,還可搭配圖像與 其他設計元素來傳達情感,做出有象徵意義的結 合。要達到這些效果,需要懂得一些操作字型的 方法,才能玩弄出不同趣味。運用不同粗細、行 距、字級與排列,單純的文字編排也能更具表現 力,產生抽象或與字面的不同解讀。某些常用字 型(例如哥德或打字機字型)能直接使讀者產生 文化聯想,為內容所傳達出的訊息加分。

33

FICTION

You have been in this country some months now. You are settling in? You are finding work. Your work is improving? You are treated well.

In home I was stand-up comedian. Now from accident to leg, sil-down comedian. But, I get no veric, get no gigs (this is correct?). But, persons hore new furd. They wish to know. They ask to me, you can come care Euroster? But, on C come under Euroster. Threed charge, how you say strapped for cash. How I look leg. Strapp too tight. Was hand. Not able to move, last worked in, stay will, count sheepers. Twenty, that you not too noisy for sleep, I travel third class. Under toders.

You left your home, family, friends? It is a very different life now.

In home, my wife were burks. They say to me, you Medialful? I say no, the most ugly woman. Have he behind them: I leave next of her them. There be you on. Bill people mixtude. They may you Adjust II will be here. I see next of her them. There is not in the property of t

[96] zembla magazine spring/summer_two thousand and four

You now enjoy the comforts of the West. You like shopping? You are free now. You like the freedom?

Nota as free zero. You like the freedom!

Illis to shopping if money. But. Voochers only, I always nik
to slop, you will have vouchers! They look in me. Lunchous
to slop, you will have vouchers! They look in me. Lunchous
Say you have card? Viata Massier! I say, goodlys.
Says you have card? Viata Massier! I say, goodlys.
Same shope solo gib. In they say exchange, exchange,
Some shope solo gib. In they say exchange, exchange,
Some stone, to the times, four times, show me things, very
Sometimes, there insee, four times, show on they gib.
Semetimes, there insee, four times, show on they gib.
They long hat me.
It erough in hat. I sometimes shop | fored, look, jo
It erough in hat. I sometimes shop | fored, look, jo
It does not shop to the musics. Sone musics. Sop,
get down dirty, but dies at him musics. Sone musics is only
one of the shop o

Nontheless, you bought it? You keep it under your locker.
You take it out at night, when the room is finally quiet, dark,
you mu your fineers across the page, searching the leature,
sentings with your diagness the rooses of memory, of your
past, the contourn of her body, breast and bone, skin over
through the hollows and clefts, reast for your soul?
Butteering back?

If planty in hat, I go time to places I was told, look for vorman bat fall, only talk. Money to talk, but is alright, is good. They tell me to come, up the stairs, come please. Doors up stairs is always chips, paint is peels, is curtains, is quiet, is smell. Is good, I feel home in such place.

You like, then, the flesh-pots of London?

Is times dark, is windows, look down, persons walk in street is dark but lights, shops, is quiet here, is safe. Is alright. But times, is men here, is knives, is fights, in stairs, in back, in dark. Times is threats to m. Tell to me. Packy, cut of your dick. They is threats to m. Tell to me. Packy, cut of your dick. They mistake. How I lost leg. Same size (this is right?).

You have a regular job now. You pay your taxes? You work in London? You work in the carpet trade.

I have job nose, is good, all right, Rugmaker, People ask to me, you make wigs? Tell to them, yes, weave, not scalp. Others to scalp. Also die. Ground, Ground colours carth colours, stir, mix, big pots, big stove, sit; mix, stir, is hard. But, colours, is nice, sky colours, nec colours.

Now work then, in the dycing mem? You blend the zolours, best the day, keeping a constant temperature, continually checked, dig the work.

You also call and that the clauses, then work on the recording, sursk, with the You do not record the continue of the property of t

sering becoming, tay thousand and four zembla magazine [97]

這兩個跨頁把字型當成圖來用,即 使手法迥異,但同樣都是具有創意 的搶眼之作。右圖是《Speak》, 這份雜誌的主題是探索搖滾與當代 藝術的關聯。文內斯基用文字編排 出飄渺虛無的感覺,當作配圖。佛 洛斯特為《Zembla》關於國家主 義的文章, 也有同樣貼切的視覺化 文字設計,相當能呼應主題。

下圖選自《Inside》雜誌,多徹提 用字型為每個單元賦予特色,「這 樣才能彰顯出彼此的不同,但仍看 得出品牌語彙。」他盡量不用太多 種字型,主文與標題各用一種, 而第三種字型則和這兩者呈現對 比。多徹提說:「第三種字型可改 變氣氛。這個專題是談德國科特 布斯(Cottbus)圖書館,建築師 在建築外殼上布滿字母紋樣,我決 定在標題上反映這項設計。我讓字 母彼此堆疊,仿效這棟建築物的外 殼。」

12 IN PERSPECTIVE Ethnay | Elaboratry of Brandway | Confus. General

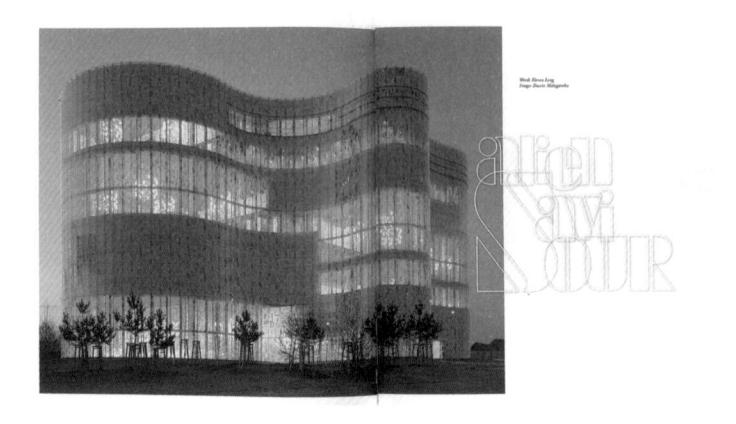

尋找活字

活字唾手可得,無論餅乾切模、冰箱磁鐵、麵條形狀或髮飾,都是活字的範例。文內斯基會到跳蚤市場和古董商店翻找;佛洛斯特大概造訪過英國每一間鑄字行;亞倫·奇金(Alan Kitching)早期即以繪製字型為業;許多編輯設計師都喜歡花大把時間,搜尋奇異的活字。凸版活字與木活字現已很少用,就算被使用,也多用在展示文字,而非內文上。現代的設計師最常透過印刷廠、線上字型目錄與鑄字公司來取得字型,只要上網購買即可馬上使用。如今設計師已經很少使用實體活字,但實體活字仍能為設計師帶來不少靈感。

這兩份跨頁以截然不同的方式,把文字當 圖來用。中間是《Inner Loop》獨立舞曲 雜誌,超大的標題與處理方式完全能配 合雜誌激動、無秩序的調性。雜誌前藝 術指導伊凡·柯特瑞爾(Ivan Cottrell) 說:「我使用截然不同的兩種標題字體, 一種是一板一眼的軍事風,另一種是手 寫風,這兩種字型搭配得很好,塑造出 《Inner Loop》的獨有風格,也能顯示 出受訪者各自不同的聲音。這些字型很 有力量,強烈的圖像元素橫放在向量圖 上,顯得很搶眼。」左圖則是古提耶雷茲 在《Vanidad》的字型運用,圖文並置得 巧妙,標題成為美麗的裝飾。「Belle de Jour I 的字母被拆開來放,與這名因「線 上日記」(online diary)而成名的電話 應召女相呼應。畫面右半邊的臉部特寫 圖,和最左邊的標題達成平衡,為跨頁創 造出和諧、溫柔卻強大的力量。

凸版印刷可使單純的編排文字看起來有插畫感,運用在封面上的效果很好。圖為英國凸版印刷講師與畫家奇金為《金融時報雜誌》共同設計的封面。

特製字型

和任何創意產業一樣,字型設計與用途常也常盲目跟隨流行,直到各種刊物看起來都如出一轍。想要異軍突起,最簡單的辦法就是請人製作專屬於你的字體集,如此不僅可創造出獨一無二的識別,也能傳神表現出品牌的特質。《Flaunt》、《Another Magazine》與《衛報》都是近年的範例。《Flaunt》的柯賓表示,他相信改變的時機到了,遂決定主文全部改用Berthold Akzidenz Grotesk與Century Schoolbook,認為這兩種字型和新字體搭配的效果很好。

「在去年的刊物中,我們用Gotham與Hoefler Text當作標準字型。這兩種字型都是出自佛瑞爾瓊斯與霍夫樂設計公司(Frere-Jones & Hoefler),搭配效果不錯。Gotham的辨識度很高,但不會太刺眼,加粗後可成視覺焦點。我們把Gotham與Hoefler搭配起來,因為Hoefler的外觀看起來很經典,又是個龐大的字體集,變化非常多。」

新 logo 需要採用新字型,柯賓設計了粗與細兩種字體,之後還作出更多變化。

「在製作雜誌 logo 時,我想要用幾何感的超粗字體。我嘗試運用一些符號,例如十字、 X、三角形與圓圈,來簡化字母。我在 logo 上做的嘗試可讓字型更有特色,也強化新的 logo,但這做法不能濫用,以免讀者看膩。」

最後,還有幾個使用字型時的注意事項:印前科技的發展代表有些專業分工快速消失(例如排字工),而他們的職責就落到設計師與電腦上。然而,QuarkXPress、Adobe InDesign 的電腦預設設定未必適合刊物,因此設計師務必了解如何使用字距微調、連字號、行間、字母間距、補漏白與平均字距。此外,頁面構圖與拼版(原

本是要實際挪動各種元素,例如展示文字、活字 盤與圖像)如今在螢幕上完成。這種做法的優劣 引來諸多討論,在數位環境製作最後會被拿在 手上閱讀的刊物,無疑在成品與情感效果上,都 會打折扣。若想彌補這樣的缺點,可先多方嘗試 紙張、顏色、油墨、照片及各種元素。盡量把版 面印出來看,因為紙本會和電腦呈現的版面差異 很大。一定要在頁面上校對,而不是在電腦上校 對,也絕不可只靠電腦程式的拼字檢查功能。所 有的標題、展示文字與圖說都要仔細閱讀;畢竟 審稿編輯的焦點是主文,對於展示文稿總是相 對輕乎,導致展示文字頻繁出錯。確保所有的連 字、連字符與字距微調都很適當。 FICTION

FICTION

by Graham Buchan

If enturned after hands to the bright, buszing epon office and there, concentratedly present, unmissable, in the darting consolidation of indoor activity, like a refugee on the doesnets, in the darting consolidation of indoor activity, like a refugee on the doesnets, in the middle of bis mouse mat set a ripe plant large, pedished, obserwed full purple.

In purple, a result of the property of a broad. It seemed to want to rapture and squirt at him. It said: "Bite me Suck me. I'll make a toward to rapture and squirt at him. It said: "Bite more of a broad. It seemed to want to rapture and squirt at him. It said: "Bite more of a broad in the part is not contained in the darkness. In an idle moment he heard it speake." I came from a tree. I was broadly here. Another hand held me. I was fished by a torogue." I cannot from a tree. I was broadly here. Another hand held me. I was fished by a torogue." I cannot be a tree, I was broadly here. Another hand held me. I was fished by a torogue. The backed doesn at I prevening the life in its burrow. He considered. He lifted it like a scientist, enveloped it in tissue. I be the said of the very sunggled parmography. But it was said was deal into the pass edger for love." 6

r

Ann zembla magazine [105]

[104] zembla magazine automos five thousand and four

將木版印刷風格的字型放到極大,在 跨頁上能清楚看出很好的組織紋理。 選用如此大膽隨性的文字編排,恰好 反映出當時《Zembla》的自信。

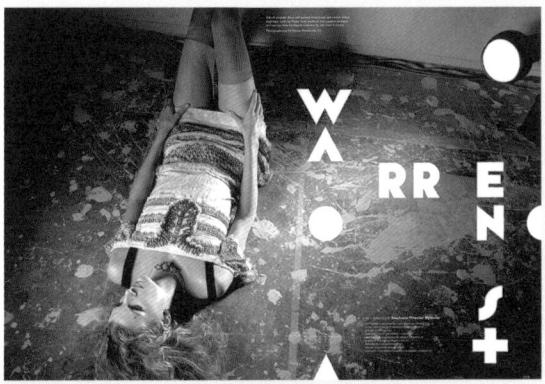

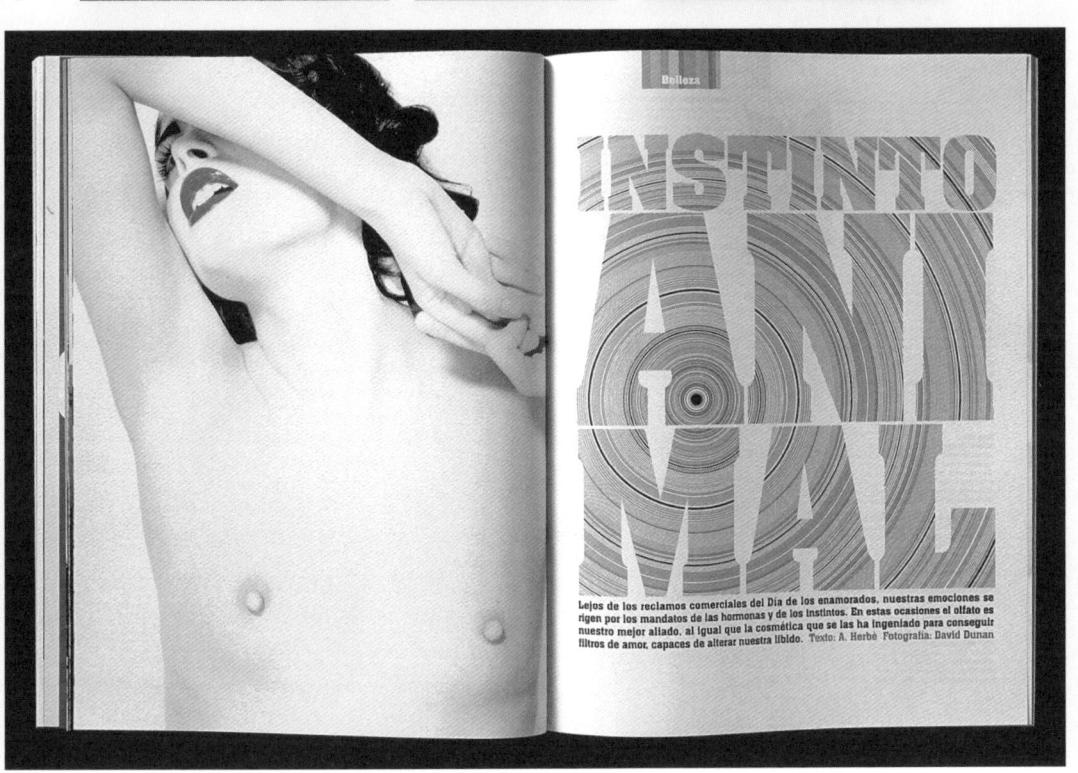

2006年,《Flaunt》雜誌自行 製作新字體(最上),柯賓說: 「當時我找不到任何現成字體, 足以傳達我對新一期刊物的感 覺。這組新字體是我們雜誌專用 的。」他也製作許多替代字母, 應用到新的《Flaunt》。柯賓指 出,這樣「能為刊物做出更獨特 的組合。這字體是源自於我改版 時設計的 logo 字型,在讀者翻 開每一期的封面開始閱讀雜誌 時,這個字型能強化他們對新 識別的印象。」在這兩種粗細 不同的字體中,粗體用得較少, 每個字母的周圍空間也較多。 「《Flaunt》新 logo 就是用這 些字母組成的, 而運用這些字 母,也強化了新的識別。細字體 較常用,也較有實驗性。因為它 不那麼重,可以放得比較大。」

最上圖是獨立雜誌《Amelia's Magazine》, 封面以插畫藝術家羅伯·萊恩(Rob Ryan) 的剪紙作品包起來,成為一個立體書封。上 圖的《Esopus》進一步運用拉頁,做出「彈 起」(pop-up)立體書。

設計實力與後製功力

編輯設計師必須要具備版面設定、平面設計與圖像後製操作軟體的實作知識(例如知道如何善用 Adobe Creative Suite 的 InDesign、Photoshop與 Illustrator等軟體套件,或是QuarkXpress)。軟體的熟練成度,會直接影響設計師發揮視覺概念的能力。此外,設計師也要反應靈敏,才能應付刊物在付印前,排山倒海而來的修改。

設計師也要懂得更多相關專業的技術,例如螢幕 校準、色彩管理、印前與印製流程,以及如何委 託插畫與攝影等的事官。

軟體

早期的排版軟體是搭配傳統的製作流程,如今隨著程式發展,多數傳統流程都由電腦(與編輯設計師)包辦。原本的師傅、排版工人、印前與校對等各項工作,如今都落到編輯團隊身上。這些程式不僅複雜,功能也非常多,編輯設計師要多多學習、多多試驗,才能善加利用。

螢幕校準

電腦螢幕是透過光來呈現色彩,是「加色」的原理,但印刷時用油墨的混色則是「減色」原理。這兩種呈現色彩的方式很不一樣,為了讓螢幕呈現的顏色盡量接近印刷成果,要使用螢幕校準軟體來修正螢幕顯示出來的色彩。蘋果電腦使用者可用伯格設計公司的共享程式「SuperCal」,效果相當顯著。亦可用電腦內建的色彩平衡功能,也就是伽瑪(gamma)控制面板。Photoshop的輔助說明選單裡有很清楚的步驟指南,說明如何使用控制面板校準。

When we can be on the thereby an out are to the control of the con

印刷

若不知怎麼選印刷廠,可以研究一下哪間廠商 最常印製和你的刊物類似的印刷品。不妨翻閱一 下那些刊物,查看印刷廠名稱,或聯絡刊物的後 製編輯詢問。此外還要考量其它因素,例如這間 印刷廠能不能接受你的印製批量?能否處理你用 的紙張與開本?能不能從印刷廠取得ICC 描述 檔(參見下文),讓你在桌面系統應用?印刷廠 能否配合你的出刊時間?費用合理嗎?在決定之 前,最好先請三、四家印刷廠給報價單。不過前 要考量仍是溝通是否順暢;和印刷廠建立良好的 長期合作關係,絕對能獲得很大的報酬。印刷廠 有你永遠無法掌握的知識、經驗與技能。好好培 養雙方的關係,可望得到最大助益。

色彩管理

控制印刷物的色彩是件複雜的工作,眼睛看到的、螢幕顯示的、印刷噴墨頭產生的顏色都不會一樣。幸好印刷業擬定出一套色彩管理系統,可幫圖像提供描述檔(稱為國際色彩協會描述檔 [International Colour Consortium] 或 ICC 描述檔),因此圖像從原作到螢幕檢視、分色、印前、校樣、製版與印刷等流程中,所有

上圖的《Twen》常使用拉頁, 呈現出效果很好的視覺元素(包 括遊戲、藝術複製品與一流的照 片故事)。

工具皆可校正調整,確保色彩精準一致。如果你的刊物沒有ICC描述檔,最好在配色時採用「安全」色或特色(可參考軟體內建的色域警告,顏色從 RGB 轉換成 CMYK 時,若外觀出現變化就會顯示),別光仰賴螢幕。在這種情況下,用 Pantone 色票來配色是最安全的作法。Pantone 色票盡量每年更新,以免褪色失準。要注意的是,並非所有的 Pantone 色都能用CMYK 複製;如果你想要用的 Pantone 顏色在排版軟體中出現色域警告時,可能得改用五色印刷。這時最好詢問印刷廠該如何處理。

打樣

印刷打樣通常稱為「確認校樣」,目的是確認印刷品文圖色彩品質的實際狀況。打樣種類很多,美國印刷廠只免費提供 PDF 螢幕校樣,其他種類的校樣都要另外付費才能取得。不過,花錢製作打樣是值得的,尤其是當封面與內頁有大量全彩圖時。

最常見也最經濟的打樣是數位樣,也就是用大型數位噴墨印表機(例如愛普生 [Epson]),印在刊物的實際用紙上的樣張。至於傳統樣(wet proof)則是用實際印刷時的油墨來印製。當封面使用了比較複雜的效果如特別色、燙金、打凸、局部上光等時,就有可能會要先打傳統樣來看,但即便是傳統樣,也未必和實際印刷的成果完全一樣。

一般影印機或印表機印出的雷射列印稿,其色彩一定不準,無法當作印刷的顏色參考,但可以用來檢查字型與位置等等,對喜歡以紙本代替螢幕校對的人來說特別有用。最後還有 PDF 校樣(也就是「軟打樣」),但這種校樣仍無法看出實際輸出色彩,多半只用來校對顏色之外的元素,除非是用校準過的 Eizo 螢幕來看樣。

圖片的取得、評估與使用

在處理照片時,要先發掘這張照片最與眾不同的特點:是取景,或是色彩(完美的藍天,或是豔紅的洋裝),還是構圖、光線、色調的細膩程度……。無論是什麼,好圖必定有值得發揮之處,在處理這張圖片時要時刻記得它的優勢——那可能會決定版面形狀、比例或結構,通常也會是版面上最重要的元素。必要的話,在螢幕校樣階段就開始和印刷廠討論,如何讓圖片特質盡量被彰顯出來。印刷廠比最厲害的設計師還懂色彩,知道要如何控制印刷過程以達理想色彩層次。不過編輯設計師可以先行考量以下要素:

原稿的完善程度:圖片的色域愈廣愈好,也就是 亮部與暗部應橫跨整個色域,而中間色調也要盡 量豐富明確。最好在印前階段,就確定亮部、暗 部及中間色調可達到最佳的輸出效果。

在 CMYK 模式下, 亮部應設定為:

C:5%

M:4%

Y:4%

K : 0%

圖像能反映出年代或事件, 這是文 字無法企及的。尋找或製作這種圖 像的能力,是編輯設計師的重要利 器。佛羅里克回憶起911事件後 的餘波時,曾討論到這一點。她 說:「911是發生在星期二早上, 《紐約時報雜誌》則是在週五完 成,因此911事件要刊登在九天 後的雜誌。我們有三天時間,撤 掉9月23日原本的內容,轉而回 應 911 事件。那時大家還深陷在事 件剛爆發的噩夢之中,但我們要提 出前瞻思考,請藝術家與建築師構 思出紀念碑。藝術家保羅·米歐達 (Paul Myoda)與朱利安·拉弗 迪爾(Julian LaVerdiere)的工作 室就曾在雙子塔,他們提出「光之

塔」(Towers of Light)的構想, 想像雙塔的原址發出兩道很強的光 束,指向天際。我用弗列德,康拉 德(Fred Conrad)拍的照片來做 後製處理,照片拍攝時間是災難發 生的當晚,曼哈頓下城漫天塵霧, 設計師用 Photoshop 做出那兩道 想像中的光束。我們用這張圖當封 面,一年後,曼哈頓下城開發公司 (Lower Manhattan Development Corporation) 實現了這封面的構 想,使它成為911事件最動人的紀 念碑, 從八十公里外都能看見。看 見雜誌封面化為真實的紀念碑,緬 懷著恐怖事件,那種驕傲又敬畏的 複雜感受實在筆墨難以形容。」

The New York Times Magazine

Remains of the Day By Richard Ford Colson Whitehead Richard Powers Robert Stone James Traub Stephen King Jennifer Egan Roger Lowenstein Judith Shulevitz Randy Cohen William Safire Andrew Sullivan Jonathan Lethem Michael Lewis Margaret Talbot Charles McGrath Walter Kirn Deborah Sontag Allan Gurganus Michael Ignatieff Kurt Andersen Jim Dwyer Michael Tolkin Matthew Klam Sandeep Jauhar Lauren Slater Richard Rhodes Caleb Carr Fred R. Conrad Joju Yasuhide Angel Franco Joel Sternfeld Katie Murray Steve McCurry Carolina Salguero Lisa Kereszi Jeff Mermelstein William Wendt Andres Serrano Richard Burbridge Paul Myoda Julian LaVerdiere Taryn Simon Kristine Larsen

中間色或伽瑪系統可調整與改善圖片整體的明亮 度或暗度,但調整時不能影響亮度。設計師可用 Photoshop 的曲線(curves)功能調整影像, 把曲線調高或低 50%,直到明亮度達到想要的 程度。

螢幕上的色彩:假定你的螢幕已正確校準,那麼螢幕所呈現的樣貌應該相當接近印製成果。如果你對螢幕顯示的畫面不滿意,就可以在送印之前調整。Photoshop有很多修圖功能,最基本的是遮色片銳利化調整(Unsharp Masking),也是多數專業人士的修圖法。一般遮色片銳利化調整的設定值是總量160%,強度為2像素,臨界值9。只要調整這些設定,幾乎所有的照片都可以更漂亮。

尋找圖片

優秀的刊物設計師會不斷透過代理商、畢業展、 其他刊物或媒體、獲獎書籍或光碟,來找新的攝 影師與插畫家。目前多數圖片製作者都有線上作 品集,但仍建議親自約他們來見面。安排一段充 分時間好好看攝影師或插畫家的作品集,再詢問 對方關於作品的問題及工作方式。發案時,你提 供的設計綱要會深深影響他們的成果,因此要講 清楚你想要什麼,並好好溝通。無論你的設計綱 要多麼清楚,都要和你委託的人親自談過,確保 他們明白你的需求,截稿期限、費用與行政要求 (發票、支出、給付、稅務)。最後,若是委託 拍攝,則要確保流程能安排得井然有序。

使用網路圖片

許多網站提供免費內容,有些網站則要付費使用。舉例來說,www.istockphoto.com網站只要付一點點費用,就可以取得圖片版權,不過,圖庫的圖片幾乎人人都能用,因此很有可能會重複。大型圖庫(例如Getty Image)的網站上會有關於版權與清算的法律資訊可供參考。

社群媒體的發展,促成許多圖片分享網站成

資訊圖表

現代人習慣在網路上找資料,對資訊圖表的興趣因此大增。資訊圖表讓設計師能變換內容的呈現方式,讓複雜的資訊容易被吸收理解。曲線圖、圖解、圖片與數據結合運用,就能清楚訴說故事。

資訊圖表很適合二十一世紀的視覺資訊文化,但早在七十多年前,設計師與文字編排者湯馬斯,梅特蘭,克雷蘭(Thomas Maitland Cleland)就為《財富月刊》(Fortune)設計出這種整合文字與視覺概念的嶄新格式。之後,諸如《Radio Times》、《WIRED》、《彭博商業週刊》將資訊圖表發展得更精美,也更廣泛運用。

設計師委託資訊圖表的案件時,必須非常清楚要解釋的 內容以及所有的正確數據,以免設計過頭的圖表到最後 反而模糊了焦點。

《Radio Times》是電視節目資訊 列表雜誌,大衛·德來弗(David Driver)利用許多技巧與風格,傳 達各式各樣的資訊,包括阿波羅 太空船 (Apollo) 與聯合號太空 艙(Soyuz)太空船如何對接(左 頁)、管絃樂團如何運作(最左 圖),以及影集《警網鐵金剛》 (Kojak) 的紐約警方轄區如何 畫分。理査・德雷波(Richard Draper)的資訊圖表也深受歡 迎,他以圖像的方式解說困難資 訊,例如下圖的「地下活動」。 德雷波用蒙太奇的手法,將跨頁 上的圖框文字和插畫整合起來, 這樣一來,即使文字量很大的刊 物也能吸引讀者。

The World About Us, Sunday 7.25 BBC2

You'll be familiar with the insect life that scuttles away is corpions? Richard Draper's drawing shows you a when you lift up a stone, of course, but were you aware sample of them and here Richard Mabey writes about of how much is going on beneath the ground's surface—is problems of making Sunday's programme from moles and earthworms to springtails and false about what's alive and well and living under our feet.

Underground movements

more of us, the notion of myriads is no exaggeration. A ground is as some kind of received count of the creatures in siline, a place to begin atnotine, a place to begin atnotices and the second of the creatures in siline, a place to begin atnotices and the second of the secon

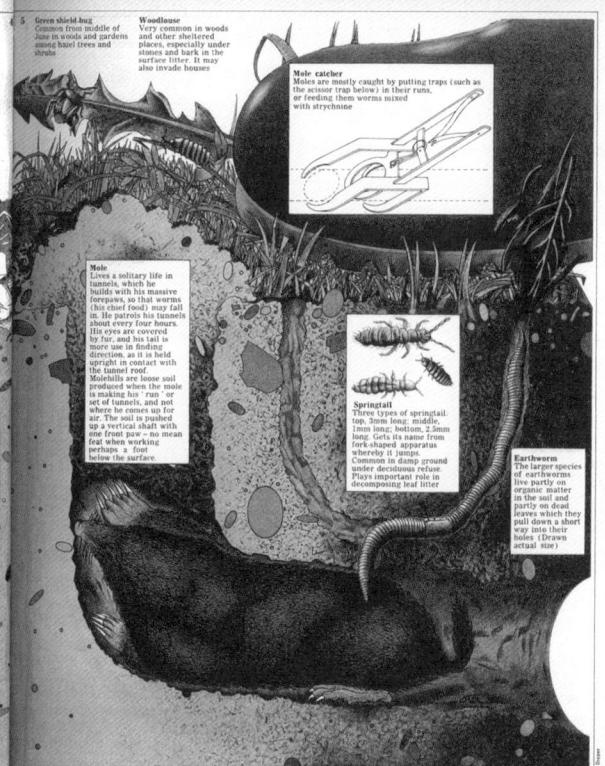

右圖巴西《聖保羅日報》說明飛機在空中相撞的跨頁,以資訊圖表來解釋這起悲劇。圖表列出飛機的航線、位置及諸多無法以照片說明的資訊。這些圖表的功用在於提供額外資訊,而不是取代照片,它們能讓讀者更了解事件。

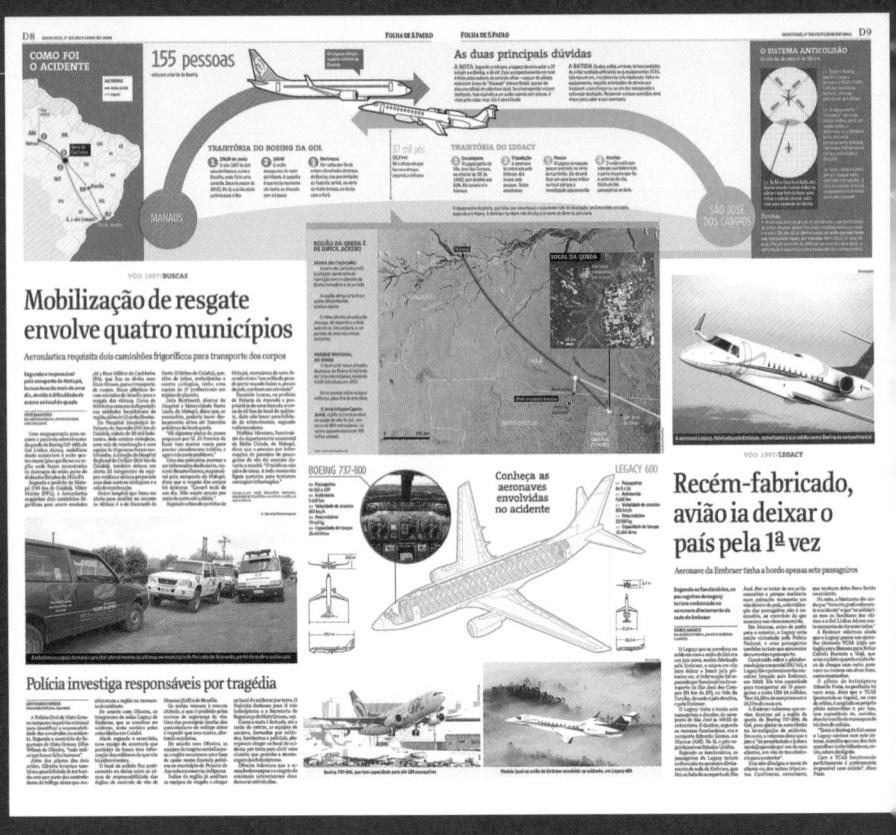

在右圖的這張跨頁中,《衛報》以 插圖說明軍火交易,將武器直接畫 出,讀者可以馬上理解。

右頁上圖:2012 年倫敦奧運期間,《泰晤士報》設計了密密麻麻的資訊圖表。這張圖表設計得像跑道。金牌、銀牌與銅牌的列表搭配了深入分析的詳細資料。這是《泰晤士報》的特長,因為報紙檔案庫中有豐富的資料與圖片可利用。

右頁下圖:《泰晤士報》的賽前分析圖上有決賽的日期資訊。小圖示、色彩、文字與圖片的運用,讓資訊展現豐富的層次。資訊圖表有助於強化內容,幫助讀者對文章留下更深刻的記憶。

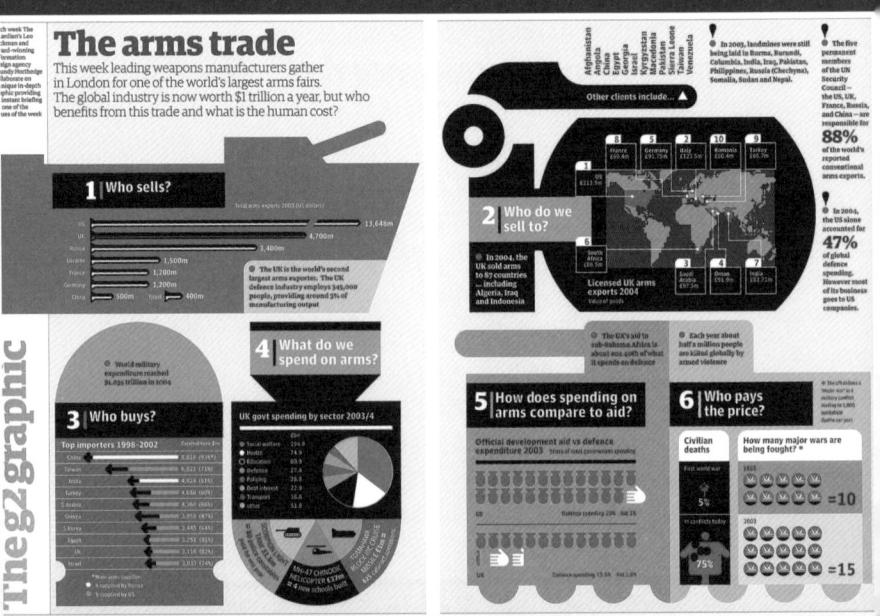

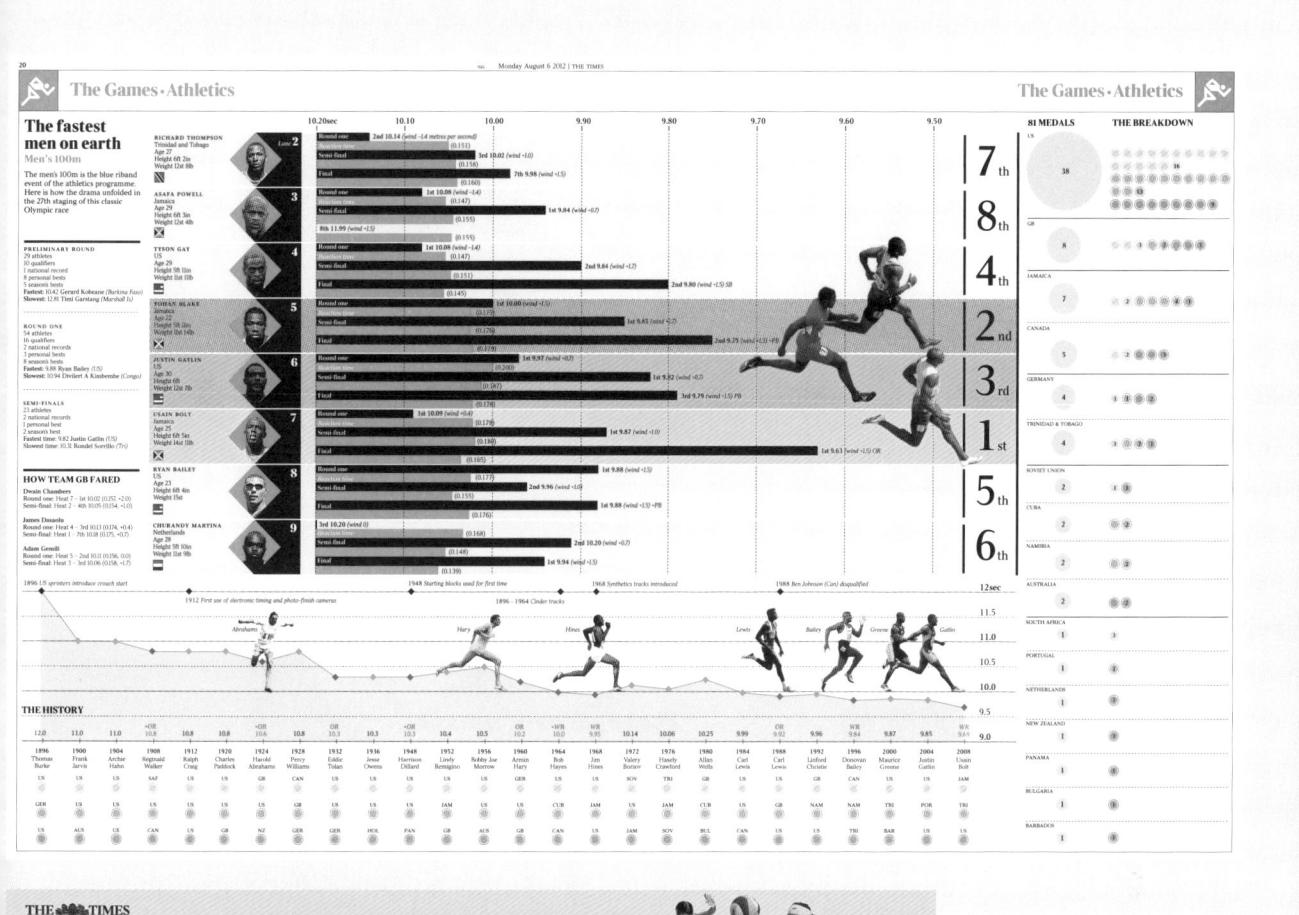

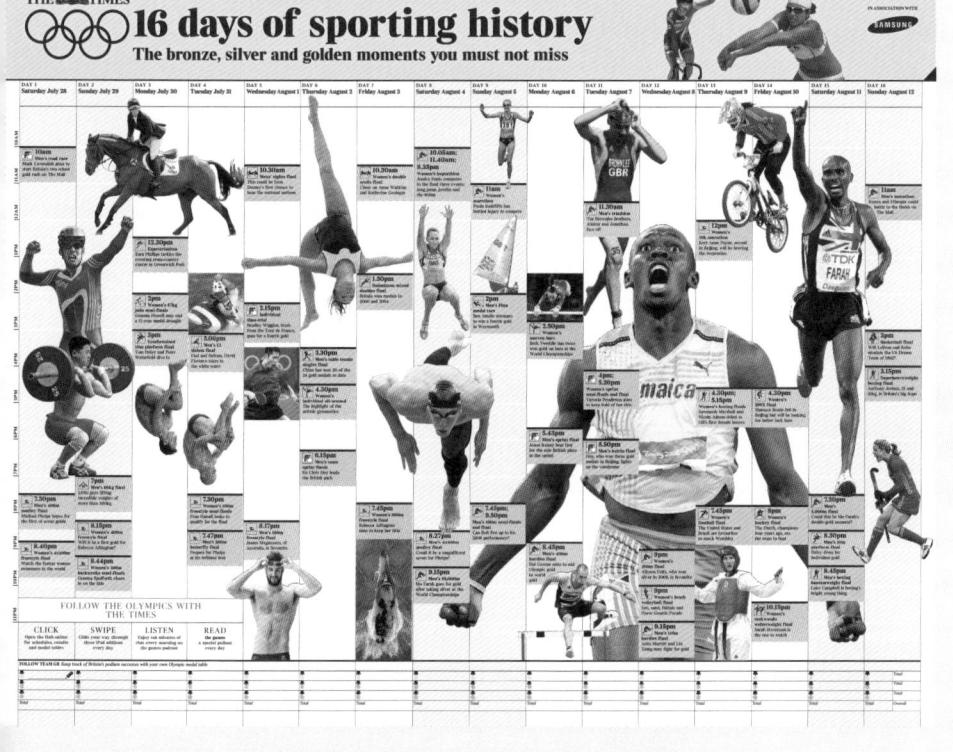

立。有些是免費的,有些則要訂閱。Flickr、Pixable 與 Snapfish 都是知名的照片分享網站,是很方便的圖片來源。

務必確認圖片的解析度能印製、版權清楚,圖片 來源標明正確。

風格一致,不等於單調

編輯設計師最困難與最享受的任務,在於創造出獨特、有個性的刊物,在清楚說明它屬於某知名品牌之餘,又要避免各期外觀或質感缺乏新意。如何做到這一點?運用能彈性發揮的良好格線系統、分頁時確保類似跨頁之間有其他頁面穿插,並發揮創意,靈活運用設計元素都是必備技能。

日報或新聞週刊的截稿期限倉促,前置時間短, 設計須以功能和易讀性為首要考量。因此,設計 師要擬定解決方案,並建立能快速製作版面的格 線與系統,加速排版與送印過程,設計的過程也 要井然有序。不過,只要比較幾種類似的刊物, 即可看出在有秩序的架構之下,仍有許多機會可 探索新奇的結構,展現不同面貌,孕育出全然不 同的成果,右圖的歐美新聞週刊就是好例子。

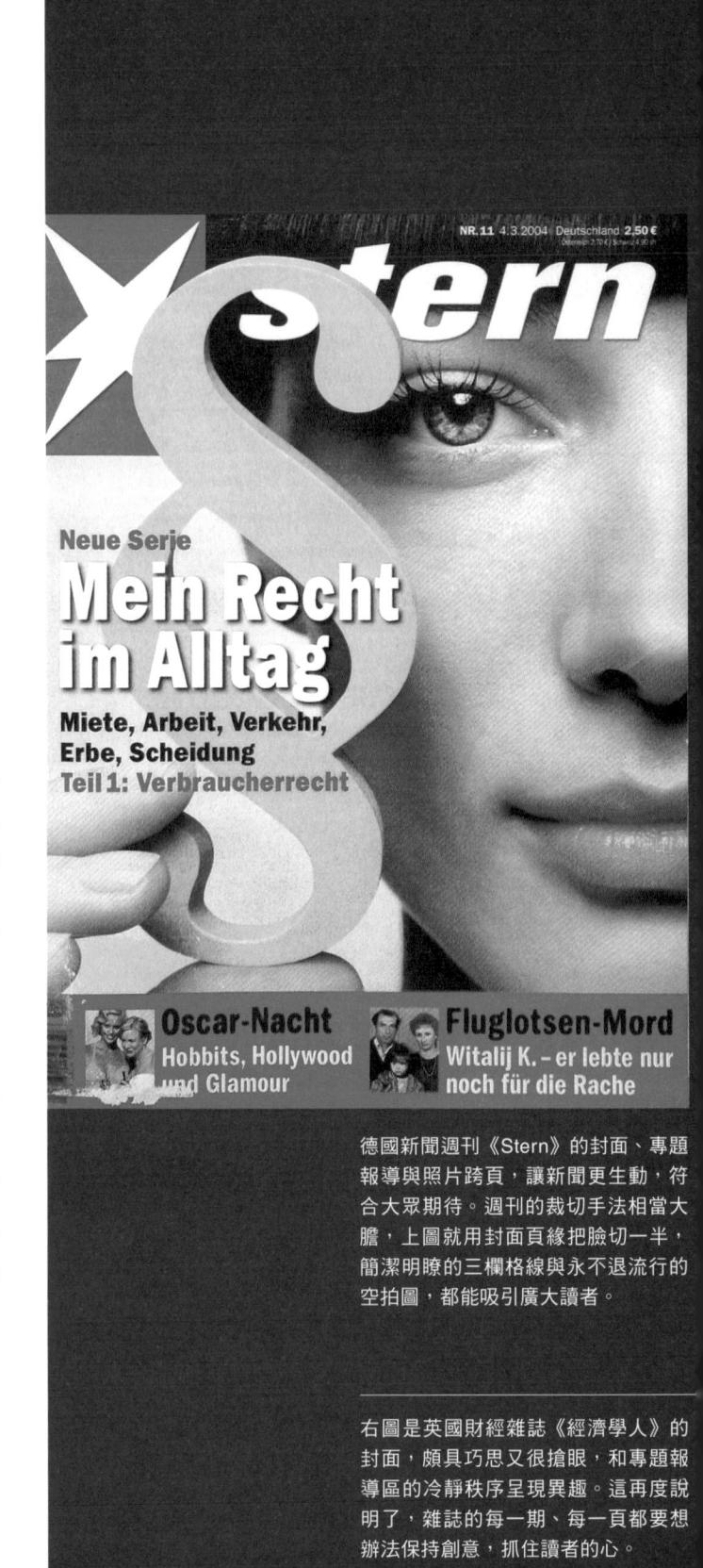

The Economist

AUGUST 26TH-SEPTEMBER 1ST 2006

www.economist.com

Why Britain has soured on immigration
Ending Iran's spin cycle
Has America's housing bubble burst?
The limits of air power
A step forward for stem cells

丹·羅勒里 Dan Rolleri

丹·羅勒里是《Speak》雜誌的編輯與發行人·1990年 代中期從大學畢業後,恰好碰上獨立雜誌風起雲湧的時 機。當時桌上型電腦與出版軟體出現,推動桌面出版革 命,催生成千上萬的雜誌,類型多到數以百計。羅勒里決 定投身其中。

羅勒里的第一份刊物是關於音樂影片的行業刊物,他自己說那份雜誌「慘不忍睹」。他的第二份刊物則是大眾文化雜誌《Speak》,這份雜誌被公認為此類型中的佼佼者。這份雜誌的成功,得大力歸功於羅勒里與藝術指導文內斯基的合作,而這兩人可說是不打不相識。從一開始,羅勒里就對雜誌的設計有強烈的想法:

「在當時,報攤的雜誌多不可數,我希望《Speak》在視覺 上夠搶眼突出。藝術指導務必願意挑戰既有形式,也要讓作 品保持有機體般的特色。更重要的是,我要喜歡藝術指導的 作品(這可不是小挑戰,因為我不太喜歡。)」

羅勒里和文內斯基吵得不可開交,還對簿公堂,鬧得滿城 風雨。但較不為人知的是,羅勒里很能感受與理解設計師 如何影響這份雜誌:

「藝術指導必須有智慧、對雜誌內容好奇。他不能只想依循 範本,或不顧雜誌內容,把雜誌當成自己的作品來秀。」

羅勒里深知文內斯基具有這些優點,不僅如此:

「他會閱讀、思考、非常認真。我想和他一樣努力,讓刊物 能透過設計而綻放生命。我或許成事不足,敗事有餘,但我 知道,和馬丁(文內斯基)共事之後,恐怕無法再和其他設 計師工作了。」

年刊、季刊或月刊的架構可以比較鬆散,圖片的預算較多,而在處理格線、字型與圖片也比較有彈性,也可自由嘗試許多版式。不過,這種做法也有缺點:自由度越大,就不容易讓品牌訊息依附其上。設計師務必讓必須保持一致的元素(品牌與識別),和每一期可變化的元素取得平衡。

「編輯與藝術指導要主動積極地密切合作、 彼此尊重,還要能爭論,有時也要願意認 輸。」

——馬丁·文內斯基,《Speak》藝術指導

刊物的標準風格與攝影

雜誌是會持續出刊的,因此每一期都要保持讓讀者認得出來的熟悉外觀。要製作出獨特但連貫的外觀,可從幾個層面著手。首先,開本、用紙與識別設計要一致,而這通常也不會每一期改變。 再下來,就是一些零碎的設定——例如照片的風格走向,或某些標顯必定為兩行等等。

維持風格的最重要工作,就是好好設定樣式表, 樣式表能詳細引導頁面上所有的字體編排。樣式 表是範本的一環,可以預先設定好字型、字級、 顏色、各項參數,並指定樣式要用於何處(大 標、引言、主文、照片出處、註腳等等),這麼 一來,只要套用設好的樣式,就能自動產生一致 化的細膩設計。

在內容的管理上,也有一些類似的規則,不過這 部分通常由審稿編輯監督。

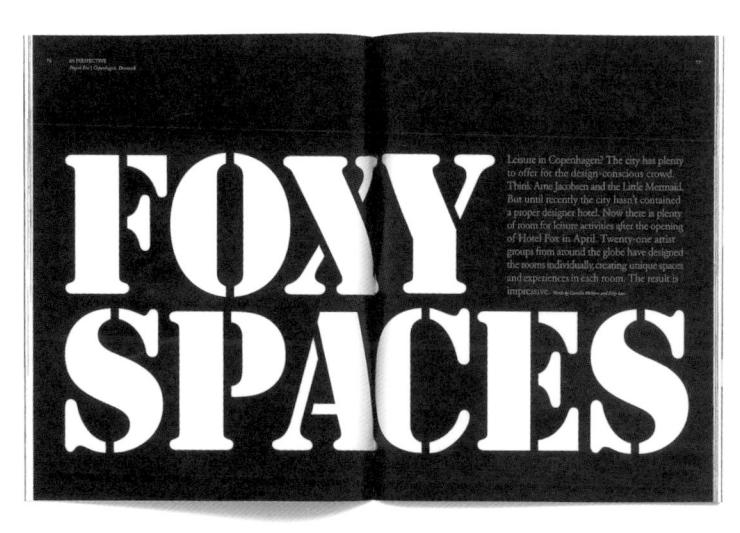

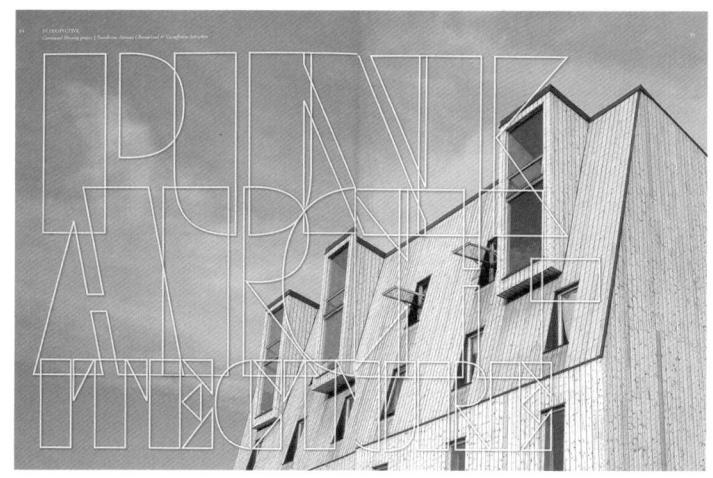

上圖是《Inside》雜誌中,「側寫」(In Profile)單元的兩個跨頁。這兩份跨頁的版面作法雖然不同,但是都大膽利用字體與設計元素。許多潛在因素會影響版面設計的流程,例如每篇文章的頁數、字數、圖片裁切,甚至是刊物中的廣告。在安排雜誌架構時,也須考量色彩與文字流動的方式。

改版的時機與原因

設計師會調整版面元素,讓刊物呈現新風貌,以維持現代感,避免與時代脫節(比如會因應時下讀者的喜好,把粗的字型以同一個字體集的一般字體或細字體代替)。不過,即使是設計得最好、歷史悠久的刊物,終究有過時、看起來缺乏生氣的一天。在這情況下,就需要考慮大幅更動或改版。許多刊物會在銷售下滑或經濟衰退時改版,期望提高廣告收益,刺激銷售,然而這策略不無風險,畢竟改版必然在吸引新讀者的同時,孤立某些原有的讀者。

編輯設計為報導提供被閱讀與詮釋的架構, 它不僅要建構刊物的文章結構(以及隱含的 邏輯結構),也要對個別報導做特殊處理, 因為有些報導內容可能會違反刊物的主張。

——馬丁·文內斯基,《Speak》藝術指導

改版最好的理由,就是為了符合與反映讀者需求;例如鎖定十六歲讀者的雜誌,過了五年之後,由於大環境的時尚、品味與風格已出現諸多變化,勢必要改版才能跟上潮流。然而重要的是,不能只顧著討好讀者,而是要參考文化趨勢與變動,讓刊物能融入大環境。別忘了,改版版語,也有更完狀態下進行。如果視覺趨勢會隨著時間轉變,刊物的其他構成元素也會改變,因此要詳加檢視內容與調性,並審慎處理,以確保沒有任何元素脫節,而整體刊物也能呈現連貫風貌,以明智的方向往前進。《Flaunt》在2006年便是採取這種態度改頭換面,還換了全新logo與特製字型。柯賓解釋:

「整份雜誌的平面設計是嶄新的,做出更多 變化與新識別。許多舊有的視覺特性必須 捨棄,新概念才有發揮空間。雜誌會持續變 化,何況我們是月刊,因此要能順應環境變 化,讓雜誌發出新聲音。」 雖然雜誌經常改版,但是報紙鮮少改頭換面——對每日出刊的刊物來說,大幅改版會勞師動眾, 弄得人仰馬翻。波特解釋:

「報紙往往是受到市場刺激才改版。編輯 通常會認為眼前的報紙好得很,只有銷售開始下滑之後,他們才明白恐怕不改不行。但 有趣的是,現在全世界新聞讀者群的閱讀量 都在下滑,而來自電視與網路的壓力,迫使 記者與設計師質疑自己是否不懂現代讀者 需求。以前從來沒有過這麼多報紙同時在改 版。」

諸如網路媒體、經銷方式與人口變化,皆對編輯設計產生影響,因此開本變小、頁面更趨一致,瀏覽方式也越漸單純。正如賈西亞所言:「網際網路創造出握了滿手資訊、卻沒耐性的讀者,他們想要紙本刊物有清楚的文字階層、好的瀏覽方式,能讓視線在紙本頁面上快速移動。」

過去五年,印前技術已出現變化,要了解最新資訊可上網自學,也可向印刷廠請益。若想得到更整體的概念,了解正確的印刷條件,可參閱安柏洛斯(Ambrose)與哈里斯(Harris)的著作《視覺設計大全:印前與製作、字型編排、平面設計、插畫》(The Visual Design Box Set: Pre-Press and Production, Typography, Graphic Design, Illustration);菲爾柴德公司(Fairchild)2012年出版。

In Review TRANSPORTATION: Stokke Stroller (reviewed by Ayse Birsel and Bibi Seck) PRODUCT: Push Braces (reviewed by Michael Wiklund) SOFTWARE: Wild Divine Computer Game (reviewed by David Womack) BOOK: Disruptive Pattern Material (reviewed by Tom Vanderbilt)

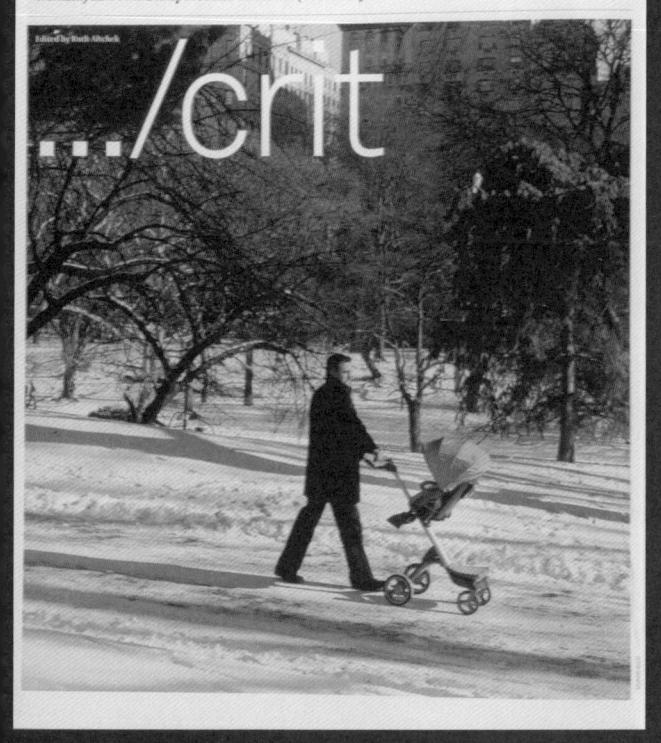

The Blues DVD

nostrou uma

Pele do corpo

Sim59% Não41% Abs56% MAI fez ajuste

ora sim

"Sim" obteve mais um milhão de votos do que no referendo de 1998

Abstenção acima de 50 por cento não torna o voto vinculativo

PS promete alterar depressa a lei e combater o aborto clandestino

directo ilegal de estudo dos fogos

Ségolène Royal propõe pacto de esquerda

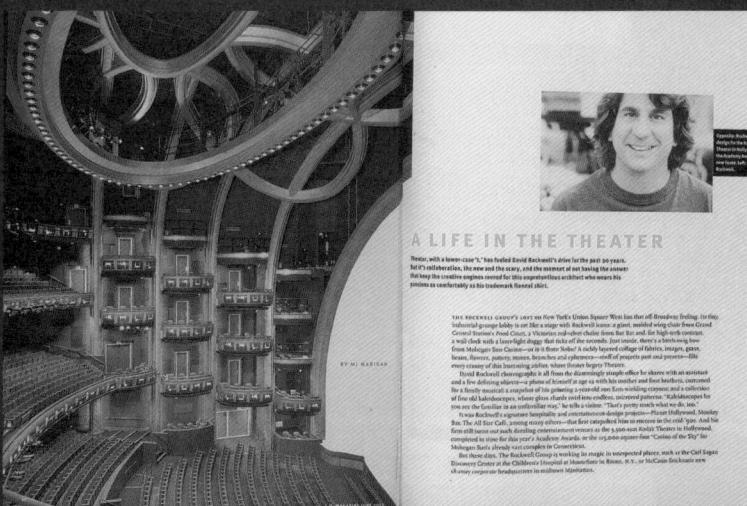

2003年,《I.D.》藝術指導科比·班內茲瑞(Kobi Benezri)與前任藝術指導尼可·史維澤(Nico Schweizer)共同主導雜誌改版(左圖)。「我們 動手設計時,就知道《I.D.》必須更新外觀。上一 次改版是 1992 年由布魯斯·莫(Bruce Mau) 進 行的。新設計和新刊物內容相互連結,例如報導更 廣泛的設計領域、以不同角度討論先前談過的主 題、增加新單元,觀點更具批判性。我們要確保設 計能具有同樣的態度,呈現出豐富客觀的資訊。同 時,我們不打算以譁眾取寵的設計元素,讓人留下 印象。版面的設計目標很清楚,我們設法保持細膩 優雅,必要時放上我們的特色。」新的特色包括新 字型:主文改以翁格設計的現代感字體 Conranto, 取代 Scala;而 Meta 也在日後因應時勢,用許多 字型替换。諸如「景觀」(Scape)的圖文跨頁, 及新的後段「評論」(Crit)都是新增的單元(左 上)。波特2007年重新設計葡萄牙日報《公共 報》時,依循 2005 年《衛報》的改版風格。

賈西亞曾在許多國家進行報紙改 版,推出新的版式。2005年,他 重新設計《觀察家報》,將大報版 式變成柏林版式。他認為改變版式 不是問題,不會有負面影響。「由 於空間變小,因此焦點要更清楚, 強調文字階層。刊物在考量什麼要 納入、什麼不納入時,要列出取捨 順序。好好研究今天的讀者,探索 視覺與刊物的過去發展,評估什麼 必須留下,什麼可以刪除。總之要 搞清楚什麼是真經典,什麼是老太 婆的纏腳布。報紙常常把舊視覺材 料看成是寶貝古董,但其實只是破 銅爛鐵,不值得收藏。」在重新設 計《觀察家報》時,賈西亞運用文 字編排,保留大報的優雅感,同時 以配色營造年輕活潑的感覺(調查 顯示,讀者喜歡活潑感)。他在不 同單元選擇不同的配色,確保配色 可和頁面元素相配。在改版時,他 是從新聞的角度出發,因為他堅 持:「讀者看報紙是為了內容,而 不是外觀。設計的目的是強化內 容。」

m

賈西亞的十條改版法則:

- 1. 改版沒有公式,要依照實際情況個別處理;找出最適合的方式,重新思考產品定位。
- 2. 要有完整的設計綱要,列出刊物期 符、目標讀者與改變幅度。我總是 說,有些刊物改版只是洗洗臉,但 有些則是好好洗個澡,連泡泡浴和 蠟燭一應俱全。
- 3. 改版時,要重新思考刊物的四大故事結構,並善加規劃:文字編排、 頁面、架構與色彩。
- 4. 第一步就應該思考故事結構,編輯 如何在這刊物中訴說故事?應該創 造多少說故事的技巧與樣式?如何 強調階層性?
- 5. 就文字編排來說,至少要測試三種 襯線體與無襯線體的組合,再從中 選擇最好用與適當者。
- 6. 就頁面架構來說,設計至少兩種格

線模式,並搭配不同的欄寬,或許 最終也會同時採納兩種範本。

- 7. 在開始配色時,至少使用二十多種 色彩組合,包括最暗到最明亮,還 有介於中間的色彩,之後再從中創 造出簡單的配色(不要超出十種色 調)來沿用。
- 8. 一再確認易讀性 現在的讀者 沒有耐性,無法耐著性子看紙本刊 物。努力守住正確的瀏覽策略,是 改版流程中的首要考量。
- 檢討整份刊物的分頁結構,亦即內容出現的順序。什麼時候要採用或不用某些元素?是否該改變順序?
- 和編輯與記者密切合作,他們會在 刊物視覺變化的過程中,提供新聞 層面的考量。

資料來源: Materials, Process, Print: Creative Solutions for Graphic Design by Daniel Mason

,Warten Sie mal,

ich schalte meinen

Gehirnschrittmacher ein"

Helmut Dubiel ist Hochschullehrer. Er leidet an PARKINSON. Tief in seinem Kopf sitzen zwei Sonden. Er steuert sie mit einer Fernbedienung. Ein kleiner Stromstoß – und er kann sprechen. Ein großerer Stromstoß – und er kann gehen. Zumindest eine Zeit lang

Von ARNO LUIK und VOLKER HINZ (Fotos

er Ostles, eines Moogenis wöchten Ses auf und wussten. Verdammt! Werdammt, lich habe Parkinson!" Nein, das Ungleick kann schleichard in mein Leben. Ich vor jahrefang ingredhele merbide, insmer veider grundlies krank. Ich hatte Schaljenschamerzen, reein finker, und mein rechtes Ausge lieferten mit verschiedene Beiter, ich hatte unstillkießiche Kralbevergangen.

r- auf dem konstendenn lag, standig Auch sichnelse die wilkende Frager. Warsischt Harmen holdt Harmen! is is, men kliente sich in dieser existenzis ken Ungerechtigheit verdieser - die Wil direkt sich werber und Binst mich zursich eine Eine Zeit Imp ir aummer ich, ich ein vienen Vergagungsgelangsfehr herrung er gefällen ins Moert, und ich sebe, wir di Schaff in der Dounkellieri verschrinisch Schaff in der Dounkellieri verschrinisch

(sa) in zon, sie sind glücklich, uber ich bleihe im in Vasuer zurück und erässte.

ji. Und im Kigel nantent der Dinktein, dasse das alles sies selestellicher Zufall att.

ja, der Terror des Zufalls. Wissen Sie, es in son Sie nehm mit raust 1000 Leuten auf einem Schmilzoff, und platzlich werden Sie — als Hissieger — obne Erklätung, obne

eier nicht einfach über hiren Körper werfig de kleenen. Die Leben ist viel krummer ich ch Thamas Hann hat in den "Buddenbrucken", Der Kinashkillt, für die es derasils nicht kin sie ein Hanne galt, die beschriebeer. Zie der sich entstehen, die sich vissel werfelt wir ur einer haltstilligen Verzendung wird. gleicher Zeit bemächtigt sieh nahmer die sein eine der

In das stimment. Plüszelich ist man in Dan ies Vorhöllic. Hann schreibt weiter: "Es besteht ein sta ies Schlatbedürfeis, allein troltz äußerst Mödigkeit ist der Schlaf somning, oberfläch behandelitiet met einemischlich ein TIP

避免版面單調的秘訣與技巧

- 建構版面時,嘗試改變方式。
- 試試看以色塊或去背圖來建構頁面,這樣能在文、圖與其他元素周圍,搭配留白空間與幾何元素。
- 多參考別人的設計,把每一種版型當 成不同的專案來視覺化。

《Stern》在專題報導頁面使用 簡潔的三欄格線(左圖),以及 廣受歡迎的俯拍圖(上圖),吸 引了廣大的讀者。

_{工作坊 5} 完成與展示作品

目標

繼續設計工作坊 4 的跨頁,提高完成度。

練習

詳細檢查版面上的所有元素,再以優良的紙列印出來看。

- 檢查細節,例如基線是否對齊、是否出現寡行 (若有排列得不美觀部分,則重新分行)。若有 照片則要註明來源,並檢查整篇文章是否有錯別 字,這對版面上的任何文字來說都很重要。作品 集不出現錯別字,才能展現出重視細節的態度。
- 2. 一旦完成校對, 先用便宜紙張把版面列印出來, 再檢查文字是否太大(在螢幕上常容易把字級設 得太大)。之後, 如果希望作品集裡的作品顏色 很準, 就用良好的彩色印表機與優質用紙列印出 來。這份跨頁作品也存一份 PDF 檔, 加入線上 作品集。不過, 檔案不要存得太大, 以免下載太 耗時。
- 3. 這些設計法則可以反覆練習,延伸到不同的設計作品與平台。為你的雜誌網站設計首頁時,可進一步規劃瀏覽方式,增添互動工具,甚至實際操作看看。想想看,如果這份雜誌要在任何地方都可以讀呢?別光把 PDF 放到網站上,就稱之為線上雜誌。如果字型太小,難以閱讀,就無法達成閱讀目的。別忘了,編輯設計師是在服務內容,包括文與圖。不過對要對自己有信心,別擔心與眾不同。即使作品不如你喜歡的設計師那麼美,但仍有其他價值,值得放在作品集中。

這份學生創作的旅遊雜誌稱為《逃脫》(Escape),製作者是大學部的學生山卓拉·奧圖凱提(Sandra Autukaite)。一開始她決定用網路上的圖片當作基礎,發展視覺與設計概念。她為照片加上簡單醒目的圖框,顯示出攝影是這

份雜誌背後的主要元素。

到了最後的階段時,奧圖凱提決定 自己拍照,如此一來,她就掌握了 所有素材的版權。雖然學生的雜誌 練習作品不太可能出版,不過製作 時還是以能符合著作權道德為佳。

ESCAPE

AMPHIBIAN ISSUE

27 TUTORS 500 STUDENTS THOUSANDS OF ALUMNI ONE ORGANISED MESS

BRINGING ORDER TO THE CHAOS

這份作品是團隊合作的成果,刊頭 以手寫字製作,並和在學校拍的照 片拼貼起來,做出「亂中有序」的 刊物。設計者班·席維爾唐(Ben Silvertown) 還把這份刊物送到印 報廠印出(右圖),也試作 iPad 版面,並在作品集中納入影片。其 他團隊成員也有功勞,每個人都把 這項設計放在自己的作品集,並註 明所有參與者的姓名。這是團隊計 畫的常規。

MATADOR

1590 VOLUME OH \$ 50.00

MATRICUL ANDRE COLUMN, COURS AND VOCADO 1968-2923

Chapter 7:回顧過去,展望未來

設計工作者要能洞察潮流趨勢、文化變遷與當下的時代精神,這些特質對編輯設計師而言更是重要。編輯設計師必須掌握潮流,以更廣的視野來探討文化、設計趨勢與新科技。此外,編輯設計師也常常可從歷史上影響力深遠、具突破性的作品或設計大師身上得到啟發,洞悉編輯設計的脈絡。過去八十年來,設計大師們透過各種印刷技巧、製圖風格、格線結構、文字編排與符號設計,製作出不僅如藝術品般賞心悦目,也反映著社會文化的刊物。史上如此優秀的設計師非常多,本章要介紹其中幾位佼佼者。當代設計師在研究前輩大師作品時,可仔細觀察、思考下列幾點:

- 設計動機及隱含原則;
- 成功刊物與當下時空背景的關係;
- 嘗試藉著過去趨勢,分析出未來的潮流。

回顧過往: 設計動機與隱含原則

編輯設計師在做研究時,經常只取材於當代作 品。觀摩當代作品固然必要,能從中了解文化 變遷,及文字編排、配圖、攝影、紙張的最新趨 勢。然而,向過去作品取經也一樣重要。設計師 應該要能從過往的成功案例中,發掘出設計者的 思考方法與設計邏輯,而這與當下的藝術、文化 運動以及政治情勢、社會氣氛密不可分。舉例來 說,1930年代的平面設計受到包浩斯學派的影 響,重視機械化與機能性,這同時也呼應當時西 方社會工業化及東歐社會主義興起。1970年代 中期,布洛狄的文字編排與幾何樣式源自俄國構 成派的反壓迫精社。現代編輯設計師若能了解所 有成功設計背後的原因,就能找出回應現代社會 的方法,與了解自己的讀者群。向設計大師取經 的方式,不是盲目模仿,而是要能分析其成功原 大。

理解作品所處的時空背景

想要了解一份刊物,就要全面檢視其所處大環境(亦即上述的設計動機與隱含原則),之後再著眼於個別作品的構成細節,了解為什麼這份刊物的版面適合它的讀者群。可以試著拆解版面上所有元素,一一檢視它們所達成的效果,再研究它們組合起來的效益。以《The Face》為例,布洛狄深知另類文化刊物可運用非主流文化的影響與風格,來使當代元素增添前衛的感覺,建立刊物的歷史定位。他高明的撿選適當語彙,使得政治品格尚未受到汙染、文化立場清晰的年輕人,一看就明白這設計的根源與意義。他透過版面上的文字編排、形狀及幾何元素(線條、方塊與比例)來傳達這些感覺。他的作品很亮眼,並且新穎、大膽、桀驁不馴,完全符合讀者的喜好。

繼往開來

接下來會列出許多影響力深遠的設計師與刊物。從這些例子可看出時代的知識、道德與文化氛圍,會深深影響設計運動,也進而左右編輯設計的風格。設計過程絕不是在真空狀態下進行,也不會因為時代精神轉變後就失去意義。過去的作品或許不再流行,但若能理解其存在價值,必能從中獲益。

如今人們可以輕易的取得資料和影像,也更容易分享訊息。更重要的是,許多設計師擁有自己的 社群媒體,並常常更新、分享新作品。因此向優 秀的業界設計師學習,再也不是一件難事。許多 編輯設計師與藝術指導樂於分享、不藏私,為設 計界帶來源源不絕的活力。接下來,我們將看到 許多值得效法的當代先鋒,及啟發了一代代設計 師的過往巨匠。他們都是推動編輯設計走過一代 又一代的大功臣。

名人堂:設計大師與出版品

阿格 M. F. Agha

梅亨費米·阿格博士(Dr. Mehemed Fehmy Agha,多稱為 M. F. Agha)為「藝術指導」 這個角色開了先河。他是出生於俄國的土耳 其裔設計師,深受構成派影響,曾設計德國版 《Vogue》。當年康泰納仕到歐洲尋找設計人 才,想把現代歐洲風格引進自家刊物時,發掘了 他。1929年,阿格擔任康泰納仕旗下的旗艦刊 物 ——美國版《Vogue》的藝術指導,不負眾 望地為刊物帶來成功。後來他又負責《Vanity Fair》與《House & Garden》。阿格的設計 清新有活力,為刊物賦予新氣象。他率先使用 無襯線字體,也大膽嘗試印刷與攝影的新技術, 例如蒙太奇、雙色套印與全彩攝影,並盡量用照 片取代時裝插畫,成功做出以照片為主的版型, 甚至讓圖片跨頁滿版,大氣的作法使讀者眼睛 一亮。他找來塞西爾·比頓(Cecil Beaton) 與艾德華·威斯頓(Edward Weston)等一流 攝影師,也委任過馬諦斯(Matisse)與畢卡索 (Picasso) 等藝術家,這些都是美國雜誌界的 創舉。

阿格把歐洲現代主義的風格信念,運用到《Vanity Fair》中,藉此將其帶進美國市場。他的字體運用既簡單又有系統,恣意操作各種設計元素與頁面留白,使版面鮮活有變化。他善於玩弄設計元素的位置與大小,例如破天荒的把小小的標題放在頁面底部的留白空間,使它們像在頁面中漂浮一樣。他將傳統的裝飾性元素全部拿掉,版面因而豁然開朗。元素間的大小比例關係,是他用來建構視覺風格的唯一手法。

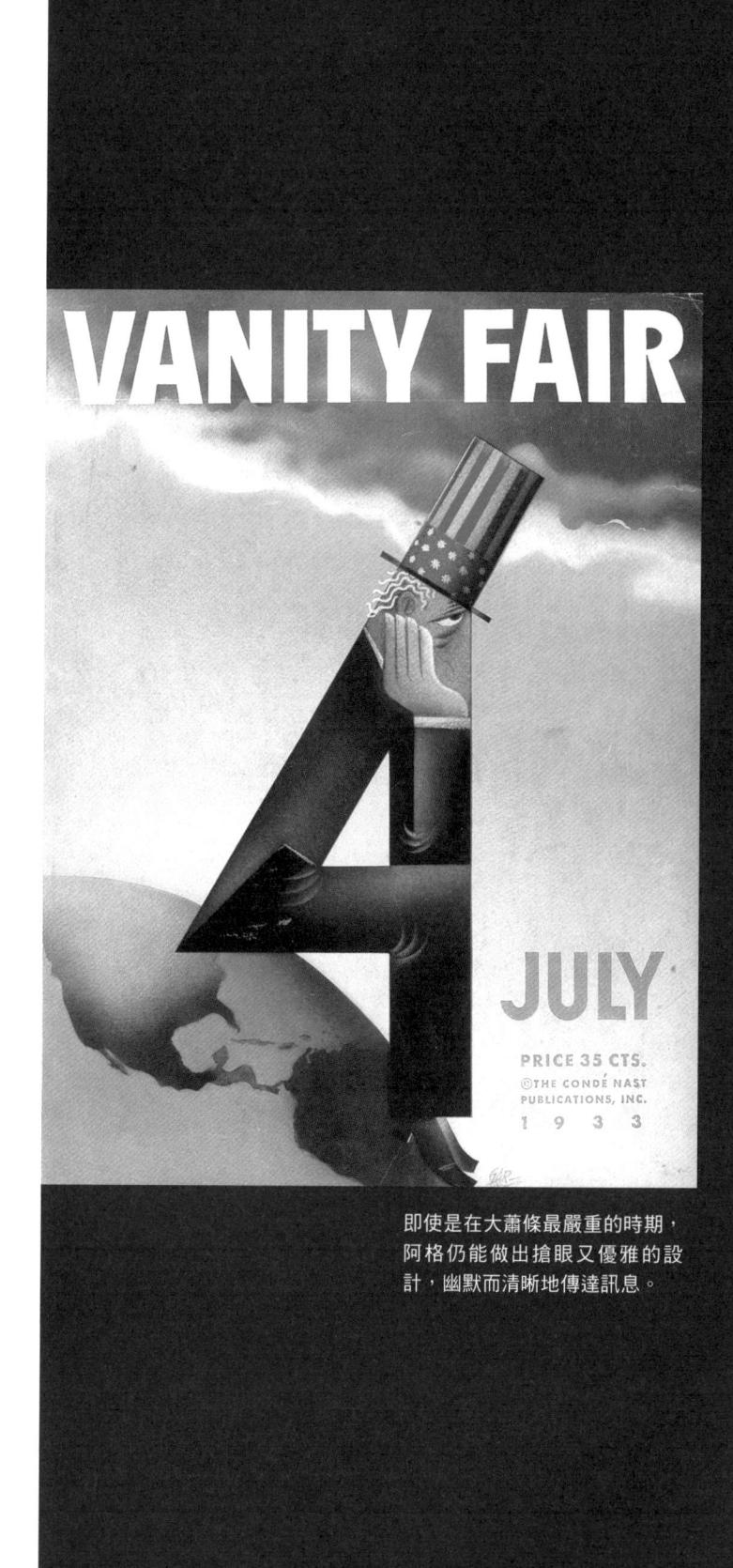

艾利克西・布羅多維奇 Alexey Brodovitch

布羅多維奇來自俄羅斯,1934到1958年期間 擔任《Harper's Bazaar》的藝術指導,發展出 許多日後被視為藝術指導必備能力的技術。他重 新定義了藝術指導的角色,除了顧及版面設計, 還提出刊物架構,並委任合適的人來為刊物量身 製作所需素材。布羅多維奇受到達達主義與構成 主義等現代主義運動與藝術設計風格的影響,為 雜誌引介不對稱版面,營造簡潔有動感的風格, 並應用活潑的圖像,帶領美國刊物揮別充滿無意 義裝飾元素的靜態頁面。他1920年代在歐洲 時,就發展單純的「現代」圖像風格,日後更致 力於採用當時革命性的新觀念(例如早期的抽象 表現主義),到了1950年代,他的風格已儼然 是優雅的代名詞。布羅多維奇善於操作留白空間 與低調色彩、精準乾淨的文字編排(以 Bodoni 字體為主),及戲劇性的照片與精彩的跨頁。

布羅多維奇善於發掘與培養新攝影人才,例如爾文·潘恩(Irving Penn)、理查·艾夫登(Richard Avedon)。他還為美國讀者引介歐洲前衛攝影師與藝術家,例如卡桑德爾(A.M. Cassandre)、達利(Salvador Dali)、亨利·卡蒂爾—布雷松(Henri Cartier-Bresson)與曼·雷(Man Ray)。他把攝影作品當作主視覺,使版面明亮寬敞、充滿動感與表現性,而這些,都是如今我們視為理所當然的雜誌風格。他十分重視時尚攝影的故事性,讓模特兒出外景,精心安排畫面中場所、人物行為和服裝之間的關連性。

AMERICAN FASHIONS 25 fr. in Paris . 50 cents . % in London Paris Report

September 1st 1939

布羅多維奇的作品蘊含創新與 實驗的渴望,他很直覺的排斥 理性與教條,不斷與時俱進。

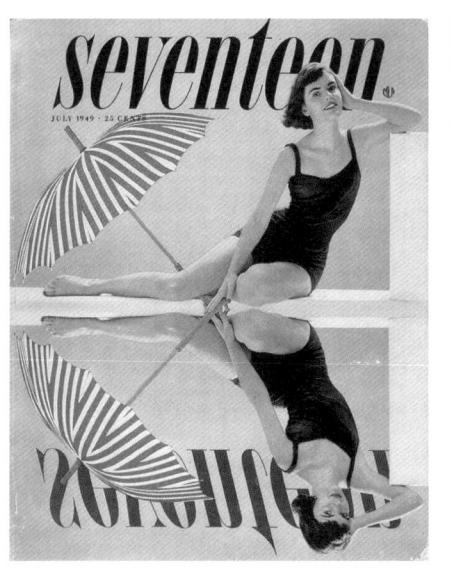

西碧·皮納勒斯 Cipe Pineles

西碧·皮納勒斯在 1946 年,為《Seventeen》 雜誌中的一篇小說委製了專屬配圖,從此編輯設 計師們紛紛敢大膽地以個性化方式來詮釋文字內 容,以確保版面的特殊性與完整性。此舉也深深 影響了現代的攝影師、插畫家、藝術家,讓他們 開始重視「說故事的方法」。

皮納勒斯最初是阿格的部屬,兩人都任職於康泰納仕。共事五年後,她在1942年擔任《Glamour》的藝術指導,成為首位有自主權的女性藝術指導。從《Glamour》開始,時尚攝影追求起藝術價值,並豪氣的使用跨頁滿版圖與戲劇化的圖文比例。刊物利用四色和雙色頁的區分,巧妙營造出閱讀節奏。皮納勒斯結合現代主義的抽象結構,將圖文呈現變得更有趣味,同時賦予刊物濃濃的個人色彩。但她是自擔任《Seventeen》的藝術指導開始,才獲得肯定。那是當時第一份青少女雜誌。

皮納勒斯與《Seventeen》的創刊編輯海倫· 瓦倫婷(Helen Valentine)認為,這份雜誌的 讀者是嚴肅、有知識的青少年,因此提供的內容 也要嚴肅、有知識。皮納勒斯卻給讀者當時最能 激發思考的藝術品,例如提倡激進政治主張的西 摩·切瓦斯特(Seymour Chwast)與班·夏 恩(Ben Shahn)。她率先以不同字型來區分 單元,還讓引進美式純文字設計版面,大玩新潮的文字遊戲。她也擅長操作手寫字,並加以特殊效果如刮擦、撕破等等,增添讀者閱讀時與文字的互動、以及文字本身的表情。她的作品呼應美國藝術界的趨勢,放棄具象的表達方式,轉而探索概念與抽象藝術。

1950年,皮納勒斯在《Charm》雜誌中進一步發揮字型的實驗與探索。這份深度刊物的標語是「給工作的女性」,也就是在變動不安的世界中,扮演重要角色的女性們。皮納勒斯將現代寫實主義融入雜誌,使之呈現新穎的風貌。雜誌內的時尚攝影常以城市與高速公路當作背景,呼應美國的工業發展,並應用富有地方色彩的字體,將版面風格在地化。最重要的是,皮納勒斯善於尋找藝術家與攝影師,並以尊重他們的專業為前提與他們合作,她因此成為最了不起的藝術指導之一。皮納勒斯幾乎得過所有的設計大獎,這說明了藝術指導與合作夥伴培養穩定友誼與良好溝通的重要性。

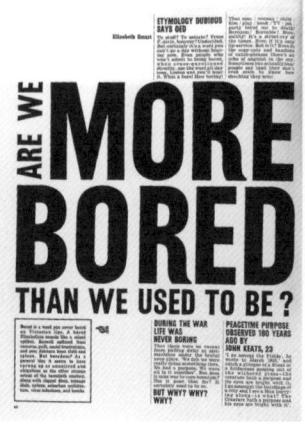

湯姆·沃希 Tom Wolsey

許多歐洲的現代主義設計大師在戰後逃離故鄉,到美國展開新生涯。不過,英國籍的湯姆·沃希卻反其道而行。他在1960年代初期設計的裁縫雜誌《Man About Town》(日後簡稱《About Town》,又改稱《Town》),將瑞士現代主義的設計理念應用到原本花俏、古典的英國雜誌。他拒絕使用格線,大膽結合粗襯線字(slab serif)搭配有現代感的無襯線字(例如 Haas Grotesk),產生強烈的視覺力道,並選用同樣強烈的配圖,在版面上橫向甚至歪斜地擺放。他設計的版面從來不曾單調乏味,充滿趣

味和動感。沃希對攝影有著一流的鑑賞力,委託過許多1960年代最好的攝影師,例如唐·麥庫林(Don McCullin)與特雷斯·唐諾文(Terence Donovan);也為了如實呈現這些攝影作品,而找來了最佳印刷工作團隊,為當時的雜誌設計樹立起標竿與風格。

亨利·沃夫 Henry Wolf

亨利·沃夫來自奧地利,曾在1952到1958年間擔任《Esquire》藝術指導,將這份前景看好的文藝雜誌徹底改頭換面。1958年,他接替布羅多維奇的位置,擔任《Harper's Bazaar》的藝術指導,並在1961年時創辦了《Show》雜誌。

沃夫能在具表現性的版型中,嚴謹地編排文字,營造出色的視覺美感。沃夫在擔任《Harper's Bazaar》藝術指導期間,以布羅多維奇奠定的設計原則為基礎,並選用簡單流暢的字型,構成寧靜簡潔的版面,使整份刊物的節奏十分穩重且不失流動感。沃夫原本較擅長以圖像為主角的開放式跨頁與封面設計,而非冗長的專題報導版面;不過,他仍然成功地製作出文字井然有序、視覺生動活潑的漂亮版面。

沃夫的名言是「雜誌不該只是反映潮流,更要創造趨勢」,他廣告設計的專長,也運用在他所設計的封面上,尤以《Show》雜誌最為明顯。這些精巧的封面展現出超現實的氛圍,從不缺乏原創性。具有敏銳洞察力的沃夫,更是 1950 年代把歐洲現代主義介紹給美國人的一大功臣。

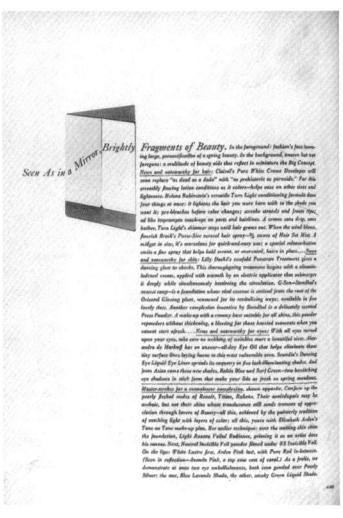

威利·弗萊克豪司 Willy Fleckhaus

德國設計師威利·弗萊克豪司只憑著兩份刊物就名聞遐邇:《Twen》(右圖)與《Frankfurter Allgemeine Magazin》(中譯:法蘭克為匯報雜誌,簡稱 FAZ)。這兩份雜誌,是戰後最有影響力的刊物。弗萊克豪司常在嚴謹的格線系統上,置入局部裁切、具有視覺爆發力的大圖,讓風行於戰後平面設計的「國際式樣」,增添 1960 年代的生命力。他在新聞雜誌《FAZ》任職十年期間,也保持一貫的風格,製作簡潔的跨頁,並以實驗性的手法處理圖插圖,而這種形式主義版面立刻在歐洲引起仿效風潮。弗萊克豪司也幫書亢(Suhkamp)等出版公司設計書籍封面,這些書封承襲了他的典型風格,散發出沉著、低調奢華的氣氛。

《Twen》雜誌

《Twen》雜誌於1959年創刊,文章內容具前 進思想,常搭配有情慾色彩的圖片,讀者多為叛 逆的年輕人。當時西方國家的青少年次文化風 起雲湧,而《Twen》目標就鎖定想與父執輩不 同,並展現自我語言與風格的新讀者群。弗萊克 豪司為青少年次文化設計出新的圖像風格,將講 究理性格線與簡單文字編排的瑞士版式,搭配美 國出版業大膽有趣的視覺風格。他設計了一套以 12 個單元組成的格線系統,供《Twen》的大 開本(265×335mm;10.4×13.2英时)使 用。這套格線可以有二、三、四、六欄等不同靈 活用法,甚至可以將橫向單元跨越數欄,版型變 化多端。嚴整的坐標定位讓頁面元素各有所歸, 《Twen》出類拔萃的版型與視覺效果,可說是 歸功於這套格線系統。弗萊克豪司透過激進的圖 像和超大特寫,讓版面構圖產生特殊造型與和超 寫實的風格。他追求設計的戲劇性和視覺上的顛 覆、與眾不同,完全符合雜誌需要的風格。弗萊

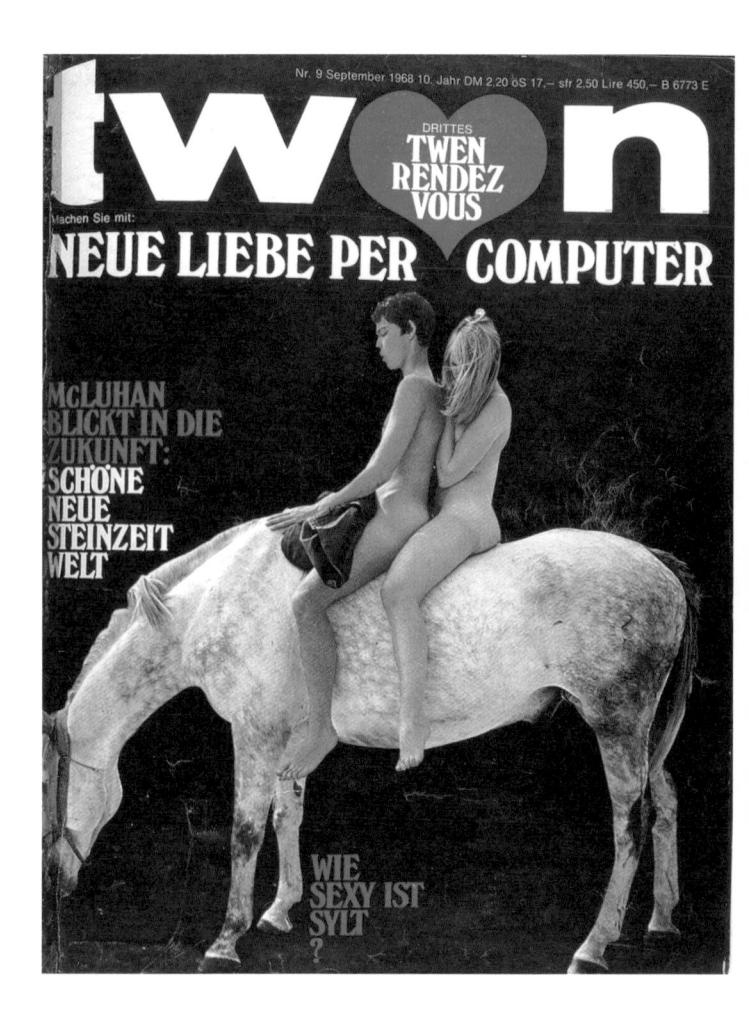

克豪司雖是文字記者出身,但他認為圖像更具說故事的力量。為了凸顯這些版面上當時最吸引人的新聞攝影,他常用全黑的頁面搭配極簡文字。《Twen》是令人驚奇、有戲劇感的新刊物,恰恰反映出所處的社會與文化環境。

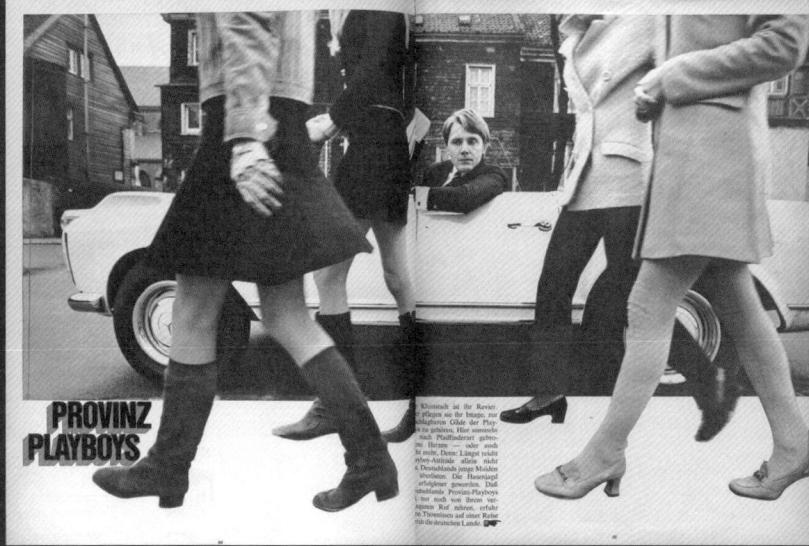

在這份超大開本的雜誌中,弗萊克豪司 用獨特的黑色頁面、極簡的文字及當時 最吸引人的新聞攝影,這令人驚奇、有 戲劇感的新刊物,恰恰反映出這份雜誌 的社會與文化環境。

《Nova》雜誌

激進女性月刊《Nova》於1965年在英國創 刊,自詡為「女子漢」。這份雜誌要提供讀者有 知識分量、概念新穎的內容,不只是談時裝與化 妝品。藝術指導佩齊諾提與編輯丹尼斯·海克特 (Dennis Hackett) 攜手合作,透過設計來反 映這種前瞻立場,並仿效 1950 年代的美國雜誌 中,由阿格與布羅多維奇奠定的象徵主義風格。 《Nova》的封面利用令人瞠目的圖片、空間與 文字,反映極具爭議的主題(如種族歧視、虐 待、性與政治等)。視覺效果相當搶眼,充滿表 現性,連同文字編排也相當醒目,例如將普通的 Times 字型放大到占滿一半頁面來展示引言。 1969 到 1975 年停刊前,擔任《Nova》設計 的大衛·席曼(David Hillman)深受佩齊諾 提影響,也採用大膽、挑釁的視覺元素與攝影來 說故事,相當能反映出這段期間社會、性別與政 治的動盪氛圍。

席曼讓編輯設計不謹能展現雜誌的識別,還能充分傳達刊物的內容、調性與立場。席曼身兼副主編與藝術指導,勇於打破成規、承擔風險,利用設計來詮釋雜誌不妥協、有個性的特色。同時,也兼顧每個單元不同的特性,把「故事」交給諸多攝影師詮釋,讓他們提出不同觀點,甚至相左的立場。正因如此,《Nova》在不違背刊物精神與思想的情況下,不斷開創新局。

《Oz》雜誌

《Oz》於澳洲創刊時,是份具有諷刺色彩的 前衛迷幻雜誌,由主編理查·尼維(Richard Neville)、副主編理查·瓦爾許(Richard Walsh),及身兼畫家、漫畫家、歌曲作家與 製片人的馬丁·夏普 (Martin Sharp) 攜手合 作。1967到1973年間,《Oz》也在倫敦發 行,是由夏普主導,成為一份嬉皮雜誌。英國版 的《Oz》獲得藝術界的好評之際,也招來不少 爭議,甚至在1970年遭到起訴,打了一場英國 法律史上最漫長的猥褻案官司。夏普在《OZ》 英國版善用先進的印刷、紙張與油墨,做出與當 時其他雜誌相較起來最具實驗性與冒險性的封 面,例如封面和封底連貫的設計、華麗的拉頁海 報,或是用金屬油墨印刷、甚至使用錫箔一般的 材質來當封面。夏普不斷挑戰並超越印刷科技的 極限,為《OZ》提供豐富的視覺隱喻,探索當 時對色情書刊、自由意志主義、淫穢與激進思考 的既定概念,拓展刊物的可能性。

《OZ》雜誌的開本經常改變,有時甚至以橫式開本的概念來製作。不過,不管開本怎麼改,精彩反映次文化的變動是其不變的特色。然而,這份雜誌從反權威,充滿服用藥物後的混亂與實驗色彩,隨著時代對次文化的接受程度逐漸稀釋,最終被其所努力反抗的主流文化吸收。《OZ》不僅運用封面來闡述這項轉變,瓊恩·古柴德(Jon Goodchild)的設計也功不可沒。柴德常與夏普等其他撰稿者合作,把設計工作室當實驗室,用拼貼與鬆散的文字來自由編排版面,讓刊物進一步悖離當時主流的瑞士設計拘謹風格,也在平面設計界產生深遠的影響。

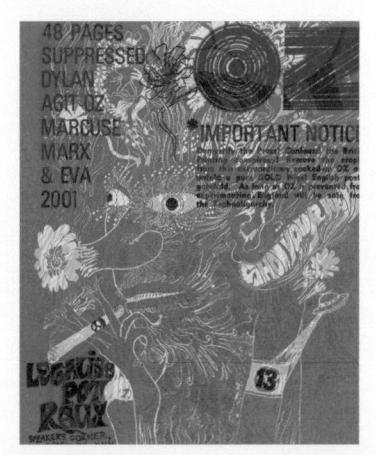

奈維爾·布洛狄 Neville Brody

布洛狄在1981年加入《The Face》之後,立 即為這份雜誌建立獨樹一格的美學。他的設計風 格可溯及二十世紀的構成主義、達達主義與表現 主義等藝術運動,但絕不只是依樣畫葫蘆。布洛 狄是有明顯政治傾向的設計師,政治反動色彩強 烈的象徵主義與表現主義,對他來說格外有吸引 力。《The Face》的文字編排便因此帶有象徵 主義色彩,以趣味的版面實驗帶領讀者體會工業 化後的印刷技術,是如何影響了平面設計。版面 上素樸、粗大的幾何形式與符號,充滿表現主義 的味道。《The Face》反權威、後龐克的政治色 彩及視覺識別,和布洛狄充滿實驗性的個性化設 計可說是絕配,兩者都秉持反抗精神,定義了當 代設計的風貌與感受。布洛狄打破了傳統字型結 構,將文字當圖像來使用,不僅靈活多變、具有 可塑性,同時又是意義的承載體。

《The Face》雜誌

奈維爾·布洛狄在1980年代為反文化雜誌《The Face》做設計時,讓字型在刊物中扮演的角色煥然一新,對平面設計影響深遠。布洛狄善善於應用字型來傳達意義,常在一段文字中使用不同字型,表現出不墨守成規的態度,編排方式也呼應俄國構成派的前衛作風。他在頁面上以圖像與符號營造視覺連貫性,並用大膽的手法來處理圖片,透過局部放大、裁切甚至加框等方法,讓圖片更加有力道,呈現時代錯置、反秩序、極度個性化的刊物特色。隨著雜誌逐漸成熟,布洛狄的文圖應用也更出神入化,與讀者一同前進之際,仍提供創新與高明的設計解決方案。布洛狄也把相同的風格應用到《City Limits》與《Per Lui》,然而卻沒那麼成功。他的《The Face》依然是編輯設計中最搶眼的代表作。

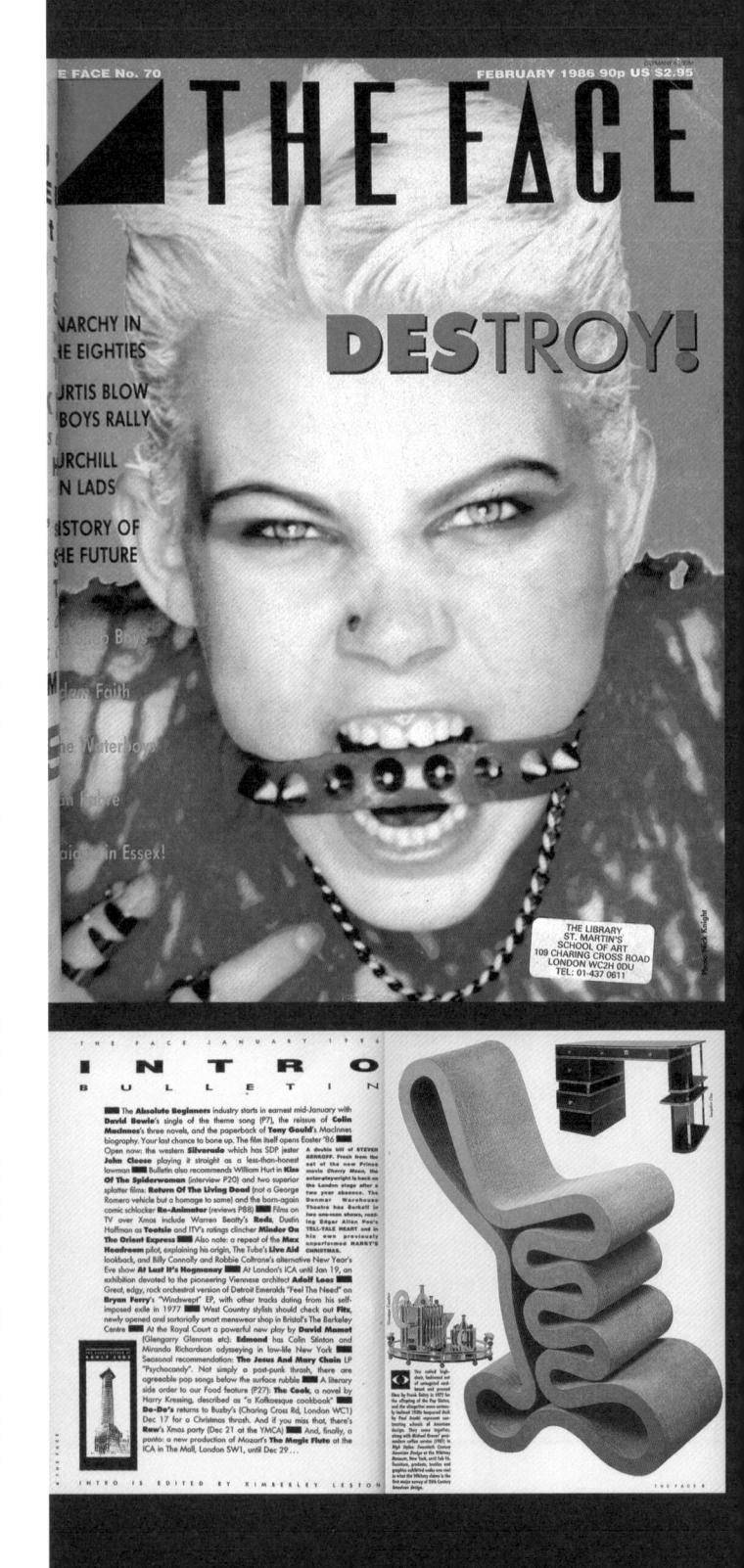

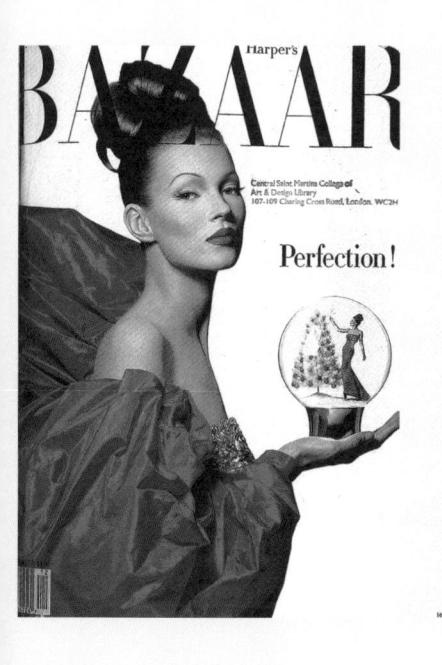

法比恩·貝隆 Fabien Baron

法比恩·貝隆從年輕就在家接受藝術指導的薰 陶。他的父親在多家法國報紙擔任藝術指導, 包括由沙特(Jean-Paul Sartre) 創辦的激進 左翼報紙《解放報》(Libération),法比 恩只在巴黎應用美術學院(École des Arts Appliqués)就讀一年,便隨同父親工作。 後來, 貝隆又到《Self》與美國的《GO》任 職。他在1988年到義大利《Vogue》,之 後在《Harper's Bazaar》與利茲·提柏里斯 (Liz Tiberis) 合作時開始大放異彩。貝隆以 強烈而獨特的藝術指導風格聞名,一舉打破所有 規範(包括商業規範)。他在為某一期義大利 《Vogue》設計封面時,曾委託艾伯特·華生 (Albert Watson) 等攝影師拍攝搶眼的抽象肖 像,而不是時尚雜誌喜愛的人物特寫,然而當期 雜誌在店面陳列時顯得格外突出。

貝隆以最少設計元素,組成力道強大的圖像,更常以原色搭配大量的黑色色塊做出搶眼效果。同樣的,他也只和固定的幾個畫家合作,例如曾設計《Interview》logo的葛斯塔夫森。黑白攝影作品是他的最愛,透過精心裁切,這些攝影呈現出令人難忘的效果。

貝隆編排、堆疊文字的方式,就像在蓋房子。例如將專題的首頁用龐大的標題字占滿,搭配極簡的風格與大量留白空間,展現新穎的現代美學。他會以文字造型呼應圖片,將版面上所有元素與文字排編相互組成特定的形狀、線條或色彩。種種視覺語彙,都呼應著雜誌精神,與之產生連結。在《Interview》雜誌中,他也針對不同的受訪內容,精心挑選合適的字型,來傳達出受訪者的個性。貝隆為這兩份雜誌打造出連貫、活潑的形象。過了十多年,他仍在《Vogue Paris》(上圖)延續這種作風,傳達出時尚的流動與活力。

馬克·波特 Mark Porter

波特曾擔任《Colors》藝術指導,之後也負責《標準晚報 ES》週刊及最初兩期的《WIRED》設計。他在 1996 到 2010 年擔任《衛報》的創意指導,主導《衛報》改版,獲得極大的肯定。當時所有的報紙都在試圖蛻變,而《衛報》的改版堪稱重要典範,曾贏得 D&AD 的黑鉛筆獎、出版設計師協會獎。波特在《衛報》任職期間也擔任該報旗下週末雜誌《Weekend》的藝術指導,並在德利的協助下,連續展開大刀闊斧的六次改版。

波特注重細節,眼光極佳。他雖是語言學系的碩士,卻自認更注重視覺。波特目前經營自己的設計事務所,近年作品包括《公共報》與《金融日報》(Financieele Dagblad)改版。《公共報》是葡萄牙全彩日報,簡明扼要的設計廣受好評。整份報紙以圖片為主,小版式讓報紙更具現代風格,簡直堪稱是日日發行的新聞雜誌。

荷蘭阿姆斯特丹的《金融日報》原本為紙本刊物,但也有網站與數位版本。波特根據刊物在不同平台上的考量,調整各個版本的設計邏輯。

蓋兒·安德森 Gail Anderson

蓋兒·安德森是作品繁多、行事低調的設計大 師,她的作品啟發了許多當代編輯設計師。安 德森出生於布朗克斯(Bronx),父母是牙買 加移民。她從紐約視覺藝術學院 (School of Visual Arts)畢業後,進入藍燈書屋(Random House)工作,之後任職《波士頓環球報》。她 最為人熟知的是1987到2002年於《Rolling Stone》設計的作品。當時她與知名設計師福萊 德·伍沃(Fred Woodward)合作,以裝飾性 文字做出美得像專輯封面一樣的頁面。安德森在 2008年獲得美國平面設計協會(AIGA)頒發的 獎項。知名藝術指導與作家史蒂夫·海勒(Steve Heller) 曾訪問她,說她的作品是「折衷式的文 字編排」(typographic eclecticism)。在她 手中誕生的《Rolling Stone》風格相當細膩、富 有手感,密密麻麻的頁面上以她委製的插畫為主 角。雖然安德森曾獲得出版設計協會與美國平面 設計協會的諸多獎項,但她仍謙虛地默默努力, 把功勞歸功於舍爾與伍沃對她的影響。

安德森離開《Rolling Stone》之後,到娛樂 廣告公司「SpotCo」任職,為影劇產業做出 不少亮眼的戲劇海報。她用趣味的圖像展現優 秀的想法,並運用插圖與文字編排技巧,創造 出令人印象深刻的設計,為百老匯許多音樂劇 的塑造品牌形象(例如《Q大道》[Avenue Q puppet])。她也為美國郵局設計郵票,擔任 郵票顧問委員。她作品中一貫的特色是強烈而 優越的觀念與技巧,以當代手法搭配新舊文字 造型,營造出引人矚目的作品。她對海勒表示 (兩人曾共同寫過許多書籍),許多想法是在 「SpotCo」鍛鍊出來的:

「我在做每一項案件時,都會尋找十幾個好想法,不能只有一、兩個點子,」安德森解釋他的作品如何贏得觀眾的注意力(與金錢)。 「做了七種設計之後,就會明白要探討一個問題有許多方式。我很享受這過程,即使知道最後只能留下一個想法。這過程能釋放創意。」

安德森目前任教於紐約視覺藝術學院學院,並經營一間小小的設計公司。

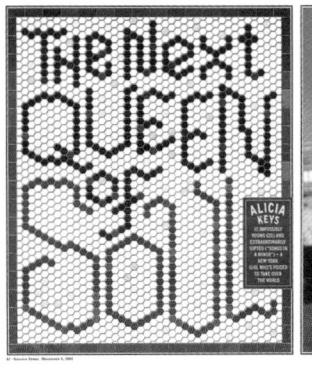

費南多·古提耶雷茲 Fernando Gutiérrez

談到班尼頓(Benetton)公司的《Colors》雜 誌,一般人會想到創意十足的創刊者奧利維耶 羅·托斯卡尼(Oliviero Toscani)與提伯· 卡爾曼(Tibor Kalman),但古提耶雷茲也功 不可沒。古提耶雷茲在 2000 年擔任創意指導, 沿用卡爾曼以圖像來報導的原創概念,成功的用 圖片來說故事。古提耶雷茲多才多藝,作品種類 繁多。他從倫敦印刷學院畢業後七年,自行創辦 公司,涉足範圍囊括書籍出版、官傳、與編輯設 計。他在不知不覺中,徹底改變了西班牙的刊物 視覺走向。古提耶雷茲先從公家機關的青年雜 誌著手,運用雙重格線當作格式。而他最著名 的設計,應屬西班牙時尚雜誌《Vanidad》與 《Matador》,兩者分別是以文字和照片為主 的雜誌。此外他還主導《國家報》的設計、以年 輕讀者群為主的增刊《誘惑》,及《國家報》週 日增刊《EPS》,全國讀者高達 120 萬。雖然這 些刊物是由低階的印報機印製,但他善用開本與 紙張的優勢,絲毫不受局限。古提耶雷茲積極地 將這些刊物以獨立雜誌的規格來做設計,而不只 是報紙的增刊,活潑、富裝飾性的視覺風格帶動 銷量一飛沖天。

從這些刊物中可明顯看出,古提耶雷茲能利用設計元素傳達刊物的特性,為讀者提供適當的體驗。不僅如此,他的作品融和文化與國族色彩,讓雜誌鶴立雞群。以《Matador》這份年刊來說,他計畫到 2022 年時正好出版 29 期,每一期按西班牙文字母順序,向一種字型致敬。這份雜誌的特色是高品質的內文紙,精美的印製和大開本。這些元素與版面搭配得極有戲劇性(右下圖),獨樹一格。他設計的刊物充滿西班牙特色,然而當需要尋求不同文化認同時,也會特別注重版面的在地化。

Astrid Hadad es cabaretera.
La más mexicana y, a la vez,
la más crítica con su país.
Especialista en articular
sarcasmos y sonrisas, su show
estalla en la cara del espectador.
Una bomba de mujer.

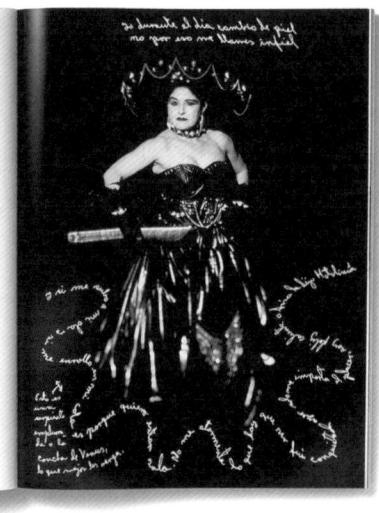

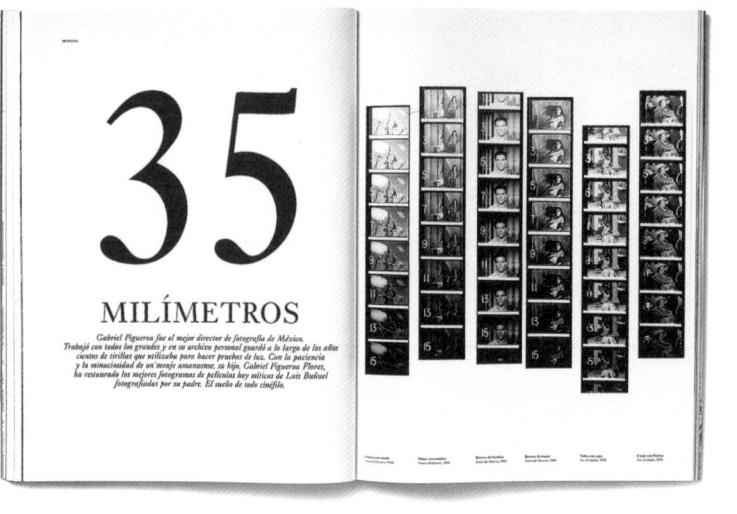

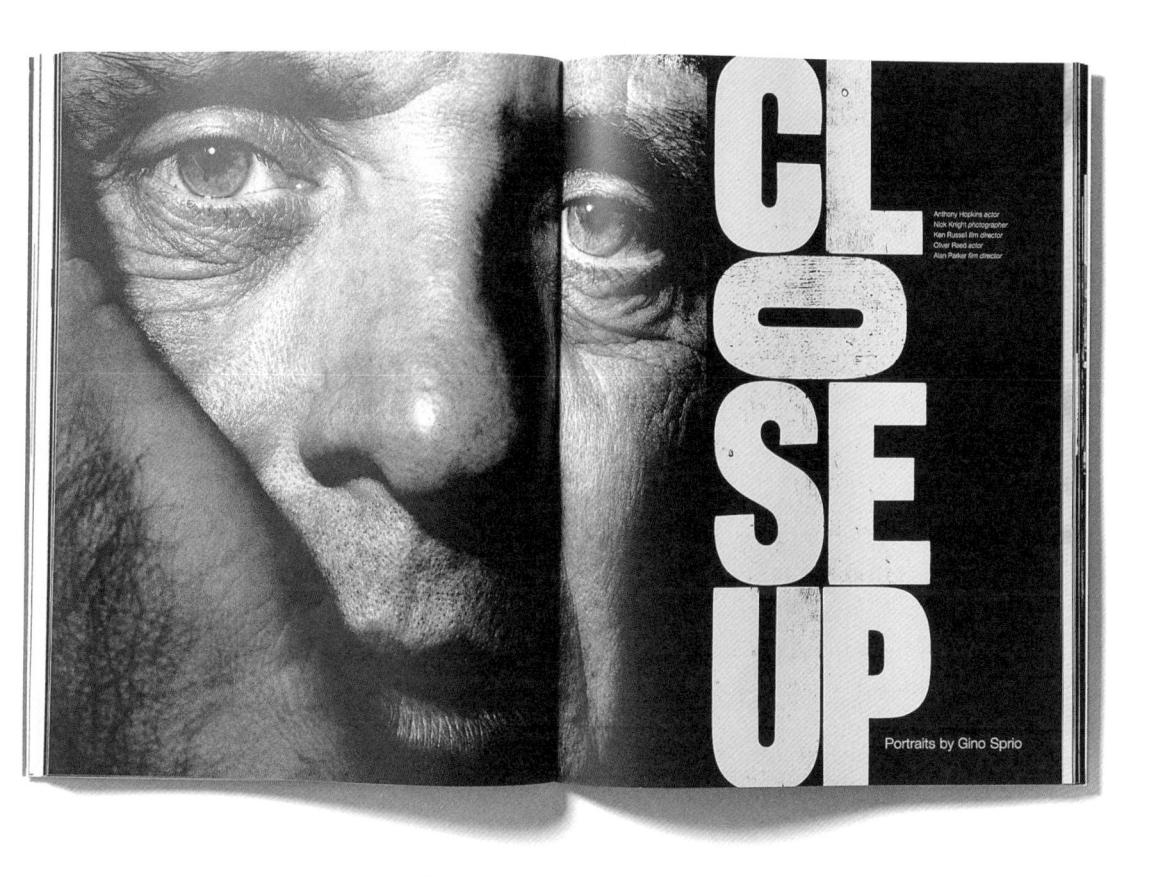

文斯·佛洛斯特 Vince Frost

在卡爾森之後,最能展現字型表現性的設計師當屬文斯·佛洛斯特。兩人的作品或許迥然不同,但是都深刻理解編輯設計(尤其是文字編排)的主要任務,是運用視覺手法來忠實傳達刊物的內容與識別。兩位設計師的作品偶爾會被批評是「為設計而設計,並且造成閱讀上的障礙」。不過,佛洛思特能不斷透過生動、刺激的設計,吸引讀者注意。

1990年代中期,佛洛斯特擔任《週六獨立報》的藝術指導,也負責《金融時報》的週末雜誌《金融時報商業週刊》,兩份刊物皆展現出知性氛圍。佛洛斯特喜歡簡潔與乾淨的設計,很懂得如何用凸板活字與木活字,做出與內容相關的裝飾元素,跳脫字體的調性與風格限制。佛洛思特不太使用花俏多變的設計手法,而是專注於讓每個元素更簡潔醒目。另類時尚刊物

《Big》(上圖)來說,佛洛斯特與凸版印刷大師奇金合作,讓字體呈現出像是摩天大樓、對話框、面具與各種物體的趣味效果,呼應一旁令人驚奇的照片,宛如紐約知名攝影師威廉·克萊恩(William Klein)的作品。而在英國文藝雜誌《Zembla》的例子中,佛洛斯特在每一頁以明亮、有活力、玩世不恭與無法預測的驚喜設計,把文字當圖來玩,讓讀者感受文字的趣味。

不過,佛洛斯特不僅在個別頁面上展現不同特色,也藉此掌握整體刊物流動,使整本刊物成為令人期待、驚喜的佳作。《Zembla》的版面以令人大開眼界的照片(多為黑白)搭配凸版活字,產生出乎意料的美麗效果,非專題的單元(信函、評論、新聞等等),也絲毫不馬虎。

珍妮·佛羅里克 Janet Froelich

珍妮·佛羅里克原本是畫家,在美國古柏聯盟學院(Cooper Union)與耶魯大學(Yale)修習美術。後成為《紐約時報雜誌》與《Real Simple》的藝術指導,不僅有高超的設計能力,對攝影與設計的熱情也令人佩服。在漫長的職業生涯中,佛羅里克曾和多方創意人才合作,做出美麗的圖片,實現好的想法。

佛羅里克在1986到2004年間擔任《紐約 時報雜誌》的藝術指導,於2004年升任創意 指導,曾抱回出版設計師協會、藝術指導俱樂 部、報紙設計師協會等機構頒發的六十多項大 獎。她的團隊幫《紐約時報雜誌》贏得2007 年出版設計師協會的「年度最佳雜誌」。2004 年,她擔任《T: The New York Times Style Magazine》的創刊創意指導。這份雜誌是設 計獎項的常勝軍,悅目的時尚攝影與內容編 排皆有她的參與。2006年,她還擔任紐約時 報運動雜誌《Play: The New York Times Sport Magazine》與紐約時報房地產雜誌 «Key: The New York Times Real Estate Magazine》的創意指導,後來又擔任《Real Simple》的創意指導,率領時代公司(Time Inc)的團隊製作這份生活風格、飲食與居家雜 誌。《Real Simple》從紙本到app、數位版本 與網站的設計與產品包裝,都由她掌管。她對設 計有清楚的願景,並追求卓越的照片呈現與文字 編排。《Real Simple》的圖片美觀有吸引力, 常靠一張圖像就成功訴說整篇故事,即使在行動 載具上縮小成一張圖示,效果也不打折扣。

2006年,佛羅里克獲選入藝術指導協會(Art Directors Club)的名人堂。她多年來在職業生涯與紐約視覺藝術學院的教職中,啟發了許多年輕設計師。她是出版設計師協會與藝術指導協會的董事,也是美國平面設計協會紐約分會的會長,透過這些組織,提升大眾對於設計的重視。

YOU

TACE

佛羅里克對美術的熱情影響她的 行事風格,並促成她和藝術家與 設計師順暢合作,製作出雋永的 版面。

WHEN YOU'RE LIMBER, YOUR BODY CAN MORE EASILY ADAPT TO PHYSICAL STRESSORS.

史考特·丹第齊 Scott Dadich

丹第齊來自德州,曾在賞心悅目的《德州月刊》(Texas Monthly)任職,2006年進入《WIRED》。他致力於設計出創新的雜誌格式,與讀者展開新互動,也因此贏得諸多獎項。丹第齊在傳統紙本轉換到數位版之際,成為優良雜誌設計的先鋒。他是《WIRED》app的概念發想人,並率領團隊著手研發程式。《WIRED》是第一個採用桌面出版系統製作的app雜誌。他也設計了另一款app,供《The New Yorker》使用,這個app是2012年同類型app中的銷售冠軍。在知名出版公司康泰納仕的支持下,丹第齊的團隊在2012年推出《The New Yorker》iPhone版。

丹第齊曾研究過如何從早期app的線性閱讀(亦即一頁頁翻閱的PDF檔),轉變成有數位閱讀特性的頁面。他把這稱為「堆疊」(Stack)系統,讓頁面像掛在晾衣繩上一樣,可以橫向快速切換、瀏覽。在康泰納仕丹的投資之下,第齊的設計與開發團隊很有先見之明的發展了這種系統。

丹第齊對於創新的渴望,讓他升任康泰納仕編輯 平台與設計副總裁。他對媒體的熱情與積極推 廣,促成他在設計界面臨印刷機發明後的最大轉 變時刻,成為傑出的貢獻者。

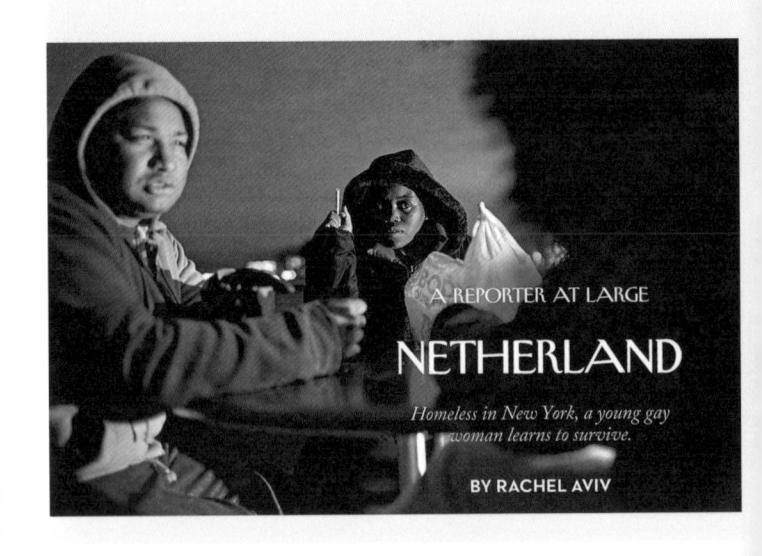

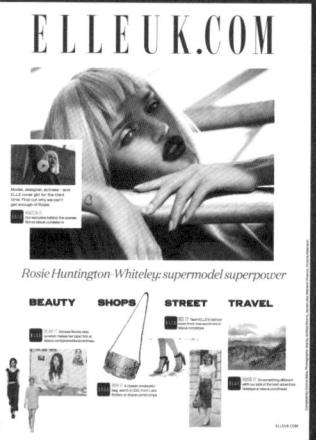

蘇珊·賽克斯 Suzanne Sykes

蘇珊·賽克斯是英國籍的藝術指導,為當時的時尚雜誌賦予令人佩服的新面貌。1989年,她與編輯葛蘭達·貝里(Glenda Bailey)合作,推出《Marie Claire》英國版。賽克斯在時尚週刊《Grazia》中,將精美的時尚月刊設計手法,融入步調快速的週刊。這對當時的暢銷時尚雜誌來說,是耳目一新的作法,也多次獲得設計與藝術指導協會大獎。《Grazia》的樣貌很有戲劇性,評價有好有壞,但是多層次的頁面與配色,確實全面改變了時尚雜誌的風貌。

賽克斯在 2007 到 2012 年間曾擔任《Marie Claire》美國版的藝術指導,之後又為英國《Elle》大幅改版。英國《Elle》在 1980 年代曾風光一時,大打超級名模牌。然而賽克斯明白雜誌作風須隨著讀者群變化,因為現代讀者不再持續購買印刷精美的雜誌,反而喜歡使用社群網站來取得時尚建議。於是她和藝術指導馬克·李茲(Mark Leeds)合作,設計出完全不同卻相輔相成的線上內容和紙本內容,不像當時多數雜誌,是直接利用紙本內容來製作網站和數位版本。

談到 2013 年 3 月的數位與紙本雜誌時,賽克斯表示:「紙本是主角品牌。我們運用紙本雜誌的優勢,帶領讀者前往數位領域。」2013 年,《Elle》每月的紙本銷售量為 177094 本,網站讀者為 45 萬人,也是英國最大的女性雜誌,Facebook 追蹤者以超過 5 百萬人。賽克斯說,她與編輯羅蘭、康迪(Lorraine Candy)的目標是「讓讀者可直接在頁面上購物」。

賽克斯的設計方向依循鮮明的母品牌刊物,拓展到功能強化的 app 版本(elle. com)。封面上的蘿西·杭亭頓(Rosie Huntington)也出現在 Elle TV 的影片中,讓讀者有不同的探索方式,也便於分享內容。

展望未來

設計趨勢如今幾乎是不可預測的,但是思考科技與種種變遷會如何影響設計實務,依然有其意義。前面提到的所有大師皆曾受惠於當時的新科技,例如彩色印刷普及,或彈性更大的排版系統問世。如今,編輯設計師桌上都有蘋果電腦,他們得十八般武藝樣樣精通:印刷術、藝術指導、製作圖片、寫程式、當編輯、寫部落格,還要會行銷……這些都還只是基本功。設計師必須了解不同媒體的經濟、文化、科技演變,還得學會各種新科技才能生存。

接下來要探討的是,在不久的未來可能出現的種 種挑戰,及業界專家所提供的珍貴見解。

科技變遷

數位雜誌

如今編輯設計業最大的挑戰在於,雜誌必須同時面對印刷、平板與社群媒體等諸多不同的發行管道。2010年 iPad 上市之後,各家雜誌競相推出自己的 app,期盼能從數位內容中獲利。Adobe、Woodwing、Mag+很快推出專供InDesign使用的外掛程式,讓紙本設計師能快速把版面轉換成 iPad 或其他平板電腦可用的版本。一夕間,報刊編輯的工作流程出現一個全新的環節。紙本完成後,設計團隊還得要把完成的頁面,轉成可供平板電腦螢幕使用的小版面。所有格式要重新調整,並增加動畫、影片、音效等互動元素。然而這些 app 能有多大的效用,仍有待觀察。

響應式設計

響應式設計最初的目的,是要讓同一頁面在桌機、平板、手機等大小不一的裝置上自動調整成合適版型。使用者在瀏覽網站時,瀏覽器視窗寬度會觸動演算的變動,來調整版面,適應不同的載具。原本為桌上型電腦寬螢幕設計的多欄位版型,可以自動變成智慧型手機的單欄位設計。

為協助設計師必免重複工作,已有人開始發展以 演算法為基礎的全新響應程式。這項技術不僅能 自動運算紙本與數位版的內容差異,而且能響應 更多不同平板螢幕的各種大小與相容的格式。

自動集結內容

雜誌可運用 RSS(簡易資訊聚合)格式服務,自動產生內容。只要利用演算,即可找出讀者想要的內容,並透過 RSS 軟體,將內容送到不同的行動裝置中。2012年,最受歡迎的聚合內容提供者是 2010年由美國人麥可·麥丘(Mike McCue)與伊凡·道爾(Evan Doll)成立的Flipboard。Flipboard是數位社交雜誌,內容擷取自 Facebook與 Twitter等社群網站,並在 iPad 或 Android 行動裝置上以雜誌格式呈現。使用者可翻閱所有與 Flipboard 合作網站的內容摘要,如果已經是某數位刊物如《紐約時報》的訂戶,也以直接透過 Flipboard 來閱讀雜誌內容。magCulture 的創意指導雷斯里表示:

「藝術指導的功能,被演算法取代了。 Flipboard 是第一個有縮放與空間概念的 app。我很喜歡用手機閱讀社群網站匯入的 內容。Flipboard 的翻頁方式也很精巧。以 往,行動裝置上的頁面往往為了功能而犧牲 美觀,看起來不太舒服。Flipboard 很聰明的 運用雜誌跨頁的感覺,在裝置上分為左右兩 個版面來呈現。」

自助出版

另一項備受出版界矚目的新技術,是取代傳統編輯流程、紙本與數位版本同步發行的概念。「新聞俱樂部」的創辦人表示,這項技術的宗旨是要讓沒有設計背景的使用者,也能自行製作紙本刊物。他們發展出一套客製化軟體「Arthr」,並和印刷廠談了很好的價格,利用非尖峰時間來印

刷。任何人皆可上傳文字與字型,用軟體自行排版後,印製出小批量報紙(懂設計的使用者可以自行上傳 PDF 檔案。)

若想要獲得更個人化的紙本與數位組合,可利用倫敦伯格設計公司研發的「小小印表機」(Little Printer)。這台印表機顛覆過去印出刊物、送到通路,指望有人購買的傳統模式,而是讓使用者從網路儀表板(dashboard)選擇內容。這些內容會透過 WiFi,用「小小印表機」的感熱紙印出來(參見 232 頁)。小小印表機可說是屢屢推出趣味設計的伯格公司典型之作,有人認為和 Flipboard 不無相似。然而公司主持人舒茲解釋:

「小小印表機有自己的特質和行為,和 Flipboard 很不同。其中最大的差異就是, 小小印表機的內容全儲存在雲端。所有歷史 記錄都可以查得出來。另外,小小印表機只 在排定的時間,送來指定的數據與資訊。 要與它互動一下,就知道該如何使用,不例 要太多學習。它可輸出一些常見內容,他有廣 業者與大型出版社(例如《衛報》)提供的內 容。重點是,小小印表機是個隨時都在身邊 的夥伴,無論內容是來自大型媒體還是小型 媒體,都以同樣的格式呈現。小小印表機一 視同仁。」

內容量有限的出版品

閱讀數位內容時,使用者往往會不斷開啟、連結到網路上的其他內容,常常好像沒完沒了。近來出現了反其道而行的概念,設下數位內容的界限,就像紙本雜誌有頁數限制。這種網站與 app 不再給予數不清的網站內容,而是明確 標出 盡頭。iPhone 的 app「雜誌」(The Magazine)就是一項嘗試。這個 app由

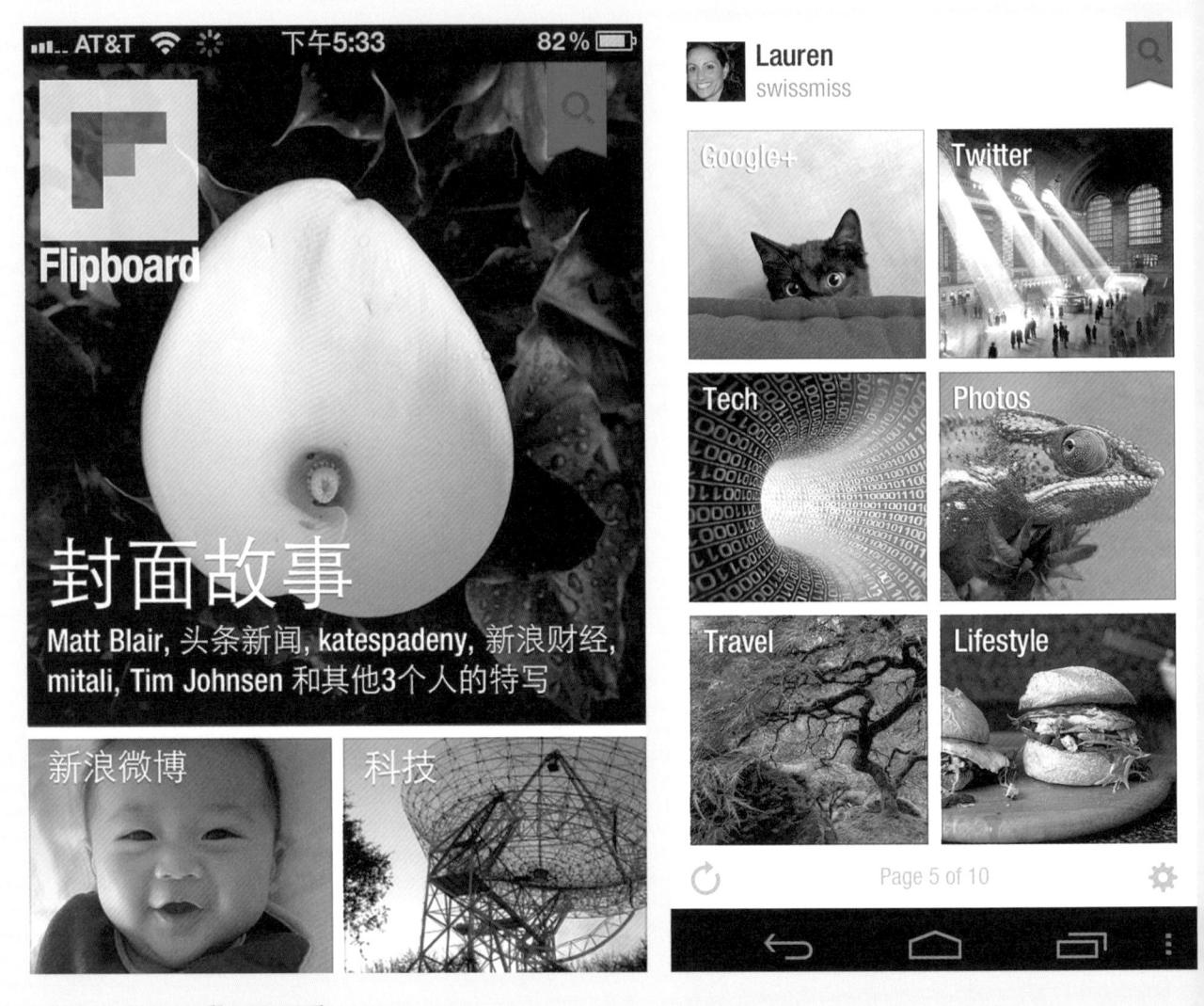

Flipboard 在 Apple 與 Android 系統都可以使用,自動產生的內容有雜誌般的質感,鮮明的黑底白字或白底黑字,簡單搭配圖片與超連結。

Instapaper 的馬可·亞蒙(Marco Arment) 推出,每兩週只送四篇文章送到使用者的行動裝置中。這 app 只能在蘋果的「書報攤」 (Newsstand)取得,沒有紙本版本,沒有圖 片或裝飾,只有少量文字供閱讀,並有清楚的結 尾或「邊界」(edge)。

另一個新起之秀是《Aeon Magazine》(中譯:萬古雜誌,aeonmagazine.com),週間每天會出一則長篇文章,同樣重質不重量。網站內容是由專家撰寫,內容很進步、發人深省,期望讀者每天能專心讀一篇好文章,而不是淹沒在無窮無盡的「必讀!」訊息中。《Aeon Magazine》在網站上每天發布,也可每日或每週透過 e-mail 訂閱,且可隨桌機、iPad 或智慧型手機的螢幕調整。

數據可得性

如今數據可得性提高,而《泰晤士報》這類公司 往往能善用這項趨勢。《泰晤士報》的設計編輯 希爾說:

「……取得數據的方式日新月異,GPS只是其中一種。另一項值得期待的發展是,我們可善用累積了225年的檔案庫中的圖片,為報導提供脈絡,……這對《泰晤士報》這樣的機構來說有很大的發揮空間……如今,我們能取得各版本的數據回饋,得知讀者的各種使用行為模式。我們能透過微數據(microdata),來分析讀者會花多少時間看我們設計的資料圖表,這些數據能告訴我們真正成功傳遞給讀者的內容是哪些。」

改變商業模式

以前人們會彼此分享概念與社論,現在則透過 Twitter或 Tumblr等社群網站來分享。這些工 具有助於把讀者帶回紙本,也是出版社用來分享 內容的管道與輔助系統。 新聞集團(NewsCorp)等新聞媒體公司目前也 致力透過各種管道的產品與服務,維持大型組織 的運作。其中有些商業模式能夠獲利,但有些較 傳統與老舊,無法獲得很高的利潤。希爾說:

「付費牆與數位版本的出現都是大事。我們必須重新審視《泰晤士報》的工作流程,看看如何有效率工作,確保設計團隊能獲得正確的資訊。我們非常努力,設法在全天候維持不同平台運作。然而我們無法幫每種新的平板電腦或行動裝置製作特定版本,因此要為設計工作排出優先順序。我們希望設計出的每種版本,都有不同之處。」

那麼,雜誌能光靠紙本生存嗎?《Eye》雜誌共同創辦人埃斯特森說:

「……很難一概而論。如今超市是刊物的大 通路,導致小型報刊店敵不過競爭而消失, 小出版商也跟著遭到淘汰。市場一方面被出 版紙本刊物的大出版公司壟斷,自助出版卻 同時開始蓬勃發展。

……網路帶來的差異是,讀者可買到過期刊物,也可從海外訂閱,讓雜誌送到家中。我們不用千方百計去尋找特殊刊物的蒐集者,只要上網就買得到。像《Eye》這種小型出版社,只要讀者能找得到我們,我們就能和他們連結,讓他們知道我們在做什麼,以及新刊上市的消息。對小型出版社來說,無法發貨到實體通路,不再是個問題。」

iPad 固然有許多粉絲,但若堅信 iPad 或其他較便宜的 Android 平板電腦會深深影響未來的消費者,或是有任何新裝置會導致紙本消失,恐怕言之過早。

傑克·舒茲 Jack Schulze

舒茲熱愛文字編排,珍視好的想法,因此在涉足前衛設計之際,仍不忘交出充滿美感的作品。他為 Mag +設計的雜誌 app,可讓使用者簡便地瀏覽各種不同內容。

2005 年・舒茲和麥特・韋伯(Matt Webb)在倫敦伯格 設計顧問公司(麥提・瓊斯 [Matt Jones] 日後也加入團 隊)不斷構思新軟體・探索不同的雜誌傳遞方式。

2012年2月,「高速企業」(Fast Company)將伯格設計顧問公司列為「全球前五十家最創新公司」。高速企業年度專刊專門列出以創新之舉深深影響科技與文化的公司。高速企業稱讚伯格「以狂放的想像力結合實體與數位。」伯格以趣味與瘋狂的想像,幫助許多企業發揮數位潛力,而伯格的創新產品(例如小小印表機),為一般的出版思維提供另一項選擇。

在接下來的訪談中,舒茲談到他對大型媒體公司及未來的 看法。

大型媒體公司如何保持靈活,不與消費者的期待脫節?

我認為大公司必須轉型為軟體公司。賈伯斯與亞馬遜 (Amazon)都改寫和消費者的關係。而要成功有兩種 辦法:一是靠數據,二是靠經驗。媒體公司必須製作軟 體,光製作內容已不足夠。

大型媒體公司還剩下什麼優勢?

大型媒體公司仍然擁有特定的價值。比方說,《衛報》編輯亞倫·羅斯布里傑(Alan Rusbridger)就很聰明,懂得如何轉型。不過,大型媒體公司確實陷入困境。以過去經驗來說,媒體企業一定要大,才會成功。要擁有許多資產,保持很大的產量,並涉足電視,在飯店房間也看得到。但是在軟體業界,三個人待在地下室即可寫出了不起的程式。

大企業仰賴其基礎設施的價值。廣電公司會有許多大樓,並到山上架十二公尺高的天線,接收電力,發出信號,播放電視與廣播節目。若觀眾沒有其他選擇,公司這樣做就夠了,可是現在大家都靠 Facebook 而知天下事,廣電公司空有一大堆硬體和事業,卻只做出平凡無奇的內容。假設你開一間報社,你要有建築物和許多印報機,也要有卡車把報紙送到通路,這一切只為了有人「可能」會花十塊錢把報紙買回家,從頭讀到尾。這樣做太昂貴了。如果

沒有其他做法也就算了,但是現在看來似嫌荒謬,浪費力 氣與金錢。

「小小印表機」如何使用?

安裝時,先上網訂閱想看的刊物,這些刊物每天會傳送一次內容給使用者。假設使用者想要它每天早上傳送過來,而這台印表機上方有個按鈕,如果有東西傳來,燈就會亮,有點像電話答錄機。如果不印出來,而下一份刊物傳內容來時,使用者會只拿到一份刊物,而不是兩份。如果使用者出門幾天,回家時不會積了一大堆刊物,只會拿到最新的一份,其他的都存在雲端。

舉例來說,我訂閱了「現在太空上有多少人」(How many people are in space right now?)。假設網站說現在有六個人,等到人數出現變化時才會再發出新資訊,畢竟我只需要在人數變成七人時知道就行了。日報必須每日出刊,得靠專欄作家拼命填滿報上的空間,即使今天沒什麼新聞也一樣,只能期盼讀者有讀報的習慣。但是小小印表機只在有值得發布的消息時才發布。何不只在有事發生時再發消息呢?為什麼要每天出版?但是傳統媒體公司不是這樣運作的。

你預測未來會出現什麼變化?

不出幾年,中國製造的便宜 Android 平板電腦會到處都是,就像 USB 隨身碟或 CD 一樣。之後還可能會搭配電影或書本贈送,而且就放在家裡的水果盤。我們想查看電子郵件時,不會再用電腦,而是拿平板電腦。

平板電腦將會是很便宜的產品,Google 讓 Android 成 為開放系統,因此三星(Samsung)、諾基亞(Nokia) 與蘋果都可在硬體上使用 Android 系統。

這份熱感式印表機能把訂閱的各種網站內容,全用這台小印表機印出。這是屬於使用者個人的友善裝置,透過家中的寬頻就可以連接網路。

文化與行為變遷

行銷、出版、廣播與廣告的界限已模糊。民眾如今每天所吸收的媒體資訊量更多,常一邊看電視一邊滑手機,或一邊上網一邊聽音樂。尼爾森圖書調查公司的行銷數據分析指出,從全球網路流量統計數字來看,民眾比以往更渴望吸收更多資訊。

記者可在社群媒體上分享想法,編輯也不如從前,可掌控報刊讀者的線性閱讀經驗。漸漸地,編輯需要尋找更多元的方式,才能讓出版品出類 拔萃。

由於紙本與數位版本刊物的界線會更加模糊,因此雷斯里說:

「現在,我們不免要檢討,紙本與數位版本 差異是什麼?編輯設計師得了解做小冊子、 發 Twitter 訊息、開個部落格或製作雜誌之間 的種種差異。再者,我們的聲音在不同領域 會如何消失?出版和傳達意見,在現階段已 不是特定人士的專利。」

旅遊文化雜誌《Monocle》就是一例。這份雜誌向來採用創新的手法,模糊廣告與刊物內容的界線。2011年,編輯布魯雷在彭博電視台推出電視節目及網路廣播電台「Monocle 24」,盼能雙管齊下,為富有的讀者群提供更親切的體驗,此舉也反映出布魯雷對讀者群的深刻瞭解,每個月下載數量達到 250 萬。廣播頻道的風格有點像是 BBC 國際頻道,讓品牌有更親切與懷舊色彩。

經濟改變與全球新興市場

金磚四國(BRIC,指巴西、俄羅斯、印度與中國)對大型媒體業者來說是新市場,但這些地區的媒體自由度顯然不如英、美。這會影響《紐約時報》與BBC之類的新聞組織,因為這些組織很難賺到錢。伯格公司的舒茲指出:

到歡迎。他把資訊與數據用簡訊發送給許多 人,這個做法值得持續觀察。

在缺乏電力設施的地方,要解決電腦或行動裝置 充電的問題不難,只要用簡單的太陽能板即可。 問題在於,偏鄉的網路涵蓋率還不高,無法下載 數位刊物,因此要等到行動網路擴張之後,才能 可突破瓶頸。但是網路公司要先確認基礎建設的 投資能有回報,才會在偏遠地區設立網路。

使用社群媒體的實質好處

下一代的出版人才仍得把值得訴說的故事說出來,不過,他們很自然地會選擇以社群媒體做為輸出的工具。不久的日後會不會有「厲害的新玩意」(the next big thing)取代印刷品,仍不得而知。不過可以確定的是,編輯與設計師總是能在令讀者著迷的媒體上說故事。《Real Simple》的創意指導佛羅里克提到:

「《Real Simple》是 Pinterest 第一個超過百萬追蹤者的雜誌,我們的照片多半會被轉貼到其他讀者的部落格及他們喜歡的頁面。我們的照片與藝術團隊會拍攝能吸引視覺的東西,把圖片貼到 Instagram 上,而通常每張照片會得到成百上千的『讚』。這些照片能擴大讀者群,讓彼此持續對話,並展示我們的願景與團隊才華。我們不停地讓紙本、數位與社群媒體能無縫整合。」

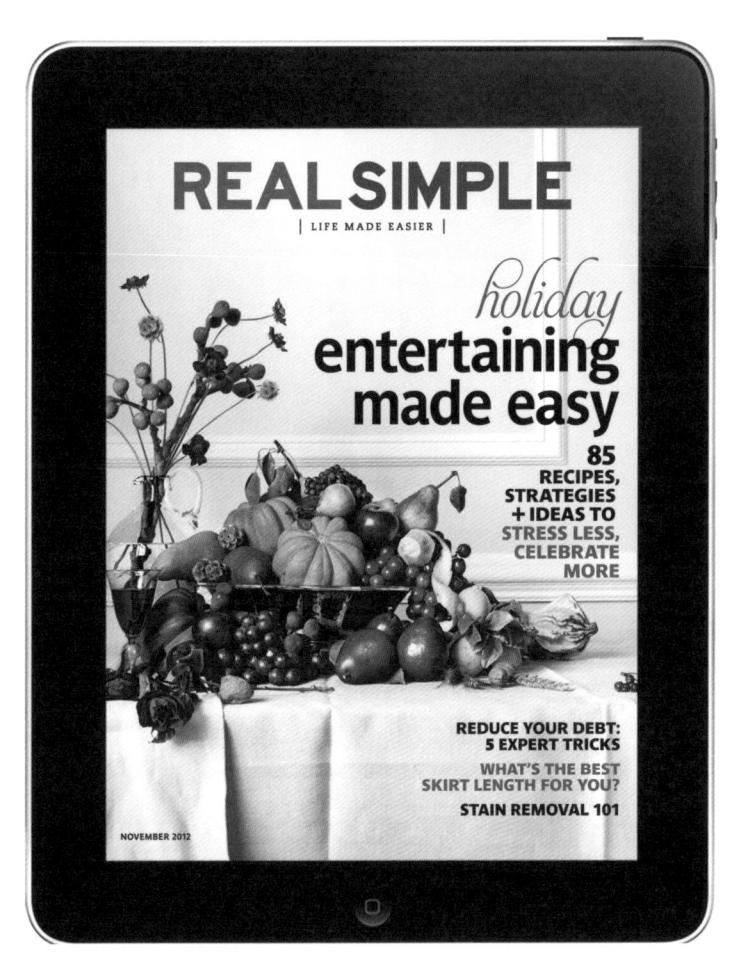

讀者閱讀時不再是靜態的,而是一邊移動或一心多用,在《泰晤士報》的「野外夏日散步」(Wild Summer walks)專題報導中,app版本有互動元素。讀者可用內容來當做散步時的指引,這裡的例子是威爾斯的海岸線,讀者可以根據自己的所在位置來和內容互動。

《Real Simple》雜誌讀者常在廚房中使用 iPad 上的數位版本,參閱雜誌內的食譜。內容是互動的,而且有步驟教學。讀者還會同時使用其他媒體,例如電視、e-mail、社群網站。我們閱讀雜誌的方式不斷在演變。

紙本印刷演變史

- 105 中國發明造紙術與紙張。
- 770 中國發明雕版印刷術。
- **868** 中國以雕版印刷而成的《金剛經》, 是史上最早有日期記載的印刷書。
- 15世 除了抄經僧侶、開始有專業作家加入書 紀初 寫的行列。此時商業發展、教育普 及,歐洲中上階級可擁有更多書籍。 巴黎的作家組成公會,出版業因而形
- 1450 德國美因茲金匠約翰尼斯·古騰堡 (Johannes Gutenberg) 發 明 活 字(也稱為「鑄字」或「熱式鑄 字」),5 年後印行 180 本古騰堡聖 經。
- 1457 德國紐倫堡印行第一份報紙《公報》(Gazette)。約翰・福斯特 (Johann Fust) 與彼德・蕭佛 (Peter Schöffer)製作的《美因茲 詩篇》(Mainz Psalter)是史上第 一份彩色印刷品。
- 1476 威廉·卡克斯頓(William Caxton) 從德國科隆反英,帶回許多活字,並 於倫敦西敏區裝設第一座印刷機。 在此之前,他已在布魯日印製出第 一本英文書《特洛伊歷史故事集》 (The Recuyell of the Histoyes of Troye)。
- **1486** 第一本有彩色配圖的英文書在英國 聖奧爾本斯印行。
- 1494 文字編排者、教師與編輯阿爾杜斯·馬努提烏斯(Aldus Manutius) 在義大利威尼斯成立阿爾丁出版社 (Aldine)。
- **1500** 全球約有 35000 種書、共 1000 萬 冊印製完成。
- 1501 弗蘭切斯科·格里福(Francesco Griffo)設計的斜體(Italic)首次在 《維吉爾》詩集(Virgil)中使用, 由馬努提烏斯的阿爾丁出版社印行。
- 1588 英國人提摩西·布萊特(Timothy Bright)發明速記法。
- **1605** 第一份定期發行的週報於史特拉斯 堡出現。
- 1622 英國報紙之父納桑尼爾·巴特 (Nathaniel Butter)在倫敦出版 《Weekly Newes》,是英國第一份 週報。
- 1650 全球第一份日報於德國萊比錫誕生。
- 1633 德國出版全球第一份雜誌 《Erbauliche Monaths-Unterredungen》。
- 1690 美國第一份報紙《海內外公共事件報》)(Publick Occurences Both Forreign and Domestick)在麻州波士頓發行,但因為沒有皇家執照,旋遭勒令停業。
- 1702 英國第一份日報《每日新聞》(The

- Daily Courant) 發行。
- 1703 俄國彼得大帝創辦《聖彼得堡 新聞》(Sankt-Peterburgskie Vedomosti)。
- 1709 英國通過《著作權法》(The Copyright Act)。倫敦推出第一份 主流雜誌《Tatler》。
- 1714 倫敦的亨利·米爾(Henry Mill)獲 得打字機專利。
- 1719 德國雕刻師約考伯·勒布隆(Jakob Le Blon)獲英王喬治一世特許,複 製全彩圖畫,是現代四色銅版印刷的 基礎。
- 1731 英國出版第一本現代雜誌《The Gentleman's Magazine》。
- 1741 班 傑 明・富 蘭 克 林 (Benjamin Franklin) 打算出本第一本美國雜誌 《General Magazine》,卻在出版 前三天被《American Magazine》 搶先。
- 1764 法 國 的 皮 耶· 傅 尼 耶 (Pierre Fournier) 發明點數系統,測量字級大小。之後經過法蘭索瓦·狄多 (François Didot) 改良,建立全球統一的字級測量系統。
- 1784 美國第一份日報《賓州晚郵報》(The Pennsylvania Evening Post)出刊。
- 1785 約翰·沃特(John Walter) 在倫敦創辦《每日環球記錄報》(The Daily Universal Register) · 三年後改名為《泰晤士報》(The Times)。
- 德國巴伐利亞的艾羅斯·塞納菲爾德 1790 (Alois Senefelder)發明平版印刷 在(Lithersenhar) 、印刷流程不再需
- 年代 (lithography),印刷流程不再需要雕板,因而簡化。
- 1791 波恩(W. S. Bourne) 推出英國 第一份週日報《觀察家報》(The Observer)。
- 1814 《泰晤士報》開始採用早期的輪轉印刷,每小時可印 1100 份。1830 年,理 查·馬 屈·霍 (Richard March Hoe)改良之後輪轉印刷後,全球才普遍運用這種技術。他將輪轉印刷機改良到每小時可印 2500 頁,到 1847 年還讓印刷機擴增到 5 個滾筒。
- **1828** 《The Ladies' Magazine》上市,成 為第一份受歡迎的美國女性雜誌。
- 1842 赫伯・英葛蘭 (Herbert Ingram) 與馬克・雷蒙 (Mark Lemon) 在 英國創辦《倫敦新聞畫報》 (*The Illustrated London News*) ・採用 木版畫與蝕刻・促成插圖刊物發展。
- 1844 泰國出版第一份報紙《曼谷記錄 者》(*The Bangkok Recorder*)出 刊。

- 1845 《Scientific America》在美國創刊, 至今從未停刊,是美國史上最長壽 的雜誌。
 - 美國出現平裝書(比德國晚四年),當 約 作報紙增刊,之後已出版書籍的就
- 1845 會用平裝製作開本較小的再版書。
- 1850 海德堡第一台印刷機在德國西南部 王權伯國的弗蘭肯塔爾完工,製造 者為安德里亞斯·漢姆(Andreas Hamm)。
- 1851 《紐約時報》創刊,價格為一美分。
- **1854** 《費加洛報》(*Le Figaro*)於法國巴黎出刊。
- 1856 《 紐 奥 良 克 里 奥 日 報 》(N e w Orleans Daily Creole)上市,為第 一份非裔美國人報。
- 1867 日本第一份雜誌《西洋雜誌》出版。
- 1874 伊利諾州的雷明頓公司(E. Remington and Sons)生產第一台商用打字機,這是七年前由威斯康辛州的記者克里斯多福·拉森·蕭爾斯(Christopher Latham Sholes)發明的,只有大寫字母但有QWERT鍵盤。隔年改良後包含了小寫字母。
- 1875 平版膠印技術問世(從平滑表面而 不是凸版,印到蝕刻的金屬板上)發 明。
- 1878 美國發明家威廉·拉瓦雷特 (William A. Lavalette)獲得印刷機 專利,可大幅提升印刷品質,尤其是 可讀性。蘇格蘭的費德列克·威克 斯(Federick Wicks)發明鑄字機。
- 1886 奥特馬·麥根泰勒(Ottmar Mergenthaler)發明萊諾鑄排機 (Linotype),可整合鍵盤、字模箱 與鑄字機,讓鑄字工每小時可以排 17000字,可以按鍵盤製作鉛條, 而原本結合起來字模可重新歸位再 利用。
- **1900** 美國約有 1800 種雜誌出版,報紙發行量每日超越 1500 萬份。
- 1903 美國的伊拉·華盛頓·魯貝爾(Ira Washington Rubel)與德國的卡斯 柏·赫曼(Casper Hermann),分 別開始使用平板印刷機。
- 1911 伊利諾州芝加哥的華盛頓·陸德洛 (Washington I. Ludlow)與威廉· 瑞德(William Reade)推出陸德洛 鑄字機,進一步改良鑄字過程。
- 1912 《Photoplay》在美國發行,成為第 一份電影影迷的雜誌。
- 1917 《紐約時報》首度出現社論頁。
- **1923** 《Time》在美國創刊。
- 1933 《Esquire》創刊,為美國第一份男性 雜誌。
- 1934 紐約《Harper's Bazaar》聘請布羅 多維奇,版面賞心悦目,更具動感。

- 1936 亞倫· 連恩 (Allen Lane) 的企鵝出 版 (Penguin Press) 在英國重新引 介平裝書。美國時代公司的亨利·魯 斯(Henry Luce)創立新聞攝影雜 誌《Life》,稱霸美國新聞市場四十 年,每週銷售超過1350萬本。
- 新聞紀實攝影開始揭露二次大戰的畫 1941- 面,雜誌推出以紀實照片為主的報
- 1944 導。有些照片被禁,遭到質疑。
- 1945 《Ebony》是第一份專為非裔美籍市 場設計的雜誌,由美國人約翰.強森 (John H. Johnson) 創刊。
- 1953 4月3日,第一份《電視指南》 (TV Guide)在美國十個城市的 書報攤上市,發行量為156萬份。 《Playboy》雜誌創刊,封面人物為 瑪麗蓮夢露。
- 1955 俄亥俄州哥倫布的巴特爾紀念研究 所 (Battelle Memorial Institute) 研 發乾式塗布紙。美國《Esquire》品 牌感強烈,因此率先在封面大膽使 用極少的封面文案。當時只有少數 其他刊物能使用彩色。
- 1956 IBM 製作出第一個硬碟。
- 1958 沃夫擔任《Harper's Bazaar》藝術 指導,讓圖像語言和照片及文字編 排整合。
- 1962 英國全國性報紙《週日泰晤士報》 (The Sunday Times) 推出全彩的 雜誌增刊,由麥克·蘭德 (Michael Rand)設計。
- 1964 美國統計數字顯示,81%的成年人 有閱讀日報的習慣。
- 1965 德國大型出版業者史普林格 (Springer) 推出《Twen》青少年 雜誌,設計者為弗萊克豪司,堪稱 是報刊設計的突破之作。英國《每 日鏡報》(Daily Mirror)推出雜誌 《Nova》,主編為海克特,設計師 為席曼。
- 1967 英國啟用國際標準書號(ISBN)。 《Rolling Stone》在美國上市,而在 1968 年有《New York Magazine》 的推出,使得特殊興趣與地區雜誌 更普遍。
- 1969 安迪·沃荷推出《Interview》雜誌。
- 1971 全球報紙開始從熱式打字的凸版印 刷,改成平版印刷。
- 1975 《Nova》停刊。
- 1977 蘋果推出 Apple Ⅱ 微型電腦。
- 1980 瑞士日內瓦歐洲核子研究組織 (CERN)的提姆·柏納李(Tim Berners-Lee)初次嘗試全球資訊 網,創造出「萬事皆可查」(Enquire Within Upon Everything)程式(源 自於為他童年時讀到的多利亞時 代百科)。英國的羅根推出《The

- Face》,這份時尚文化雜誌與過去 圖片很多的女性雜誌不同。
- 1981 《Rolling Stone》推出全裸的約翰藍 儂與衣著完整的小野洋子封面。這 張里柏維茲拍的知名照片, 説明雜誌 在音樂產業的力量。
- **1982** 《今日美國》(USA Today)日報出 刊,模仿電視的視覺引導,整份皆為 全彩,有許多圖像,立刻受到歡迎。 新科技發展能輔助流通方式,讓最 終版本可以在國內各個地點印行。
- 1983 蘋果推出 Apple Lisa 電腦,採用新 的圖形使用者界面(GUI),使電腦 在家庭與出版上更簡單、更便宜。
- 1984 蘋果推出麥金塔電腦(Mac),是圖 形使用者界面首度大受歡迎,如今 電腦多使用此界面。《Emigre》雜誌 在加州創刊,旋即成為數位字體與圖 像的創意展示中心。
- 1985 保羅·布蘭內德(Paul Brainerd) 與阿圖斯公司(Aldus)製作出第一 款桌上出版軟體 Aldus Pagemaker 1.0, 供麥金塔電腦使用。桌上出版 軟體帶動新形態的出版,讓每個人都 能掌握設計與編輯的工具。
- 1987 QuarkXPress 推出。雖然晚了 Aldus Pagemaker 兩年,仍很快成為主要 的桌上出版程式。
- 1991 全球資訊網推出,使用柏納李的 HTML(超文件標示語言),任何人 都可架設網站,分享者從幾百人立 即飆升到數千萬人皆可分享。
- 康泰納仕在義大利出版 A5 手提包 1994 大小的《Glamour》。美國網景公 司(Netscape)推出摩塞克瀏覽 器(Mosaic)的測試版。俄勒岡 州波特蘭的沃德·坎寧安(Ward Cunningham)發明Wiki概念,讓 使用者能用非線性的協作方式, 創 造並連結內容網頁。
- 1995 《Salon》是一份美國自由派的雜 誌,只在線上出版,挑戰傳統紙本媒 體的商業模式。
- 1997 《紐約時報》在新聞頁面採用彩色照 片。
- 2004 英國《獨立報》從大報版式改為小 報版式,同年,《泰晤士報》也製作 小報版式日報。
- 2005 《衛報》改成柏林版式,使用全 彩。英國《第一郵報》(The First Post)線上新聞雜誌推出。
- 2006 Google 以 16.5 億美元股票收購影 片分享網站 YouTube。美國報紙協 會 (Newspaper Association) 的報 告顯示,美國新聞網站吸引了5800 萬讀者。
- 2007 英國《金融時報》線上版的廣告收

- 益提高了30%。無線電子書閱讀器 Kindle 上市。
- 2008 一份調查顯示,前一天有看報紙的 美國成年人比例為30%。
- 2009 全球金融危機之後,報紙銷售 量一落千丈。美國人山姆·艾波 (Sam Apple)推出《快速時報》 (The Faster Times), 探索隨 選新聞的模式。《泰晤士報》網站 (thetimesonline.co.uk)每日讀者 達到 75 萬人。
- 2010 蘋果iPad上市,30天內賣出超 過300萬台。亞馬遜書店宣布, 電子書的銷售量首度超過紙本書。 《WIRED》雜誌推出iPad版本。 《泰晤士報》推出有互動功能的平 板電腦版本。維基解密發表來自匿 名來源的文件, 違背業界常規, 惹惱 新聞媒體。在大型新聞出版商面臨 存亡之際,網路新聞報導的可靠性因 此遭到質疑。
- 2011 《衛報》推出平板電腦版本。iPad 2 上市,第一年賣出超過 1500 萬台。 《紐約時報》宣布,將對網站內 容使用者收取費用。新聞國際公司 (News International) 為《泰晤士 報》建立付費牆。
- 2012 跨平台雜誌《Little White Lies》與 《Letter to Jane》發展不同格式, 捨棄紙本。
- 2013 獨立雜誌能運用網際網路來降低製 作成本, 開始蓬勃發展。勒弗森聽 證調查委員會調查媒體的不當行 為,提議透過皇家憲章,強化英國 媒體的自律,但這建議遭到眾多編 輯反對。現代雜誌大會(Modern Magazine Conference) 在倫敦召 開,用「黃金時期」一詞,表示在 iPad 上市後三年,產業活動已經恢 復正常。大型出版商與小型獨立出 版社都能運用數位媒體帶給產業的 白由。

延伸閱讀

藝術指導們的著作 Editorial art direction

- Theodore E. Conover, revised by William W. Ryan, *Graphic Communications Today*, fourth edition, Clifton Park, New York: Thomson Delmar Learning, 2004
- Stephane Duperray and Raphaele Vidaling, Front Page: Covers of the Twentieth Century, London: Weidenfeld and Nicolson, 2003
- Roger Fawcett-Tang (ed.), Experimental Formats: Books, Brochures, Catalogues Crans-Près-Céligny, Switzerland and Hove, Sussex: RotoVision, 2001
- Peter Feierabend and Hans Heiermann, *Best of Graphis: Editorial*, Zurich: Graphis Press, 1993; Corte Madera, California: Gingko Press, 1995
- Chris Foges (ed.), Magazine Design, Crans-Près-Céligny, Switzerland and Hove, Sussex: RotoVision, 1999
- Sammye Johnson and Patricia Prijatel, *The Magazine from Cover to Cover: Inside a Dynamic Industry*, Lincolnwood, Illinois: NTC, 1999
- Stacey King, Magazine Design That Works: Secrets for Successful Magazine Design, Gloucester, Massachusetts: Rockport Publishers 2001
- Jeremy Leslie, foreword by Lewis Blackwell, *Issues: New Magazine Design*, London: Laurence King Publishing Ltd, and Corte Madera, California: Gingko Press, 2000
- Jeremy Leslie (ed.), MagCulture: New Magazine Design, London:
 Laurence King Publishing Ltd, and New York: HarperCollins, 2003
- Jeremy Leslie (ed.), *The Modern Magazine: Visual Journalism in the Digital Era*, London: Laurence King Publishing Ltd, 2013
- Horst Moser, Surprise Me: Editorial Design, translated from the German by David H. Wilson, West New York, New Jersey: Mark Batty Publisher, 2003
- William Owen, Magazine Design, London: Laurence King Publishing
- B. Martin Pedersen (ed.), Graphis Magazine Design, volume 1, New York:
 Graphic Press 1997
- Jan V. White, Designing for Magazines: Common Problems, Realistic Solutions, revised edition. New York: Bowker, 1982
- Jan V. White, Editing by Design: For Designers, Art Directors and Editors

 The Classic Guide to Winning Readers, New York: Allworth
 Press 2003
- Kaoru Yamashita and Maya Kishida (eds.), *Magazine Editorial Graphics*, Tokyo: PIE Books. 1997

字型設計參考書籍 Typography

- Phil Baines and Andrew Haslam, Type and Typography, London: Laurence King Publishing Ltd and New York: Watson-Guptill Publications, 2002; revised edition, 2005
- Andreu Balius, *Type at Work: The Use of Type in Editorial Design*, Corte Madera, California: Gingko Press, 2003
- Robert Bringhurst, *The Elements of Typographic Style*, Vancouver: Hartley and Marks, 1997
- Carl Dair, Design with Type, Toronto: University of Toronto Press, 2000
- Steven Heller and Mirko Ilic, Handwritten: Expressive Lettering in the Digital Age, London and New York: Thames & Hudson, 2004
- David Jury, About Face: Reviving the Rules of Typography, Hove, Sussex: RotoVision, and Gloucester, Massachusetts: Rockport Publishers, 2002

- Ellen Lupton, Thinking with Type: A Critical Guide for Designers, Writers, Editors, & Students, New York: Princeton Architectural Press, 2004
- Ruari McLean, *The Thames & Hudson Manual of Typography*, London and New York: Thames and Hudson, 1980; reprinted 1997
- Rick Poynor (ed.), *Typography Now: The Next Wave*, London: Booth-Clibborn Editions, 1991
- Andrew Robinson, *The Story of Writing: Alphabets, Hieroglyphs and Pictograms*, London and New York: Thames and Hudson, 1995
- Erik Spiekermann and E. M. Ginger, *Stop Stealing Sheep & Find Out How Type Works*, Berkeley, California: Adobe Press, 1993; second edition, 2002
- There are many great sources for typographic inspiration on the web.

 The photo-sharing website Flickr (www.flickr.com) has numerous groups devoted to type, such as the excellent Typography and Lettering group to be found at: www.flickr.com/groups/type.

版面設計參考書籍 Layouts

- Gavin Ambrose and Paul Harris, Layout, Lausanne: AVA Publishing, 2005
- David E. Carter, The Little Book of Layouts: Good Designs and Why They Work. New York: Harper Design, 2003
- David Dabner, Graphic Design School: The Principles and Practices of Graphic Design, London and New York: Thames & Hudson, 2004
- Kimberly Elam, *Grid Systems: Principles of Organizing Type*, New York: Princeton Architectural Press, 2004
- Gail Deibler Finke, White Graphics: The Power of White in Graphic Design, Gloucester, Massachusetts: Rockport Publishers, 2003
- Allen Hurlburt, The Grid: A Modular System for the Design and Production of Newspapers, Magazines and Books, New York: John Wilev. 1982
- Carolyn Knight and Jessica Glaser, *Layout: Making It Fit Finding the Right Balance Between Content and Space*, Gloucester,
 Massachusetts: Rockbort Publishers. 2003
- Lucienne Roberts, *The Designer and the Grid*, Hove, Sussex: RotoVision, 2002
- Timothy Samara, *Making and Breaking the Grid: A Graphic Design Layout Workshop*, Gloucester, Massachusetts: Rockport Publishers, 2003

影像處理參考書籍 Imagery

- Gavin Ambrose, *Image*, Lausanne: AVA Publishing, 2005
- Charlotte Cotton, *The Photograph as Contemporary Art*, London and New York: Thames & Hudson, 2004
- Geoff Dyer, *The Ongoing Moment*, London: Little Brown, and New York: Pantheon Books, 2005
- Angus Hyland and Roanne Bell, *Hand to Eye: Contemporary Illustration*, London: Laurence King Publishing Ltd, 2003
- John Ingledew, *Photography*, London: Laurence King Publishing, 2013
- Scott Kelby, *The Photoshop CS2 Book for Digital Photographers*, Indianapolis, Indiana: New Riders, 2003
- Robert Klanten and Hendrik Hellige (eds.), *Illusive: Contemporary Illustration and its Context*, Berlin: Die Gestalten, 2005
- Gunther Kress and Theo van Leeuwen, Reading Images: The Grammar of Visual Design, London and New York: Routledge, 1996

- Susan Sontag, On Photography, New York: Farrar Straus and Giroux, 1977; London: Allen Lane. 1978
- Susan Sontag, Regarding the Pain of Others, New York: Farrar Straus and Giroux, and London: Hamish Hamilton, 2003
- Julius Wiedemann, Illustration Now!, Cologne: Taschen, 2005
- Lawrence Zeegen, The Fundamentals of Illustration, Lausanne: AVA Publishing, 2005

尋找靈感 Inspiration

- Lewis Blackwell and Lorraine Wild, Edward Fella: Letters on America, London: Laurence King Publishing Ltd, and New York: Princeton Architectural Press, 2000
- Lewis Blackwell and David Carson, *The End of Print: The Grafik Design of David Carson*, revised edition, London: Laurence King Publishing
- David Carson, Trek: David Carson Recent Werk, Corte Madera, California: Gingko Press, 2003
- David Crowley, Magazine Covers, London: Mitchell Beazley (Octopus Publishing Group Ltd), 2006
- Alan Fletcher, The Art of Looking Sideways, London: Phaidon Press, 2001
- Richard Hollis, Swiss Graphic Design: The Origins and Growth of an International Style, 1920–1965, London: Laurence King Publishing Ltd. and New Haven. Connecticut: Yale University Press. 2006
- Cees W. de Jong and Alston W. Purvis, *Dutch Graphic Design: A Century of Innovation*, London and New York: Thames & Hudson, 2006
- Tibor Kalman and Maira Kalman, *Colors: Issues 1–13*, New York: Harry N. Abrams, 2002
- Barbara Kruger, Barbara Kruger, Cambridge, Massachusetts: MIT Press. 1999
- Beryl McAlhone and David Stuart, A Smile in the Mind, revised edition, London: Phaidon Press, 1998
- The Society for News Design, *The Best of Newspaper Design 27*, Gloucester, Massachusetts: Rockport Publishers Inc., 2006
- Martin Venezky, It Is Beautiful ... Then Gone, New York: Princeton
 Architectural Press, 2005

印刷與色彩應用 Printing and colour use

- Josef Albers, *Interaction of Color*, revised and expanded edition, New Haven, Connecticut: Yale University Press, 2006
- Leatrice Eiseman, Pantone Guide to Communicating with Color, Cincinnati, Ohio: Grafix Press, 2000
- Mark Gatter, Production for Print, London: Laurence King Publishing
 Ltd, 2010
- Johannes Itten, *The Art of Color: The Subjective Experience and Objective Rationale of Color*, revised edition, New York and Chichester: John Wiley & Sons Inc., 1997
- Naomi Kuno and FORMS Inc./Color Intelligence Institute, Colors in Context, Tokyo: Graphic-sha Publishing, 1999
- Alan Pipes, Production for Graphic Designers, fifth edition, London: Laurence King Publishing Ltd, 2009
- Michael Rogondino and Pat Rogondino, *Process Colour Manual:*24,000 CMYK Combinations for Design, Prepress and Printing, San
 Francisco: Chronicle Books, 2000

Lesa Sawahata, Color Harmony Workbook: A Workbook and Guide to Creative Color Combinations, Gloucester, Massachusetts: Rockport Publishers Inc., 2001

新聞與傳播 Journalism and communication

- Harold Evans, Editing and Design, five volumes, London: William Heinneman (Random House Group Ltd), 1972–1978
- Harold Evans, Essential English for Journalists, Editors and Writers, London: Pimlico (Random House Group Ltd), 2000
- Stephen Quinn, Digital Sub-Editing and Design, Oxford: Focal Press (Elsevier Ltd). 2001
- Mike Sharples, How We Write: Writing as Creative Design, Oxford: Routledge (Taylor & Francis Books Ltd), 1998

一般設計書籍 General design books

- Joshua Berger and Sarah Dougher, 100 Habits of Successful Graphic

 Designers: Insider Secrets on Working Smart and Staying Creative,
 Gloucester, Massachusetts: Rockport Publishers Inc., 2003
- Charlotte Fiell and Peter Fiell, *Graphic Design Now*, Cologne: Taschen, 2005
- Lisa Graham, Basics of Design: Layout and Typography for Beginners, Clifton Park, New York: Thomson Delmar Learning, 2001
- Richard Hollis, A Concise History of Graphic Design, revised edition, London and New York: Thames & Hudson, 2002
- Johannes Itten, *Design and Form: The Basic Course at the Bauhaus*, revised edition, London: Thames & Hudson, 1975
- Michael Johnson, *Problem Solved: A Primer in Design and Communication*, London: Phaidon Press, 2002
- Ellen Lupton and J. Abbott Miller, *Design Writing Research. Writing on Graphic Design*, New York: Kiosk Press, 1996
- Quentin Newark, What Is Graphic Design?, Gloucester, Massachusetts: Rockport Publishers Inc., and Hove. Sussex: RotoVision. 2002
- Rick Poynor, *Design Without Boundaries. Visual Communication in the Nineties*, London: Booth-Clibborn Editions, 2000
- Adrian Shaughnessy, *How to Be a Graphic Designer, Without Losing Your Soul*, second edition, London: Laurence King Publishing
- Edward P. Tufte, Visual Explanations. Images and Quantities, Evidence and Narrative, Cheshire, Connecticut: Graphics Press, 1997

索引

Page numbers in italics refer to captions About Town 80, 173 see also Town Abrahams Stefan 151 Adbusters 30, 62, 65, 81 Adobe Creative Suite 19, 186 see also InDesign; Photoshop Aeon Magazine 229 Agha, M.F. 207, 209, 214 Amelia's Magazine 186 Anderson, Gail 219 Annrak 47 126 Another Magazine 183 Ansel, Ruth 102

apps 23, 24, 29, 37, 47, 59, 165, 167, 224, 226 Arena 73 Arment Marco 227 art directors/editors 14, 18, 21, 32-3, 60, 99, 128, 153, 165, 196 Arthr (Newspaper Club) 227 Autukaite, Sandra 202

Bar, Noma 42 Barnes, Paul 180 Baron, Fabien 55, 84, 179, 217 Bass, Saul 148 Bauhaus 139, 140, 179, 206 Beach Culture 55, 57, 179 Belknap, John 21 Benezri, Kobi 199 BERG Design 164, 186, 227, 230 Big 221 Black Boger 156 Blah Blah Blah 70 Blitz 56, 124, 126 blogs 35, 48, 60, 91, 124, 126, 146, 206 Bloomberg Businessweek 32-3, 190 Blueprint 146 body copy 8, 83, 85, 87, 88, 90, 96, 114, 116-17

Boston Sunday Globe 46 box copy 82, 88, 90, 121, 140, 176 branding 35, 42, 57 covers 30, 41, 42, 44, 45, 47, 50,

Bonnier R&D 164

Boston Globe 29, 59, 219

57, 65, 98 logos 42, 69-70, 85 style 35, 42, 73, 83, 91, 141, 142,

143, 156 supplements 31, 34, 85 typography 42, 88, 177, 182, 183 see also identity

Brodovitch, Alexey 50, 179, 208, 211, 214

Brody, Neville 55, 57, 82, 92, 97, 141, 179, 206, 216 Brown James 64

Brûlé, Tyler 10, 232 budget issues 34, 97-8, 127, 128, 188 197

Burrill, Anthony 48 Business 2.0 82

husiness-to-husiness (B2R) magazines 35

bylines 27, 87, 88, 110, 113, 114, 121, 163, 177

captions 88, 89, 90, 98, 110, 120-1, 166, 174 Carlos 36, 62, 103, 104, 145 Carson, David 55, 57, 70, 91, 115, 122, 141, 173, 178, 179, 221 Chambers Tony 10

Charm 209 City Limits 56, 216 Cleland, Thomas Maitland 190 collage 50, 64, 215 Colors 18, 218, 220 colour printing 27, 34, 50, 52, 55, 57,

187, 188, 190 colour selection 37, 42, 46, 72, 85, 92 columns 27, 83, 96, 110, 113, 114, 130,

150, 158, 160, 163 Condé Nast 24, 50, 52, 68, 207, 209,

224 Constructivism 70, 82, 97, 179, 206,

consumer magazines 30, 35, 57, 60,

Cook, Gary 82, 127 copy see body copy; box copy; panel

Corbin, Lee 143-4, 173, 183, 185, 198 Cottrell, Ivan 182

cover lines 30, 47, 55, 64, 69, 70, 73, 86

covers 41, 44 abstract 65-6

and branding 30, 41, 42, 44, 45, 47.50.57.65.98 brief 74-5

celebrity covers 55, 56, 57, 59 components *64*, 69-73 custom-made 48-9, *65*

design approaches 62-7 development of 50-61

digital media 41, 44, 47, 60, 68, 98 figurative 62-3, *65*

importance of 44, 50, 52, 98 logos 50, 62, 64, 65, 66, 69-70, 73.86

magazines 44, 47, 50-7, 59 newspapers 45, 101 photography 50, 52-3, 55. 62. 64 supplements 52, 55

text-based 66-7 Creative Review 124, 126, 143 credits 87, 88, 110, 121 see also

picture credits cross-heads see subheads

customer magazines 35, 36, 57, 124

Dadaism 97, 115, 179, 208, 216 Dadich, Scott 68, 224 Dagens Nyheter (DN) 130, 174 Daily Mirror 163, 174 Dazed & Confused 48, 57, 62, 139 deadlines 127, 128-9, 154, 187, 190, 194

design directors 14, 21 design skills 7, 95

artwork skills 153, 186-7 see also images brief 202-3

concepts 38-9, 153, 157, 190 consistency 153, 194, 197 digital design 32, 160, 164-5, 168 monotony, avoiding 135, 153, 156,

194, 197, 201 production issues 153, 186-7

visualization 153, 154 see also page design; typography Deuchars, Marion 102

digital media 24-5 automated content 60, 227 covers 41, 44, 47, 60, 68, 98

data availability 229 digital design 32, 160, 164-5, 168 finite publishing 227, 229

the future 226, 227, 229, 230.

grids 126, 151, 160, 161, 162 magazines 19, 20, 29, 36-7, 59, 164, 166, 224, 226 see also named magazines

navigation 8, 16, 29, 60, 160, 164, 166-7, 168

newspapers 28, 29, 59, 166, 167 see also named newspapers print crossover 227

print media compared 29, 124-5,

responsive design 226-7 terminology 29 see also tablets; websites

Diprose, Andrew and Philip 12, 47 Dixon, Chris 81 Docherty, Jeffrey 133, 158, 182

Domus 146 Douglas, Sarah 10, 12-13, 167

Draper Richard 191 Driver, David 191 drop caps 34, 92, 110, 116, 117-18, 123, 140, 174, 179

Duff-Smith Rehecca 151 Dvorani, Jetmire 75

Eat 105 The Economist 31, 143, 194 Editions 37 editorial, defined 7, 8 editorial design

defined 7, 8 design factors 18 129-38 designers 18, 98 see also design

the future 226-9 232-3 kev staff 14, 18-21 the past, exploring 205, 206

purpose 8, 10, 18 editors 14 18 21 60 92 98 Edwards, Neil 48 Elle 53, 225

Ellis, Darren (Sea Studio) 104 Emigre 55, 91, 99, 173, 178 ES Magazine (Evening Standard)

Esopus 136, 186 Esquire 50, 52, 66, 211

Associates) 15, 35, 146-7, 229 Eureka magazine (The Times) 92, 168

Evans, Harold 27 Expressionism 208, 214, 216 Eve 146, 229

The Face 55, 82, 97, 126, 141, 179, 206, 216 Facebook 37, 44, 206, 225

Fact 66 fanzines 30, 48, 103, 145 Fassett's theorem of legible line length 114, 156, 158, 159 Feltier, Bea 102

Financiele Daghlad 218 Fire & Knives 48, 126 Fishwrap 112, 116, 121, 176 Flaunt 69, 89, 123, 139, 143-4, 171, *173,* 183, *185,* 198 Fleckhaus, Willy 18, 84, 212, 213

Flipboard 37, 60, 61, 227, 228 fold-outs 186, 187 Folha de S. Paulo 142, 192 folios 88, 90-1, 110, 121, 172

digital media 24, 55, 91, 92 print media 50, 82, 90, 91, 92, 172, 176, 177, 178, 199

Fortune 190 Frankfurter Allgemeine Magazin (FAZ) 212

Frere-Jones, Toby 178, 183 Froelich, Janet 24, 34, 65, 66, 70, 79, 114, 116, 117, 123, 135, 149, 178, 188, 222-3, 233

Frost, Vince 8, 18, 57, 59, 64, 115, 117, 179, 181, 182, 221

FT The Business Magazine 70, 82,

Garcia, Mario 31, 45, 46, 97, 134-5, 142, 144, 172, 200 Gentile, Massimo 142 golden section 134

GPS (Global Positioning System) 8,

16, 28, 29, 37, 229 GQ 24, 73, 217 Graphic International 121

grids 55, 80, 84, 85, 110, 127, 135, 151, 155-62, 212

The Guardian 15-17, 45, 59, 60, 101, 102, 103, 124, 146, 155, 160, 162, 164, 177, 183, 192, 218, 232

Gustafson, Mats 70, 217 Gutiérrez, Fernando 65-6, 73, 156, 182, 185, 220

Hackett, Dennis 214 Hall, Alistair (We Made This) 49 Harper's Bazaar 50, 70, 102, 179, 208. 211. 217

Harrison-Twist, Jordan 108 headings 13, 113-14, 119, 128, 162, 165 174 203 see also subheads headlines 8, 13, 16, 26, 45, 64, 83, 87,

88, 89, 96, 110, 113-14, 131, 173-4, 175 see also running headlines Hill, Jon 92-5, 160, 161, 168, 229 Hillman, David 15, 18, 146, 178, 214

Holley Lisa Wagner 176 Hort 48 House & Garden 207

Huck 47 the human eye and how it scans a page 128

ICC Profile 187 icons 81, 82, 119, 192 i-D 48, 55, 62, 124 I.D. 104, 105, 137, 138, 199 identity 14, 15, 28, 34, 36, 42, 47, 110, 197 see also branding The Illustrated Ape 104 Illustrated News 52 illustration 48, 62, 63, 91, 102,

103-4 images

bleeding 85, 123 cropping 8, 100, 104, 122, 138, 185, 194 cut-outs 27, 64, 85, 201

finding 98-9, 190, 194 full-bleed 8, 66, 83, 85, 98, 136 importance of 98, 121, 122, 188 from the Internet 98-9, 190, 194 originals, evaluating 188, 190

and text combination 99, 122,

working with 97-8, 121-2, 123, 188-94

see also illustration; photography The Independent on Saturday 64,

independent publications 14, 30, 32, 47 InDesign (Adobe) 21 167 183 186.

infographics 14, 28, 190-3 initial caps 116, 117-18, 178

Inner Loop 113, 182 Inside 158, 182, 197 Instapaper 29, 227

International Style 212 Interview 53, 70, 217

intros see stand-firsts iPads 10, 16, 23, 24, 68, 99, 124, 160,

iPhones 20, 60, 94

The Jewish Chronicle 21 Jones Dylan 18 Jones, Jasmine 151 Joyce, James 48 jumplines 119, 120, 142 junior designers 19, 85

Kalman, Tibor 18, 220 King, David 52, 56 King, Scott 66 Kitching, Alan 183, 221 Kuhr Barbara 65 68

Lappin, Criswell 80, 100, 103, 122, 135 137 140 143 157 177 Lasn, Kalle 81 Lawyer 35

lavouts 197 alignment 110, 113, 116, 135, 139 balance 27, 114, 129, 130, 133, 134, 137. 139. 150. 185

brief 150-1 colour, use of 110, 128, 131, 134-5, 137, 145, 197

components 110-19, 143-4 construction 127-38 contrast 85, 113, 136, 145

depth 83, 123, 137, 171 discord 117, 130, 139, 140-1 see also tension below

flow 78 130 135 192 format 129, 143, 145, 155, 172, 173, 176

harmony 122, 130, 135, 139-41, 144, 182

inspiration, finding 50, 79, 115, 148

leading 110, 114, 116, 139, 174, 179 movement, implied 83, 98, 105, 123, 138

placement issues 73, 112, 131, 132,

repetition 54, 135

structure 143

scale issues 27, 42, 98, 110, 135-6, 185

shape 82, 90, 113, 114, 116, 130, 134-5 145

spatial issues 124, 129-30, 131, 132 see also white space stock 143. 145. 155. 170-2, 176

tension 110, 122, 123, 135, 136, 139 see also discord above

type/typefaces 110, 112, 114, 133, 134, 143-4

see also grids; page design; style Leeds, Mark 225 Leslie, Jeremy 10, 35, 63, 66, 103, 124-6, 145, 154, 168, 227, 232 Libération 217 Licko, Zusanna 55 Liebermann, Alexander 50, 52 Life 52 Little Printer (BERG) 227, 230 Loaded 64, 73, 83, 87, 128 Logan Nick 82 124 branding 42, 69-70, 85 covers 50, 62, 64, 65, 66, 69-70. 73.86 typography 34, 70, 73 Lois, George 66 Lowe Boh 48 Lubalin, Herb 66 M-real 35, 63, 124, 143, 169 MacUser 55 Mag+ software (BERG and Bonier) 165 230 The Magazine 227 magazines 8, 14, 18, 23, 30-7 automated content 60, 227 back sections 78, 85-6 contents pages 78-81, 82 covers 44 47 50-7 59 digital 19, 20, 29, 36-7, 59, 164, 166, 224, 226 feature well 78, 81, 83-5 front sections 78.82 independent publications 14, 30. 32.47 news pages 78, 81, 82 section openers 85, 86 typography 55, 57, 70, 82, 83, 173-4 see also named magazines: supplements magCulture 124, 126 Magdalinski, Stef 232 Marchbank, Pearce 64, 66 Marie Claire 73, 225 Marshall, Joseph 150, 151 Martinesva, Esa 19 mastheads 38, 47, 69, 82, 96 see also logos Matador 143, 156, 220 McCall's 179 McCue, Mike 227 McNav. Mike 15 Metropolis 80, 100, 103, 122, 135, 137, 140, 157, 177 mobile devices see mobile phones: tablets mobile phones 14, 16, 23, 60 see also iPhones Modernism 122, 208, 210, 211 Manacle 126, 232 montage 62, 191, 207 Morla, Jennifer 65 Murray, Peter 146 navigation digital media 8. 16. 29. 60. 160. 164, 166-7, 168 print media 27, 78, 81, 91, 121

Neal, Christopher 103

Net-a-Porter 20, 166

The New York Times 24, 47, 113, 227.

The New York Times Magazine 32.

34, 65, 66, 70, 79, 90, 102, 114, 116,

Nest 70

The New York Times Style Magazine 34, 70, 222 The New York Times T: Travel Magazine 85, 123 The New Yorker 59 224 Newspaper Club 29, 227 newspapers 8, 18, 21, 23, 26-8 Berliner format 15, 28, 130, 160 172, 200 broadsheet format 15, 28, 57, 172, content 78 82 covers 45, 101 digital media 28, 29, 59, 166, 167 horizontal and vertical design 27. 45, 130, 162 sizes 28 tabloid format 15, 27, 28, 130, 172 typography 15, 16, 27, 28, 47, 92, 174, 176, 177, 180 websites 57 166 see also named newspapers; supplements Newsweek 29 Nova 10, 53, 70, 178, 179, 214 The Observer 134-5, 200 The Observer Music Monthly 112 Oh Comely 47 Oliver, Vaughan 57 Oz 10, 52, 215 page design 153, 155 digital design 164-5 double-page spreads (DPS) 52. flatplans 14, 155, 163, 168-9 format 143, 145, 155, 172, 173, 176 autters 96, 110 pagination 155, 162-3, 168, 169, signalling 16, 34, 113, 131, 132, 162, 163 stock selection 143, *145*, 155, 170-2.176 templates 82, 85, 110-11, 162, 167, 197 see also grids page furniture 64, 82, 90, 165, 216 El País 45, 65-6, 89, 113, 220 panel copy 27, 88, 90, 121 paper, selecting 170-2 Pariscope 145 Het Parool 118, 128 Patterson, Christian 104 paywalls 29, 57, 92, 229 Peccinotti, Harri 179, 214 Per lui 216 photography 99-101 close-ups 63, 104, 105 covers 50, 52-3, 55, 62, 64 reportage 16, 52, 55, 96, 130, 131, 212, 214, 220 selecting photographs 99, 101, 188 Photoshop (Adobe) 20, 186, 188, 190 picture credits 98-9, 121, 194 picture editors 14, 99, 101 Pineles, Cipe 209 Plunkett, John 65, 68 Part 19, 47 Porter, Mark 14, 15, 16, 18, 27-8, 32, 45 103 130 160 166 177 180

117, 135, 136, 149, 159, 178, 188,

198, 218

digital crossover 227

124-5, 126

177.178,199

96, 143, 187, 188

Publico 27, 146, 218

Radio Times 190, 191

Read, Steve 64, 83

Ripoli, Paula 142

Rolleri, Dan 196

140

Self 217

Show 211

Rvan. Rob 186

Salomi 38, 39

Robinson, Nigel 48

Roinestad, Eric 148

QuarkXPress 21, 167, 183, 186

Real Simple 36, 37, 222, 233

The RiDE Journal 12, 47

Rolling Stone 53, 55, 219

Schwartz Christian 180

screen calibration 186, 190

Schweizer, Nico 199

sells see stand-firsts

Sharp, Martin 52, 215

sidebars 88, 121, 135, 138

Shively, Hudson 151

Silvertown, Ben 203

Sleazenation 57, 66, 80

Facebook; Twitter

spines 73, 110, 122, 136

Stack Magazines 47

Stark, Gemma 20

Statements 143

SODA 143 145 157 171

social magazines 37, 61, 229

227 see also apps: named

stand-firsts 83, 85, 87, 88, 110, 114

Sims, Michael 104

slugs 13, 120

software

Der Spiegel 53

Self Service 126

Seventeen 209

48-9

188

Queen 179

print media

Stern 194, 201 Storch, Otto 179 digital media compared 29, fonts 50, 82, 90, 91, 92, 172, 176, the future 29, 206, 229, 232 navigation 27, 78, 81, 91, 121 see also magazines: newspapers printing and printers 47, 52, 55, 57, Pritchard, Meirion 10, 12-13, 24, production managers 14, 18, 162 proofs/proofing 14, 57, 128, 185, 186, pull quotes 85, 87, 88, 89, 110, 118-19, 163, 174, 175, 176, 179 quotes 118 see also pull quotes RayGun 55, 57, 70, 91, 99, 141, 179 redesigning 15, 32, 45, 142, 146, 198, Tank 173 rules 81, 82, 86, 119, 121, 134, 135, running headlines 88, 119, 128, 139, San Francisco Chronicle Magazine turns 45 Schulze, Jack 164, 227, 230-1, 232 social media 35, 47, 48, 146, 167 194, 227, 229, 232, 233 see also software 16, 24, 29, 91, 95, 164, 186, Speak 90. 91, 115, 141, 179, 181, 196

straplines 119, 209 studio managers 18, 166 advertising style 144 and branding 35, 42, 73, 83, 91, 141, 142, 143, 156 defined 142 design style 143-4 editorial style 143 house style 83, 197 style sheets 21, 82, 106-7, 114, 197, sub-decks see stand-firsts subeditors 14, 21, 87, 114, 118, 129, 160.185 subheads 87, 110, 114, 118, 158, 175 Substance UK 70 Sudic. Devan 146 The Sunday Times Magazine 34 SuperCal (BERG) 186 supplements 23, 31, 34, 52, 55, 65 see also named supplements Sykes, Suzanne 225 tablets 23, 230 development of 23, 59, 60, 226 importance of 10, 14, 16, 19, 29 navigation 16, 60, 166, 167 see also iPads tag-lines 64, 87. 117 Tang, Kam 48 Tentaciones (El Pais) 65-6, 220 Texas Monthly 224 3D techniques 171, 186 Time Out 64, 66, 67, 124 The Times 26, 92, 160, 161, 168, 192, Toscani, Oliviero 220 Town (prev. About Town) 179, 210 Turley, Richard 32-3, 218 turn arrows 119, 120 Turner, Jim 69, 171 Twen 53, 80, 84, 100, 119, 187, 212, Twitter 12, 32, 37, 126, 146, 206, 227, type/typefaces capitals see drop caps; initial caps custom-designed 183, 185, 199 expressive use of 177, 179, 181. 182, 216, 221 finding 182 in layouts 110, 112, 114, 133, 134, 143-4 myths about 96 selecting 70, 112, 139, 143-4, 156, 173-7, 184 serif vs. sans serif 118, 121, 139. 174, 176, 180 woodblock 70, 182, 184, 221 see also fonts typography 86-91, 95, 96 branding 42, 88, 177, 182, 183 brief 106-7 digital media 29, 86, 91, 92, 161 digital techniques 48, 55, 57, 59, 183, 185 interpreting text 116-17, 179, 181, 182, 217 letterpress 182, 183, 221 logos 34, 70, 73 magazines 55, 57, 70, 82, 83,

173-4 newspapers 15, 16, 27, 28, 47, 92, 174, 176, 177, 180 playing with 70, 117, 177, 179, 219 style sheets 106-7, 197 supplements 31, 34, 90 see also fonts; type/typefaces VanderLans Budy 55 91 Vanidad 73, 182, 185, 220 Vanity Fair 24, 73, 207 Venezky Martin 10 87 90 91 115 121-2, 141, 148, 179, 181, 182, 196, 197, 198 Visionaire 143 Vogue 50, 55, 59, 73, 179, 207, 217 Vogue Paris 84, 173, 217 WAD 65 87 Wallpaper* 10-13, 42, 48-9, 73, 87, 98, 99, 167 Warhol, Andy 53 Watson, Steve 47 Watts, Michael 99, 101 the web 8, 21, 24, 59, 82, 98-9, 119 see also websites Webb, Matt 230 websites 23, 24, 29, 44, 57, 95, 166 226-7 see also named websites Weekend magazine (The Guardian) Weidmann, Micha 67 white space 15, 46, 83, 84, 85, 99, 114, 129, 130, 135, 201 WIRED 12, 18, 24, 59, 65, 68, 82, 190, 218, 224 Wolf, Henry 50, 70, 211 Wolsey, Tom 179, 210 Woodward, Fred 219 zines 30, 48

Zembla 59, 79, 115, 117, 179, 181, 184,

圖片來源

6, 73, 182b, 185b, 204, 220 Courtesy Fernando Gutiérrez: 8, 65tr Courtesy WAD magazine; 9tl, 86 Courtesy Numéro magazine; 9tr Paper Sky; 9bl Courtesy Time Out Group, August 11-18 1993, no. 1199; 9br FT Business cover 26.02.00. Photographer: Gareth Munden; 11-13, 49, 98 Courtesy Wallpaper* magazine; 14 Photographer: Cath Caldwell; 15 @ Guardian News & Media Ltd 2013; 16t © Guardian News & Media Ltd 2013. Photographers: Darren Kidd and Erci Ogden / Retna; 16b © Guardian News & Media Ltd 2013. Photograph © www.lfi.co.uk; 17, 162, 165t © Guardian News & Media Ltd 2013. Courtesy Mark Porter. Creative Director: Mark Porter. @ Mark magazine. Designer: Jeremy Leslie. Coding: Tim Moore. Design Assistant: Esa Matinvesi; 20 Courtesy Gemma Stark, Net-a-Porter; 21 Courtesy John Belknap, Jewish Chronicle; 22, 34tr, 34b, 65bl, 65br, 66r, 79r, 85b, 90, 113br, 114, 116b, 117, 123t, 135, 136t, 149, 159, 178t, 189 The New York Times Magazine. Courtesy Janet Froelich; 25, 37bl, 37br Real Simple magazine. Courtesy Janet Froelich; 26, 92-94, 160-161, 168, 193, 232 Courtesy Jon Hill, The Times; 27, 199tr, 218 Publico: Creative Directors: Mark Porter and Simon Esterson. Publico Design Director: Sonia Matos; 30, 62, 65tl Courtesy www.adbusters.org; 31t Courtesy San Francisco Economist Newspaper Limited, London, November 17, 2012; 32 Creative Director: Richard Turley. Photo Illustrator: Justin Metz; 33t Creative Director: Richard Turley. Graphics Director: Jennifer Daniel; 33bl Creative Director: Richard Turley. Illustrator: David Folvari; 33br Creative Director: Richard Turley. Illustrator: Noma Bar; 34tl The New York Times Magazine. Courtesy Janet Froelich. Photographer: Raymond Meier, 35, 631, 169b Courtesy M-real magazine; 36, 103t, 144 Courtesy Carlos magazine; 37tl, 37tr, 60-61, 228 Courtesy Flipboard; 38-39 Designer and Photographer: Salomi Desai (sdesail.workflow.arts.ac.uk); 40, 42-43 Courtesy Wallpaper* magazine. Illustrator: Noma Bar, 44, 89b, 113bl Courtesy El País; 45 @ Guardian News & Media Ltd 2013. Photograph: Reuters / Namir Noor-Eldeen; 46 Boston Sunday Globe; 47 Courtesy Andrew Diprose, The Ride Journal. ILoveDust / Shan Jiang; 48t Courtesy Fire & Knives. Art Director: Rob Lowe. Illustrator: Marie Claire-Bridges. Editor: Tim Hayward; 48b Courtesy Pop Sox Designed and printed by Mr Edwards; 50, 661 Images courtesy of Esquire magazine / Hearst Corporation: 51, 102t, 208, 211, 217tl Images courtesy of Harper's Bazaar magazine / Hearst Corporation; 52, 215 Courtesy Hapshash and the Coloured Coat; 53 Interview magazine, August 1972, Liza Minelli. Photographer: Berry Berenson. Designer: Richard Bernstein. Courtesy Brandt Publications, Inc.: 54 Cover image by Annie Leibovitz, Rolling Stone, No. 335. January 22, 1981, © Rolling Stone LLC 1981. All Rights Reserved. Reprinted by Permission; 55, 172b, 179b Designer: Rudy VanderLans / Emigre; 56l Courtesy Jeremy Leslie; 56r David King Collection. Designer: David King; 57t Courtesy Dazed & Confused. Photographer: Rankin; 57b, 81b ©www.PYMCA.com; 58 Photographer: Lachlan Bailey, MAO/Model: Magdalena/*Vogue* Paris/Vogue.fr © Condé Nast Publications Ltd; 59, 78-79, 115t, 181t, 184, 221 Courtesy Vince Frost, Frost Design. Editor: Dan Crowe. Creative Director: Vince Frost. Designer: Matt Willey; 63r Courtesy Pop magazine; 64tl, 83, 128 Courtesy Loaded magazine / Blue Publishing Ltd; 64tr Courtesy Time Out Group, January 13-19 1978, no. 406; 64br, 172tl Courtesy The Independent; 671 @www.PYMCA.com. Art Directior and Designer: Scott King and Earl Brutus; 67r Courtesy Time Out Group, December 14-21 2005, no. 1843; 68 Courtesy Scott Dadich. WIRED © Condé Nast Publications Ltd; 69, 89t, 123b, 139t, 170r, 185tl, 185tr Courtesy Flaunt magazine; 70tl, 71 The New York Times Magazine. Courtesy Janet Froelich. Photographer: James Wojcik; 70tr The New York Times Magazine. Courtesy Janet Froelich. T by Philippe Apeloig; 70b The New York Times Magazine. Courtesy Janet Froelich. Photographer: Stephen Lewis; 74-75 Designer: Jetmire Dvorani (jetmiredvorani.wordpress.com); 76 Photographer Nick Knight. Vogue © Condé Nast Publications Ltd; 80, 85t, 100b, 119t, 119m, 119br, 187, 212-213 Twen magazine; 81tl, 173b, 210 Collection Tony Quinn; 81tr, 122, 137b, 157b, 177 Courtesy Metropolis; 82, 97, 141t, 216 Courtesy Neville Brody, Research Studio Ltd; 84 Vogue par Sofia Coppola, Sofia Coppola. Photographer: David Sims, Art Partner - © Vogue Paris © Condé Nast Publications Ltd; 88, 96, 118, 129 Courtesy Het Parool; 91 Courtesy Speak magazine. Photographer: Ira Nowinski; 100t Courtesy Metropolis. Photographer: Sean Hemmerle; 101 © Guardian News & Media Ltd 2013. Photograph: Allsport/Getty Images; 102br © Guardian News & Media Ltd 2013. Illustrator: Marian Deuchars: 103b Courtesy Metropolis. Illustrator: Christopher Silas Neal; 104 Image courtesy Paul Davis/Illustrated Ape magazine www. theillustratedape.com; 105t Courtesy Eat Creative. Creative Director: Steve Martin. Art Director: Tin Brown. Writer: Antony Head, Photographer: Satomi Ono; 105bl, 105br, 137t, 138bl, 199tl, 199b Courtesy I.D. magazine; 106-107 Photographer: Jordan Harrison-Twist; 108 © Guardian News & Media Ltd 2013. Courtesy Simon Esterson; 112t © Guardian News & Media Ltd 2013. Courtesy The Observer, Photographer: Murdo MacLeod: 112b, 116t, 121, 176 Courtesy Fishwrap magazine; 113t, 182m Courtesy Inner Loop; 115b, 181b, 196bl Courtesy Speak magazine; 119bl iStock; 120 Graphic International; 124, 125t Courtesy Port magazine. Designer: Matt Willey; 127 FT Business. Photographer: Sasha Gusov; 130, 174t Courtesy Dagens Nyheter, 133, 158, 182t, 197 Courtesy (inside) magazine www.australiandesignreview.com; 134 Courtesy Metropolis. Photographer: Michelle Litvin; 136b Courtesy Esopus. Photographer: © 2004 David Michalek; 139b Courtesy Dazed & Confused; 140 Courtesy Metropolis. Photographer: Conrad Kiffin; 141b Courtesy Speak magazine, Illustrator: Brad Holland, Photographer: Steve Sherman; 142, 192t, 226 Courtesy Mario R Garcia, Folha de S.Paolo; 1451 Courtesy soDA www.soDA.ch, Benjamin Güdel www.guedel.biz; 145tr Courtesy Pariscope; 146-147 Courtesy Simon Esterson; 150 Designer: Joseph Marshall (www.josephbisatmarshall.co.uk); 151t Designers: Stefan Abrahams, Rebecca Duff-Smith, Jasmine Jones and Hudson Shively; 152, 219 Courtesy Gail Anderson; 156 @ Guardian News & Media Ltd 2013; 157t Courtesy soDA www.soDA.ch, Alex Capus - www. alexcapus.de / Benjamin Güdel - www.guedel.biz / Marc Kappeler - www.mojre.ch; 163, 174b Courtesy Mirrorpix; 164, 165m, 165b, 167, 231 Berg Ltd and Bonnier AB; 166 Courtesy Jon Hill; 1701 Courtesy soDA www.soDA.ch, Courtesy soDA. Marc Kappeler - www.moire.ch; 172tr Courtesy Tank magazine. Thierry van Biesen; 173t Vogue Paris © Condé Nast Publications Ltd;

178b, 179t, 214 Courtesy David Hillman; 180t © Guardian News & Media Ltd 2013. Photograph: Francesca Yorke 2006; 180b @ Guardian News & Media Ltd 2013. Photograph: Getty Images; 183 FT Business. Courtesy: Alan Kitching; 186t Courtesy Amelia's Magazine. Art Director: Amelia Gregory. Illustrator: Rob Ryan; 186b Courtesy Esopus. Ghost Form, 2004 © William Christenberry; 190, 191tl Courtesy Radio Times © BBC Worldwide Limited; 191tr Courtesy Radio Times © BBC Worldwide Limited. Illustrator: Lyn Gray; 191b Courtesy Radio Times © BBC Worldwide Limited: Illustration: Richard Draper; 192b @ Guardian News & Media Ltd 2013. Grundy Graphics 2006: 194 Courtesy Stern: 195 @ The Economist Newspaper Limited, London, August 26th-September 1st 2005; 196br Courtesy Speak magazine. Illustrator: Austin Cowdall / New Studio; 200 @ Guardian News & Media Ltd 2013. Courtesy The Observer, 201t Courtesy Stern. Photographer: Vincent Laforet/Polaris; 201b Courtesy Stern. Photographer: Volker Hinz; 202 Designer: Sandra Audukaite; 203 Joint project by Ben Silvertown (bensilvertown.com), Iliana Dudueva, Manon Dafydd and Violetta Miller. Portrait of Haley Ma: © Tate; 207 Vanity Fair © Condé Nast Publications Ltd: 209 Courtesy Seventeen magazine / Hearst Corporation; 217tr Vogue Italia © Condé Nast Publications Ltd. Photographer: Barry McKinley. Stylist: Krizia; 222t, 222m Real Simple magazine. Courtesy Janet Froelich. Photographer: Rodney Smith; 222b Real Simple magazine. Courtesy Janet Froelich. Christopher Griffiths; 223 Real Simple magazine. Courtesy Janet Froelich. Photographer: Robert Maxwell 224t Courtesy Scott Dadich, The New Yorker © Condé Nast Publications Ltd; 224m, 224b Courtesy Scott Dadich; 225 © Grazia magazine. Courtesy Suzanne Sykes; 233 Real Simple magazine. Courtesy Janet

作者謝辭

特別感謝所有圖片提供者與側寫者,尤其是珍妮,佛羅里克、 瓊恩,希爾、馬克,波特、莎拉,道格拉斯、傑瑞米,雷斯 里、理查,德利與史考特,丹第齊。

感謝羅倫斯·金出版公司(Laurence King Publishing)所有成員高超的編輯能力,特別是彼德·瓊斯(Peter Jones)與蘇珊·喬治(Susan George),以及瑪麗·威斯特(Mari West)的圖片編輯。

感謝中央聖馬丁學院平面設計系的學生,慷慨分享工作坊中提到的作品:史蒂芬·亞柏拉姆團隊、珊卓拉·奧圖凱提、奧立佛·巴隆(Oliver Ballon)、莎樂米·德賽、伊蓮娜·杜德娃(Iliana Dudueva)、傑特邁爾·德弗朗尼、喬登·哈里森-特威思特、約瑟夫·馬歇爾、班·席維爾唐團隊。

謝謝我父親艾迪·柯德威爾(Eddie Caldwell),身為排版員的他鼓勵我畫圖,喜愛印刷。也要感謝我先生約翰·貝克奈普(John Belknap)給我建議,送上一杯杯的熱茶。還要感謝山姆(Sam)、艾德(Ed)與黛西(Daisy)的耐心。謝謝凱倫·西姆斯(Karen Sims)與海柏里圖書俱樂部(Highbury Book Club)的支持。

也要感謝中央聖馬丁學院畢業的尤蘭達·澤帕特拉(Yolanda Zeppaterra)。她在 2007 年的紙本印刷年代,完成本書內容精良的初版。